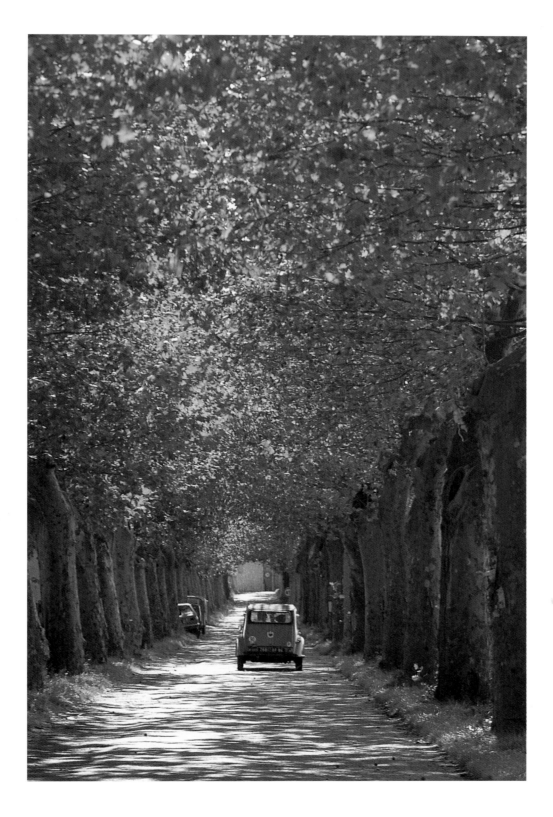

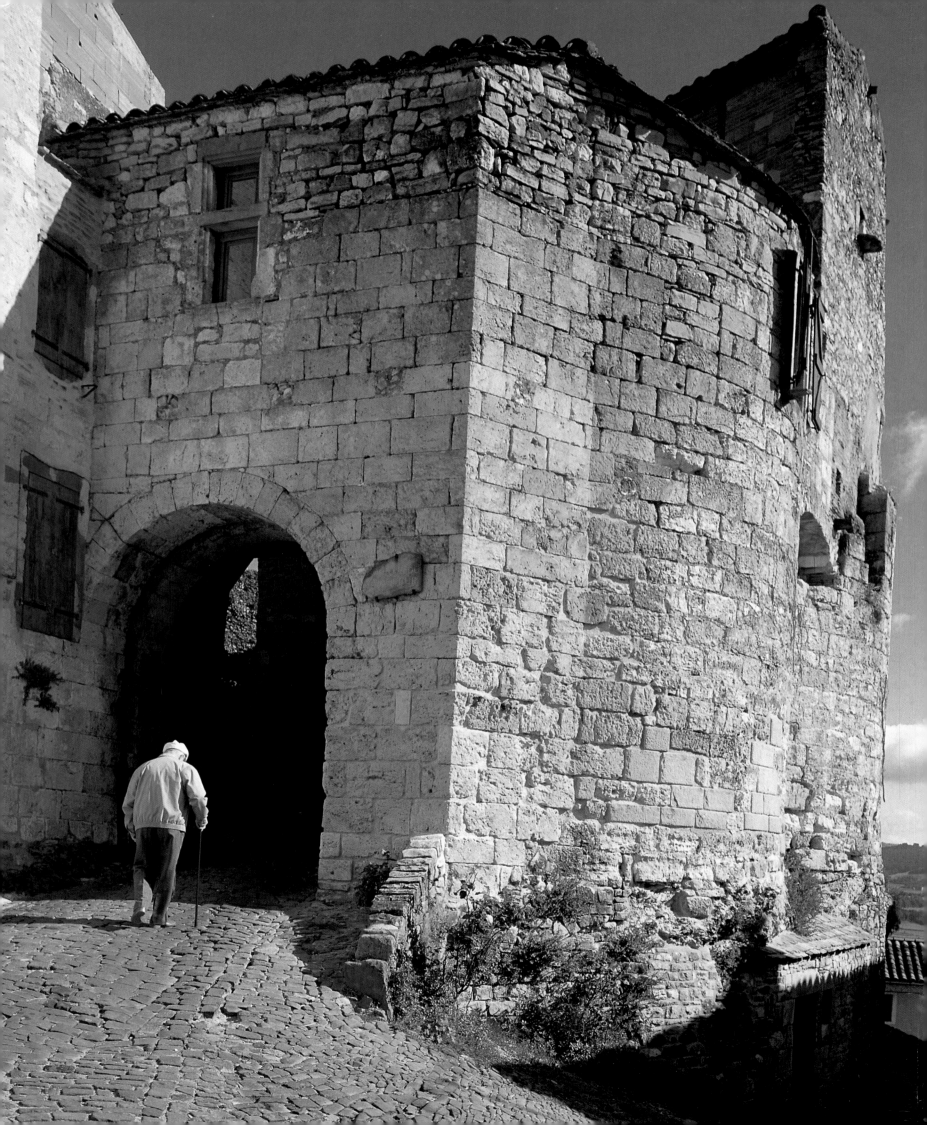

To Live in France

James Bentley

PHOTOGRAPHS BY
Michael Busselle

With 260 color illustrations

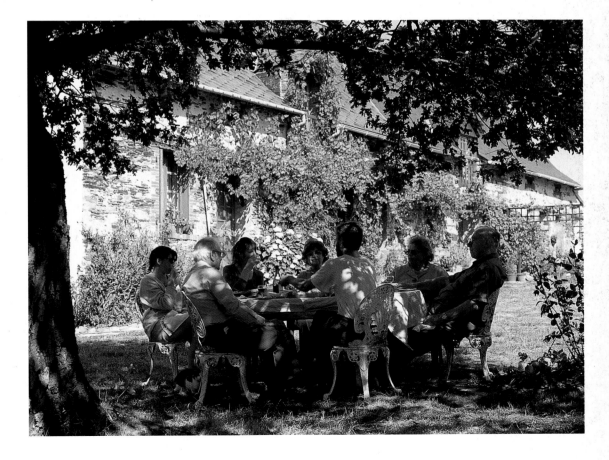

Thames and Hudson

AUTHOR'S ACKNOWLEDGMENT
James Bentley wishes to extend his thanks to *Small Luxury Hotels of the World* for their help during the preparation of this book, especially for the hospitality he enjoyed at the Château de Bellinglise at Élincourt-Sainte-Marguerite.

PHOTOGRAPHER'S ACKNOWLEDGMENT
Michael Busselle would like to thank Michele Fox of Eurotunnel for her very kind help with his travel arrangements for his many journeys to France during the shooting of the special photography for this book.

Half title

An avenue of trees and a 2CV, quintessential France, near Bagnols-sur-Cèze, Gard.

Frontispiece and title page

The best of past and present: France's culture is rich both in historical memory and the delights of today. In the middle of the thirteenth century Count Raymond VI of Toulouse created a fortified town which he named 'Cordoue', after the Spanish city of Cordoba. Today, it is called Cordes. The town was surrounded by a double row of fortifications, pierced by defensive gates, such as the one shown here, protecting a group of medieval houses as beautiful as any in the south-west of France. **Contentment for many French people still includes eating with friends and neighbours in the open air. To eat in France is to converse, to communicate and enjoy the fruits of the land.**

This classical fountain (opposite) **plays quietly in Vaison-la-Romaine in Provence, a place which today preserves both Roman remains and a medieval heart.**

© 1997 Thames and Hudson Ltd, London
Text © 1997 James Bentley
Photographs © 1997 Michael Busselle

First published in the United States of America in 1997 by Thames and Hudson Inc., 500 Fifth Avenue, New York, New York 10110

Library of Congress Catalog Card Number 97-60323
ISBN 0-500-01796-4

Printed and bound in Singapore

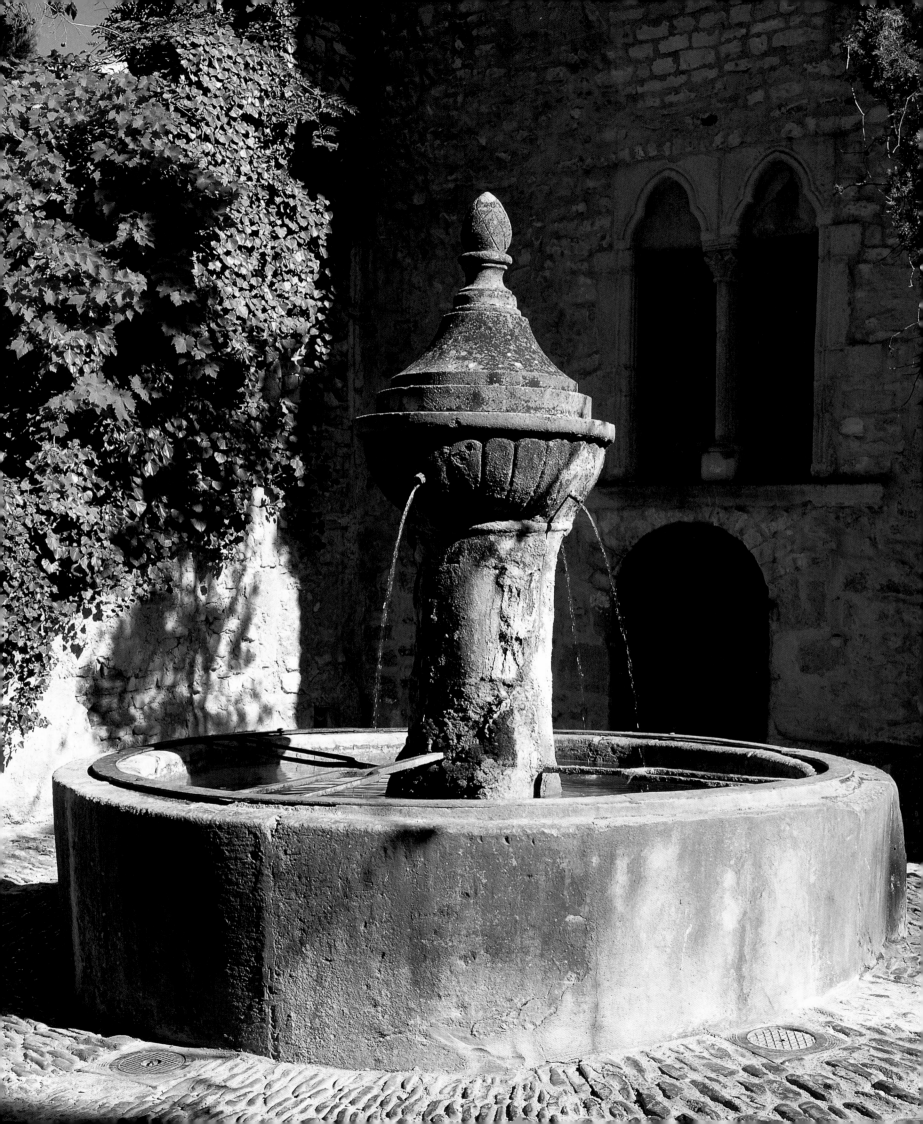

Contents

To describe the life of France outside the cities and large towns is to evoke the many-sidedness of the country: the diversity of village and small town; the complexity and richness of its landscape; the glories of regional gastronomy; the distinctive cultures and crafts of the people.

Blessed with three major coastlines, on the Channel, the Atlantic and the Mediterranean, the ports, fishing villages, cliffs and beaches of France offer social and geographical variety, to say nothing of a sea-food gastronomy without equal. The Opal Coast of Normandy, so-called because of the milky-white seas which wash its shores, finds a visual counter-balance, by way of the magnificent beaches of the Atlantic, in the violent greens of the southern vineyards, the hot reds of the Côte Vermeille and the ochre cliffs of Provence on the Mediterranean.

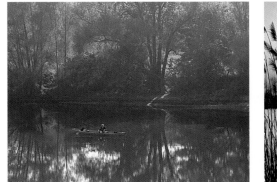 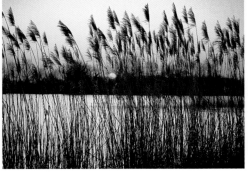 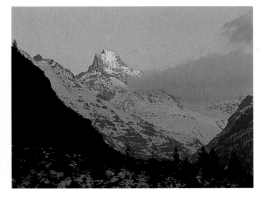

Until the last century, the communities of France were largely connected by waterways and river traffic. Many *départements* take their names from rivers – Marne, Loiret, Lozère and Somme. The mighty and varied waterways of Loire and Rhône are equalled in charm and often in splendour by the diverse scenery and dramatic gorges of such as Dordogne, Lot and Tarn, while more tranquil waters flow by the vineyards and villages of Burgundy and Champagne.

The wetlands and lakelands of France are famous for their game and gastronomy. Savoy has the greatest lakes in France, but scarcely less beautiful are the wetlands and marshlands of the Sologne and Normandy, breathing adventure and mystery, and offering a feast for wildfowlers and fishermen. The many French forests are especialy popular in the autumn hunting season; those of the Ile-de-France, especially, are reminders of this sport of nobles.

From the 'Swiss Alps' of Normandy to the true Alps of the east, lovers of uplands and mountains are superbly catered for in France, often in the form of national and natural parks. Wild and alpine landscapes characterize the great mountain complexes: the Pyrenees, Jura and the peaks of Savoy. But below such heights are gentler slopes, like those of the Lubéron in Provence, familiar to Francophiles everywhere and the location of some of the most beautiful villages of France.

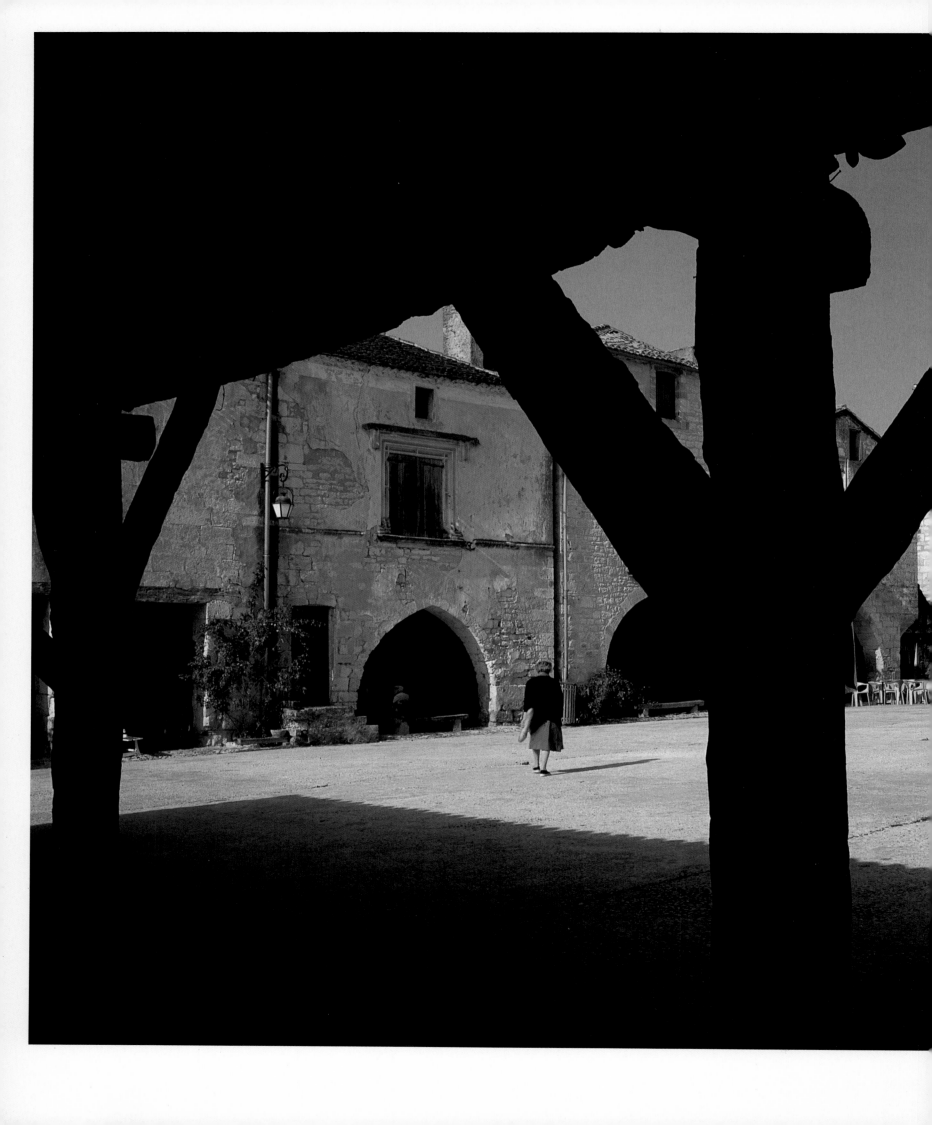

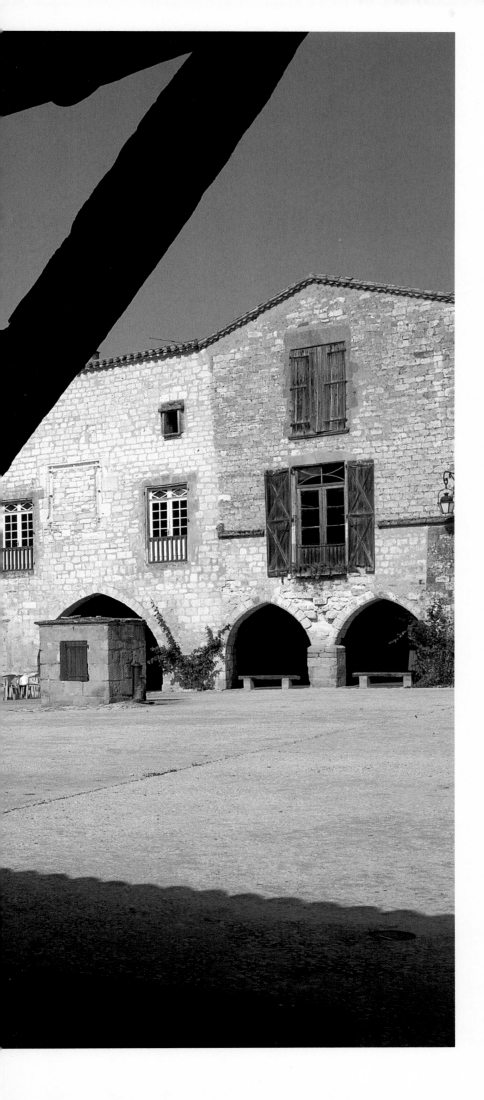

'ONLY FEAR CAN UNITE THE FRENCH,' declared Charles de Gaulle. 'You cannot weld together a country that has two hundred and sixty-five different kinds of cheese.' The diversity implied in that remark is the concern of this book: to explore and exult in this varied country, seeking its many flavours outside the cities and large towns. Evoking this France is to expound the many-sidedness of the country: the complexity and richness of its landscape; the charm of village and small town; the ripe glories of regional gastronomy; the distinctive cultures and crafts of the people. This is a France to be lived in, to be explored by type of countryside and *terroir*, the country of three coasts, of river and valley, of forest, lake and wetland, of upland and mountain. Many different faces of the country emerge, but each reveals how over the centuries Frenchmen and women have responded to their God-given territories and in part transformed them.

The reminiscences of two distinguished English-speaking literary men, Hilaire Belloc and Henry James, encapsulate in their different ways the variety of France. 'I was

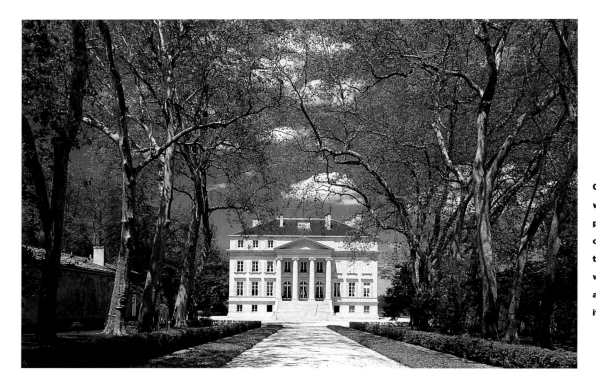

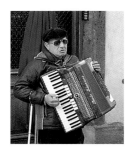

Château Margaux (left), with its splendid Grecian portico, was built in 1804 on the profits of one of the most celebrated wines of the Médoc, and as a symbol of pride in its excellence. The **blind accordianist** (above) is a native of another region of great viniculture, Alsace, where German traditions mingle with French skills to produce uniquely flavoured wines.

Preceding pages

The market-place of Monpazier is the glory of one of the finest small towns in south-west France. The tradition of selling at market is still vigorous throughout France, a practice wonderfully encapsulated in this photograph of a farmer and his produce near Colmar, eastern France.

an hour or more going down the enormous face of the Jura, which here is an escarpment, a cliff of great height, and contains but few such breaks by which men can pick their way,' wrote Belloc in 1902. 'It was when I was about half-way down the mountain side that its vastness most impressed me. And yet it had been but a platform as it were, from which to view the Alps and their much greater sublimity.' In 1884, in a totally different part of France, as he travelled by train from Tours to Le Mans, Henry James had been equally delighted: 'The country was charming – hilly and bosky, eminently good humoured, and dotted here and there with a smart little château.'

The remarkable variety of France stems not only from the different terrains of this expansive country, for it also applies to the customs and gastronomy of all its regions. For many centuries after the Roman occupation, France lacked easy means of communication, apart from its rivers. Metropolitan France was relatively slow in being formed. Local differences continued, even after the establishment

of the road system, and still flourish.

As well as reflecting on the geographical variety of France, Hilaire Belloc also wrote of the splendours of French wine: 'Though man made wine, I think God made it too... Praised be God! Who taught us how the wine-press should be trod.' Since France prides itself on its superb wines, annual wine fairs abound.

There are few better illustrations of the sheer richness in variety of the many parts of rural France than the vineyards of the Bordeaux region, in particular those of the Médoc, where the Cabernet Sauvignon grape reigns supreme. For a long time, wine was the principal French export, much of it to England and the Low Countries through the port of Bordeaux. By the thirteenth century the trade was already substantial, a factor perhaps in the Bordelais retaining an allegiance to the English throne long after other parts had begun to form themselves into greater France. The dense historical fabric of life in the Médoc has strengthened over the years, yet is not untyp-

ical of the density of culture and social history in many a highly individualized French region. One of the Médoc's *premiers crus*, the Château Margaux, for instance, was acquired by the Comte d'Hargincourt in 1768; the Comte was the godson of Mme. Dubarry, mistress of Louis XVI. D'Hargincourt was executed during the Revolution, and Margaux was then briefly state-owned, before passing into the hands of the Marquis de la Colonilla in 1804, from when dates the elegant First Empire building which stands today and proudly decorates the label of the Château's wine.

Less grand, more homely, is the cultural variety best expressed in the many weekly markets in countryside France, which often combine with the monthly or annual fairs of France. Some of these are rare treats: the annual apricot fair at Rivesaltes in the Pyrénées-Atlantiques; the garlic festival held on 24 June at Uzès; the fair of the Magi, on the Saturday before Epiphany, at Brive-la-Gaillarde; the black and white pudding fair held from 1 to 15 March at Mortagne-au-Perche, Normandy; and the pumpkin and rare vegetable fair held on 16 October at Tranzault, Indre. The nineteenth-century Félibrige movement, notably inspired by the Provençal poet Frédéric Mistral (*d.* 1914), led to a revival of numerous ancient festivities, and today the citizens of many a French village and town regularly don traditional costumes and dance age-old dances. While for daily relaxation, everywhere Frenchmen and women still play the traditional game of *pétanque*, while the Basques devote themselves to *pelote*.

Religious festivals still play a significant part in rural France. And places of pilgrimage still attract many visitors – among them those to venerate the Black Virgins of Rocamadour in the Lot and of Notre-Dame-de-Vassivière on Le Mont-Dore in the Auvergne, to follow the pilgrimage routes to Santiago de Compostela in Spain, and to attend the Pardons of Brittany. These last, based on patronal festivals, were revived in the nineteenth century and flourish today.

And the routes to Santiago de Compostela are enhanced not only by superb churches but also by the hospices where pilgrims would stay and by the statues of the saint which they would venerate. These pilgrimages modified church architecture, the astounding variety of which never ceases to amaze visitors to France. To accommodate worshippers who needed to pray before the shrines of saints, churches now added an ambulatory, a 'space for walking', where the sanctuary was surrounded by continuous aisles. In these, pilgrims would kneel in a series of chapels built around the apse, and the ceremonial processions could follow the same progress. The splendours and stylistic variety of such religious masterpieces as the Gothic cathedral of Rouen and the fortified one at Albi are often matched by the charm and fascination of many a rural church, which is the focal point of a village. That of Salviac in the Lot, founded in the fourteenth century by the Bishop of Albi, circles delightfully around its fifteenth-century church, a model of planning repeated endlessly thoughout the country.

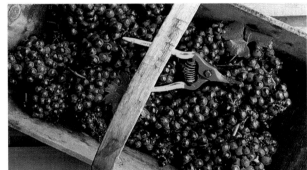

Changing patterns of secular architecture have also enhanced French towns and villages. Fortresses developed out of the old defences; these fortresses were often transformed into castles; and as the Hundred Years' War and the Wars of Religion came to an end many such castles gradually became gracious Renaissance homes and later classically regular residences. Frequently the owners of these châteaux preserved the older buildings while adding newer ones.

This, then, is the variety of France, 'a compleat self-sufficient Country, where there is rather a Superfluity than Defect of anything' – an observation as true today as when the seventeenth-century royalist and allegorist James Howell made it. Gorges, opulent plains, long and meandering rivers, the mountains of the Jura and the Massif Central, the high Pyrenees and a wealth of villages – some built of rose-pink stones, others gleaming white, others with houses whose walls seem to crumble in the sun yet miraculously stay upright – this is not only the tourist's image of France but also the truth. And many such entrancing places and regions exist which few tourists explore or penetrate.

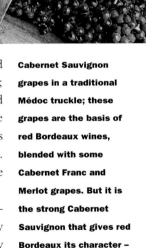

Cabernet Sauvignon grapes in a traditional Médoc truckle; these grapes are the basis of red Bordeaux wines, blended with some Cabernet Franc and Merlot grapes. But it is the strong Cabernet Sauvignon that gives red Bordeaux its character – high in tannin, growing gentler as it ages.

ALL THE PROVINCE, MOUNTAIN and river names of France, from the Limousin to the Lubéron, from the Lot to the Somme, are resonant with history; they also bespeak rich pastures and extensive plateaux dotted with massively fortified farms and villages with solidly built houses. The valleys are tree-shaded, many hills also wooded and some regions forested. Some of the undulating roads run as straight as the Roman roads which are their foundations. Speaking of northern France, the poet Paul Verlaine enormously relished this country of rivers whose present aspect is precisely that which he described. Sailing along the river Scarpe, he observed, 'Along the richly varied banks grew seemingly endless fields of cereals,

oats, wheat, rye and winter fodder. Pike slept in virtually bottomless pools, and eels swam amidst the stems of bulrushes and water-lilies. Black poplars, white willows and the tall grey grass shaded the river.'

This coast of Normandy is where most visitors to France first arrive, and so it is with Normandy that each chapter of this book begins, before making its way west, south and then east and finally to the centre and north of the country. The province is intimately connected with Britain, for in 1066 the illegitimate son of Duke Robert the Devil became William I of England. He and his wife built splendid churches there, but also founded two magnificent abbeys - one for men, one for women - at Caen.

Normandy is also notable for lesser but still entrancing buildings: its pigeon-houses, usually circular, some half-timbered, some dating back to the thirteenth century when the eggs and flesh of pigeons came to be particularly prized; buildings of granite, such as the church at Pontorson, founded by William the Bastard when, as he believed, the Blessed Virgin Mary had intervened to stop his army foundering in the quicksands of Coueson; wooden market-halls, such as that at Saint-Pierre-sur-Dives, which is pegged with chestnut stakes and dates back to the eleventh century; and ruined abbeys, such as the one founded in the Fontenelle valley in 694 by St. Wandrille, and many times rebuilt.

The lower half of this ancient farm (opposite) once sheltered Limousin cattle, famed throughout France for their russet-coloured beef; further south, spring blossom comes early in the natural park of the Lubéron (above). Rich produce enlivens this market-stall (right) at Cahors in the Lot.

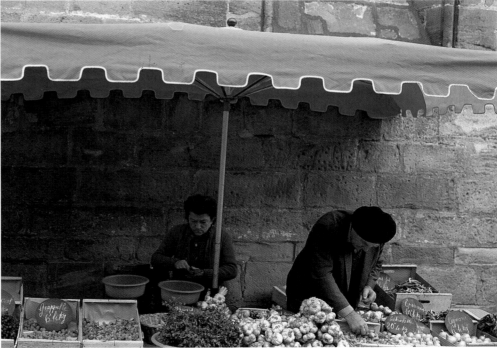

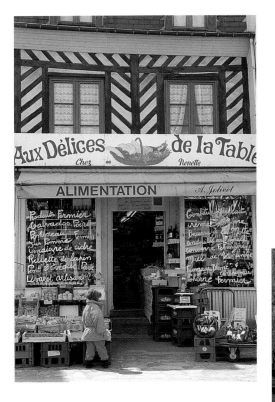

Carafes of cider are placed on Normandy tables. From time to time during a meal the local diners may take a glass of potent Calvados as a palate cleaner. Along with its neighbouring *département*, the Orne, that of Calvados glories in the cheese of the Pays d'Auge. But this is not the only famous Normandy cheese, as such evocative names as Camembert, Neufchâtel, Livarot and Pont-l'Évêque proclaim. And the diet is also rich because of *sauce à la Normande* (which is enriched by the milk of the region and by its *champignons*), and in part because of the succulent flesh of the game which teems in its forests and the sheep and cattle which graze its pastures.

This is also a land of fashionable seaside resorts, all of them developed in the nineteenth century. Deauville is the most expensive and the most stylish, but Cabourg runs it a close second and was the adopted home of Marcel Proust, while Trouville is probably the one most loved by Parisians. Reminders of other lovers of this coast are Honfleur, the haunt of painters, and Merville-Franceville, which still retains fortifications constructed in the eighteenth century to the plans of Vauban.

Nowhere is the variety of France more easily demonstrated than in the transition from Normandy to Brittany, province of saltpans, marshlands and heath. Fierce winds from the sea have eroded its rocks. Heather grows sparsely on some of the moorland hills, surviving on beds of quartz and sandstone. Elsewhere, trees survive the winds. Here are peat bogs, some of them today drained to provide lush pastures. In Brittany the occasional hill, such as the mere 610-metres-high Ménez-Hom which rises in one of the least domesticated parts of the land, seems like a mountain.

This *Alimentation* (food store) (above) at Beuzeville, west of Pont-Audemer, displays the half-timbered decoration typical of this part of Normandy; Beuvron-en-Auge, Calvados, one of the prettiest villages in France, has a splendid ensemble of such houses (right). Stone, too, has its charms, as in this ancient house in Loir-et-Cher (below).

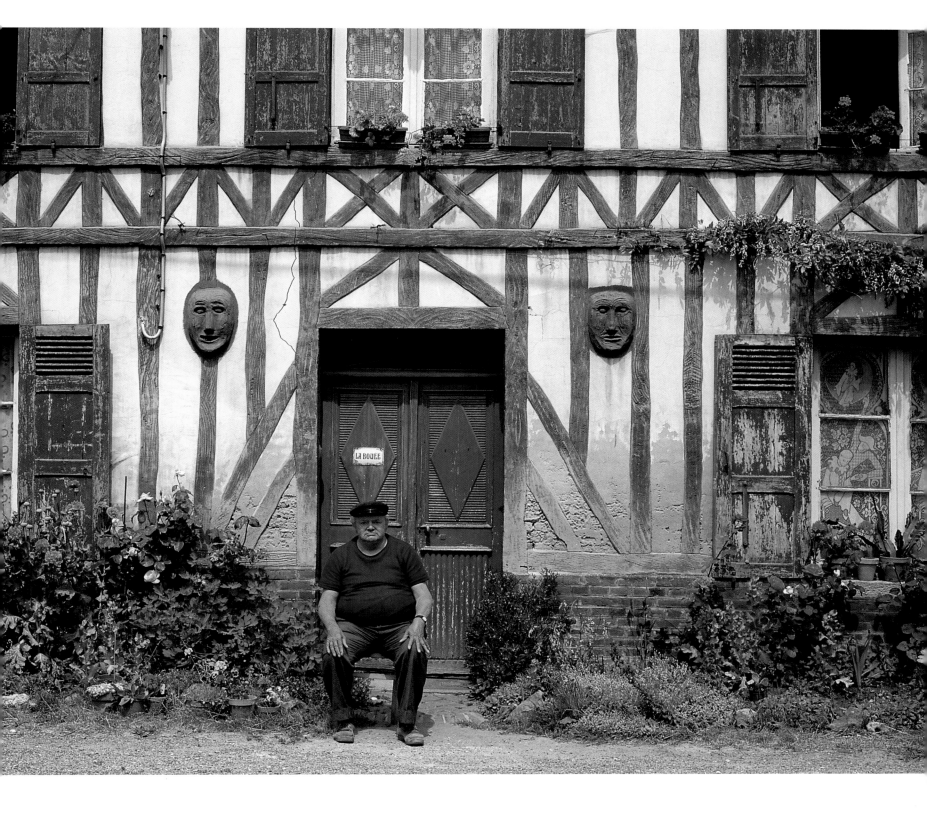

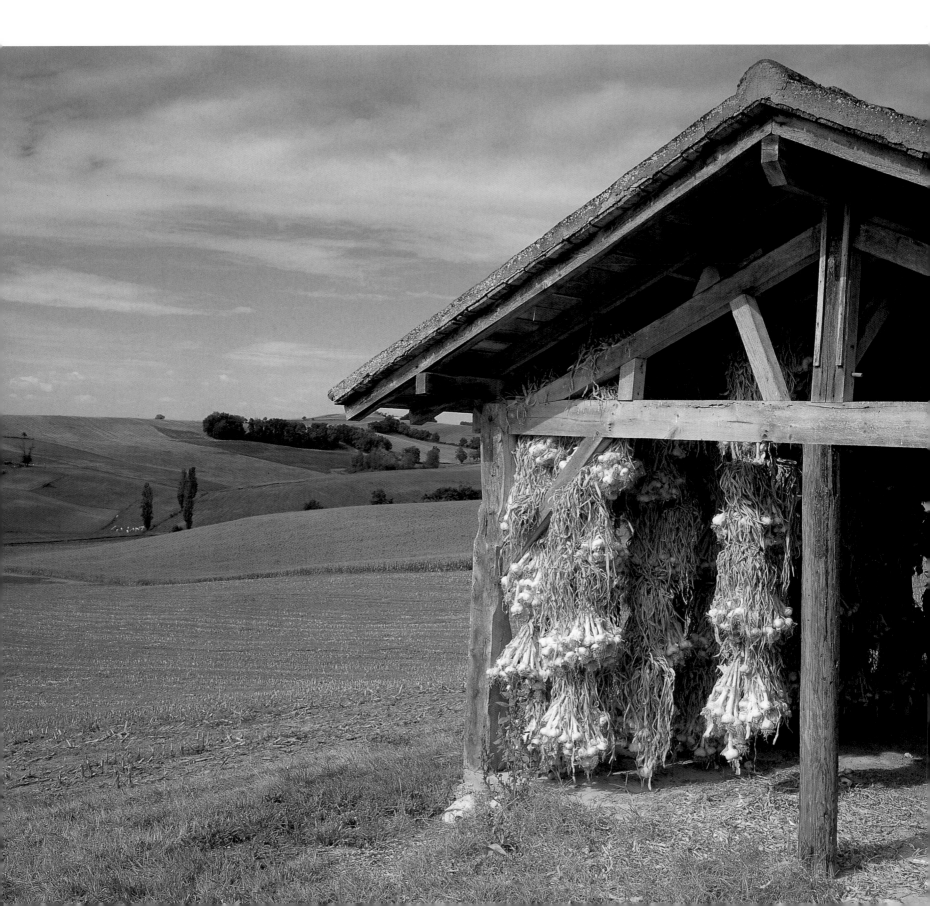

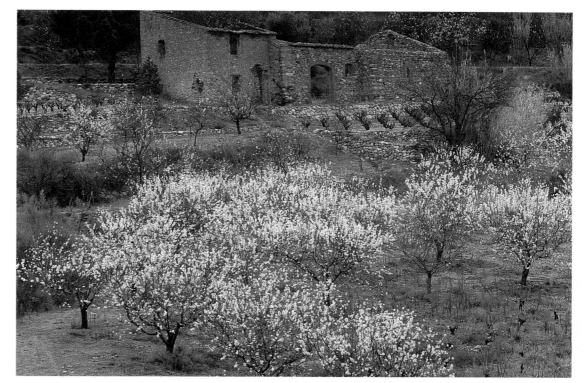

The valley of the Loire, the longest river in France (which rises in the Cévennes and flows for a thousand kilometres to the Atlantic), is entered by many other rivers: the Cher, the Creuse, the Indre, the Sèvre and the Vienne among them. Here the countryside is harmonious and enchanting, with hillocks and copses and sometimes massive trees. 'I kiss the view of the Indre', enthused Balzac during the writing of his novel, *Le Lys dans la vallée*, 'The silence is marvellous.'

The many faces of the region of Berry offer an even gentler France, though still varied. To the north between the river Sauldre and the forest of Vierzon the land is watered by many lakes and rivers. Further south, there is the scent of pine trees and moss on the air.

South of the Loire is the centre of France: the Limousin. This is a country of lakes, rivers. and noble forests, while Limoges heralds the uplands of the Massif Central and the volcanic country of the Auvergne, with its spas and domed hills. North-west is the Vendée, an exceedingly pretty country as Henry James described it.

To the south a new territory opens up, characterized not only by its topography but also by its language. The Languedoc is the land where for centuries the people have spoken *occitan*, a language (not a dialect) so-called because its word for 'yes' is not *oui* but *oc*. Quite apart from the word *oc*, many more words and phrases in *occitan* are quite different from 'official' French. As well as being linguistically exceptional, the Languedoc is so vast and varied that it constitutes a geographical entity in itself, a land of vineyards, torrential rivers, mountain scrublands, and forest.

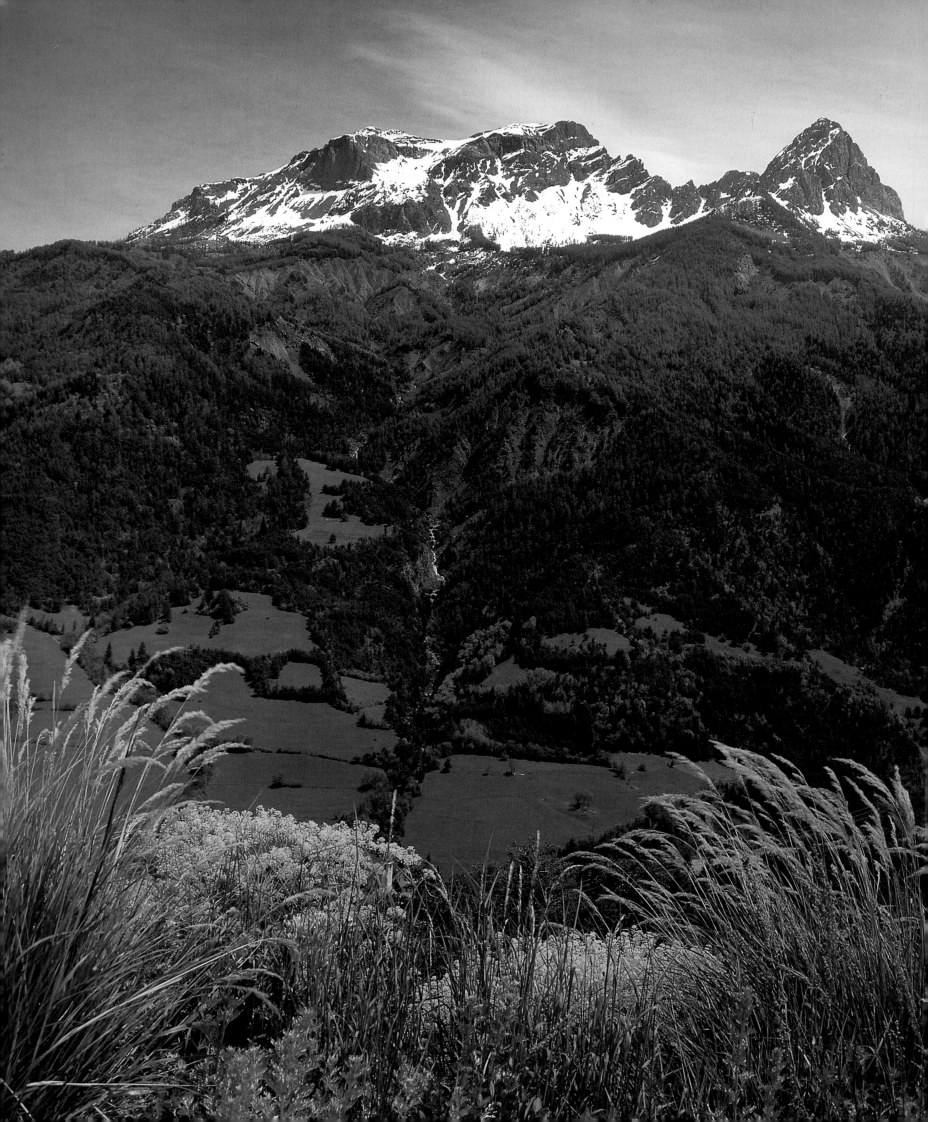

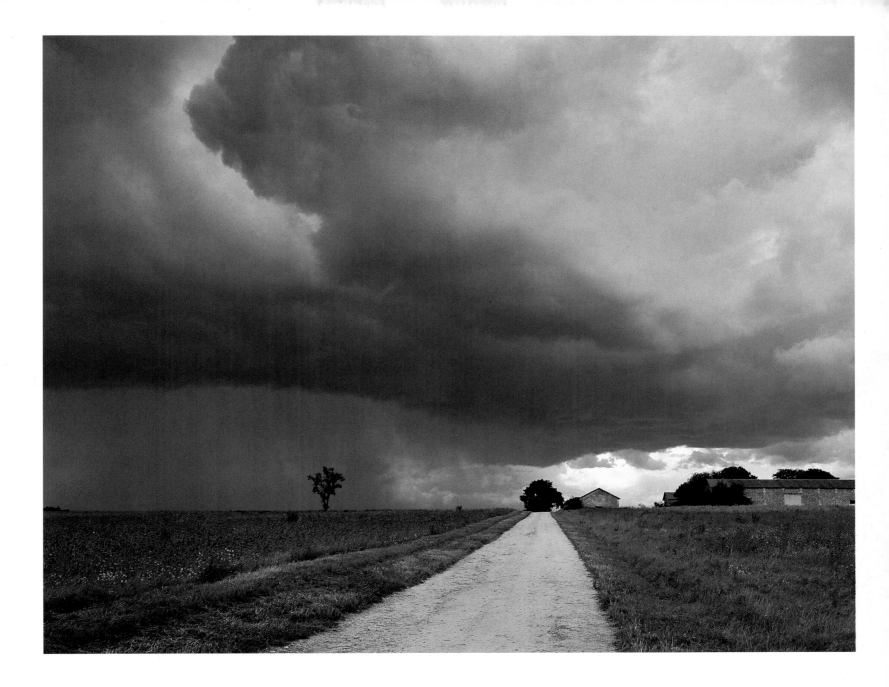

Mountain ranges add glamour and excitement to the diversity of France, notably the south-west (the Pyrenees) and the east, where the French Alps, some of which surpass 3000 metres, stretch from upper Provence north as far as Lac Léman, through the ancient provinces of Savoy and the Dauphiné. Here are found spas and glaciers, ski slopes and savage valleys, and in upper Savoy exquisite lakes. As for the Alpes-Maritimes, the painter Auguste Renoir declared that the light was the most beautiful in France. Here the valleys of the Var, the Tinée and the Vésubie have been dug by rivers rising in the massif of the Mercantour.

France is also a land of wildernesses and barely tamed regions, which nonetheless have made provision for intrepid visitors in the form of natural parks and well-marked routes. At the centre of the country, in the *département* of Allier, for example, beech trees, some of them three hundred years old, populate the forest of Tronçais, with its many lakes. The forest is threaded by paths set out for walkers. To the south, at the heart of the Cantal and taking up a good half of that *département*, rise the oldest volcanoes (now extinct) of the Massif Central. They are not massively high – the Plomb du Cantal reaches 1,855 metres, the Corne du Puy Mary 1,757 metres – but they are often inaccessible in winter.

West of the Cantal, the Corrèze is a land cut through by some 3,000 kilometres of water, which sometimes cascade and at other times have to be retained by dams. The least populated *département* of France is the Lozère, sliced in two by the valley of the Lot and known as the Lozére desert. Here, too, rise the rivers of central France.

On a gentler note, north-eastern France includes such charmingly diverse regions as Burgundy and Franche-Comté, Champagne-Ardenne and Alsace-Lorraine. Burgundy is threaded by several major rivers: the Seine, which flows north; the Armançon, flowing west to join the Yonne; the Arroux, flowing towards the Loire; and the winding Ouche, whose waters flow towards Dijon before enriching the Saône. As one local writer, Henri Vincenot, piquantly observed, of every half-a-dozen raindrops which fall on Burgundy, two end up in the English Channel, two in the Mediterranean and two in the Atlantic. 'Opulence' is the adjective that most springs to mind in the case of Burgundy - not only the opulence of its wines, whose aroma enhances such classic dishes as *coq au vin* and *bœuf à la bourgignonne*, but also the opulence of its Romanesque abbeys and the glamour of many of its multi-coloured tiled roofs.

This is a land of fortresses, of ancient monasteries, of fine houses, of quiet villages and above all of vineyards. It also boasts its own mountain, the Morvan (Celtic for 'black mountain'), where stand stone-built farmhouses with slate roofs and geranium-clad balconies. In western Burgundy, the Puisaye countryside is dissected by hedged roads offering glimpses, perhaps, of the tree-shaded river Loing, then winding through hamlets and beside village ponds. But the great glory of Burgundy, as of the Beaujolais to the south and Champagne-Ardenne to the north-east, is in the vineyards and their produce.

THE ARTS AND CRAFTS OF THE LAND

Appreciation of wine-making is deeply engrained in the souls of French country-men and countrywomen. The grape, the soil, the annual amount of sun and the annual amount of rain, all determine the amazing variety of French wines, as does the skill of the vineyard owners themselves. Vineyards are planted almost throughout the whole of France, the most northerly being those of Champagne. As for the grapes, Cabernet Sauvignon and Cabernet Franc dominate the Bordelais; Grenache and Syrah bring body to the Côtes du Rhône; Alsace has seven noble grapes;

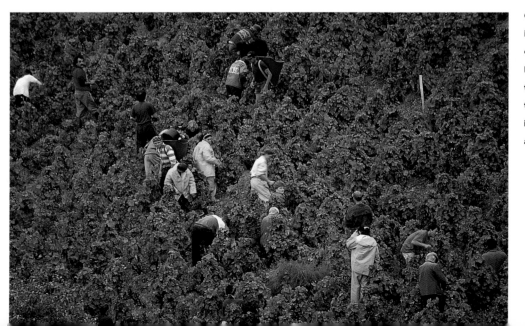

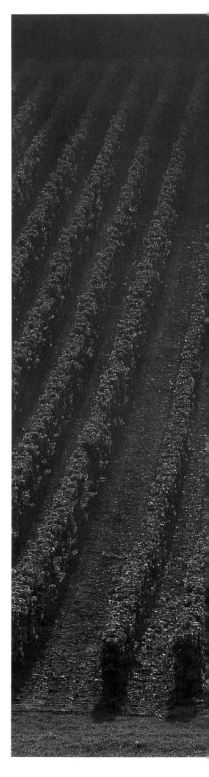

One of the most important sequences of rural activity in the French calendar is the tending of vines and the harvesting of grapes: in the Beaujolais (left), and Mâconnais (right).

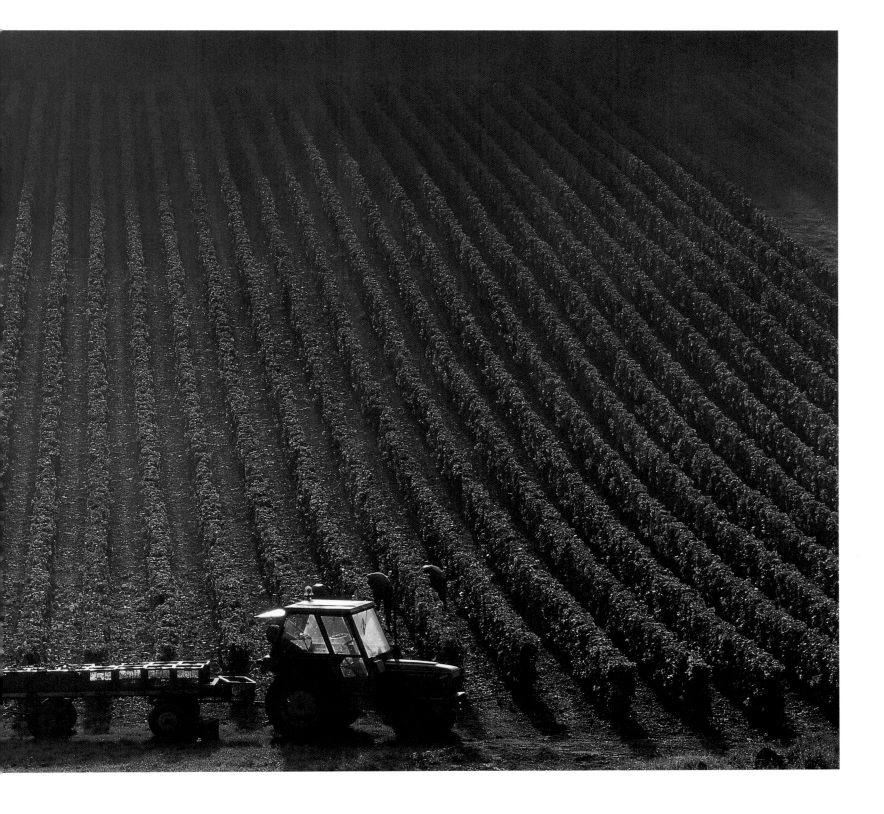

white, red and rosé wines are all produced in the Loire valley; replanted and replenished vineyards now flourish beside the Mediterranean coast; the majestic Pinot Noir and delicious Pinot Blanc enrich Burgundy; all create a depth and variety in the national wine production which remains unrivalled elsewhere.

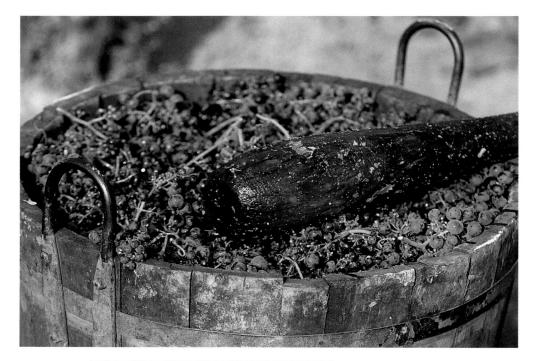

The care lavished on the making of wine is also found in many small craft-based industries throughout France. Saint-Véran in the Hautes-Alpes has preserved a tradition of intricate wood-carving. For over five centuries in the region of Lyons potters have created exquisite ceramics. The kaolin of Limoges is used to create world-famous porcelain, while the porcelain factory at nearby Saint-Yrieix-la-Perche dates back to 1775 and has consistently pioneered new designs and techniques. At Vallauris in Provence pots are still baked over wood fires. Grasse in Provence is the perfume capital of the world. The Basque town of Mauléon in the Pyrénées-Atlantiques is famous for its boots, *sabots*, sandals and above all for its rope-soled *espadrilles*.

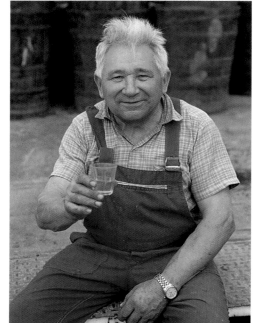

The ceramists of Limoges and Vallauris are relatively well-known, but the craftsmen in many obscure towns and villages produce exquisite work. There are, for instance, the stringed-instrument makers of the little town of Mirecourt, in the heart of the Vosges plain. Their workshops date back to the eighteenth century and possibly earlier, and were established by the Dukes of Lorraine.

Traditional crafts and industries flourish in the countryside around Langres in the *département* of Haute-Marne – cutlery at Nogent, basketry at Fayl-la-Forêt. In Normandy, metalwork skills still flourish.

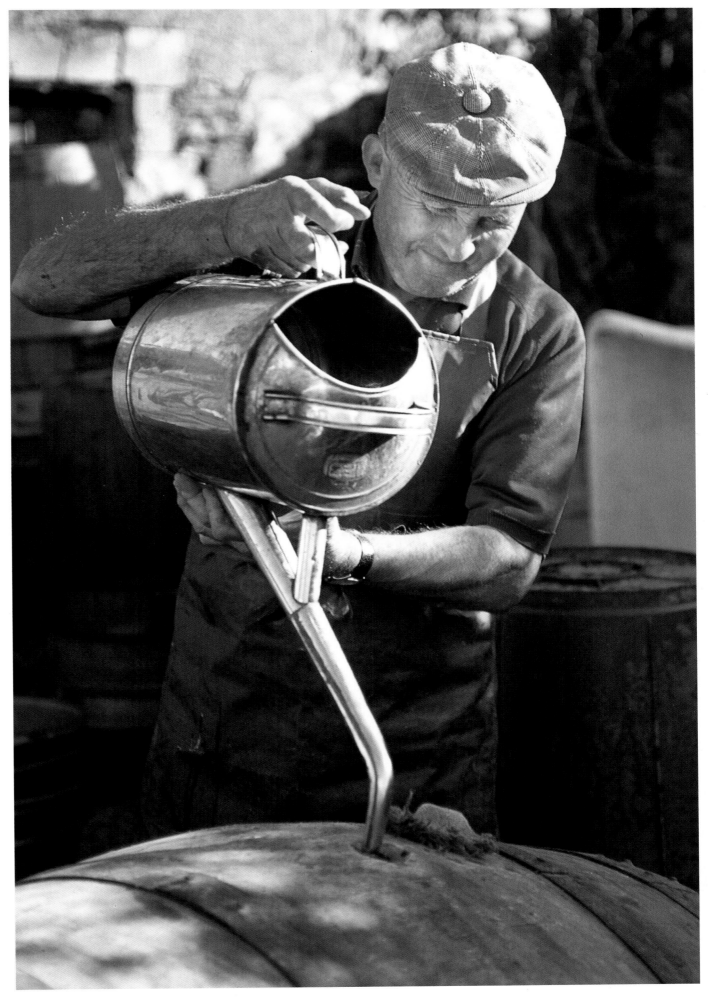

Grapes (opposite above) which help to create the mouth-watering wines of Bordeaux look especially succulent in a tub at Fronsac; the *appellation d'origine contrôlée* wines of Fronsac include Canon-Fronsac, Côtes-Canon-Fronsac, and simply Fronsac itself. Enjoying the fruits of his own labour, a wine-grower of the Loire (opposite below) **has** doffed his beret and sits, glass of *eau-de-vie* in hand, while another Muscadet *vigneron* **fills a sterilizing barrel** (right).

For many French people, even city-dwellers, the memories of their place of origin is strong – the recollection of ancient houses in mature landscapes: a venerable façade is glimpsed amid trees (left) at Château-de-Ripaille, Haute-Savoie; Villeneuvette, on the banks of the Dourbie, in the Hérault (below), still awaits paving for its square; the peaceful landscape of beeches and cattle (opposite) at Vigneulles-lès-Hattonchâtel, Lorraine, is protected as a natural park.

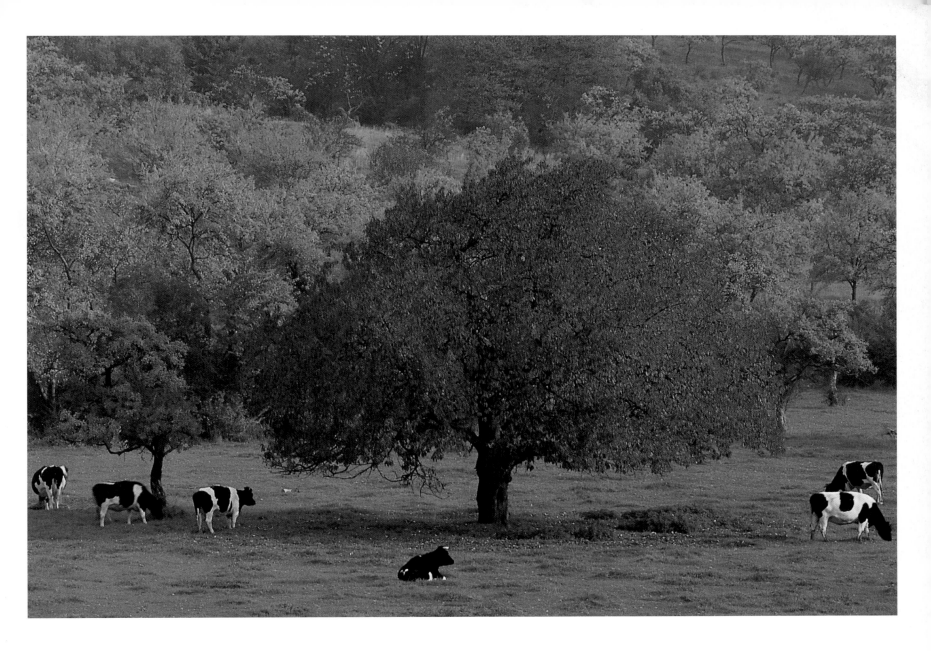

A SENSE OF *TERROIR*

Memories of family connections with wine-producing and other famous gastronomic regions haunt even the most hardened of Parisians. In the French capital, people from the Périgord set up *périgourdin* restaurants, while Parisian restaurant owners from Alsace serve Alsatian wines. This identification with territory occurs largely because France is so vast and diverse. The flavour of the south contrasts strikingly not just with the tastes of Flanders but also with the bouquet of Burgundy wines, the scent of the wind- and rain-swept villages of Brittany, the rich cattle pastures of the Limousin and the watery Sologne. Alpine villages are far removed from the villages of the Basques. No-one can belong to the whole of France. So in France a person's

very identity depends in part on knowing where he or she comes from.

More than fifty million people inhabit France. In the centuries when the governments strove to centralize the country, even the local *patois* (not so much a dialect as often a separate language) was frowned on and sometimes banned by the rulers of the country. The sense of territory amongst the French people meant that these tongues were never forgotten. In the end, the persisting strength of local tradition forced the powers of metropolitan France to cease regarding these local tongues and ways as somehow deviant. The centralizers were finally routed in the mid nineteenth century. Local turns of phrase, poetry and novels were recognized in their own right, rather than as an inferior product

of inferior folks. So today, schools in the Languedoc, for example, teach *occitan*, the traditional language of that region. Yearly, citizens gather for their local festivals, don their local costumes and dance their local dances. On the feasts of All Saints and All Souls they come back to the villages in which they were born to honour the graves of their dead.

Traditional local food is cherished. After all, the gastronomy of France varies enormously throughout the country, for the ingredients depend on different soils, waters and climates. In local gastronomy the past merges into the present, a tradition of territory tasted in food. Not so long ago, for example, it was necessary to preserve geese and duck in a *confit* of fat. That necessity is no more; but the French

26

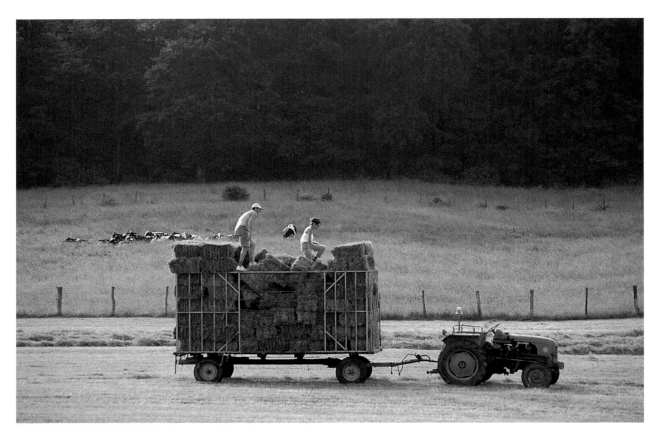

France, market-garden
and land of plenty:
forty per cent of the
département of the
Haute-Marne is taken
up by forests, but this
tractor with bale wagon
reveals another
countryside (right); corn-
cobs hang out to dry at
Ruffieu in Savoy (below);
vegetables, created by
men and women as well
as nature, include the
Brittany artichoke
(opposite).

housewife has not given up her *confits*,
often making her own, bottling them and
saving them for the winter months. Hams
even more display the regional basis of
French cooking, either salted or smoked.
Their names – *jambon de campagne, jambon
de montagne, jambon de l'Aveyron*, or even
simply *jambon de pays* – reveal that the
different traditions of the countryside
still hold sway in the hearts of many
Frenchmen and women.

Again, since food is cooked in liquid,
this liquid varies throughout France,

whether wine, beer, cider, Calvados or
Cognac. And the cuisine is often enriched
with cheese, so the vast variety of French
cheeses here comes into play. For a time
the etiolated *nouvelle cuisine* rocked the
boat of many a French restaurant. Soon
traditional cuisine made a recovery, for
the French do not forget their origins.

Finally, in the French countryside and in
its fishing ports, traditional ways are handed
on, and the lore and skills of territory do
prevail. A farmer's ancient barn may fall
down but, until he has time to rebuild it,
he and his wife will paint numbers on the
corner-stones of the walls. Their ancestors
had worked out how to put these rough-
hewn stones together. This is their own
place and they will be concerned about its
continued existence. In the rain, a fishing
smack will sail up to and moor on the
Normandy coast beside the estuary of the
Seine. The two fishermen begin to put their
catch into boxes. One, grey-haired, wears
a cap. The other has a thick shock of black
hair and goes bare-headed. From their
features you can see that they are father
and son. Instinctively, one has passed to
the other the lore he learned from his
fishermen forefathers.

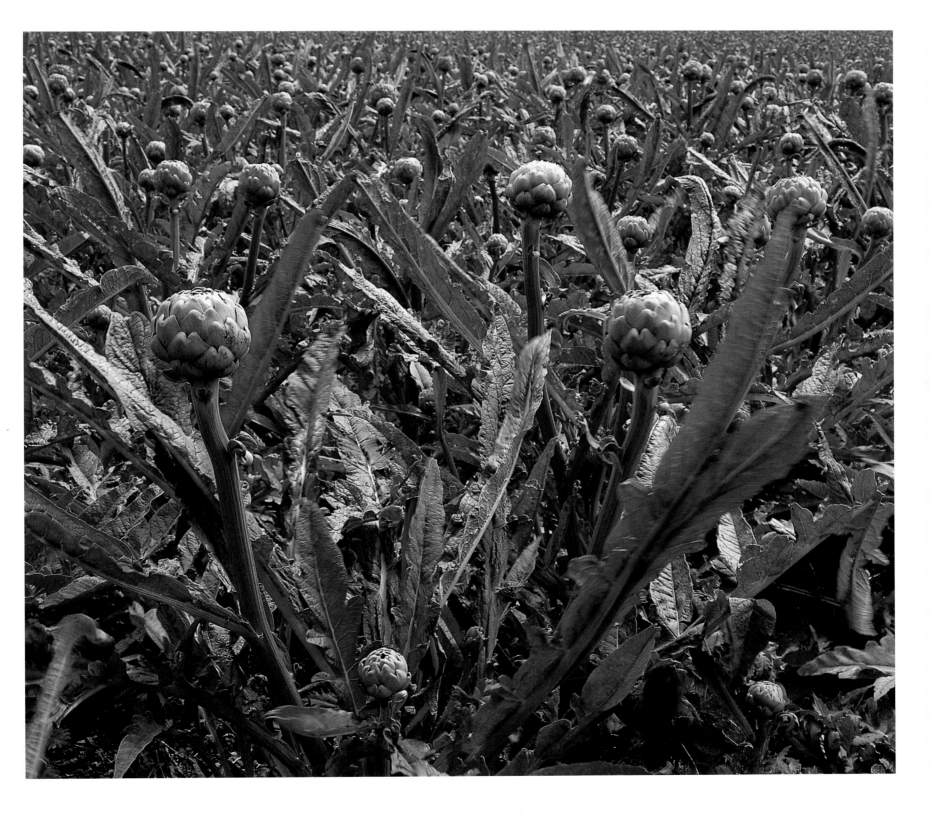

Lavender graces much
of Provence; these
fields bloom just outside
Apt in the Vaucluse,
the world's chief
producer of the plant.

Equally delightful are
the oil-producing fields
of sunflowers around
the neighbouring village
of Bonnieux.

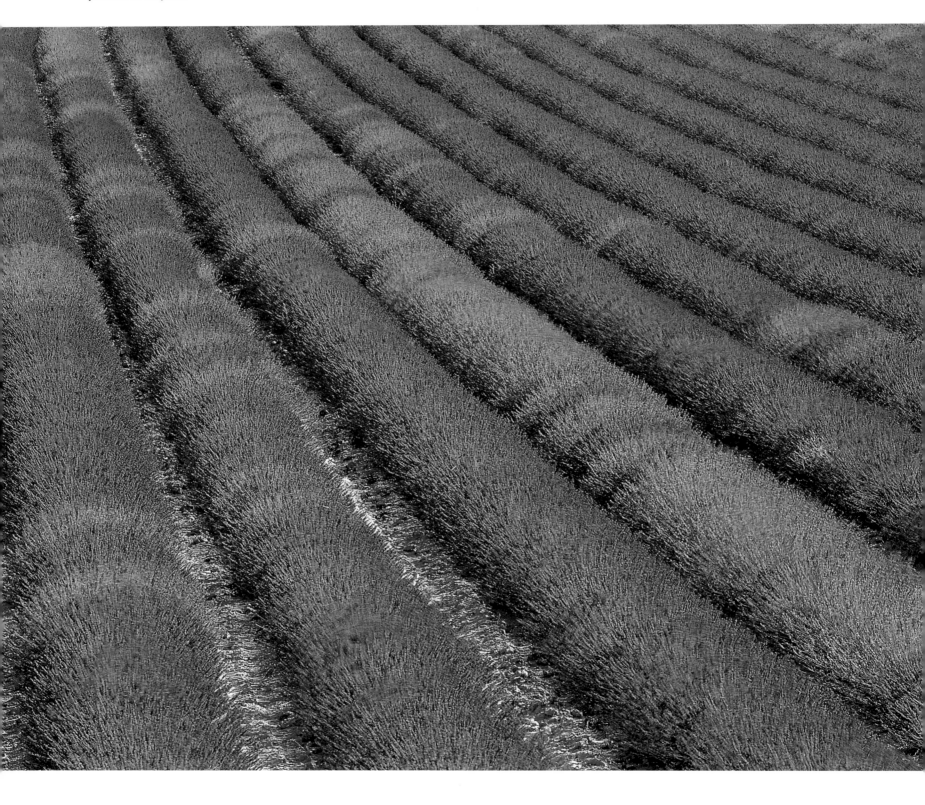

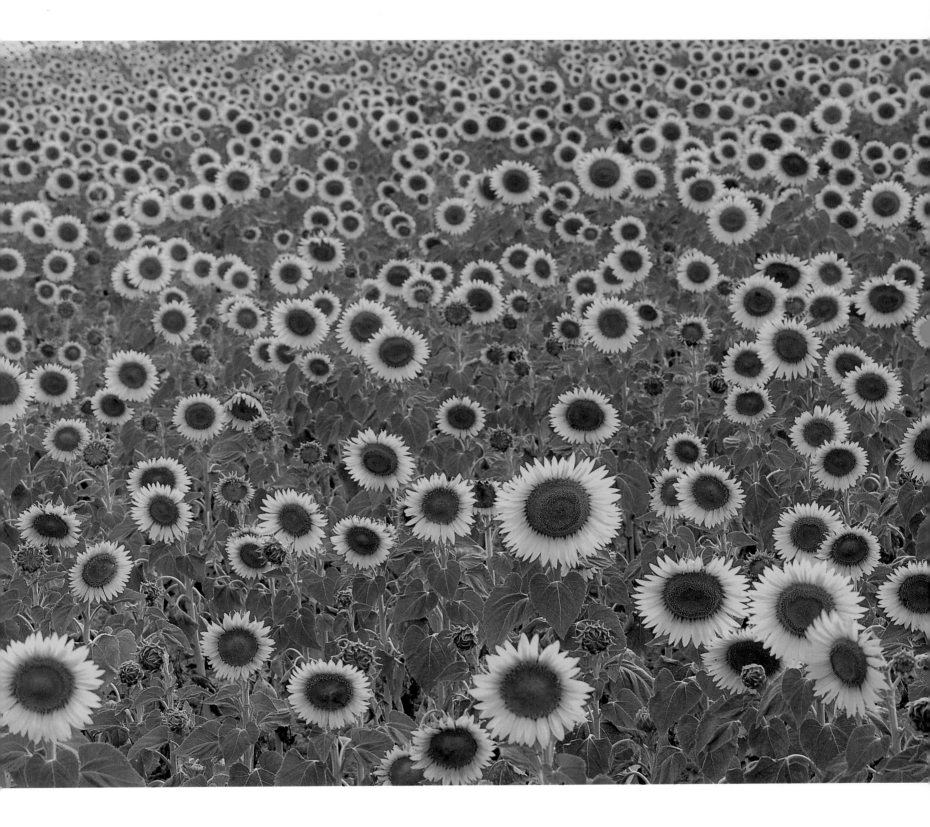

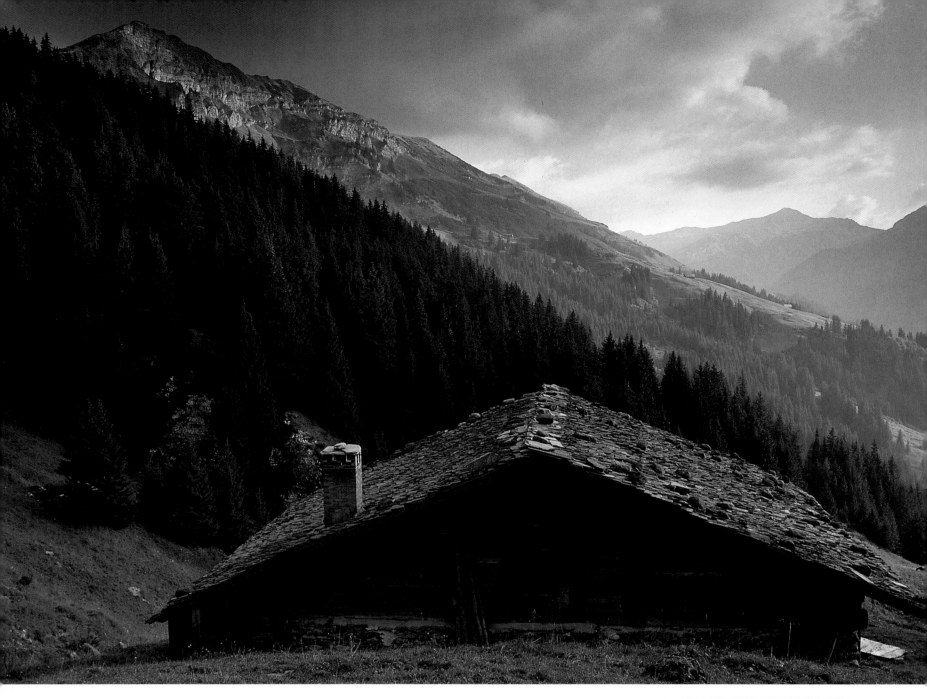

Many of France's
mountainous regions
are protected as
national parks, such
as La Vanoise, Savoy
(above). Provence,
too, has spectacular
mountain scenery:
escarpments at
Roquebrune in the
Var (right).

A LAND OF EXTREMES

Much of that territory is mountainous and
much is covered with forests; some of them
(such as those of the east and of the Maures
and the Estérel in Provence) are upland, but
most of them (such as those of the Landes)
cover plains. Their aspect varies from region
to region. Pine forests offer a different hue
from oak forests, well-tended forests
contrasting with unkempt ones. Some
have grown up without much help from
the people. Others are comparatively recent
plantations, such as the forests of the Landes.
Yet others, such as those around Paris, were
planted to allow the nobility to hunt. Today,
because of these forests, rural France in
season is a land of hunters.

The combination of forest, mountain-
side and lake in the country produces
extraordinary variety in climatic conditions
and therefore in vegetation and crops. The
village of Orbey, for instance, in the Haut-
Rhin, gazes up at the 'Forest of the Two
Lakes', one lake known as the Lac Blanc,
the other the Lac Noir. In the Forêt des
Deux Lacs grow Scots pines, sorbs and
beech trees, while at their feet flourish
bilberries and holly. This forest is also the
home of black grouse and buff-coloured
fawns. The countryside around Briançon,
for example, each year regularly enjoys
three hundred days of sunshine. Lavender
flourishes, as do olives and almonds. Small
wonder prehistoric men and women settled
in this hospitable region.

Many mountainous regions are now
protected natural parks. Covered by
conifers, oaks, beech and ash until the
altitude means that trees can no longer
survive, they are havens for butterflies, rare
birds, foxes, moufflons and alpine goats,
while eagles and kites soar over them. Blue
gentians, wild orchids and wild rhododen-
drons thrive here. In the south, Provence
and the Côte d'Azur are places of rare
natural riches. The novelist Colette
observed that there are several Provences:
Mont Ventoux, the Plateau de Valensole,
the Lubéron and Var.

**The late autumn
hunting season is
widely celebrated in
France; these huntsmen
and their dog await their
prey in woodlands near
Ancenis on the Loire.**

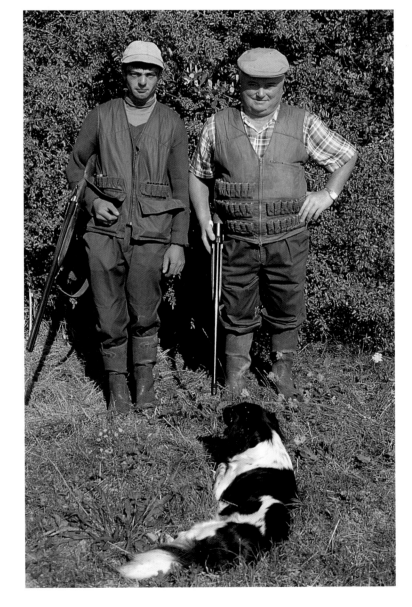

A kitchen-garden graces many homes in rural areas of France, where the *potager* is an essential support of culinary prowess.

FRANCE — THE GARDEN

Painters have been seduced by different parts of France. In the 1840s the Barbizon school painted romantic landscapes around Fontainebleau. Monet repeatedly painted Rouen cathedral and the countryside surrounding his home at Giverny (where the garden he created has been lovingly restored), as well as the Normandy coast, which equally inspired Eugène Boudin of Honfleur, as did Brittany where his wife was born. In the twentieth century the Mediterranean coast, notably around Collioure, stirred the imagination of the Fauves and beguiled Pablo Picasso. Their art altered others' perception of French landscape and seascape, much of which remains exactly as it was in their day.

French regionality and variety has marked the work of poets, novelists and painters, eulogizing favourite parts of this diverse country. Paul Verlaine sang the praises of the Pas-de-Calais. Joachim du Bellay, far away in Rome, wrote nostalgically of his birthplace in the Loire valley. Gustave Flaubert celebrated the town of Clisson, which lies between the rivers Sèvre and Moine, and in 1847 visited Brittany and recorded his admiration for the place. Honoré de Balzac, as a guest in the château of Saché, praised the country of the Indre in *Le Lys dans la vallée* (and often acted out the characters of his greatest novels before his friends at the local inn). Two of George Sand's most celebrated works (*Journal de Gargilesse* and *Promenades autour d'un village*) describe mid nineteenth-century rustic life in the upper valley of the Creuse, where she had a home. Alain-Fournier's *Le Grand Meaulnes* conjures up the lost domain of the Sologne. Michel de Montaigne especially relished the Périgord; Marcel Proust, Normandy; Barbey d'Aurevilly, the Cotentin. The poet (and painter) Max Jacob was born at Quimper in 1876 and never ceased to celebrate his origins, while both Tristan Corbière and José-Maria de Heredia wrote lovingly of north Finistère. And Jacques Prévert, whose father was a Breton, movingly lamented the destruction of Brest in World War II in *Rapelle-toi Barbara*.

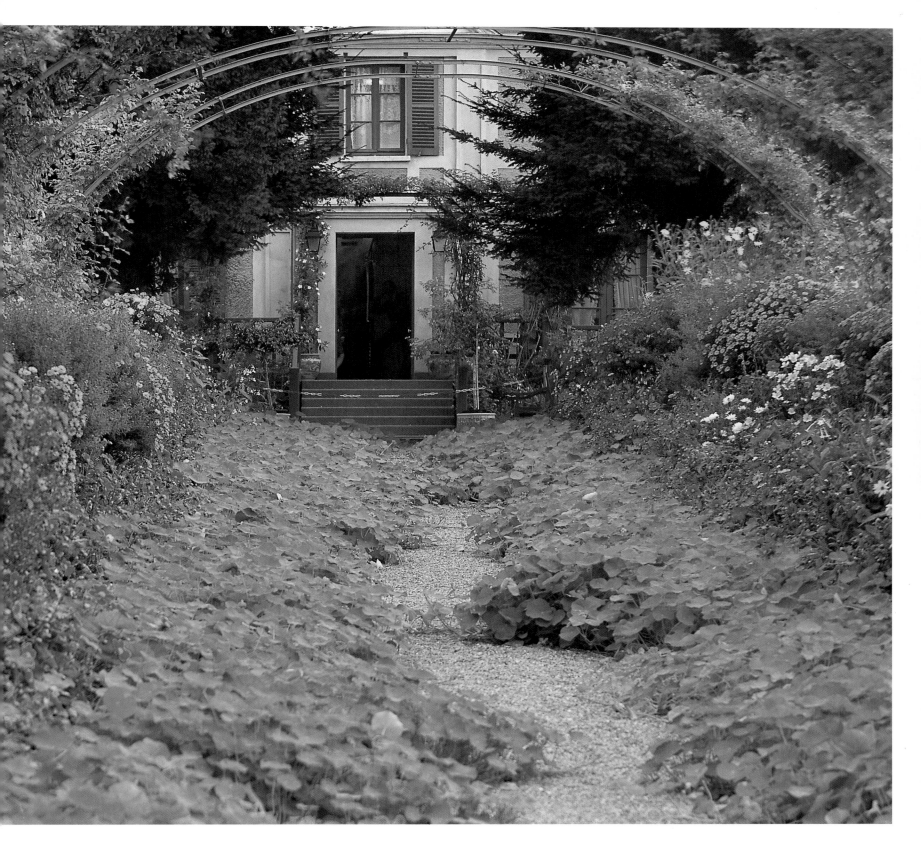

In 1883 the painter Claude Monet and his family moved to Giverny. There he created gardens whose beauty match his own Impressionist brilliance: water-lilies, apple-trees, gladioli, cornflowers, hollyhocks, roses, irises, lupins, weeping willows, rhododendrons, azaleas and such exotic trees as tamarisks and the yellow-leaved albizzia are all brilliantly deployed.

BUILDINGS IN A LANDSCAPE

In a country of such variety, as evidenced and celebrated in the works of its artists and writers, the sites and settings of its villages and small towns play a special part in the appreciation of the buildings and communities implanted there. Sainte-Énimie (Lozère), for example, lies in a deep valley alongside the wide river Tarn. Reached by a series of hairpin bends, this is a landlocked medieval survival whose steep cobbled streets lead up to a Romanesque church surrounded by half-timbered, turreted houses, drinking fountains and little arches which lead as far as a ruined abbey (save for its still intact chapter-house). Tende, by contrast, a little village in the Alpes-Maritimes, nestles on the side of a mountain, its slate-clad houses rising several storeys high. Scarcely four hundred

people inhabit the fortified village of Villefranche-de-Conflent in the valley of the Têt (Pyrénées-Orientales), where the Romanesque church of Saint-Jacques looks benignly on houses built between the twelfth and the fourteenth centuries. And Saint-Véran, the highest village in Europe, sits two thousand metres above sea-level on the slopes of the Beauregard mountain, its cube-shaped houses built entirely out of wood, with steep roofs that allow the snows to slide off as speedily as possible.

Everywhere, available materials affect the look of French villages and towns. In the Dordogne, the houses are built of white and honey-coloured stone, some with steep roofs of stone known as *lauzes*. In Quercy, the village of Collonges-la-Rouge derives its name from the lovely red sandstone from which were built its gates, its former

market-hall, its manor-houses (which date from the fourteenth to the sixteenth centuries) and its church (with a Romanesque belfry and a twelfth-century sculpted tympanum); the whole rises exquisitely from the green, wooded countryside. Further north, approaching the Limousin, the stone becomes a darker grey. Travel north to Picardy to find brick, elegantly deployed. The oldest château in the region guards the village of Rambures in the *département* of the Somme and was built in the fifteenth century of brick and stone.

Rural architecture in the Lot is quite different. Generally two storeys high, the peasant or farmer's house here will be built of local stone, the lower level serving as wine cavern. The upper part will be reached by an external staircase leading to a main entrance that is often arcaded. Frequently

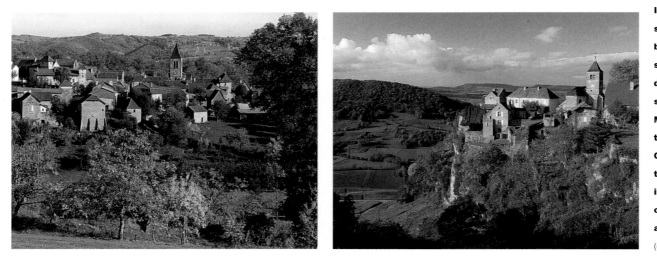

In their materials and siting, many French buildings and villages seem to have grown directly from the surrounding land: Saint-Médard-de-Presque, in the Lot (far left); Château-Chalon (left) dominates the valley of the Seille in the Jura; the château of Beynac perches high above the Dordogne (opposite).

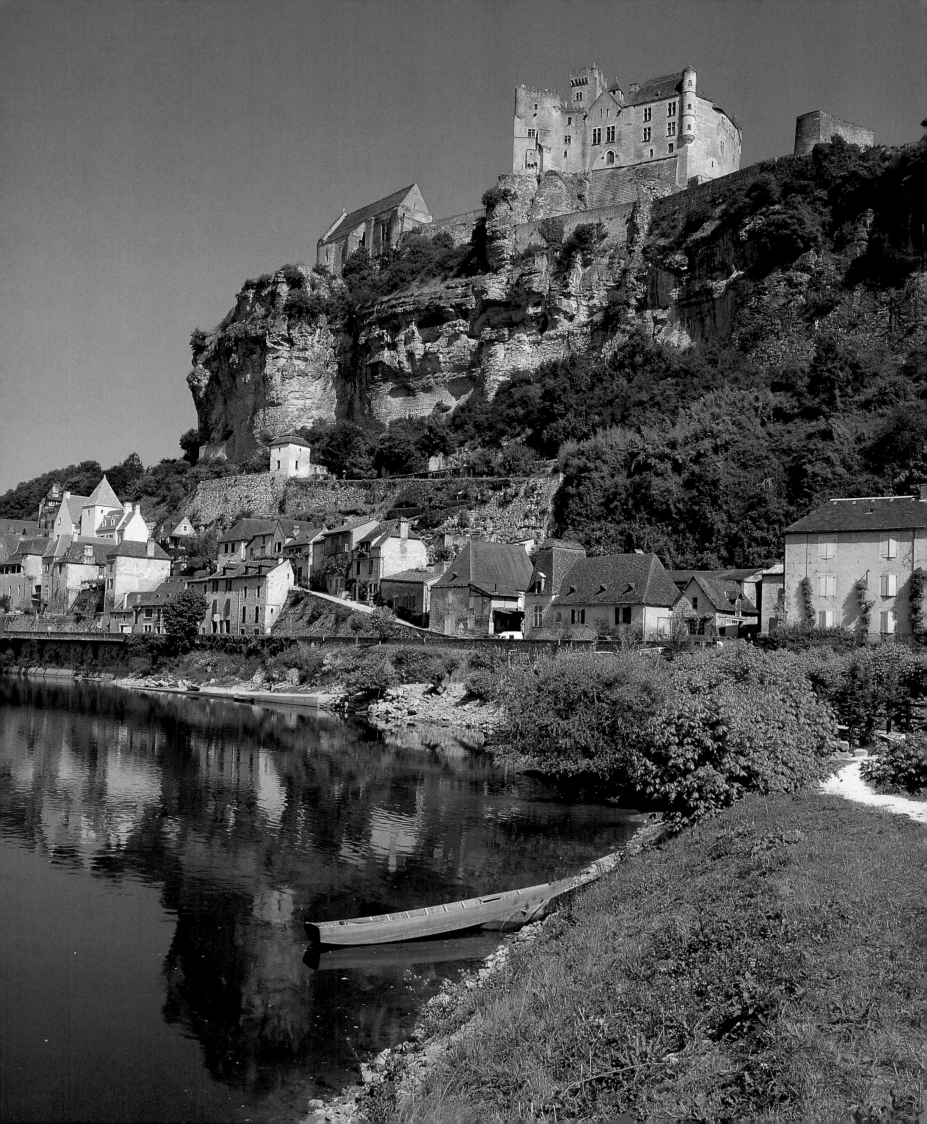

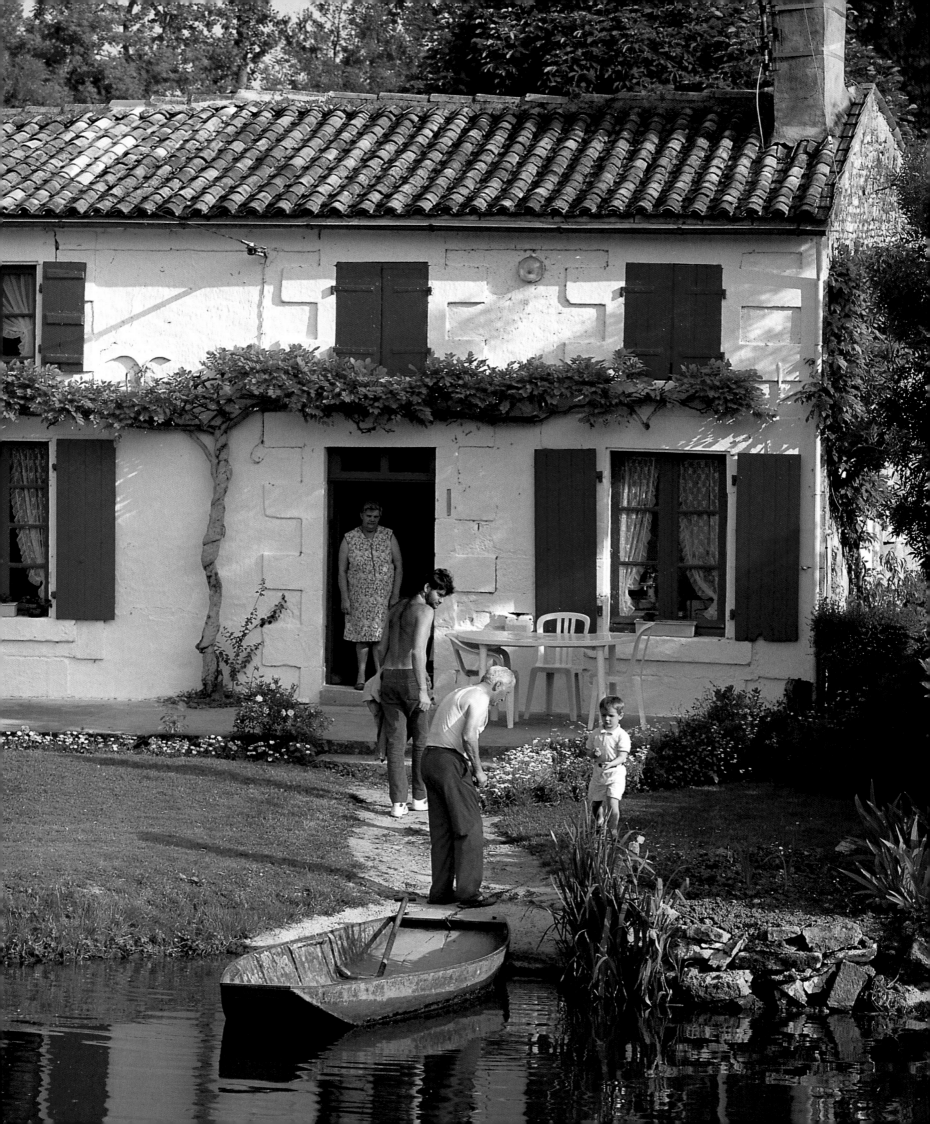

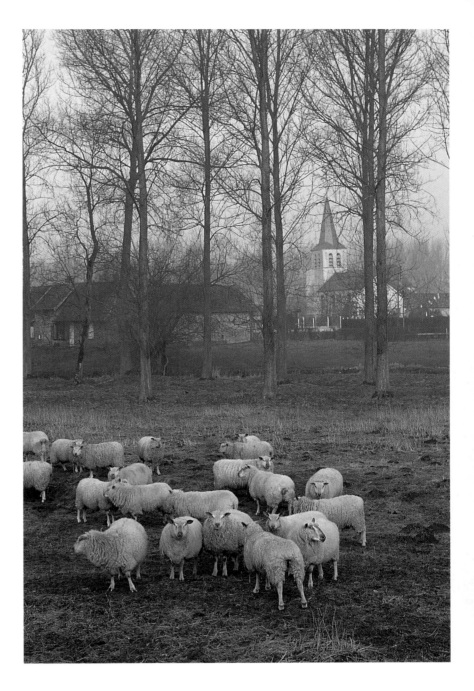

the house will culminate in an attic, sometimes enlivened by a dormer window and covered usually in tiles. A nearby dovecot completes the ensemble, unless this is a prosperous farm with perhaps barns, chicken-houses, pigsties and a well.

In Savoy, French houses resemble Swiss chalets. Golden stone warms the houses in the small villages of the Jura, which in their turn warm their inhabitants during the harsh winters of this mountainous region and cool them during its temperate summers. The narrow *vignerons'* houses have arched doorways giving entrance to the cellars, while the traditional peasants' houses of the plateau are solidly built of stone, and roofed with tiles of grey lava.

In the west are wetlands, and in the south-west more mountains, where Aquitaine meets the Pyrenees. Again, the houses, communities, and means of communication are highly individual. Flat-bottomed boats are moored beside the canals which connect the groups of white-washed houses in the Marais Poitevin. Elegant country-houses punctuate the Bordeaux vineyards, while the archetypal Pyrenean dwelling would be a stone-built shepherd's hut. Aquitaine is vast, taking in the region long known as the Périgord, which is much enhanced by the exquisitely meandering river Dordogne, the Lot (yet another *département* named after a majestic river), the countryside around Bordeaux, the forested, sandy Landes, whose dunes continually threaten to overwhelm the pine trees planted to contain them, and – at the southernmost part of the province – the Basque country, gateway through the Pyrenees to Spain.

This latter region is deliciously bizarre. The Basque people have their own flag and their own language, *Euskara*, the only non-Indo-European language spoken in Europe. Basques are recognizably physically different from other French men and women. Traditionally, the menfolk wear black berets, but when they dance they wear red ones, as well as local costumes. Many of their churches are characterized by three steeples topped by three crosses (symbolizing the Holy Trinity). The language surfaces in the architecture of the village of Aïnhoa, set on the north bank of the river Alachuruta, where the asymmetrical roofs of the houses overhang beams and shutters painted with Basque inscriptions.

The gentle rhythms of rural life still persist in many parts of France. At Coulon, in the Marais Poitevin, transport is still by traditional flat-bottomed boat (opposite). **Farming methods** (above) **are often still small-scale; winter is braved by a flock on a small farm in the Pas-de-Calais.**

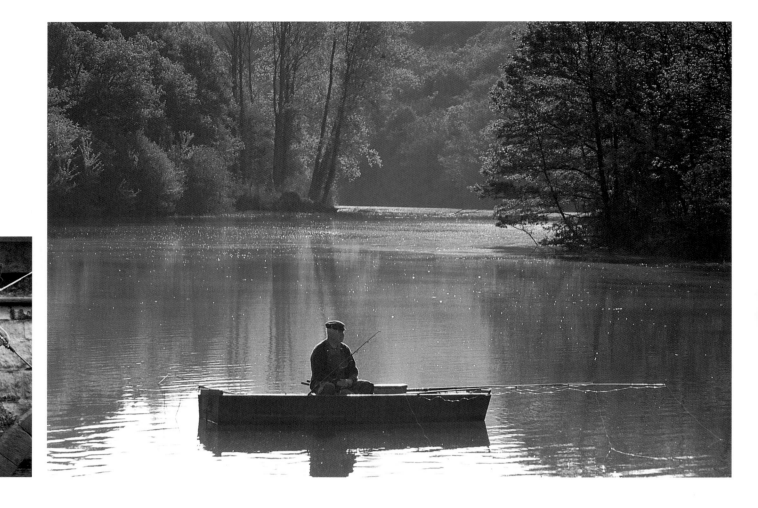

WATERWAY AND WETLAND

Hilaire Belloc records crossing a canal near Épinal in the Vosges; he noted its useful alliance with the river Moselle: 'They take the water from the Moselle (which is here broad and torrential and falls in steps, over a stony bed with little swirls and rapids), and they lead it along at an even gradient, averaging the uneven descent of the river.

This pattern of taming a river by means of a canal can be seen throughout France. In Burgundy, for example, the Canal de Bourgogne was dug alongside the river Armançon to serve such delightful places as Tonnerre, Tanlay, Ancy-le-Franc and Nuits-sur-Armançon, which once marked the frontier between Burgundy and Champagne. Of all such canals, the Canal du Midi, dug to link Toulouse with the Mediterranean, was the most ambitious. The first stretch, from Toulouse to Sète, opened in 1691. It brought prosperity, and soon other cities and towns begged to be linked with it. Toulouse was also served by the river Garonne, where ships of 160 tonnes, made from wood of the forest

of Sainte-Croix-Volvestre, plied the river. For centuries the Garonne was known as the 'river of Bordeaux', where its estuary, subject to winds and ebb tides, is flanked by vineyards, fortified towns and little ports. Thus man-made waterways augmented those rivers which had long-time served as the great thoroughfares of France – the Loire, the Dordogne, the Seine, the Rhône, the Rhine. *Gabares*, flat-bottomed boats, were built to negotiate those parts of the rivers (particularly the Dordogne and the Lot) where shallows brought gravelly or sandy hazards.

Humbler, more beguiling rivers have also played their part in the development of France. Take the Sèvre Niortaise as it flows to its confluence with the Pamproux and beyond. It washes Exoudun, whose name derives from the phrase *es ol dun*, the water of a hill, where a feudal château still stands. Beside such rivers rose monasteries, for the waters were needed not only to provide the fish which the religious ate on Fridays, but also for the ritual ablutions of the monastic life.

Waterways – rivers and canals – have always been crucial to communication in France, and a source of fish for wonderful and varied cuisine. These peaceful scenes (opposite) are from the west of France, which also boasts a number of intriguing wetlands, such as the natural park of La Grande Brière (right).

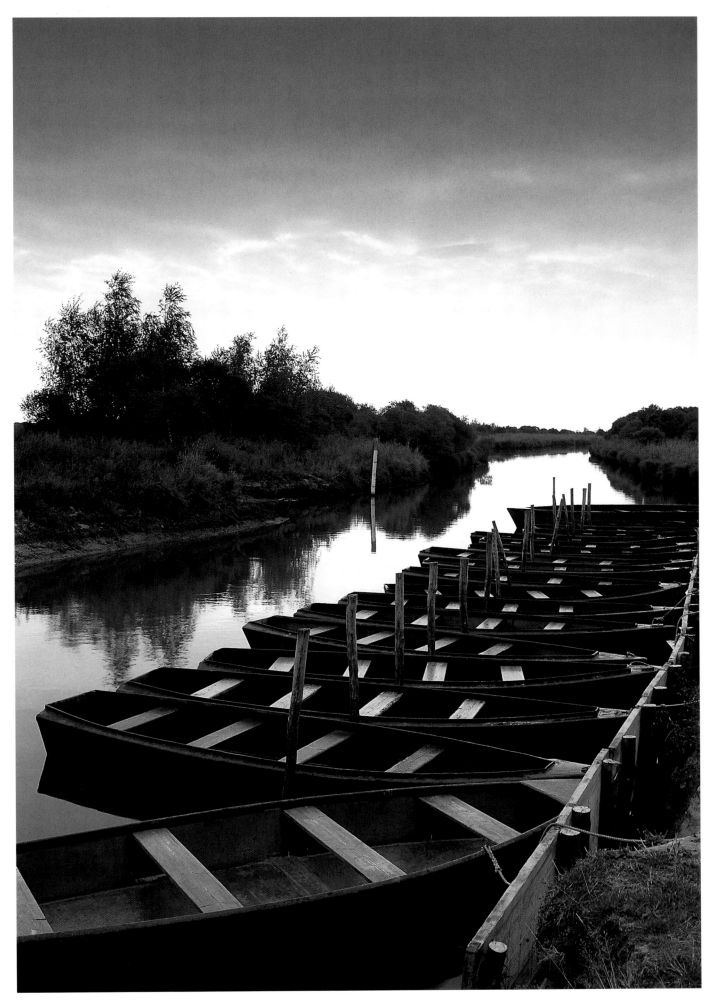

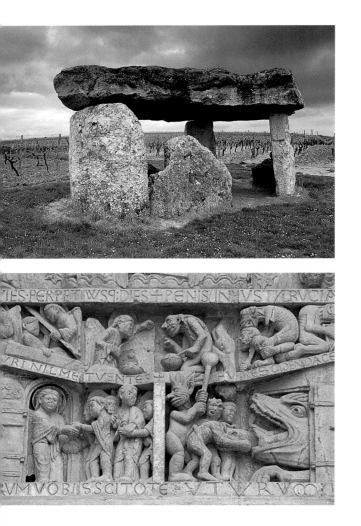

The marks of France's history are everywhere to be seen in the landscape: a superb stone dolmen at Saint-Fort-sur-le-Né, Charente (top); part of a Last Judgment, created in the twelfth century, on the tympanum of the abbey church of Sainte-Foy, Conques, in the Aveyron; a metal cross near Agincourt, where in 1415 Henry V of England defeated the French.

HISTORY, OFTEN RELIGIOUS

As the development of the waterways for transport and settlement left its imprint on the development of metropolitan France, so we find many signs, often religious, of the country's growth and development from earliest times. No-one today lives in underground caverns, but troglodyte homes are still in use, for instance in the delightful village of Trôo in the *département* of Loir-et-Cher. Trôo has a fortified mound on which rises the twelfth-century collegiate church of Saint-Martin, its central tower athwart the rest of the building. Its Romanesque doorway is carved with birds hungrily pecking grapes. Inside are medieval carvings of Daniel in the lions' den (the friendly beasts licking him), a couple of stonemasons, a peasant with an axe, centaurs with crossbows, and St. Martin about to give half his cloak to a beggar. A steep path leads from this mound down to remarkable troglodyte houses, all privately owned and inhabited, some with walled gardens, set beside a hillside tunnelled like Gruyère cheese.

France is a country which, as its many surviving memorials reveal, has over the centuries been conquered and recon-quered. The battlefields and graveyards of the Somme recall World War I, the beaches of Normandy World War II. And earlier military feats are celebrated elsewhere in France; in the town of Bayeux the famous tapestry illustrates the conquest of England in 1066 by Duke William of Normandy. Yet later, in 1248, St. Louis, King of France, set sail from the bizarre, walled town of Aigues-Mortes on the seventh crusade to the Holy Land. In Normandy, at the small town of Les Andelys, the gleaming white walls of Château Gaillard, built by Richard

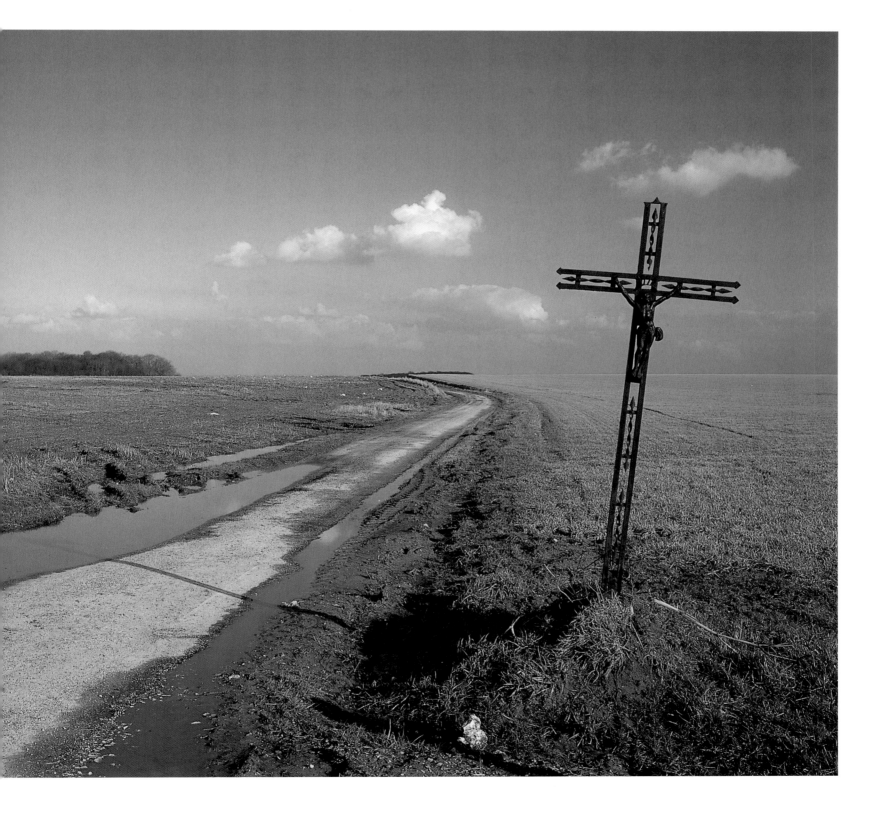

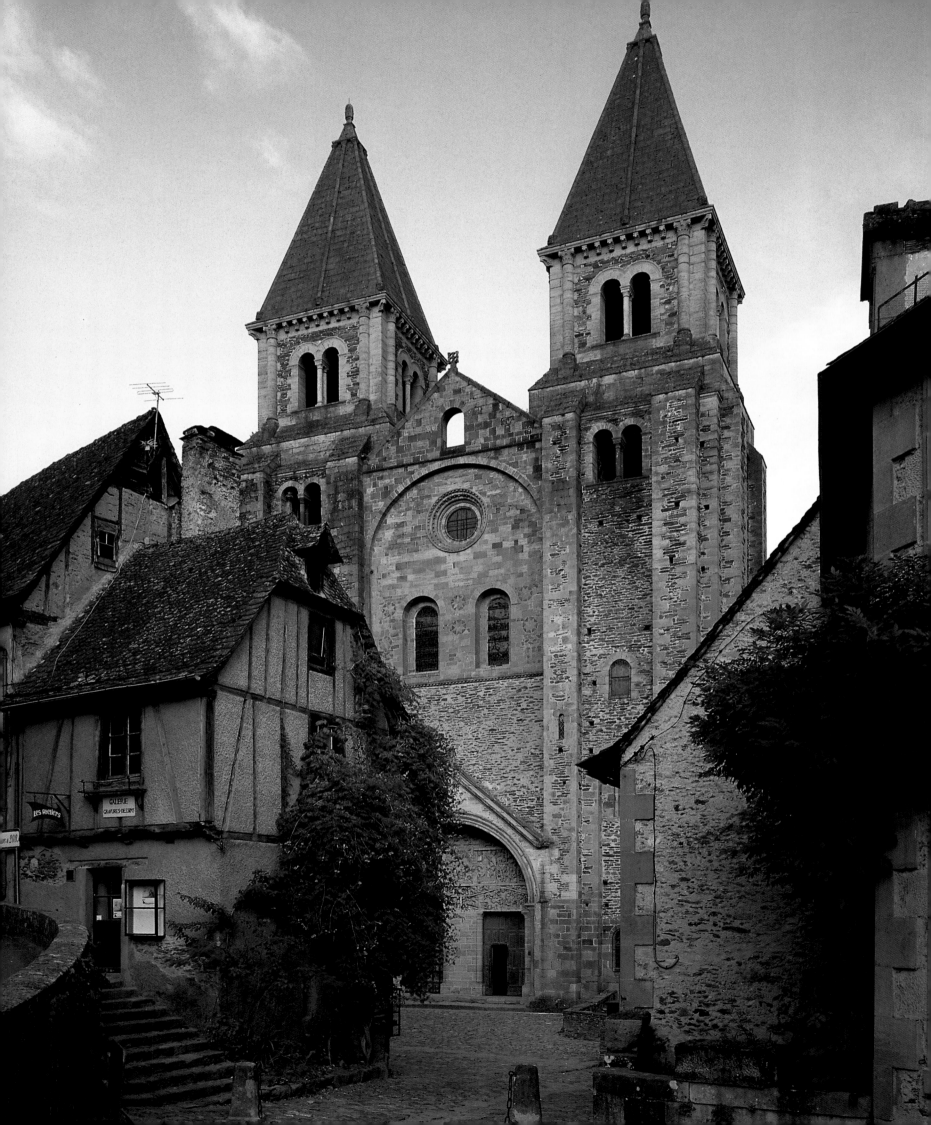

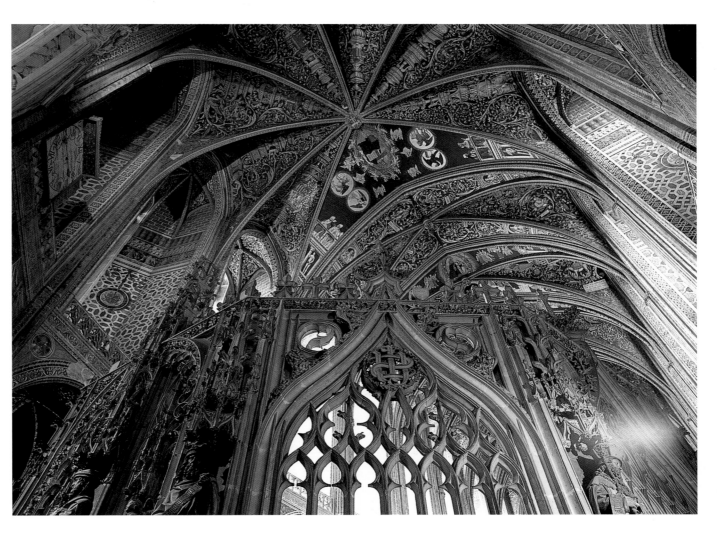

France has a heritage of Romanesque and Gothic architecture beyond compare: dominating the village of Conques is its abbey church, built for Benedictine monks in the eleventh century (opposite); an extravagant example of flamboyant French Gothic is the cathedral of Sainte-Cécile at Albi (right); the co-existence of the ecclesiastical and secular (below) can still lead to heated debate in rural French communities.

Cœur de Lion in 1196 to defend Normandy against the rest of France, rise above the curving river Seine.

Romanesque churches abound throughout the villages and small towns of France, their round arches and narrow windows, their clover-leaf apses, their barrel vaults and their domed roofs bringing to worshippers an ethereal coolness. And from this style, beginning in the Ile-de-France, evolved Gothic, where churches soared to greater heights, walls supported by flying buttresses, vaults ribbed, windows of stained glass. French Gothic became more and more flamboyant; in the small town of Pithiviers in the Loiret the church of Saints-Salomon-et-Grégoire startles worshippers by its audacity (while still retaining vestiges of its original Romanesque form).

Church architects in France never hesitated to change the buildings they inherited. At Prades in the Pyrénées-Orientales, for example, the church retains its Romanesque tower but its inside has

been transformed into classical seventeenth-century. But Prades is near the Spanish border, and the church's interior also displays a riot of Spanish Baroque carving.

Churches, too, were often fortified against attack and many remain fortified to this day. At Albi, for instance, during the conflict between Catholics and Cathars, the bishop transformed his cathedral into a fortress. During the Hundred Years War the Romanesque church at Esnandes in Poitou-Charentes was surrounded by all the appurtenances of a contemporary citadel, with fortified walls, machicolations and crenellations. Villagers who lived in frontier country were especially disposed to fortify their churches. The region known as the Thiérache, near the Belgian border, was sporadically fought over for some two hundred years from the time François I acceded to the French throne in 1515. In over fifty villages of the Thiérache the church became a physical refuge.

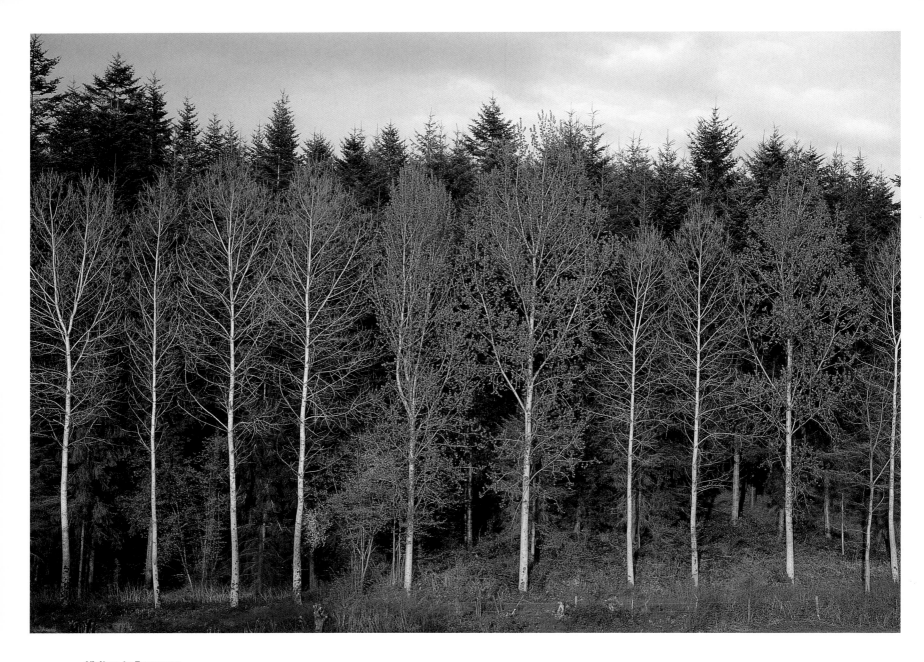

A PATCHWORK QUILT

This varied architecture, a complex human imprint, sits in a diverse and spacious landscape. The plain of Alsace, for instance, is two hundred kilometres long and forty kilometres wide. Five ample regions characterize the Champagne region. They include the wooded hills of the Barrois, which stretches southwards to the harsh countryside of Langres, and the fields of cereals of the Champagne plain. The Roussillon plain, extending from mountains to the Mediterranean, offers a delightful landscape of vineyards. By contrast, not much further south the Camargue, though sewn with lakes, is in parts virtually sterile.

In another part of the country, Henry James noted this variety with relish. As he travelled south from Bordeaux to Toulouse in the 1880s, he found the wide, smiling garden of Gascony to be 'a land teeming with corn and wine, and speaking everywhere (that is, everywhere the phylloxera had not laid it waste) of wealth and plenty.' The river Garonne he described as a 'slow, brown, rather sullen stream.' When he left Toulouse on his way to Carcassonne he declared the countryside charming, merging its flatness in the distinct Cévennes on the one side and far away on the right in the richer range of the Pyrenees. 'Olives and cypresses, pergolas and vines, terraces on the roofs of houses, soft iridescent mountains, a warm yellow light – what more could the difficult tourist want?' he asked. Very little, it must be said.

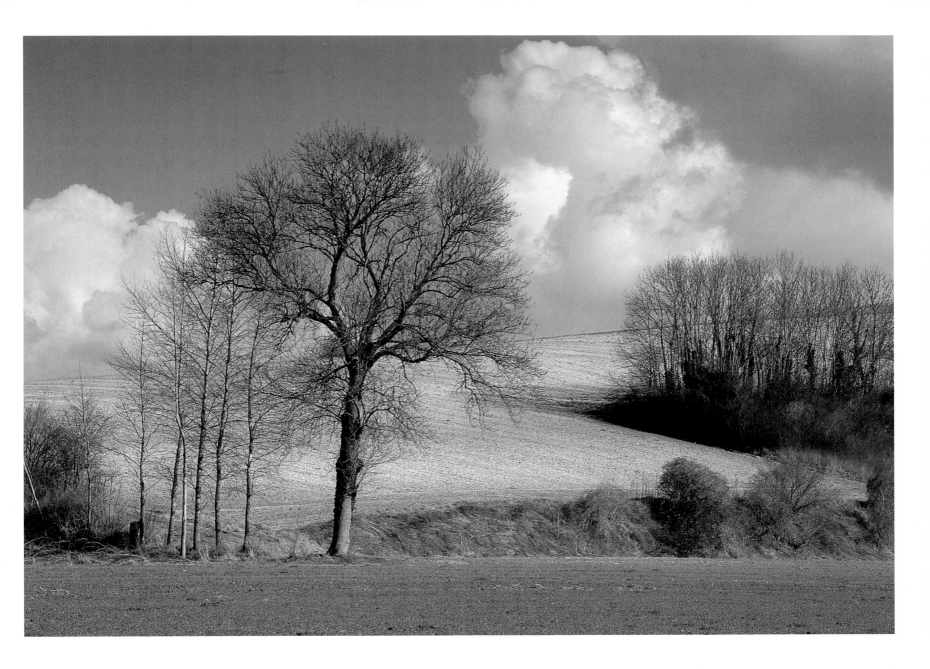

Surrounding Paris, the ten royal forests
of the Ile-de-France shelter some amazing
architectural jewels. In the forest of
Ermenonville lies the thirteenth-century
abbey of Chaalis, with its superb eighteenth-
century monastic buildings. The Compiègne
forest embraces the colossal, fairy-tale
château of Pierrefonds, overlooking its lake.
Seek out Villers-Cotterêts in the Aisne,
birthplace of Alexandre Dumas the Elder,
in the Forêt de Retz. Race-goers and horse-
lovers should not miss the pure-blood
specimens bred and trained at Chantilly,
on the edge of the Chantilly forest.

The whole ensemble of France is
unsurpassed in beauty, created by nature
and by the imprint of human history. Mark
Twain encapsulated this unique charm, as

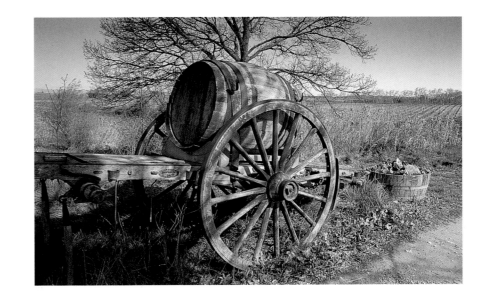

old red-tiled villages with mossy medieval cathedrals loooking out of their midst; of wooded hills with ivy-grown towers and turrets of feudal castles projecting above the foliage; such glimpses of Paradise, it seemed to us, such visions of fabled fairy-land!'

In the Massif Central and in Languedoc-Roussillon the variety and richness of landscape is especially striking.

Tarn-et-Garonne, for example, divides into three distinct areas: the limestone plateau of the Rouergue; the plains and fertile valleys to the north-west, which are known as lower Quercy; and the abundantly fertile centre, where the valleys of the Garonne, the Tarn and the Aveyron meet. As for the neighbouring *département* of the Tarn, this is a region of picturesque valleys, wooded mountains and deep forests. The diversity of the Gard is startling, stretching as it does from the Mediterranean in the south as far north as the Cévennes.

A patchwork quilt is the best way of describing the geography of the Hérault, while the Lozère is even more diverse, with two mountain ranges to the north and the volcanic Aubrac mountains to the west. Further east is Alsace-Lorraine, two provinces divided by the Vosges mountains and in many respects linked culturally, architecturally and historically with neigh-bouring Germany, yet refusing to be swal-lowed up either by Germany or France. This is a land of mountains and valleys, pastures, vineyards and hops, a blend of cities, towns and villages, bordered by the Rhine and set amidst grand, yet strangely unthreatening hills. As Victor Hugo wrote, after crossing the Vosges and visiting Strasbourg cathedral, 'Vying with each other in grandeur, mountains and cathedral represent God's work for man and man's work for God.'

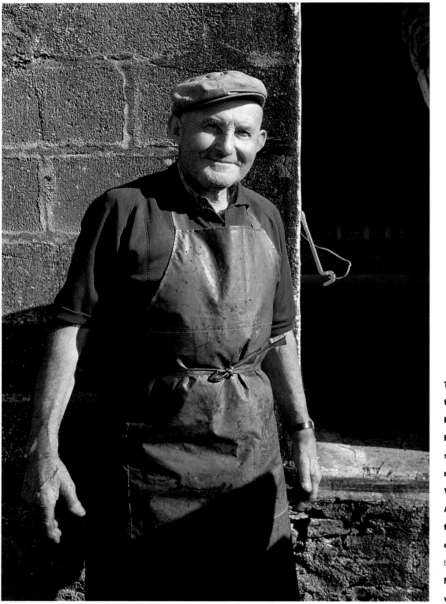

There is a seeming timelessness in France, both topographical and human; this can be sensed equally in the rolling landscape of the Vosges mountains in **Alsace** (opposite above), **the rugged Auvergne countryside** (opposite below), **and in this Muscadet vineyard worker** (left).

he reached the south of the country: 'We had glimpses of the Rhône gliding along between its grassy banks; of cosy cottages buried in flowers and shrubbery; of quaint

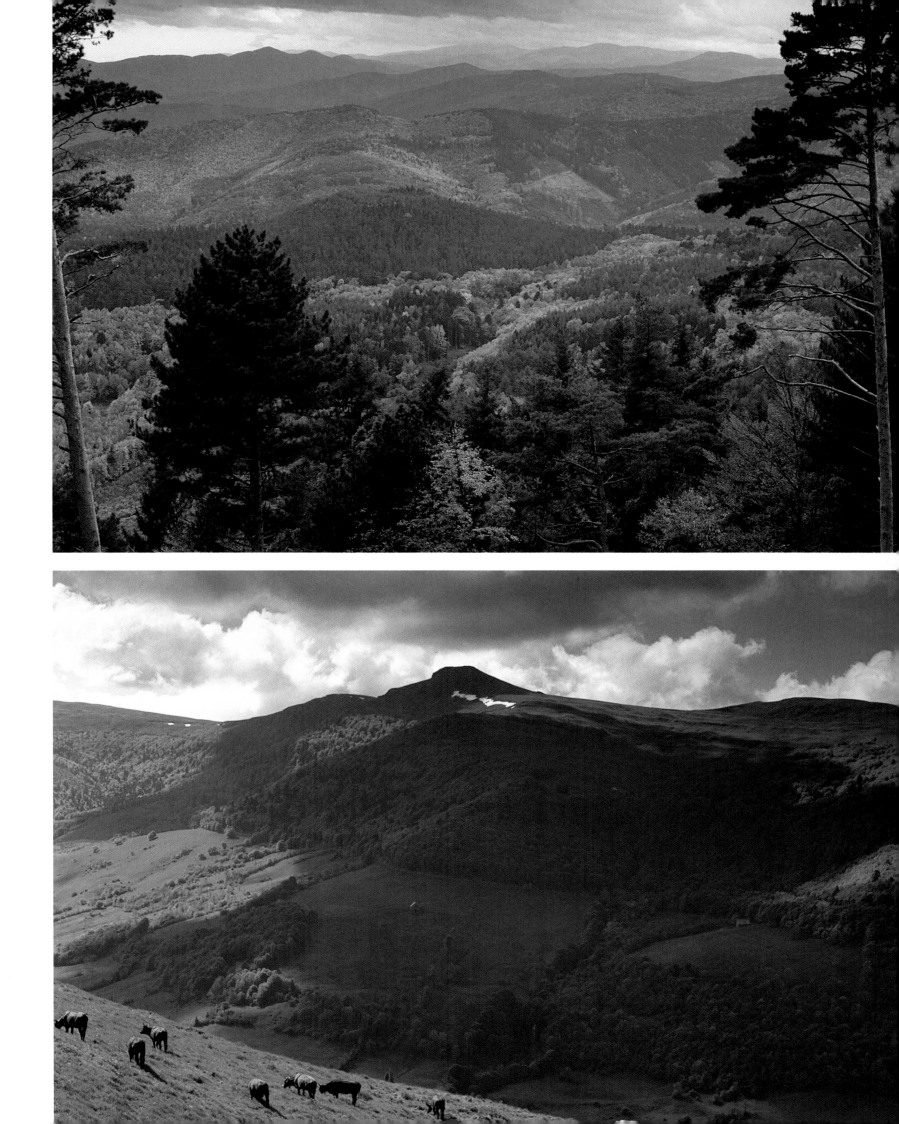

The immediate impression of variety in France springs largely from the different ways in which communities have left their imprint on the landscape. For instance, when Hilaire Belloc reached the village of Flavigny-sur-Moselle he was entranced by its seventeenth-century parish church and even more so by the pattern of the village, which he described as 'a long street of houses all built together as animals build their communities.' Here he saw the imprint of ancient hands. 'This way of stretching a village all along one street is Roman, and it is the mark of civilisation,' Belloc judged. 'When you see a hundred white-washed houses in a row along a dead straight road, lift up your hearts, you are in civilisation again.' He also noticed that, as still so often in rural France, most of the village houses had, for a ground floor, 'cavernous great barns out of which came a delightful smell of morning - that is, of hay, litter, oxen and stored grains and old wood.'

Sometimes a great nobleman will have made his unique mark on a town, as did Cardinal Richelieu, who in the seventeeth century founded a walled, chequerboard-pattern town named after himself in the Indre-et-Loire. He dedicated its parish church to St. Louis, patron saint of the monarch he served, King Louis.

Even with a single province, the variety can be marked. In Alsace, for instance, the one and a half thousand villagers of Eguisheim are protected by no fewer than three concentric sets of fortifications, the first built by the Bishops of Strasbourg in 1295. Inside the walls the flower-bedecked streets, too, are circular, flanked by stone-built or half-timbered vintners' houses, many with interior courtyards. At the heart of the village are the ruins of an octagonal

château, founded in the eighth century and rebuilt in the thirteenth. In front of the château a statue of Pope Leo IX (born in 1002, son of Count Hugh of Eguisheim) stands atop a fountain. Another fountain, dedicated to the Virgin Mary, dates from 1542. The parish church of Saints-Pierre-et-Paul has a Gothic belfry and a Romanesque porch whose carvings depict not only Jesus between the church's two patron saints but also his parable of the wise and foolish virgins.

Andlau is a different Alsace village, equally beguiling, crammed with half-timbered houses, decorated with oriel windows, carved corners and pointed gables. The former town-hall, a Renaissance house in the Grand' Rue, has a balustrade and two oriel windows.

Variety in architecture and setting makes every corner of rural France a fresh delight: the riverside houses and church of Saint-Florent-le-Vieil on the Loire (opposite)**; a half-timbered house in the exquisite village of Lyons-la-Forêt, Normandy** (above)**; a fishscale slate roof in the Auvergne** (below right).

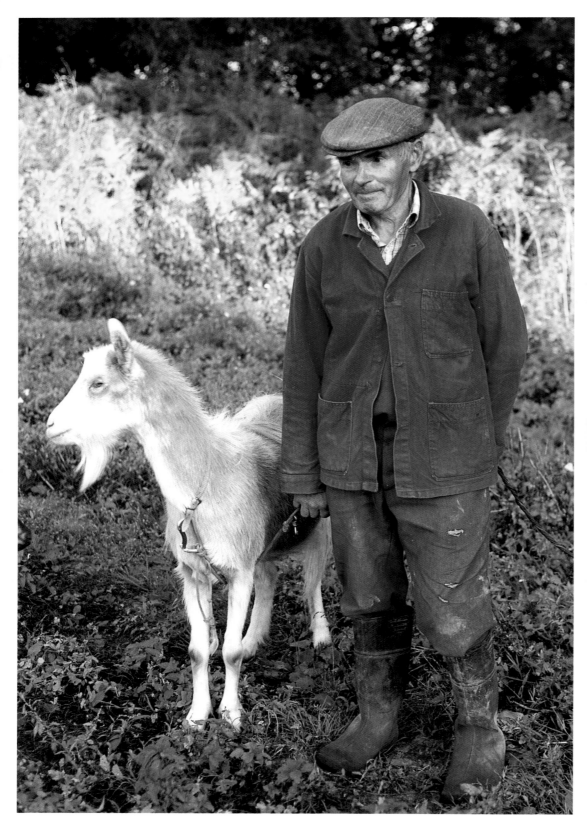

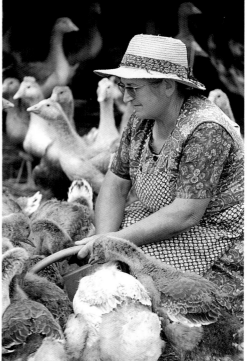

Goats and their cheese play an important role in the farming and gastronomy of Brittany (left). Further south, in Gascony, geese are stuffed with boiled maize to swell their livers and eventually create *foie gras*; this goose farm is at Lupiac, Gers (above and opposite).

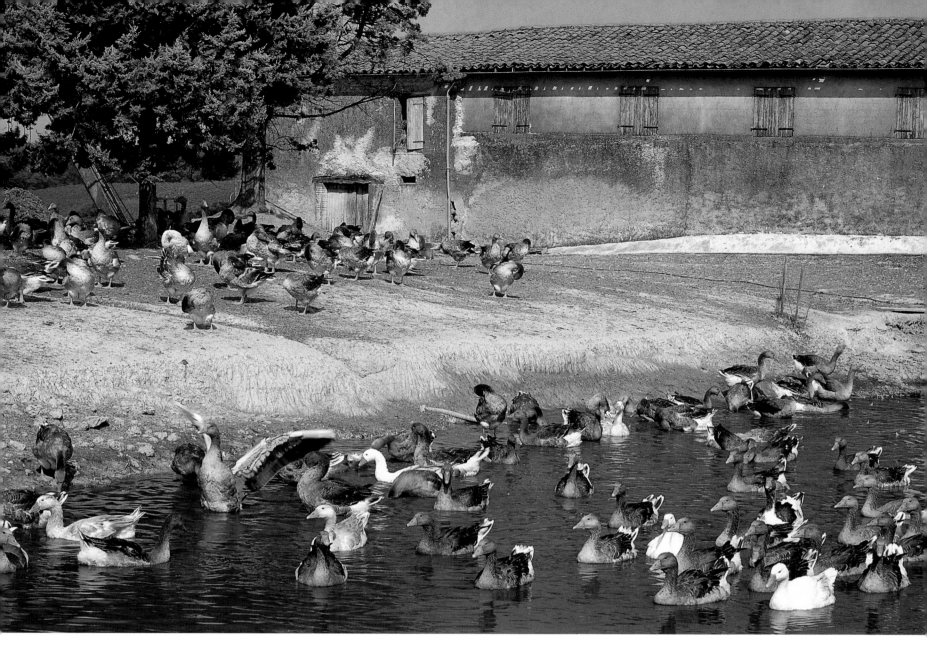

Périgord use this and not butter in their cooking), small white onions, garlic and chicken stock, its unique flavour and its colour derive from the liberal addition of chicken's blood. Travel south from the Périgord to the Minervois to discover the same succulent mushrooms but a different cuisine, in part created from the olives, figs and wine, in part from the ducks and pigs of the Lauragais.

Even futher south, the region around Collioure, a town whose houses are coloured to remind one of pink salmon, is famed for its anchovies and its olives, some of the finest of which are sold in the Sunday market.

Food and drink are indeed one way of defining the different regions and seasons of France. Its varied appearance on the tables of restaurants depends on the time of the year; its origin is always local. In the Périgord a *mique* of maize thickens the waists of the inhabitants of this blessed land, also celebrated for its truffles and *foie gras*.

Bread, cheese and wine are sometimes said by the French themselves to sum up their gastronomy. That is hardly the truth; in fact every region of the country has its own specialities, and many different wines, beers and spirits enhance the dishes. Alsace, for instance, has seven superb wines, equally fine beers, cheeses and *sauerkraut*. The wine

villages of Burgundy complement their alcohol with feasts of oysters and snails. In the Languedoc around the town of Limoux in the Aude an *occitan* fruit salad includes figs, pears and red and white grapes doused in the sparkling pale yellow wine known as Blanquette de Limoux. In the Alps *fondue savoyarde* consists of a dip of hot melted cheese and white wine, eaten on cubes of bread. During the hunting season, wild boar and venison appear on every menu.

Castelnaudary, the chief town of the Lauragais, is not only an architectural treat but also claims to have invented *cassoulet*. Some say that it originated during one of the sieges of the Hundred Years War, when

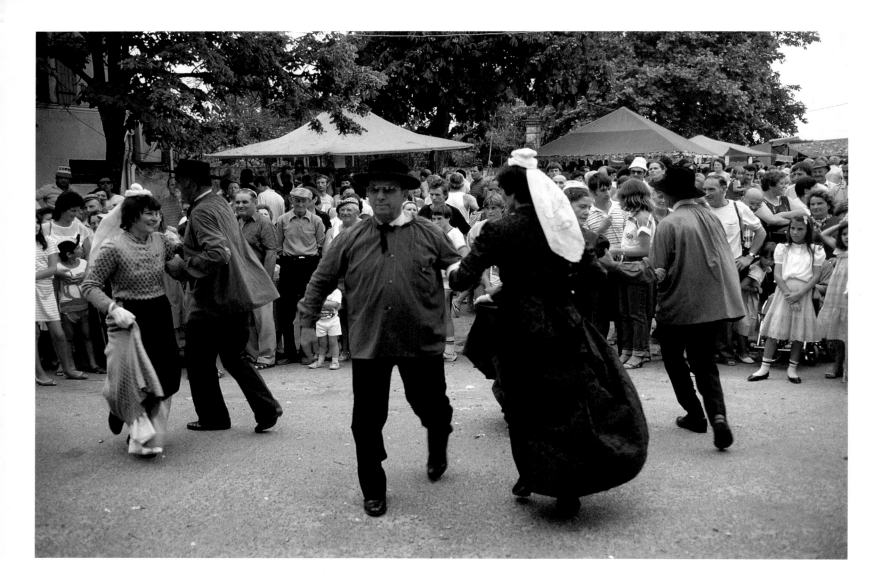

all that was left in the beleaguered town was salt and fresh pork, a few sheep and geese and some old sausages. Later *haricots verts* were added, imported from the New World after 1492. The fame of the dish spread and regional varieties appeared, so that today the Toulouse version uses less pork and more sausage, while the chefs of Carcassonne may add a mutton chop (or sometimes even a shoulder of mutton) and a partridge.

The town of Prades, west of Perpignan, has an ancient Benedictine abbey and lies amidst apricot, cherry and peach orchards. Here the townspeople delight in grilled mussels (called in Catalan *la moulade*) and *la cargoulade*, which consists of little grilled snails, sausages, lamb chops and bread with *aïoli* (a blend of olive oil, egg yolks, lemon juice, salt and garlic). Another dish much

relished in Catalan country is *escargots à la catalane*, in which the snails are garnished with ham, onion, peppers and parsley.

Cheeses are legion in France, ranging from the luscious varieties created from the rich milk of Normandy cows to the pungent Munster of Alsace (invented by monks in the seventh century) and the yet more pungent, blue-veined Roquefort, which is made by infiltrating cheese made from the milk of the ewes of Lacauze with a bacillus found in the caves of Roquefort-sur-Saulzon in the Aveyron, north-west of Toulouse.

Eating is traditionally linked with the plethora of festivals celebrated in rural France. The variety of these festivals is bewildering. Burgundy rejoices in wine fairs, such as the Tête Raclet at the village of Romanèche-Thorins on the last

Saturday of October. In the Basque village of Tardets-Sorholus each August the local inhabitants parade in traditional constumes riding hobby-horses. More serious animals are the bulls which pursue people through the streets of such partly-fortified Catalan towns as Millas (Pyrénées-Orientales). Not far away, at Céret (a town admired by Picasso, Braque, Chagall, Derain, Dufy, Gris and Maillol), the bullring carries a plaque in memory of José Falcon, killed at the age of thirty-three by the bull Culchareto on 11 August 1974. Each August the arena also hosts a more peaceful festival of traditional Sardane dancing.

Lower Normandy is famed for its ancient horse fairs, as is Brittany. Each Monday throughout Whitsuntide, horses from every part of the world are sold at Landivisiau in

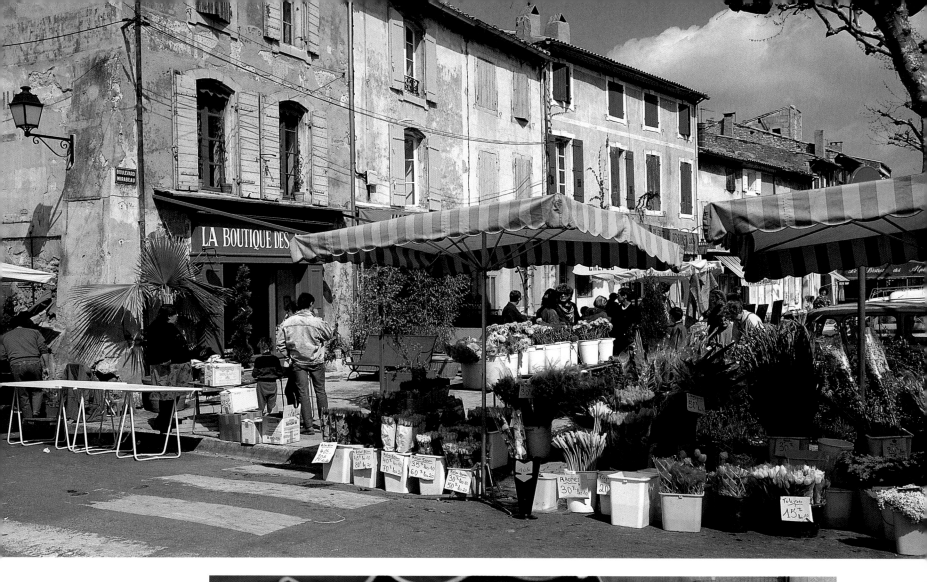

The central role of
gastronomy in French
culture is underlined by
the many festivals in
honour of food and drink,
such as this Dordogne
celebration (opposite),
and the ubiquitous
market: flowers at Saint-
Rémy-de-Provence
(above) and *saucissons*
in the Auvergne (right).

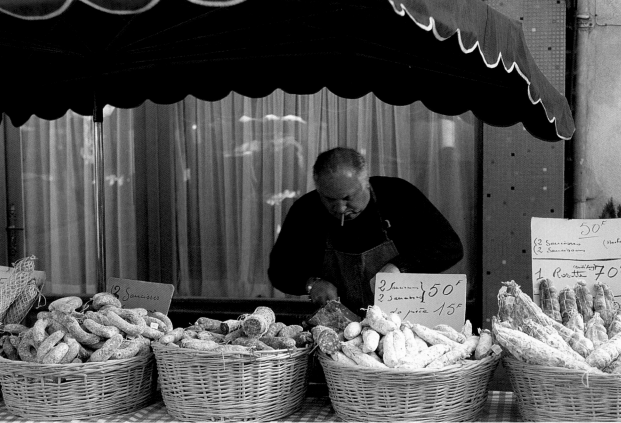

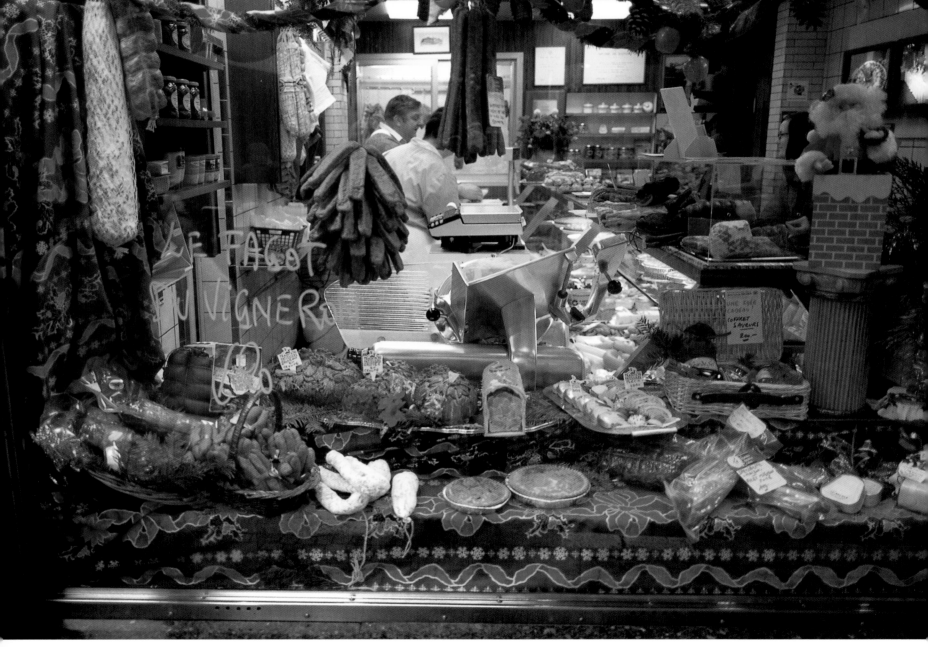

north Finistère, following a centuries-old tradition. At the other end of France, in the village of Espelette in the Basque country, ponies known as *pottoks*, which throughout the year roam the neighbouring hillsides, are sold at the annual January fair. In between these parts of France, the people of the Périgord relish their annual truffle fairs as much as their annual walnut fairs.

Inevitably, many festivals relate to religion. At Les Saintes-Maries-de-la-Mer in Provence gypsies arrive in the last week of May and carry into the sea a statue of St. Sara (the legendary servant of Mary Magdalene and two other biblical Marys who are said to have landed here after the crucifixion of Jesus). More seriously, throughout France around the feast of All Saints, villagers and townspeople gather at their cemeteries and stand devoutly beside the graves of their dead, while the local priest prays and blesses the tombs with holy water. In Brittany are held annual 'pardons', when in traditional costume Bretons, led by their clergy, process with banners and statues to their churches, seeking pardon for their sins and also miraculous cures for their illnesses. Pardons take place from March till the end of October, the most famous at Le Folgoët in Finistère. Held on the Sunday after 8 September, it attracts visitors from the whole of Brittany.

Christmas in Provence is spectacular. On 6 December (the feast of St. Nicolas) the shepherds of Istres drive 2,000 sheep into the town for three days of Masses, sheep-dog trials and wool sales. And the Provençal Christmas dinner, on the evening of 24 December, is known as the Gros Souper. On white tablecloths Jesus and his Apostles are represented by three loaves and thirteen desserts. That same evening the

people of Séguret in the Vaucluse process to midnight Mass, some of them in historic costumes and carrying lanterns.

French literature shares and reflects the national preoccupation with food and drink. Many writers have linked food with a strong sense of place. Gustave Flaubert in *Madame Bovary* describes the manure heaps of Normandy, and in *Bouvard et Pécuchet* evoked the making of one: 'Into the compost heap he threw together tree-branches, blood, chicken feathers, every-thing he could lay his hands on. He bought Belgian chemicals, Swiss fertilizers, pickled herrings, seaweed and rags. He ordered guano dung and even tried to manufacture it himself. His extreme principles forced him not to waste a drop of urine. The farm privies were suppressed. The fragmented carcase of any dead animal was brought into the yard where his dungheap festered. In the midst of the stench Bouvard smiled.'

Twenty-five kilometres south-east of Chartres, Illiers-Combray in the Eure-et-Loire is notable not only for its fourteenth-century church and its late-medieval château but also as the spot where Marcel Proust spent part of his youth. Indeed, the name 'Combray' was added only because that is what he called it, though no-one has yet changed the name of the river Loire to his own fictionalized name, the Vivonne. After he developed asthma, he never returned here, preferring between 1907 and 1914 to spend his summers in the Grand Hotel of the Normandy seaside resort of Cabourg (which in his writings he called Balbec). Since the small cakes known as *madeleines* played a vital part in inspiring him, inevitably they are widely sold in these love-ly towns. And the promenade at Cabourg on which the Grand Hotel stands is now called

An Auvergnat proudly displays the produce of his fields at market (below right); a delicatessen store (opposite) in Kaysersburg offers every conceivable variety of Alsace cooked meat; in the Hautes-Pyrénées, as in most French regions, the varieties of bread are fascinating and bewildering (right).

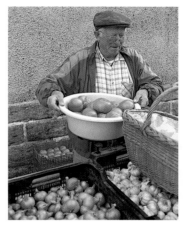

Overleaf
Succulent olives, both black and green, come from Provence, which is also rich in aromatic herbs (above left and right). On countless market-stalls, like these at Honfleur, Normandy, are sold side by side radishes, raspberries, shallots and mushrooms (below left and right).

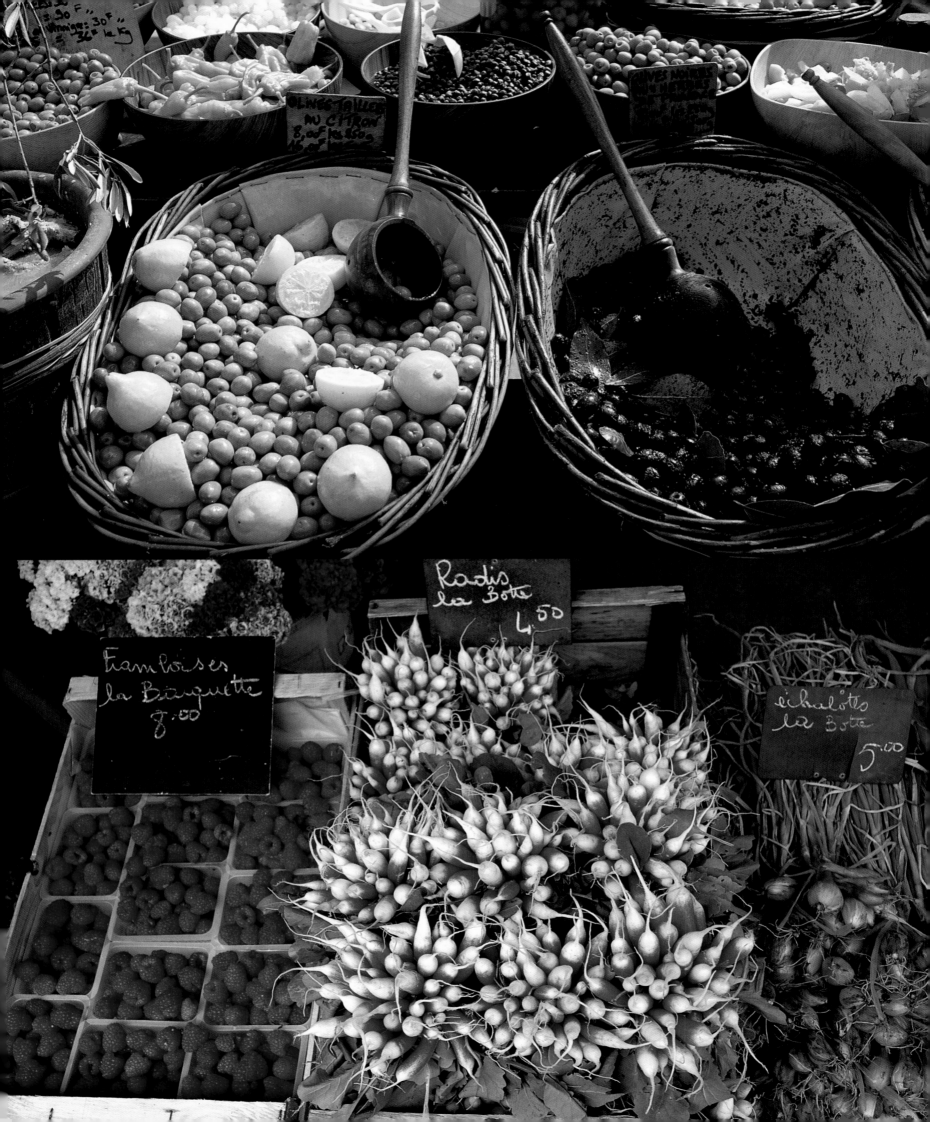

The endlessly
fascinating faces of
France: a straw-hat and
sunburn (below) reflects
the heat of the south,
while the autumn glades
of the northern forest of
Compiègne, once the
hunting grounds of the
French court, invite us
to another part of this
varied land.

the Promenade Marcel-Proust.

To remain in Normandy with the writers who have celebrated it is to come repeatedly on tantalizing descriptions of food. Some authors even regard their female characters as juicy dishes. In *Boule de Suif* Guy de Maupassant described his heroine as if she were delectable Normandy food: 'Short and round, fat as butter, her podgy fingers with their nipped-in knuckles looked like chitterling sausages… Her succulence was exceedingly tempting, and her face was a red apple.' Would the women who dance at the wine-fair of Sigoulès regard such descriptions as a compliment? Would the stall-owners and shop-keepers of Provence be delighted with comparisons to their olives, herbs and *cèpes*?

LIVING IN FRANCE

Similarities to local foodstuffs apart, any observant visitor to France is immediately struck by the diversity both of its people and its landscape. Three coasts, gentle hills and formidable mountains, plains and plateaux, majestic rivers and placid lakes present a diverse face to the world. In spite of a relentless flight from the countryside, the small towns, villages and hamlets often seem to safeguard a quintessential France.

Its religious heritage is rich: abbeys sitting alongside rivers; cool Romanesque buildings; flamboyant Gothic houses of God; cathedrals; quietly beautiful parish churches. Some of these are today in ruins, while others remain intact. Secular buildings are equally evocative. In rural France abound tithe barns, ancient hamlets, wind-mills, shepherds' huts dating from Romano-Gaulish times, fortified ports, fortresses and châteaux – the last both dominating and protecting lowly hamlets. In many parts of

France, the ensemble of a village or the heart of a medieval town leaves a gratifying, unforgettable impression.

Every French community seems to have its own particular gastronomy, and in many regions its own reputed wine. At Beaune in 1766 the Scottish physician and author Tobias Smollett observed, 'We found nothing good but the wine.' Apparently and strangely he disliked or failed to see the fifteenth-century Hôtel-Dieu, the remains of the fourteenth- and fifteenth-century ramparts, the distinctive multi-coloured tiles of the houses and the twelfth-century church of Notre-Dame.

The inhabitants of different regions of France are equally distinctive. For centuries

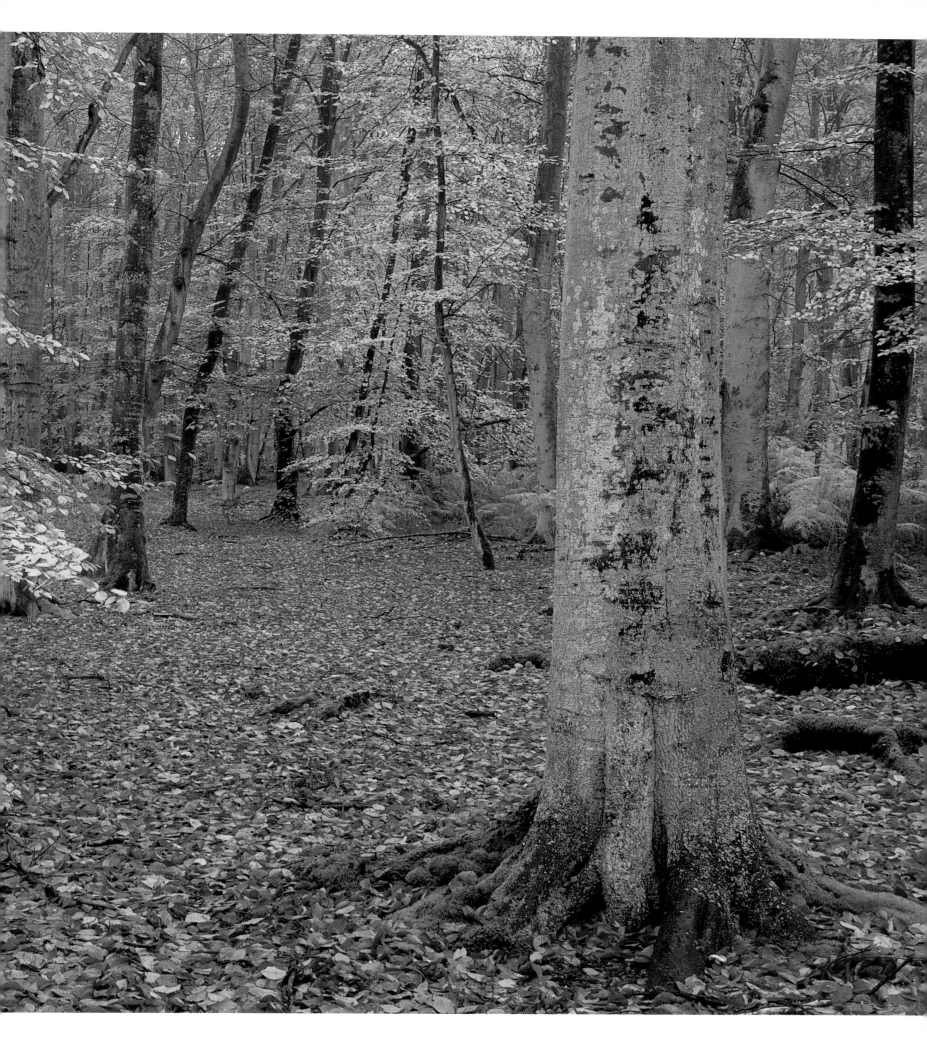

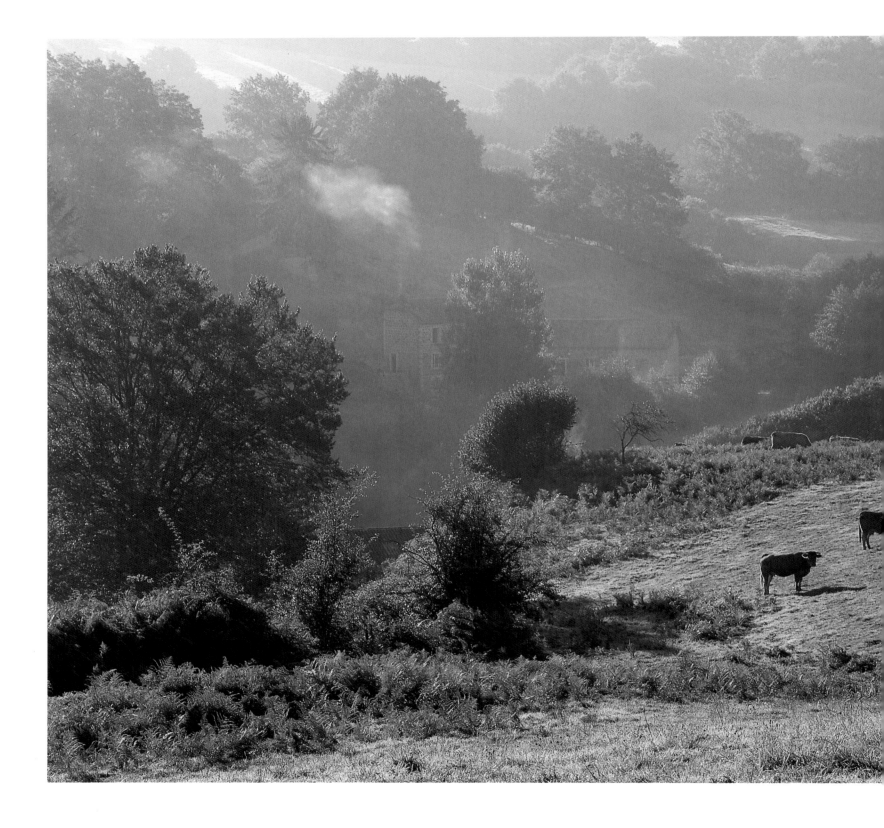

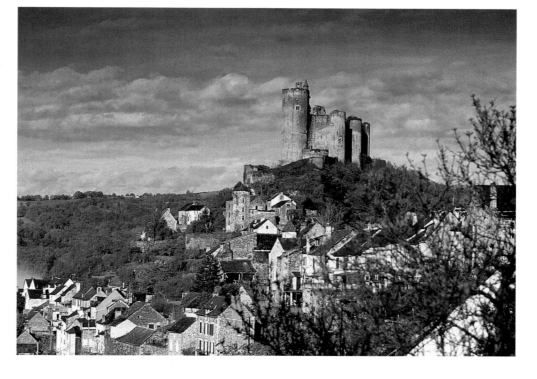

Classic scenes from rural France: a misty morning near Poitiers presages the clear skies of another sunny day (below); the village of Najac (right), in the Aveyron, sleeps beneath its medieval château.

they have jealously guarded their own individuality. As the Flemish poet Émile Verhaeren expressed it, 'These are men of toil, far removed from those painted insipidly by Greuze to enliven the chocolate-box decorations of a Louis-Quinze drawing room. They are, instead, dark, coarse and bestial.' No doubt Verhaeren exaggerated, for French peasants today are far from coarse and bestial; but they have an unmistakable sense of their own significance.

To tour the country and even to choose a place to live reveals at every turn a totally different aspect. The north, the *départements* of Nord and the Pas-de-Calais, has undulating roads laid out by the Romans. In the Pas-de-Calais grow more corn and oats than in any other French *département*. Here are canals, forests and meandering rivers. Farmers' houses are characteristically long and low. Move into Normandy to find a curious language, especially connected with the names of towns and villages. A house is known as a *hogue* or *hague*; a lake is a *mare*; a stream is a *bec*. Visit the Dordogne to find place names ending in *ac*: Bergerac, Turnac, Boulazac, Eyzerac, Payzac and Plazac. This indicates that the spot was either founded or invested by the Romans, for *ac* is an abbreviation of the Roman suffix for 'at

the place of'. Grolejac thus means, 'at the place where the Gauls lived'.

Move eastward to the Côte d'Azur and the region of Nice, to find yourself half-way into Italy and in a totally different environment. The Musée Matisse has been set up in a seventeenth-century Genoese villa. Here is a nineteenth-century Russian Orthodox church, its six onion-domes gleaming with glazed tiles, its interior packed with icons and decorated with frescoes. The food is utterly different from that offered elsewhere in France: *pistou*, for instance, a vegetable soup enhanced with basil; *pissaladière*, that is a pizza with black olives, anchovies and onions; *pan-bagnat*, a roll that has been stuffed with *salade Niçoise*.

But ultimately it is the French village that epitomises each region of this diverse land. Old traditions die slowly in France and perhaps will never die. The French are still taking care of their heritage – even gastronomic appreciation is part of the school curriculum, and still a matter of serious concern to all French men and women. It should seriously concern visitors, too; for to savour the remarkable variety of French regional gastronomy offers multiple insights into the diversity of this land, which the following chapters, in their evocation of contrasting regions, so emphatically underline.

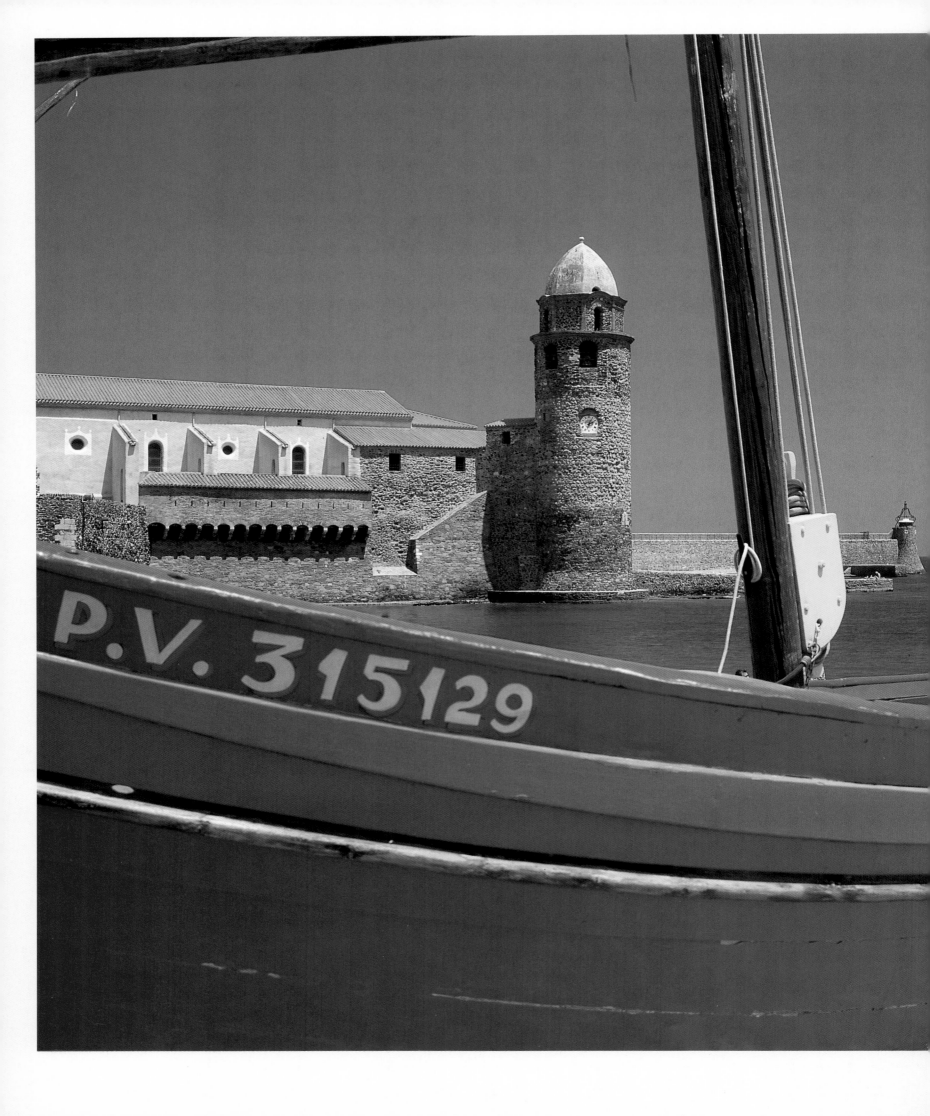

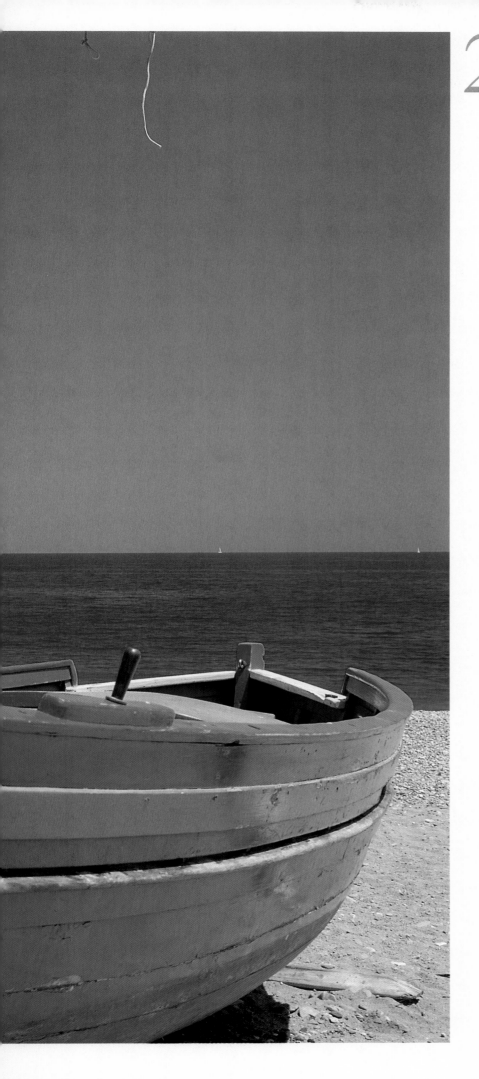

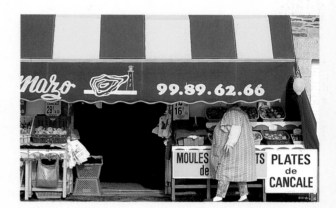

TO ENJOY THE BRACING AIR of the northern coast of France, to relish the offshore islands and the seaside towns of the Atlantic coast, to laze on a beach beside the Mediterranean coast, or perhaps swim in its welcoming waters, are three delights of the three coasts of France.

Even when at times the sea is menacing instead of welcoming, its mark is fascinating. The granite villages of Brittany are powerful enough to stand up to the gales which sometimes lash its coastline. The Landes along the Atlantic coast boast a sand dune, the Dune de Pilat, which rises to a height of 115 metres, higher than any other in Europe. A medieval pilgrim, Aimery Picard, left a warning that some of his fellows had sunk into this vast pile and suffocated to death. Perhaps; but the Dune de Pilat continually grows and moves, as the Atlantic brings in more and more sand, while the local inhabitants plant trees to try to contain it. As for the Mediterranean coast, in spite of the cliffs which plunge into it, this scarcely menaces anyone – as Edith Wharton described it, since the times of the Greeks and before, a 'warm, peaceful temperate heaven .'

'Heaven' it certainly became to the rich, famous and fashionable, at least after the apparently ill-tempered Lord Brougham had succumbed to the charms of Cannes in 1834. From that time on, the eastern Mediterranean became one of the world's great playgrounds, a blessed place indeed and an inspiration to

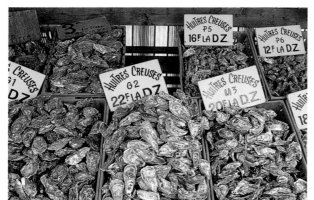

Since the seventeenth century the white oysters of Cancale (above) **have been even more renowned than its shellfish.**

Preceding pages
The Mediterranean port of Collioure on the Côte Vermeille gained fame in the early twentieth century when painters such as Picasso, Matisse, Derain and Dufy began to work there, enthralled by its charm and the luminosity of its colours. Equally fascinating is the northern coast, where this shellfish and oyster stall graces the Brittany fishing port of Cancale on the Côte Eméraude.

countless artists and writers, although the local population has never been behindhand in singing the praises of the magical strip from the Spanish to the Italian borders. The people of Cannes, for instance, quote the words of a local poet, 'Cuisine in Cannes is like a slice of sunshine eaten on a tablecloth of blue sea.' It is likely, too, that the sharp-tongued fish-wives of Pagnol's Vieux Port of Marseilles would have had many a well-directed word to say in defence of that rumbustious, polyglot city, now sadly showing very evident signs of decline and decay.

Like the heyday of Marseilles, that of the coast as a whole seems somehow gloriously fixed in the nineteen-twenties, a decade of elegant hotels, sophisticated parties and endless sunshine, associations which made a deep impression on that other icon of the Jazz Age, Scott Fitzgerald: 'On the shore of the French Riviera, about half-way between Marseilles and the Italian border, stood a large, proud, rose-coloured hotel. Deferential palms cooled its flushed façade, and before it stretched a short dazzling beach. Now it has become a summer resort of notable and fashionable people…'.

West of Marseilles, the coast of Roussillon stretches to the Côte Vermeille and the Spanish border. Red earth and green vineyards give it a violence of colouring. Coupled with the brilliance of the Mediterranean, this natural palette seems to have made it irresistible to some of the most ferocious colourists of twentieth-century art, the Fauves, whose violently realized canvases seem to be a part of the fabric of this part of the Mediterranean coast rather than a depiction of it.

After the drama, natural, literary and artistic, of the long Mediterranean coast, the west coast of France seems low-key, retiring. Though it, too, has its historically fashionable resorts in Biarritz and Saint-Jean-de-Luz, much of the coastline seems very much at one with many extensive, mysterious wetlands which make up its hinterland. The estuary of the Gironde does, however, recall the

Anglo-French struggles for supremacy in the south-west, and also a happier phase of relations between the two countries - the centuries-old wine trade, which meant that virtually no Burgundy was drunk in Britain before the beginning of the twentieth century, as 'claret' ruled in the better-off homes of the nation. La Rochelle recalls the Wars of Religion, while the Ile de Ré heralds the beginning of the complex coastline and offshore island groupings which reaches full fruition in Brittany, land of the Celtic twilight and raging Atlantic gale. It is also a coast of great gastronomic delights, and none more delightful than the famous oysters of Cancale on the north coast of the province.

For the traveller making the journey east from Brittany to Normandy, the first coastline encounters could scarcely be more different or more historically poignant. This is one of those areas of the world where men and women have lived for centuries in a state of confrontation with each other, with the elements, where the violent history of mankind seems uniquely concentrated: the coming of the Vikings, the Norman invasion of England, the counter-invasion of Henry V, the struggles of the fisher-folk, and the Normandy landings.

To traverse the coastal villages and towns of this province is indeed to wander through history. In 1588, offshore of the town of Gravelines, the English fleet routed the Spanish Armada. Lying on the right bank of the river Aa, the town is still protected by its ramparts and by its glacis, a sloping bank created in 1160. The fortifications were designed by Vauban on behalf of Louis XIV. Its citadel, known as the arsenal, is likewise intact, and the belfry of Gravelines dominates the red-roofed houses of a charming, irregular square.

A couple of kilometres north west, the fishing villages of Petit-Fort-Philippe is named after King Philippe II of Spain, whose troops twice defeated French armies nearby in the 1550s. From the other bank of the river Aa, this pretty village, with its low, Flemish houses, is overlooked by Grand-Fort-Philippe, its lighthouse visible for miles around.

The Baie de la Seine off the Normandy coast offers more poignant memories of World War II. A stele by the

beach at Courseulles-sur-Mer records that this was the first port officially liberated in 1944 when General de Gaulle stepped ashore here. Normal life is revealed by the oyster farms and fishing smacks of the town, as well as its seventeenth-century château. By beaches where the Allies doggedly landed and the Germans desperately attempted to repel them, we find at Saint-Laurent-sur-Mer a plaque declaring that one cemetery contains no fewer than 21,160 German soldiers, while in others rest 29,606 Allied dead.

Before reaching the Plages du Débarquement, however, our traveller will already have encountered the province's past at the very border with Brittany. The rock of Mont-Saint-Michel was a shrine long before a Christian church was built upon it, probably devoted to the cult of Mithras, a god popular with the Roman legionaries. Its peculiar geography has made it a focus for pilgrims through the centuries, and now for tourists, for the mount

is the third most visited location in France, after Paris and Versailles.

I recall vividly my first visits to Normandy and the excitement of its charms: the rugged cliffs and fishing villages, the sophisticated resorts and their elegant hotels and casinos, the richness of the countryside and its produce – cream, cider and Calvados, lunches of mussels or salmon terrine in an assertive sauce, followed by flounder in one based on cider and then the joy of reading the great literature which this magical place has inspired: by Stendhal, Guy de Maupassant and Proust. And arriving at Ouistreham, the port of Caen, I still remember the sight of women selling *fruits de mer* along the route from Caen to Falaise, indicating to me instantly that the delights of Normandy would be many and richly rewarding.

We shall look at many of the aspects of the province and its coast: culinary, historical and literary – in this chapter and the chapters which follow. But, in the meantime, I leave you with the story of Jean Bart, which

seems to sum up the spirit of the place and the undoubted qualities of the sturdy and enterprising folk which inhabit this northern coast.

Born into a family of Dunkirk fisherfolk in 1650, Jean Bart became the most celebrated corsair of France. He learned seafaring in the Dutch navy but soon turned against his mentors, joining their French enemies. By the 1690s, when the British bombarded Dunkirk no fewer than four times, Bart was commanding a squadron of ships in the North Sea, sank several British vessels and made a daring raid on Newcastle. In 1694 he presumed to take on the Dutch fleet, capturing cornships and bringing them and their cargo back to Dunkirk. Once the British captured him and imprisoned him in Plymouth, but Bart escaped and sailed in a fishing smack back to France. Louis XIV was greatly impressed, especially when he honoured the corsair and heard his reply, 'Well done, sire.' The courtiers of the Sun King laughed, mocking Bart for his arrogance. Louis XIV rebuked them with the words, 'His response reveals a man who knows his own worth.' Fittingly, on Place Jean-Bart, Dunkirk, Bart's statue, sculpted by David d'Angers, depicts him bestriding an enemy cannon, pistol in hand and brandishing his sword.

To the north of the Place Jean-Bart rises Dunkirk's fifty-nine-metres-high belfry, built in 1440, symbol in Flanders of civic pride, symbol here in the Middle Ages of urban freedom as well. A fat, square tower, it grows more graceful as it rises for six storeys. On each quarter hour its carillon of forty-eight bells rings out, playing first a traditional chime, next the Carillon de Dunkerque, thirdly a tune celebrating a Viking who ravaged these shores until he became a Christian. Finally, on the hour each bell combines to sing the Cantate à Jean Bart.

Between Saint-Raphaël and Cannes the coastal road twists along the rocky Massif de l'Estérel (centre page). **Piles of fishermen's nets** (below) **indicate that the Mediterranean coast, though now adored by tourists, is also the home of fishermen who furnish local tables with cod, bream, red mullet, mackerel, hake, Saint-Pierre and the rest.**

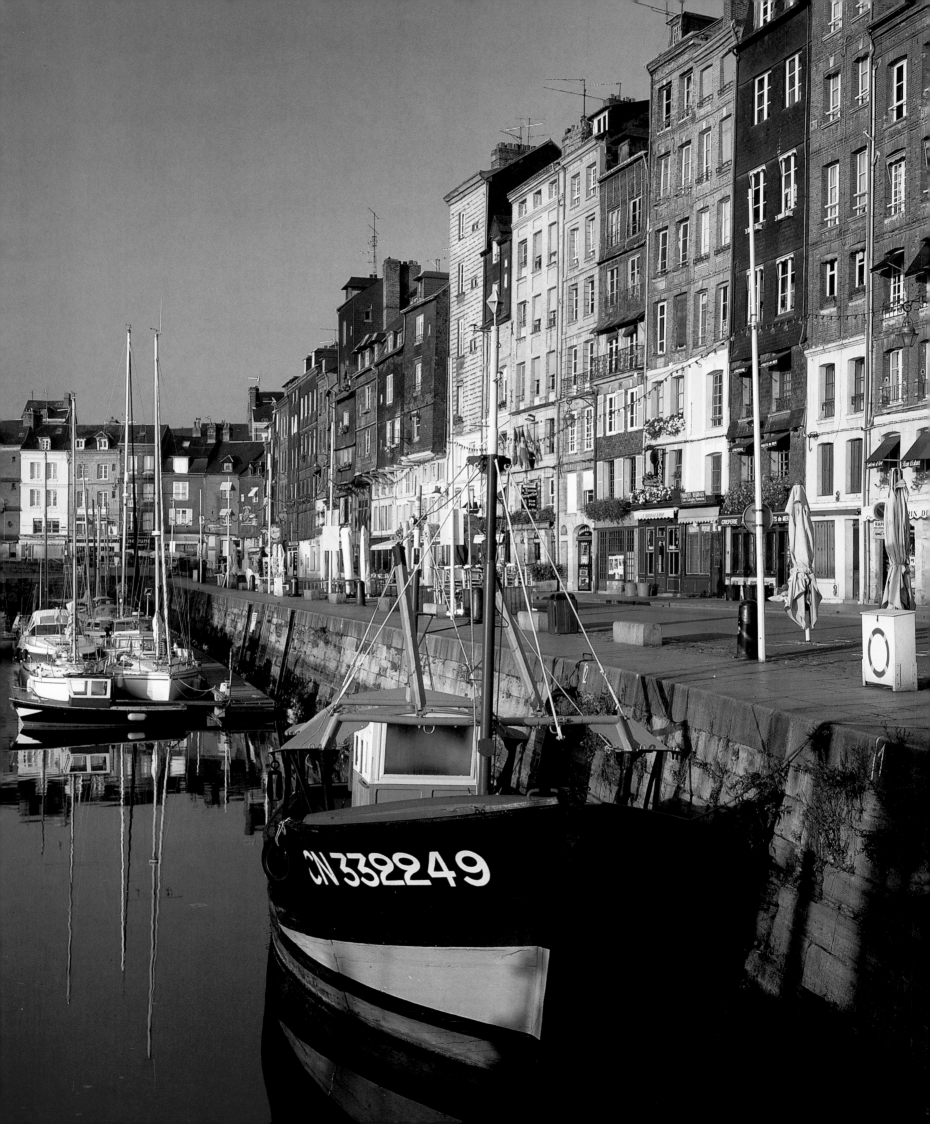

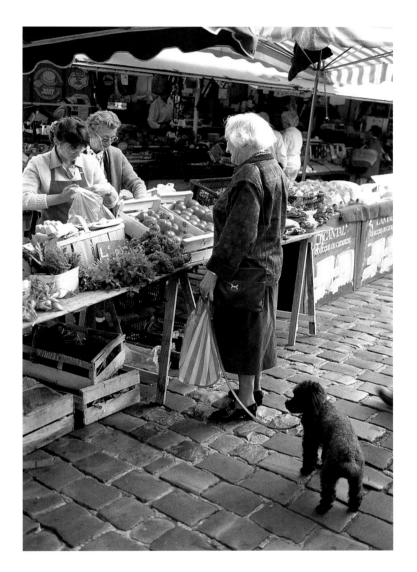

The old basin of the port of Honfleur (opposite) is lined with elegant houses, some made of wood, many roofed with slate. Long the haunt of artists, Honfleur was the birthplace of Eugène Boudin, born in 1825 in a house which still stands. Colourful awnings cover Honfleur's market-stalls, where the serious business of food shopping tests canine patience.

THE **O**PAL **C**OAST, which stretches from Belgium to Normandy, derives its name from the milky-white seas which wash and sometimes lash it. Craggy with estuaries sheltering ports and fishing villages, at its northernmost point, overlooked by the hills of Flanders, the river Colne flows into the English Channel. The coast is thought to have been so named because of its opalescent (though sometimes also blue, sometimes even golden) waters. Its main town is Calais which capitulated to the English in 1347. They managed to hold on to it until 1558, when François de Guise took it from them after an eight-day siege. The English queen, Mary Tudor, died in November of the same year. According to the chronicler Holinshed, she remarked, 'When I am dead and opened, you shall find "Calais" lying in my heart.' The English never took the town again.

In 1837 Victor Hugo described the route from Calais to Boulogne in words which are still apposite. It runs, he judged, 'through the most beautiful countryside in the world, hills and valleys rising in magnificent undulations'. On the way to Boulogne is the entrance to the Channel Tunnel at Sangatte, a project accomplished in the twentieth century but envisaged by Napoleon Bonaparte almost two centuries earlier. The road then climbs up to Cap Blanc-Nez, a chalk and clay cliff which drops steeply into the sea. On a clear day you can see across to England. Close by is Wissant, whence in 55 B.C. Julius Caesar set sail to conquer England. At Cap Gris-Nez, Napoleon Bonaparte's statue rises forlornly on a column.

Shortly you reach Boulogne-sur-Mer, which rises on the Opal Coast on a couple of steep hills where the river Liane flows

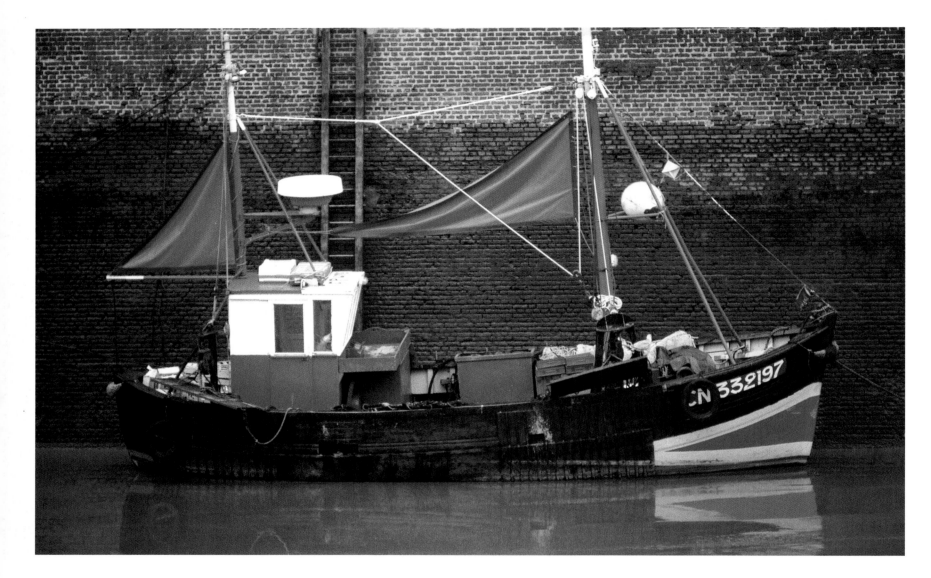

into the sea. Because of a celebrated statue of the Virgin Mary, the town was once a noted centre of pilgrimage. Étaples, due south, where the river Canche flows into the sea, is a town with rusty vessels occupying the quay alongside the huts of shipbuilders and chandlers. The port has a little maritime museum displaying mariners' traditional costumes, model ships and

ancient fishing tackle. Low, gabled houses line the twisting streets of the fisherfolk's quarter. On Tuesday and Friday the fishermen and their wives set up their stalls in the triangular town-hall square to sell kippers and sprats, whelks and mussels, juicy cod and conger eels, burbot and herring fillets, marlin and clams, brill and lobsters.

Seaside resorts continue southwards: Le

Touquet, with its casinos and eight hundred hectares of pine woods which shelter elegant villas; Stella-Plage, with more pine trees and green lawns; Berck-Plage, a resort which developed in the nineteenth century around a hospice where children suffering from arthritis were treated by bathing in the sea.

This coastline has constantly produced idiosyncratic maritime villages. Le Crotoy,

In the sixteenth and seventeenth centuries many fishermen set out from **Honfleur** (opposite) to cross the ocean, when French sailors were among those beginning to explore the New World. Samuel de Champlain, for instance, made his first voyage to Canada with a crew from Honfleur in 1603. The chief seaport of the Cotentin in the Middle Ages, **Barfleur** is now a fishing port (right).

The Channel ports and villages are places of social vigour: two inhabitants of Cherbourg (left) **and** (opposite) **a** pavement café on the Quai Sainte-Catherine, Honfleur, a port where the light still 'bathes the ground and is shimmeringly reflected in the water, as well as playing over people's clothes', as Eugène Boudin observed.

set in the bay of the Somme and surrounded by numerous prehistoric circles, is where in November 1430 Joan of Arc was imprisoned before being taken to Rouen, hence her statue in the village. The village passed successively from the English to the Burgundians and from the Burgundians to the French. Jules Verne, Colette and Toulouse-Lautrec were all entranced by the spot. A curiosity further south is the last resting place of Chinese soldiers, buried in the World War I cemetery at Noyelles-sur-Mer. Coming from Indo-China, although these men fought alongside the British and the French, they died not in battle but of Chinese 'flu. From Noyelles the route runs west, through a countryside which nurtures plump cattle as well as beetroot and cereals, to cross the Canal Maritime de la Somme and reach Saint-Valéry-sur-Somme, where Victor Hugo stayed in 1837.

Le Tréport, the first station in Normandy, is divided in two. The lower part, at the foot of a high cliff, was in part destroyed in World War II. It had suffered before, in the fourteenth and sixteenth centuries from the depradations of the English, and in 1562 from the Protestants of Dieppe. The upper town perches on its cliff. Especially notable is the sixteenth-century church of Saint-Jacques, with its superb portal and a sixteenth-century statue of the Virgin Mary, carved in stone and dubbed Notre-Dame-des-Marins. In addition, here are Renaissance houses, the remains of an eleventh-century abbey and a lovely sixteenth-century sculpted cross in the market-place. Louis-Philippe built a villa here and twice entertained Queen Victoria as his guest.

More entrancing coastal towns line this road: Criel-sur-Mer, with its fourteenth-

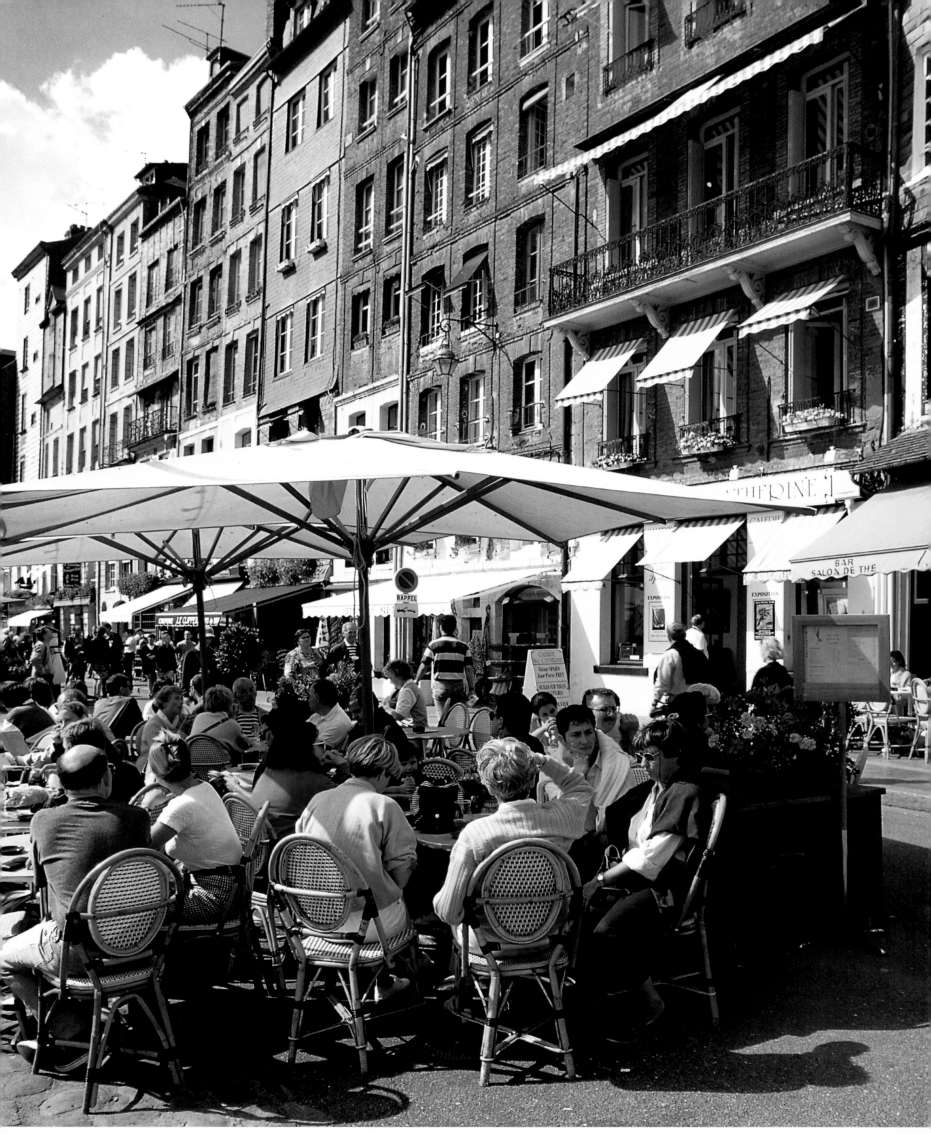

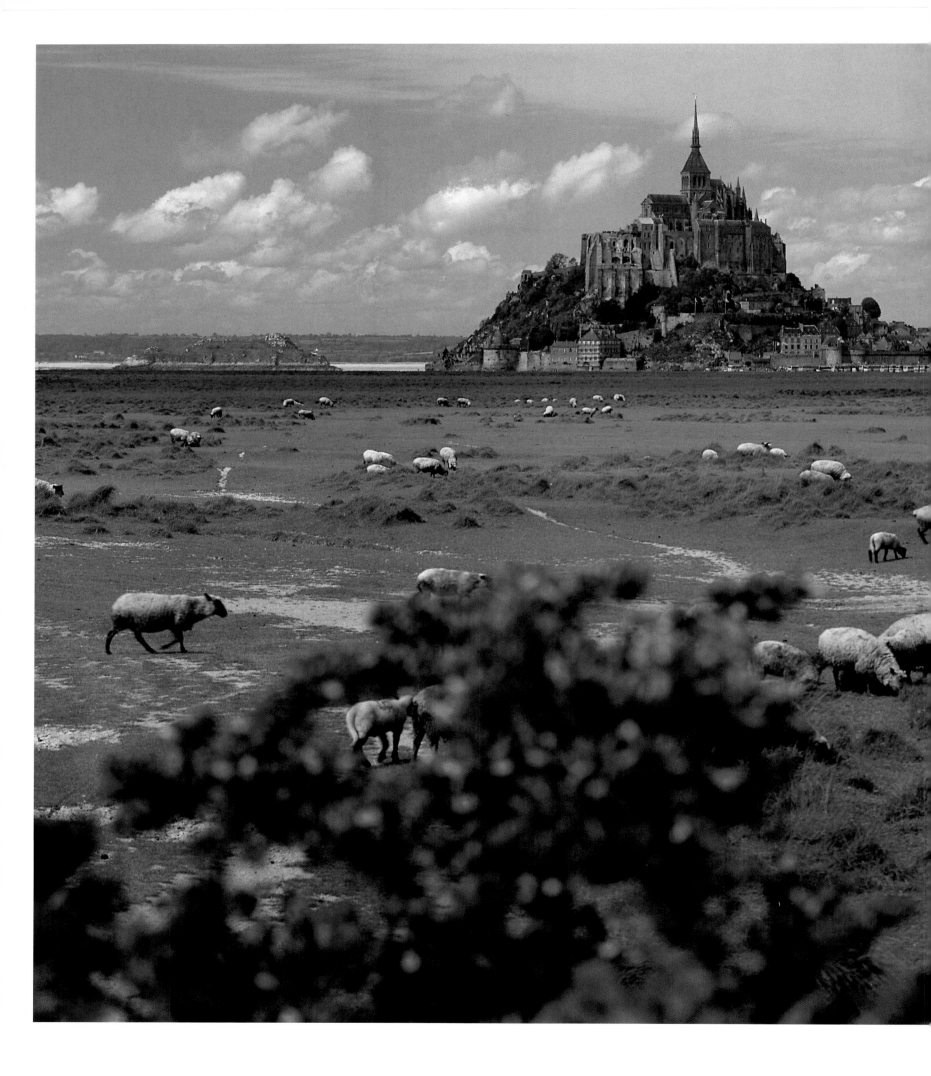

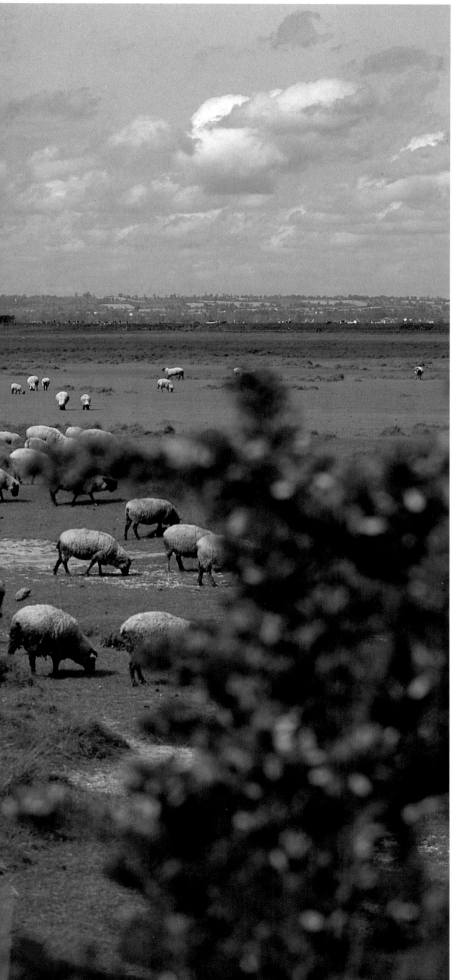

Mont-Saint-Michel, 'an equilateral triangle, often of increasingly brilliant red verging on rose,' as Stendhal described it, is in fact a conical hill, often crowded with visitors; the village itself is protected by its fortifications and has its own Gothic parish church.

in cider, cod baked with onions and potatoes, and above all lobsters.

Barfleur overlooks a wild and rocky coast and has a long history, for it once served as the chief port of the Cotentin and was invested by the Vikings and subsequently by Anglo-Normans. Nowadays a seaside resort as well as a fishing port, the town has two handsome churches, one the sixteenth-century Saint-Nicolas (dedicated to the patron saint of seafarers), the other a former Augustinian priory built in 1739.

INTO BRITTANY

Reaching Mont-Saint-Michel by the coastal route demands negotiating Cherbourg and the Hague promontory, at the furthermost point of which is Saint-Germain-des-Vaux with its six windmills, and the Nez de Jobourg, which juts out into the sea and at 128 metres is the highest promontory in Europe. Between here and Mont-Saint-Michel is Granville, an English bastion during the Hundred Years War; the granite houses of its upper town are still protected by granite walls. Then Mont-Saint-Michel appears, an island in the shape of a pyramid, as Stendhal put it.

In 708 the Archangel Michael allegedly appeared in a dream to Aubert, Bishop of Avranches, commanding him to build a church atop a rock near the estuary of the river Couenon. The result of this is undoubtedly thrilling. 'From the sand dunes the abbey changes its appearance from that of a maritime cathedral to that of a feudal château,' wrote Guy de Maupassant, 'as if it planned to put fear into the invading ocean by menacing it with a crenellated wall pierced with slits for arrows and sustained by huge buttresses.' Three defensive gateways guard the

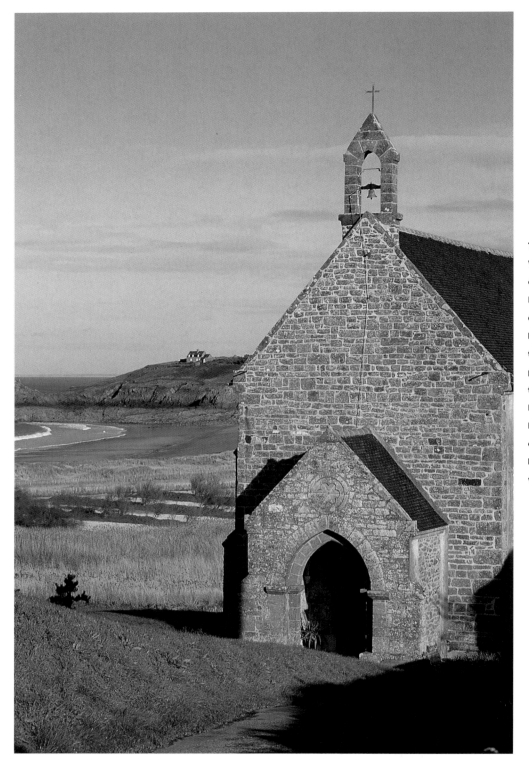

entrance to the village which grew around Bishop Aubert's monastery. Half-timbered houses overhang the Grand' Rue. Honey-coloured stone is enriched by stone of darker hue – green, deep brown and maroon. The lower church of the mount is dedicated to St. Peter; its eleventh-century pillars are joined by sixteenth-century arches. Then the road twists up to the abbey itself, a Romanesque nave topped by a wooden barrel-vault, a flamboyant chancel, a refectory with narrow windows, a sumptuous guest-chamber. Boutiques, restaurants enliven the tortuous, steep streets of the village. The sight of the whole ensemble in the evening, when Mont-Saint-Michel is illuminated, is ravishing. Stretching west from the bay of Saint-Michel, the Côte

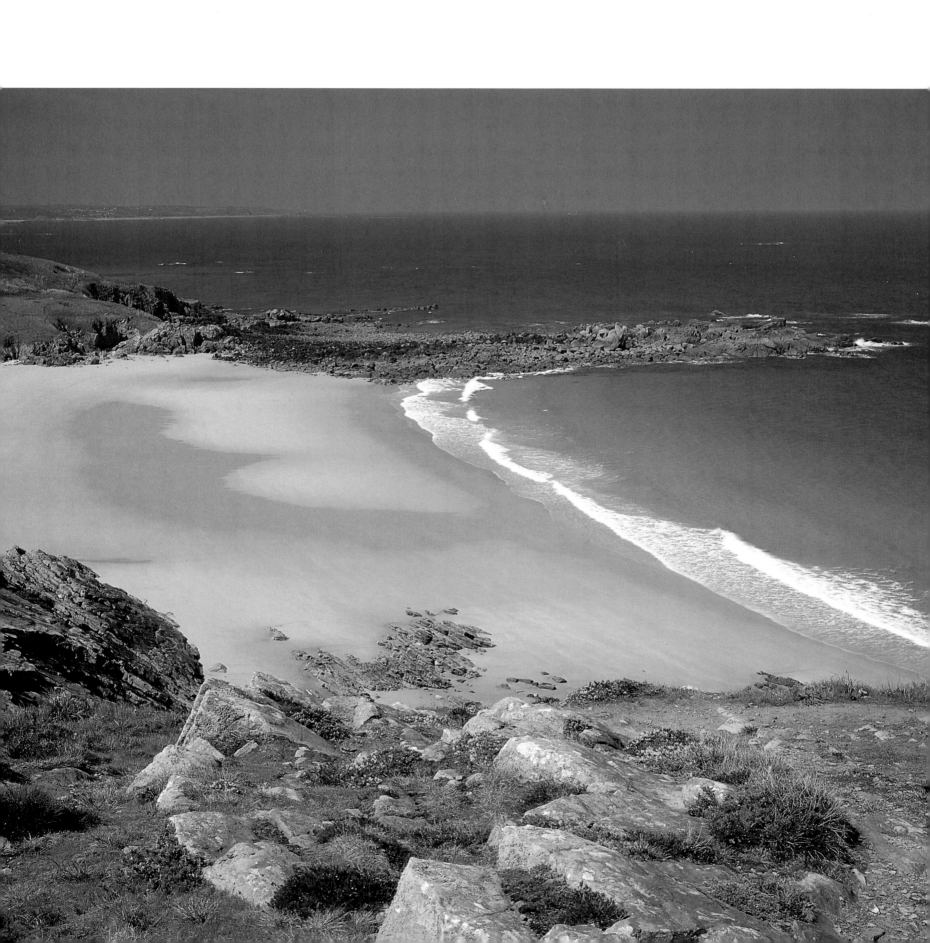

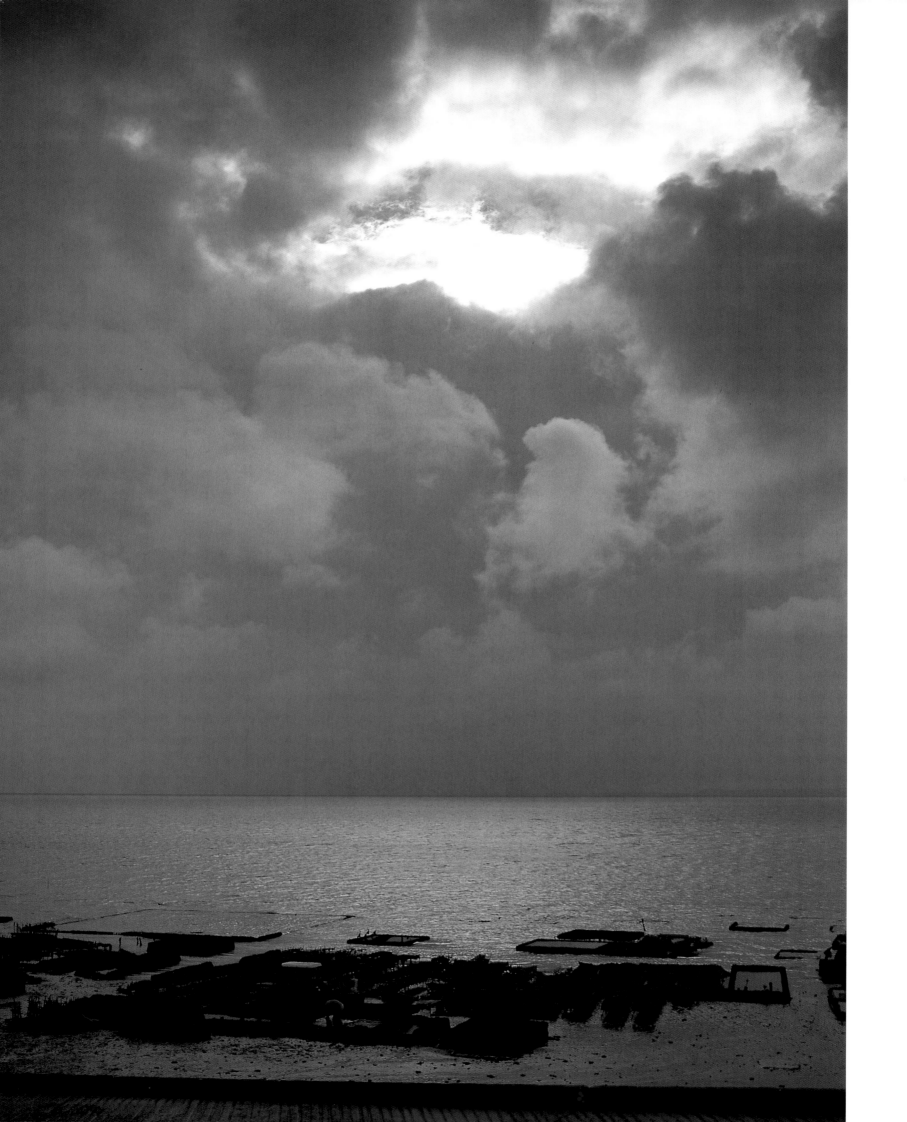

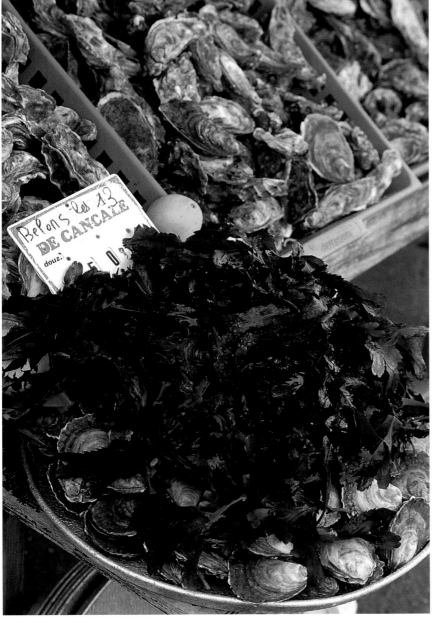

Eméraude includes Cancale, the quintessential Breton fishing village, particularly celebrated for its oysters (the village boasts an oyster museum), but also noted for the catch which its fishermen daily bring to the port. West, Saint-Malo was the birthplace in 1768 of the romantic novelist Châteaubriand, who grew to love this wave-lashed coastline. 'Here the plough and the fishing smack both shear their way through earth and sea', he wrote.

West of Saint-Malo the village of Erquy has a sixteenth-century château with a double ring of fortifications, the whole built of pink sandstone. Jagged cliffs rise at Cap d'Erquy. A few kilometres south-west is Pléneuf-Val-André created as a seaside resort in the nineteenth century, its streets laid out chequerboard fashion. The island of the Verdet, just off Pléneuf-Val-André is a bird sanctuary. *Armor* in Brittany refers to the country near to the sea, contrasted with *Arcoat*, the country of the forests. All these Côtes d'Armor comprise countryside and landscapes of exceptional quality. Around Fréhel, for instance, are four hundred hectares of savage beauty, while the headland of Cap Fréhel itself rises some seventy metres above the sea. Close by is Forte la Latte, a medieval fortress, restored in the seventeenth century but still preserving its drawbridge and guardroom. Lamballe is another major treat on this coast. Vestiges of fortifications and a curtain wall reveal that the collegiate church of Notre-Dame was once the chapel of Lamballe's château. Begun in the thirteenth century, though still retaining some Romanesque features, this basically Norman Gothic church dominates the town from the hill of Saint-Sauveur. Lower down in the town the church of Saint-Jean, which once belonged

to an eleventh-century priory, has a quaint, but locally typical wooden porch. Just over fifteen kilometres east of Lamballe rises the evocative fifteenth-century Château de la Hunaudaie, in part ruined, half-Gothic, half-Renaissance. Another romantic spot on this coast is Hillion, its eleventh-century church of Saint-Jean-Baptiste housing fine stained-glass windows.

Treats of the Côte de Granit Rose include Perros-Guirec, whose church of Saint-Jacques, built between the twelfth and the sixteenth centuries, is indeed of pink granite; Pleumeur-Bodou, where for centuries the sick have assuaged their suffering by rubbing themselves against the menhir beside the chapel of St. Samson. The delights of the Côte du Léon include Saint-Pol-de-Léon, a town renowned for its spires, especially that of its Romanesque-Gothic former cathedral, which rises fifty-five metres towards the heavens. North of

Saint-Pol-de-Léon is Roscoff, a harbour and seaside resort, whose parish church has splendid furnishings. Further west are two vast estuaries (known in this region as *abers*), Aber-Wrac'h and Aber-Benoît.

Due west of Brest, the Pointe de Saint-Mathieu is one of the major sites of the *département* of Finistère, where unfolds a panorama of the islands of Ouessant and Molène. The bay of Douarnenez further south shelters the port of the same name, notable for its shipping museum and fisherfolks' chapels. In this bay is situated the fascinating Michel-Hervé-Julien ornithological reserve, twenty-five hectares of coastline, a terrain chiefly consisting of lichen and moss, a refuge for most of the seabirds of Europe: penguins; seagulls; cormorants; petrels; puffins; guillemots; maritime parrots. Across the estuary is the seaside resort of Tréboul.

On the Côte de Cornouaille stands Pont-

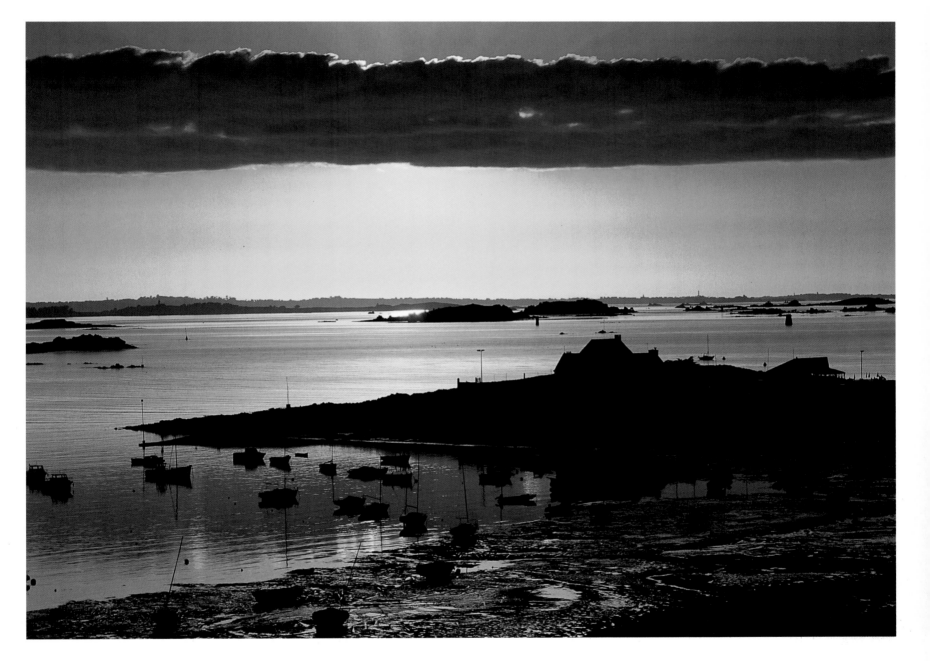

The *Loup des Mers* looks beached at Erquy (above). **From Brittany, south along the west coast, seaboard France has many fine, peaceful estuaries** (opposite and overleaf).

l'Abbé, whose name derives from a thirteenth-century bridge built across the river Odet in the tenth century by the abbots of Loctudy. This river meanders picturesquely inland as far as Quimper, with its ancient quarter and Gothic cathedral. Follow the Côte Sauvage to discover Quiberon, with its chaotic rocks, its fisherfolks' quarter, its beaches. Range along the Côte d'Amour to explore Guérande, Le Croisic, the pine trees of the Bois d'Amour and the beaches of Saint-Marc and Pornichet.

The west coast of Brittany is made considerably more interesting by the off-shore islands of Belle-Ile and the Ile de Houat. Among the delights of Belle-Ile is a fortress built in the sixteenth century. The route southwards passes through the powerfully fortified village of Saillé, whose menfolk rake salt from the village's long, low salt pans. Guérande is also fortified, its ancient walls, with their six towers and four powerful fifteenth-century gates, remaining almost intact. Inside the walls, the streets twist and turn, revealing two lovely churches, the fourteenth-century Notre-Dame-de-la-Blanche, and the church of Saint-Aubin, built between the eleventh and the fourteenth centuries. The capitals of its pillars are a delight, depicting not only the deaths of martyrs but also jugglers and the rich miser being chastized for not giving to poor Lazarus. This coastline has a quite exceptional beauty. The French themselves describe the beach of La Baule (close to Le Croisic) as the most beautiful in France; its white sand stretches for eight kilometres along the bay of Pouliguen.

Le Pouliguen, a town whose ancient ramparts survive, was the most important port of the Côte d'Amour until its decline

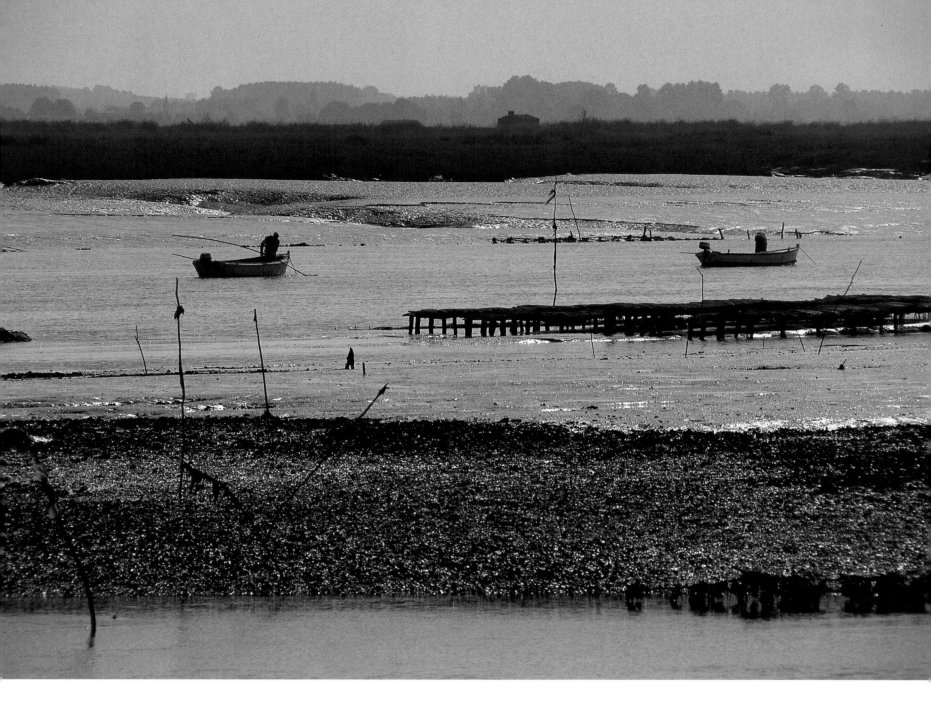

in the nineteenth century. Prospering on the salt trade, its citizens built themselves little white houses, while the grandees of the town constructed châteaux just as the community went into decline. They also built a neo-Gothic church. In earlier times the humbler citizens were content with their chapel of Penchâteau, built in the sixteenth century and housing a granite font and unpretentious sixteenth-century statues. Le Croisic is three kilometres north-west along the coast, here guarded

by menacingly twisted granite rocks, which the ocean has moulded into shape over the centuries. Near Le Croisic lies Batz-sur-Mer, a quintessential French fishing village; it was founded by Benedictine monks in 945. The present parish church, dedicated to St. Guénolé, was built in the fifteenth and sixteenth centuries, and from the top of its sixty-metres-high belfry (which once also served as a lighthouse) is a magnificent view of the ocean and its hinterland. Underneath their umbrellas in the main

square of the village, clog-makers still carve wooden *sabots*. The tortuous streets twist picturesquely, and the local *pâtisseries* sell the delicious butter-biscuits known as *galettes de Bretagne*. The inhabitants board up their windows in winter against the Atlantic gales which persistently sweep the coast from the west. Fortunately, their homes are solid; granite stands up to all the attacks of the Atlantic. In mid August, however, the weather is mild and the town celebrates the pardon of St. Guénolé.

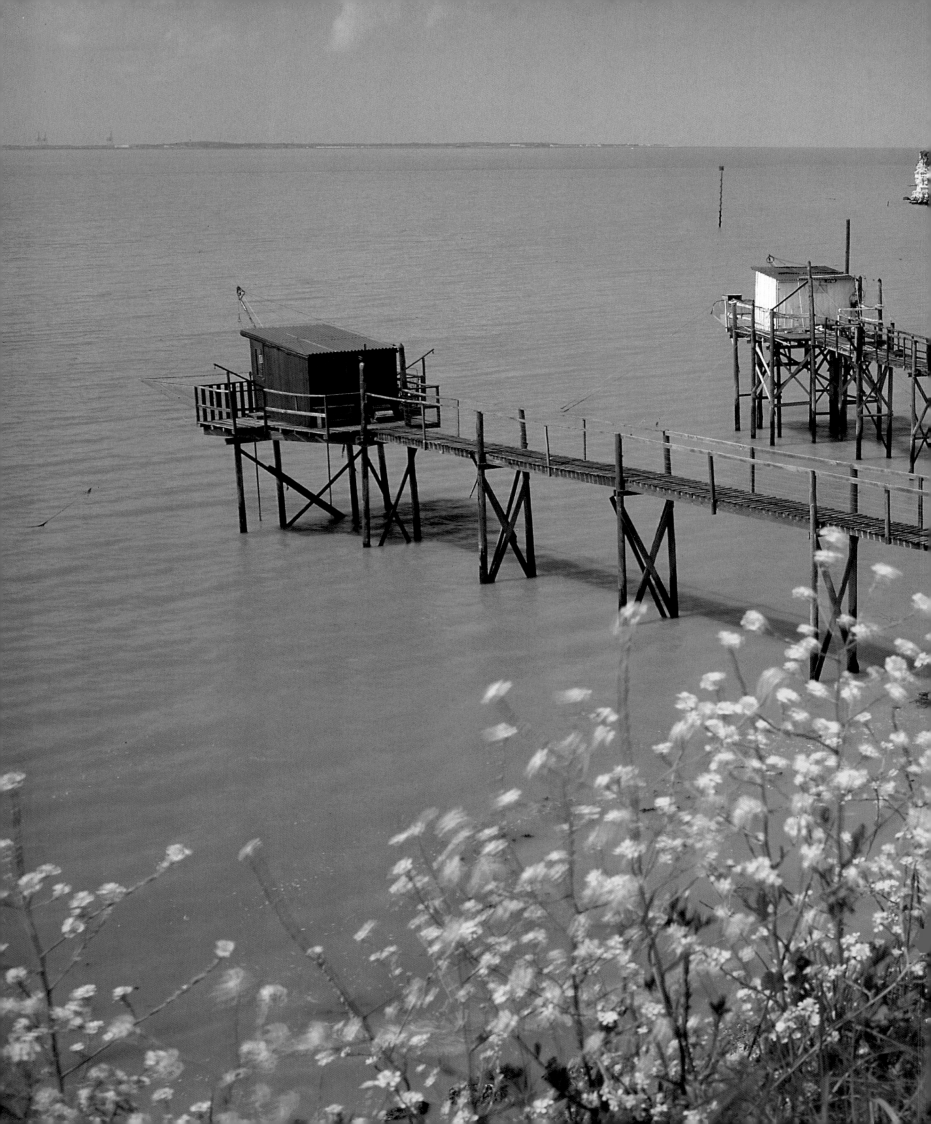

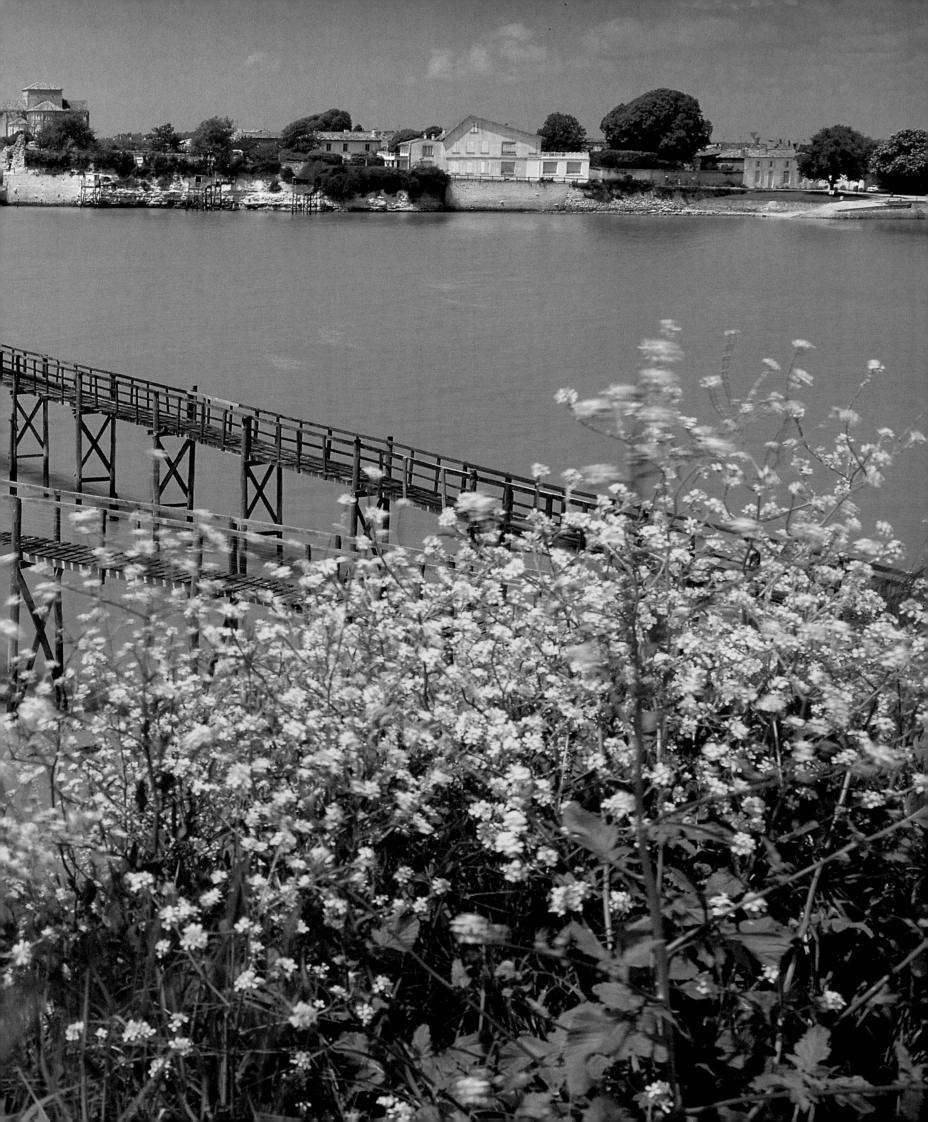

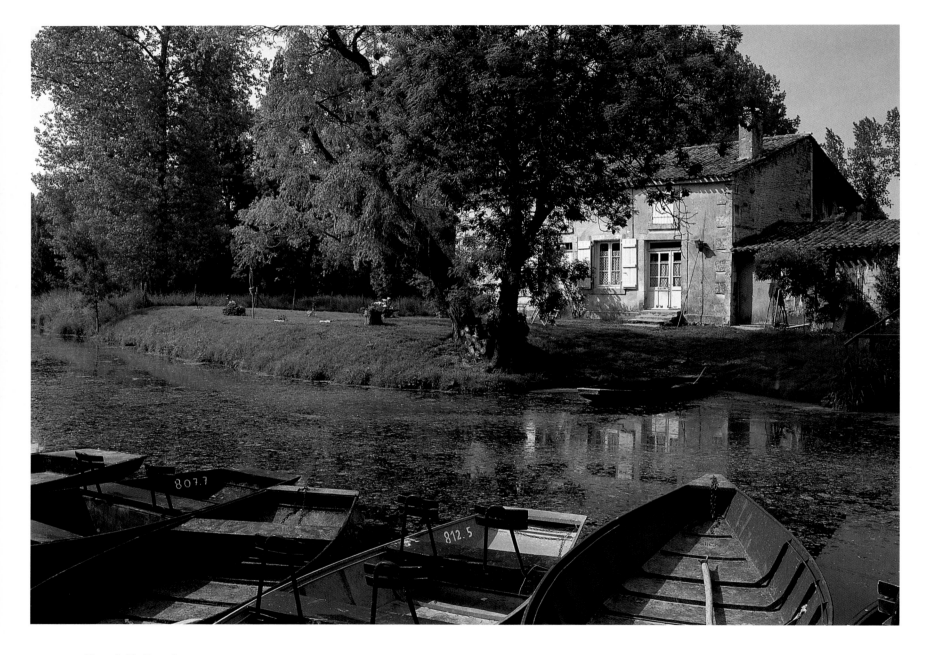

These flat-bottomed
boats (above) are moored
at Arcais in the Marais
Poitevin, where
communities are often
connected by
waterways.

WEST COAST SANDS

Many picturesque ports dot the coast further south. Among them, Olonne-sur-Mer has houses with external staircases, an eleventh-century Romanesque church with sixteenth-century stained-glass windows and an eighteenth-century château surrounded by a park. Thirteen kilometres south-east, Talmont-Saint-Hilaire, with its extensive beaches of fine sand, still retains the keep of a château rebuilt by Richard Cœur de Lion, another Renaissance château, and the Gothic church of Saint-Hilaire.

Another nineteenth-century delight awaits at Les Sables-d'Olonne, a resort created around a medieval fishing port whose church of Notre-Dame-du-Bon-Port dates from the previous century. Another immense beach brings tourists to La Tranche-sur-Mer, further down the coastline, where the gentle climate encourages bulbs and where pine trees approach the dunes. Out to sea, its white sands have given the Ile de Ré the soubriquet 'Ré la Blanche', the white island. It is only about thirty kilometres long and at its widest only five kilometres. The chief town, Saint-Martin-de-Ré with a fifteenth-century church, is still surrounded by the remnants of Vauban's fortifications. Even more enchanting is one of the island's oldest villages, Sainte-Marie-de-Ré. Long cut off from the mainland, the Ile de Ré is now reached by a splendid curving bridge, supported by twenty-nine pillars and stretching for 2.9 kilometres to connect it with La Rochelle.

Oyster-farming is the staple industry of the Arcachon basin, centred on the little town of Gujan-Mestras, many of whose houses are built of wood. Annually in August Gujan-Mestras hosts an oyster

festival. Nearby, is the ornithological park of La Teich, covering 120 hectares and sheltering thousands of birds. And in the middle of the basin is the Ile aux Oiseaux, another refuge both for resident and migratory birds. Arcachon itself is a town of nineteenth-century villas and serene beaches. And as the Atlantic coast approaches Spain, seaside towns such as Hossegor, with its pine trees and villas, and Capbreton, an important port as long ago as the tenth century (with a church tower that also used to serve as a lighthouse) pave the way for fashionable Biarritz. The fifteenth- and sixteenth-century houses of

Fishermen have set out from Esnandes (above) **since the Ist century A.D. This part of Charente-Maritime is now famous for the cultivation of mussels in the bay of L'Aiguillon.**

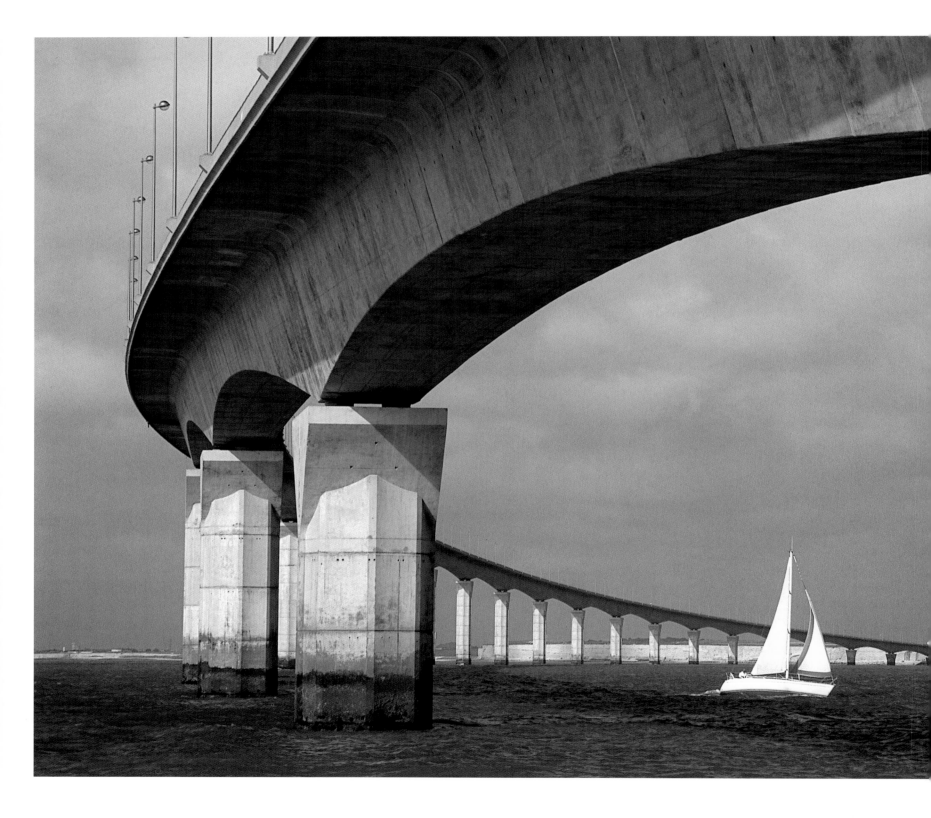

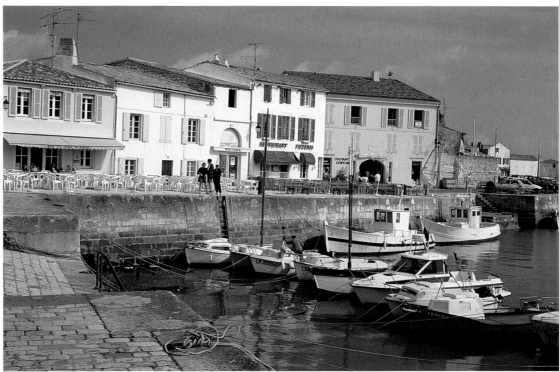

The nautical charm of the Ile de Ré, known as 'the white island', is typified by this scene (left) under the massive Pont de Ré, built in two years from 1986. The Ile de Ré itself - a mere five kilometres wide and some thirty in length - has delightful fishing villages and sandy beaches sheltered by pines. The harbour of Saint-Martin-de-Ré (above) is a major attraction.

Saint-Jean-de-Luz, situated to the south of Biarritz at the mouth of the river Nivelle, were once the homes of whalers and cod-fishers. Its parish church dates from the fifteenth century. And a house called La Maison Louis XIV is where the king stayed in June 1660, when at Saint-Jean-de-Luz he married the Infanta Maria Theresa.

A little way inland are exquisite Basque villages: Ciboure, whose old quarters have half-timbered, corbelled houses (one of them the birthplace of the composer Maurice Ravel), a fortress built by Vauban and a majestic sixteenth-century church; Sare, with its fine church and seventeenth- and eighteenth-century houses – a village celebrated by Pierre Loti in his novel *Ramuntcho*; Saint-Pée-sur-Nivelle, with its ruined medieval and Renaissance château; and Urrugne, whose half-timbered houses are defended not only by its sixteenth-century château but also by a fortified church (whose sundial declares that every hour blesses, save for the last one, which kills you).

The frontier town of Hendaye lies west of Urrugne. This is where Pierre Loti was born. Its beaches are complemented by its Belle Époque casino. A delicious surprise is the Château Abbadia, a nineteenth-century masterpiece by Viollet-le-Duc.

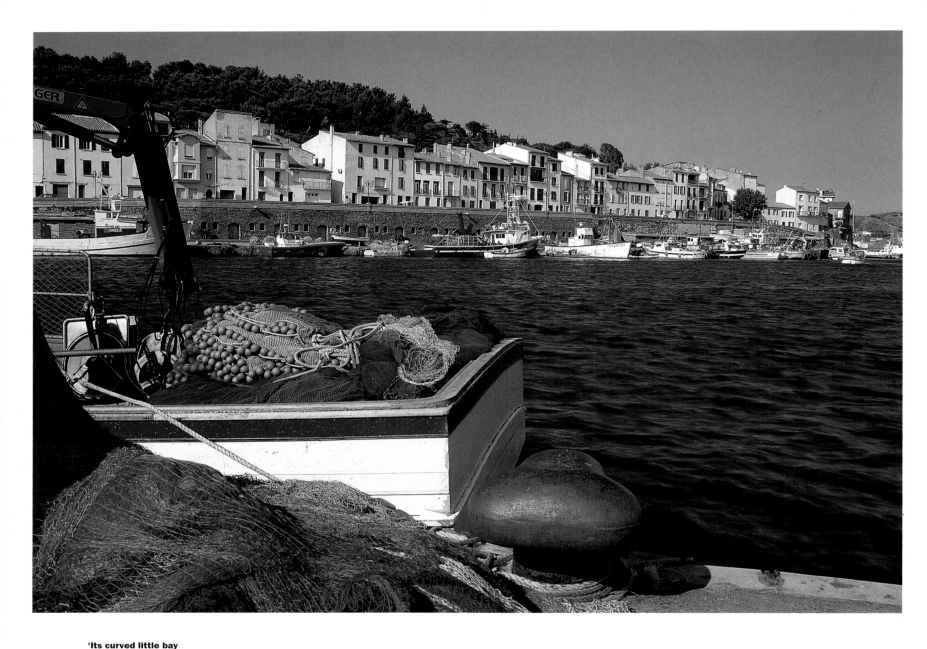

A VERMILION COAST

The third coast of France, washed by the Mediterranean, stretches from the Pyrenees to the Italian frontier, arching round the Golfe du Lion. It begins with creeks, harbours and vermilion rocks and ends with the Côte d'Azur. Because of its rocks and the brilliant red skies of evening, the coast which stretches for thirty kilometres from Argelès-sur-Mer to the Spanish frontier is known as the Côte Vermeille. Creeks, cliffs, beaches and ports enliven the coastline. The Roussillon coast was once a defended frontier, and Argelès-sur-Mer, which became part of France only in 1658, retains vestiges of its fortifications. Further on, towards Spain, are Port-Vendres and Banyuls-sur-

Mer, both frontier towns and thus in need in the past of strong defences. The first was fortified by Vauban. The second retains a keep and four towers from its fourteenth-century fortifications.

The jewel of this stretch of coast is the entrancing, ancient port of Collioure set in a rocky, horseshoe-shaped bay and shaded by the Albères mountain range. Collioure's lighthouse acts as the belfry for the seventeenth-century parish church of Notre-Dame-des-Anges (which is filled with gilded reredoses, sculpted in the seventeenth and eighteenth centuries in the Catalan Baroque style). Its château is sturdy, begun in the twelfth century and finished in the seventeenth. Here the violent green of the

vineyards and the hot red of the fields contrast with the deep blue of the sea. In 1905 the painter Henri Matisse arrived there, and these colours transformed his art. Critics called him and his followers 'wild beasts', or *fauves*, but a new form of art had been born, the Fauvism which influenced other masters such as Picasso and Derain.

Six kilometres north-west of Collioure, Argelès-sur-Mer, today a resort for bathers and tourists, displays its ancient past in the ruins of the thirteenth-century abbey of Valbonne, a fourteenth-century Gothic church with magical sixteenth- to eighteenth-century furnishings, and the thirteenth-century Pujols barn. Three kilometres from Argelès-sur-Mer is its pleasure beach, while the surrounding countryside includes vineyards and forests of eucalyptus and pine trees.

Two seaside resorts north of Argelès-sur-Mer ought not to be neglected. Saint-Cyprien, so-named only in the tenth century after a Bishop of Carthage martyred in the third century; the town once had a Romanesque church dedicated to the martyr, but this was replaced in the eighteenth century by the present building. Its beach is sandy. Still further north is Canet-en-Roussillon-Saint-Nazaire. In part, this name is derived from the reeds (*cannae*) which once covered its lakes. The resort served as a port for the Greeks and Romans, and in the Middle Ages was a major trading post for salt, oil, fish and wine. Its parish church of Saint-Jacques was begun in the fourteenth century. The twelfth-century church of Saint-Martin was once the chapel of a twelfth-century château, which now lies in ruins. One hundred hectares of land around the lake of Saint-Nazaire have been classified as a nature zone.

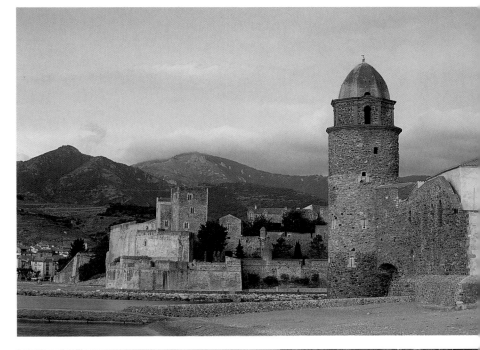

The late-seventeenth-century church tower of Notre-Dame-de-l'Assomption at Collioure used to serve as a lighthouse for the boats which sailed into the port.

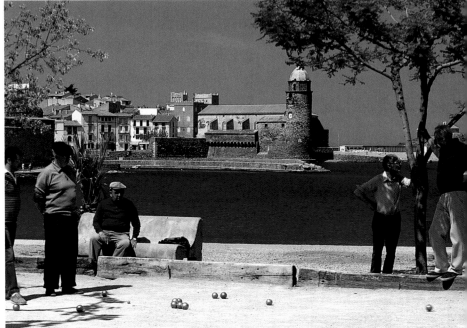

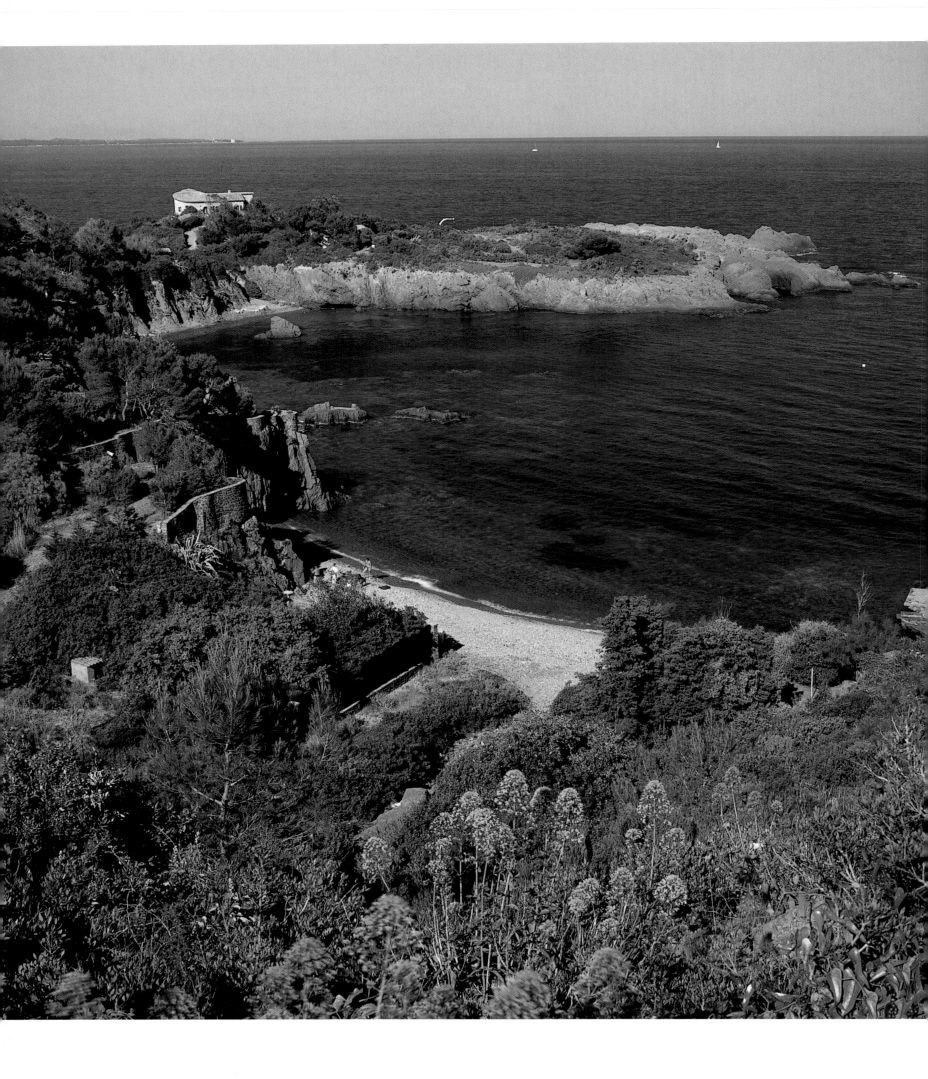

The coast of Provence provides many more delights than those of the fashionable and crowded Côte d'Azur: the rugged Massif de l'Estérel supports as well as its trees a remarkable number of wild plants and flowers.

A COAST IN PROVENCE

Around Marseilles the coastline is startlingly beautiful and savage. Sheltered creeks with precipitous cliffs plunging down into the sea are topped by patchily green slopes nurturing oak and pine. The fishing port of Cassis was painted by Henri Matisse and Raoul Dufy. Though the Château de la Maison des Baux dates from the late fourteenth century, the heart of the port was rebuilt with military precision in the eighteenth. The poet Frédéric Mistral described the celebrated white wine of Cassis as 'shining like a limpid diamond and perfumed with the rosemary, the heather and the myrtle which covers our hills.' This is a coast of rocky inlets, abrupt cliffs and the quiet coves of Cap Canaille. Between Cassis and La Ciotat, nineteen kilometres south-east, is a magical coastal road, the Corniche des Crêtes, running alongside the highest cliffs in France.

Beyond Toulon, between Saint-Raphaël and La Napoule, rises the untamed massif of the Estérel, sometimes red, sometimes black, a volcanic land covered with forests and slashed by ravines. Another massif rises between Hyères and Fréjus, the Massif des Maures. Its name is not a reference to the invasions of the Moors and Saracens, but is derived from a Greek word meaning 'sombre'.

Further east along the coast lie the entrancing islands of Hyères, known locally as the 'golden islands' – Porquerolles, Port-Cros and Levant – with fortresses, sandy beaches, pines, myrtles and other scented plants. Then lavender and mimosas add another flavour in the region of Le Lavandou. This seaside resort doubtless derives its name from the ubiquitous laven-der. Boats ply from this port to the Hyères.

These fish in the market of Saint-Raphaël await their transformation into the culinary delights of Provence. Fashionable villas dot the hinterland, but there is still a wild note struck by the red volcanic porphyry of the Estérel (opposite) **as it plunges craggily into the sea.**

North-east of Le Lavandou, outside the crowded holiday season, Saint-Tropez returns to its role as a town of fewer than 6,000 inhabitants, a resort described by Guy de Maupassant as among the most charming and unspoiled daughters of the sea. In the old town, huge plane trees shade the main square, from which run semi-pedestrianized narrow streets, some of them arcaded, lined by five-storey shuttered houses. The town's parish church was rebuilt in the eighteenth century in the Italian Baroque style. Two other churches, Sainte-Anne and Notre-Dame-de-la-Miséricorde, date from the sixteenth century. Some of the old ramparts survive. A fish market is held daily in the delightful Place aux Herbes.

A couple of kilometres north-west of Le Lavandou is one of the prettiest villages of this whole coastal road. Many years before it acquired its suffix, Bormes-les-Mimosas was simply called Bormes. Over the centuries, Saracens, corsairs and the Genoese sacked it, and Bormes suffered grievously during the Wars of Religion. Today its well-restored, spick-and-span houses, its maze of streets and alleyways, its gardens, steps and arcades, its churches and its shops displaying the wares of craftsmen and women, climb up to a ruined thirteenth-century château. The massive parish church of Saint-Trophyme was built in 1783 and has a sundial (wrong by one hour and fifteen minutes) with the inscription *Ab hora diei ad horam Dei* (' From the hour of the day to the hour of God'). Another religious building is the sixteenth-century chapel of Saint-François-de-Paule, dedicated to a saint whose prayers in 1482 saved the village from a plague. In every available cranny the villagers cultivate cacti and flowers.

Oddly enough, mimosa was not first cultivated at Bormes-les-Mimosas but at La Bocca, not far from Cannes. Here in the winter of 1880 a milkmaid taking her pails to the Villa Primavera spotted a bush covered in yellow flowers. She called her friends to admire the blooms. The gardener told them that the seeds had come from Australia. Collecting some seeds, the milk-maid and her friends planted them, and when the time came to prune them, threw the cut-away twigs on to a manure heap, only to discover that they began to bloom profusely. A local horticulturalist spotted that the plants had been artificially forced, developed the technique, and thus the celebrated Provençal mimosa was born.

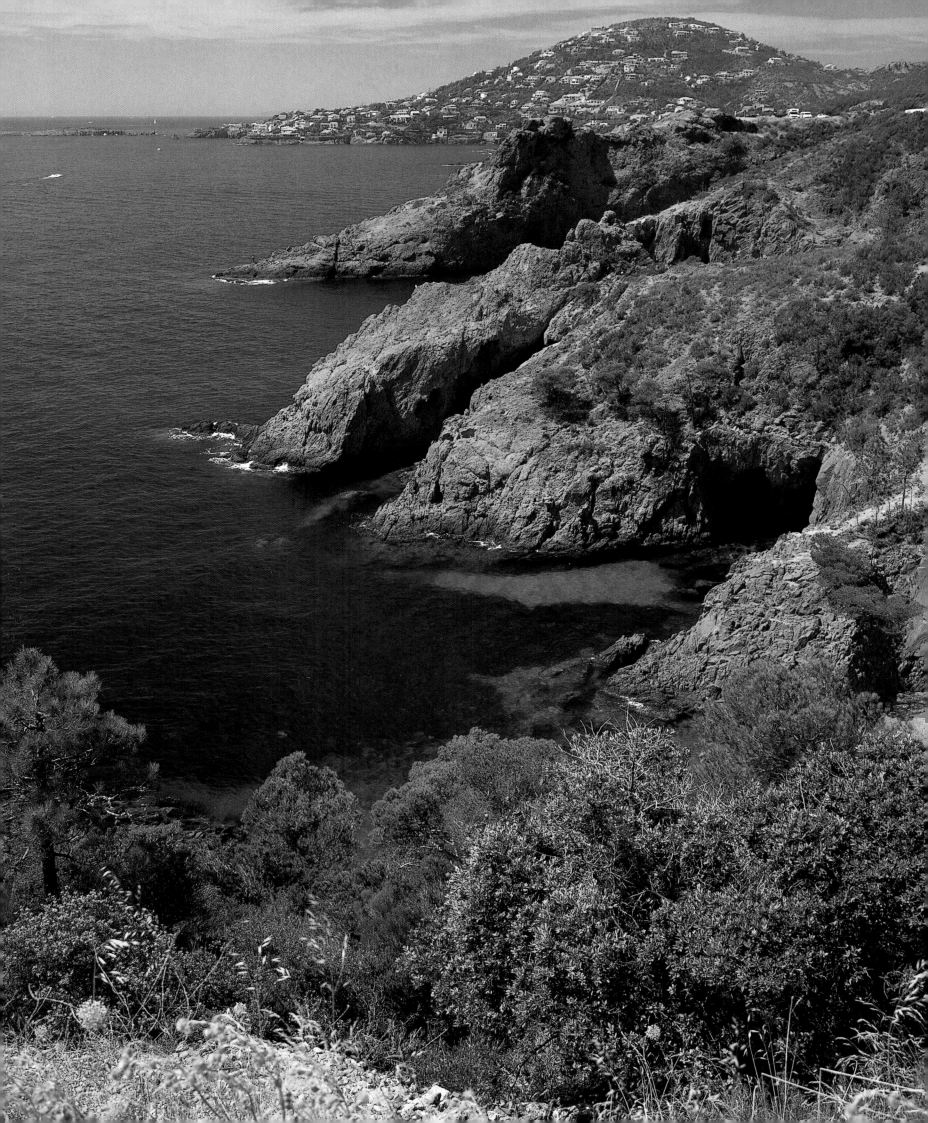

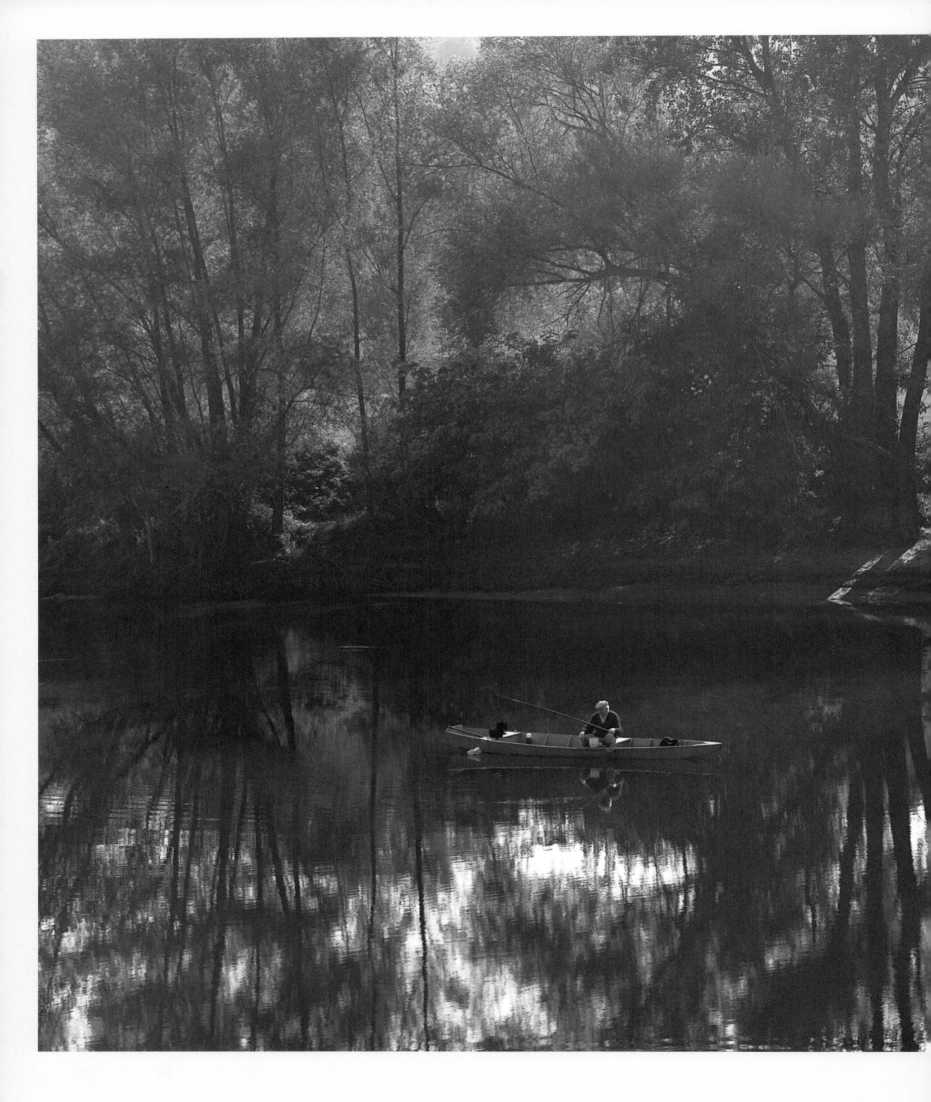

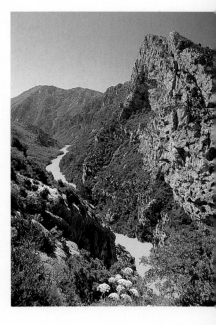

FRANCE IS A LAND OF MAJESTIC RIVERS which flow
through noble cities as well as riverside villages with half-
timbered houses and Romanesque churches. So impor-
tant in the past were these rivers that many French
départements are named after them. Their variety is remark-
able, and as a river flows through France not only does it
water a territory of contrasts, in addition its own aspect
frequently changes. Thus, for example, the river Lot at
some points offers peaceful beaches for fishing, lovingly
embraces Cahors, elsewhere rushes impetuously and in
other reaches is gentle enough for pleasure boats.

Perhaps it is that very diversity in their courses – under-
standable in a land of such topographical contrasts – which
makes French rivers and their valleys so endlessly fasci-
nating. Like the Lot, the apparently gentle Dordogne, well
known to foreign visitors, starts as a rushing torrent in the
uplands of the centre. The largeness of France has always
accorded exceptional importance to the rivers, as they con-
nect upland with lowland community, mountain with
rolling pasture. As well as any practical use, the pleasure
they give in their different forms is immense: imagine,
from the viewpoint of one of the fortified villages of the

region, looking over the valley of the Dordogne, a band of mist delineates the course of the river; slowly, the sun burns the mist away to reveal the snaking band of navy-blue in a landscape of castles, promontories and farmland, apparently lifted wholesale from a medieval miniature.

Other great French rivers can be precipitate, witness the Aveyron gorges, or those of the magnificent Verdon, whose blue-green waters pour through a canyon in northern Provence. Others are tolerant of those who live by them, witness the confluence of the Tarn and the Garonne, the river crossroads of the Mediterranean and the Atlantic. France is also criss-crossed by lesser, yet enchanting waterways, where small boats are tied up against ancient, shuttered cottages. These rivers enhance already magnificent towns, in the way for example that the river Vilaine enhances Vitré in Brittany, a spot so delightful that in 1598 Henri IV declared, 'If I were not king of France, I should like to be a citizen of Vitré.'

In France, significant history certainly follows the rivers. The hamlet of Minerve in Languedoc-Roussillon occupies a remarkable site above gorges dug by the rivers Cesse and Briand. As more than fifty near-by dolmens and tumuli reveal, prehistoric men and women found this a congenial place. Cicero praised the local wines, which are reputed to this day. Minerve's Romanesque church of Saint-Étienne has preserved a high altar inscribed with the date 456. In the turbulent Middle Ages, Minerve became a stronghold of the Cathars. On 15 June 1210 the Catholic champion Simon de Montfort began a siege of Minerve which lasted seven weeks before the inhabitants capitulated. Simon spared the life of Vicomte Guilhem de Minerve, but the papal legate insisted that the rest of the inhabitants convert to Catholicism. Most of them refused and were burnt to death.

The rivers were also a vital means of transport, as well as being obvious attractions for settlement along their banks. Villagers would cross in their boats from one side to the other, or wend their way upstream and downstream to local markets. Merchants would profit from a river trade which, for example, took wines down the Dordogne to Bergerac and beyond. As Blaise Pascal observed, rivers are moving roads (just as Napoleon Bonaparte similarly observed that Paris, Rouen and Le Havre were one city and the river Seine was its high streeet).

This use of the rivers and their communities continued well into the nineteenth century, until the coming of the railways ended their major role in the communications and trade systems of the country. Nor was this movement of goods and people confined solely to the great rivers, the Rhône and the Loire; lesser flows and their tributaries were also influential in setting patterns of settlement and commerce along their courses. Again, the case of the Dordogne is instructive. Timber from the uplands was floated downstream on the wilder, upper reaches of the river, which were not navigable, as far as Souillac, where the gentler current allowed the loading of cargoes on to the boats which would continue the journey to Bordeaux. Water-coaches had become a regular means of transport by the beginning of the eighteenth century: two days from Agen to Bordeaux, while regular services were run from Paris and on the Loire.

Until the coming of the railways, transport by water, certainly of heavy loads, represented a more than viable alternative to road haulage. During the eighteenth and nineteenth centuries, boats would travel pretty well the full length of the great rivers, notably the Loire and the Saône, and by 1843 the natural waterways of the country had been augmented by 4,000 kilometres of canals. In time, these canals were supplemented by others, such as the Burgundy canal, which connects wine villages from Tonnerre in the Yonne to Bussy-le-Grand in the Côte d'Or, and the one connecting Toulouse with Bordeaux in 1856. Their industrial architecture is often breathtaking, for example the aqueduct over the river Orb at Béziers. The Canal du Midi has gracefully elliptical locks and elegant late seventeenth-century bridges; its banks are lined with 45,000 oaks, cypresses, plane trees, pines and poplars. The canal is still cruised by pleasure boats and commercial barges with very varied cargoes.

Set beside such a canal or river, towns and cities prospered. Langon in the Gironde boasts medieval and Renaissance houses and became the capital of Entre-Deux-Mers, with its superb white wines, its citizens rich enough to repeatedly rebuild their church of Saints-Gervais-et-Protais (though happily they retained its thirteenth- and fourteenth-century Gothic choir and transepts). A mere two kilometres east, the town of Saint-Macaire fared less well. Once situated beside the river Garonne, it became wealthy by exporting the wines of Bordeaux to England. In the fourteenth century Saint-Macaire managed to obtain a royal decree prohibiting any other wines of the Lot and the Tarn to be exported before Christmas. The English so prized Saint-Macaire that in 1341 they annexed the town to their own realms and made it a royal city, exempting its six thousand inhabitants from feudal taxes.

Then, in the sixteenth century, the river changed its course. The port of Saint-Macaire silted up. Many citizens left for other parts of the Gironde. (Today Saint-Macaire has scarcely 1,500 inhabitants.) But they left behind a treasure-trove of ancient houses, built between the fourteenth and seventeenth centuries, a splendid Romanesque priory church, and the remains of their ramparts, including three fortified gateways.

Although the great rivers of France have variety, drama and charm, other waters display their qualities in more concentrated ways. Far more spectacular than the Loire, for instance, is the river Tarn, noted above all for the breathtaking gorges which it has gouged through the French countryside. But the Tarn also displays gentler aspects: where it washes the walls of the city of Albi and passes under the ancient arches of an eleventh-century bridge. Another fine bridge, this one Gothic, spans the Tarn at its confluence with the river Alrance. Here on a stunning site is the village of Brousse-le-Château, whose fortress still dominates this strategic spot. At the magical city of Montauban the Tarn passes under a long bridge, built between 1303 and 1316. In 1659

the bishop of Montauban commissioned for himself a palace here, overlooking the river. And four-and-a-half centuries earlier, at Moissac, the Benedictines began building an abbey beside the Tarn whose Romanesque porch and whose cloister, with its Romanesque capitals, represent a peak of late twelfth-century sculpture.

The Tarn flows into the Garonne and the two rivers have given their name to a *département*, Tarn-et-Garonne, created in 1808 under Napoleon I, a land whose rich soil supports sunflowers, maize and sorghum, as well as vineyards, and whose climate is remarkably gentle: mild in winter, sunny in spring, warm in summer and nourishing in autumn. Other *départements* of France – Marne, Loiret, Lozère, Somme, Gard, and so on – have taken their names from great rivers. Rightly so, for these rivers bring fertility to their soils and often dominate their characters.

A stretch of the river Loire as it flows near Ancenis, on the borders of Brittany.

A pretender to the throne of king of French rivers would be the Rhine, save for the fact that much of it does not flow through France. The southern part of the Rhine valley is where Germany and France embrace, a region also watered by the rivers Ill and its tributary the Thur. This is Alsace, with its own traditions of architecture (half-timbered houses, fortified villages), the Vosges mountains and a celebrated wine road.

The crown of French rivers, however, must belong to the Rhône, as it follows its stately march (as Henry Wadsworth Longfellow put it) from its Alpine source to the sea.

Trees beside the river Jonte, whose gorges stretch from its confluence with the Tarn at Le Rozier.

In traditional blue
overalls and beret, a
farmer of the Loire valley
tends his fields of beans
(below). **Poplars line
countless rivers in
France, as these beside
the river Sarthe** (right)
near Alençon, in a
département **which
takes its name from
another French river,
the Orne.**

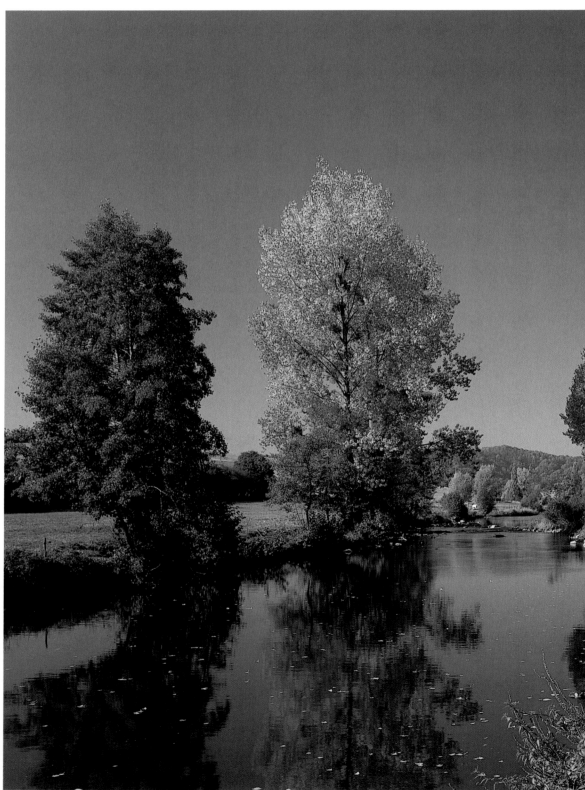

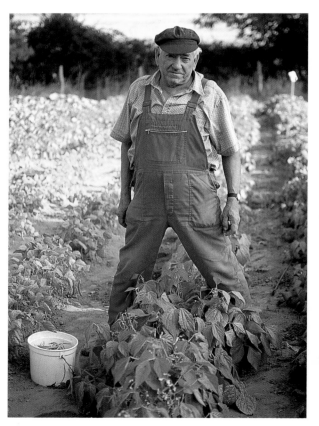

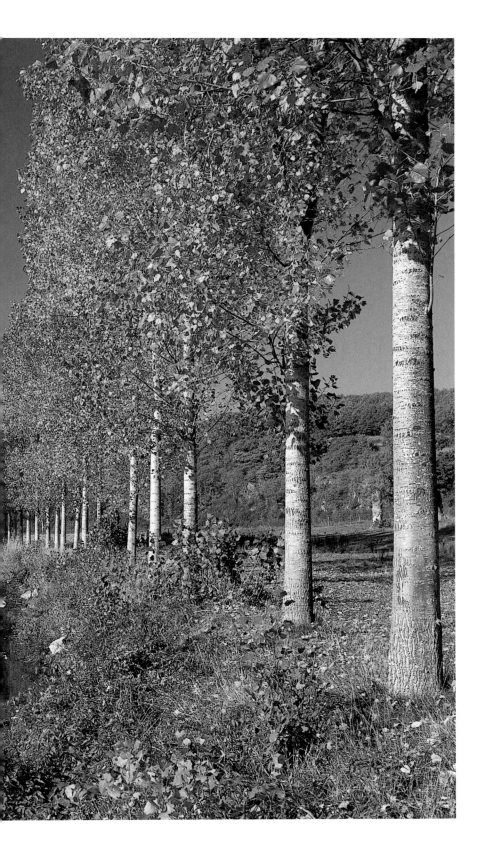

THE GREAT ARTERY OF NORMANDY
is the river Seine, with the Eure a good
second; but the province is also served
by many lesser rivers. The lovely town
of Eu, for example, with its huge Gothic
collegiate church, its perfectly symmetrical
Renaissance château, its red-brick and
sometimes half-timbered houses flanking
winding streets, stands by the waters of
the Bresle. On its way to the sea the
sinuous Orne flows through Caen. Lisieux
and Pont-l'Évêque are made much more
interesting by the Touques. And no fewer
than four rivers reach the Baie des Veys.
The delightful town of Saint-Saëns is
an excellent starting-point to explore the
valley of the Varenne. Saint-Saëns sits on
the edge of the Eawy forest. Its partly
Romanesque church is lit by sixteenth-
century stained-glass windows depicting
the Passion, Pentecost, the tree of Jesse and
the life of St. Louis. The ruins of a twelfth-
century fortress rise nearby. And from here
you can follow the river till it joins the
Euline and flows into Dieppe.

The river Sarthe, south-west of Paris,
has given its name to a *département*. Beside
the river sits one of the region's finest
villages, Malicorne-sur-Sarthe, with an
eleventh-century church and a tradition of
producing ceramics dating back to 1740.
Close by is the Château de Malicorne, origi-
nally built in the twelfth century, but today
boasting mansard roofs and living quarters
mostly rebuilt in the eighteenth century.

The château at Sablé-sur-Sarthe, a town
straddling the same river, is an altogether
grander affair, constructed in 1720 for a
nephew of the great Colbert, but incorpo-
rating a Gothic Revival gateway defended
by a couple of round towers. Although the
town's Gothic church dates from the nine-

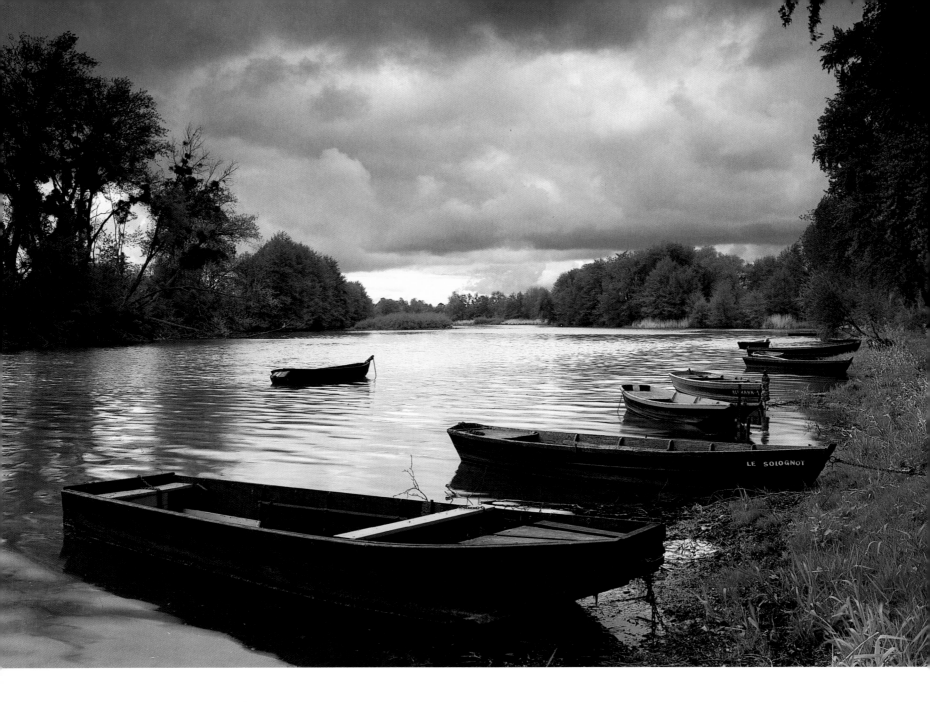

teenth century, the lovely stained-glass windows date from the sixteenth, the legacy of a predecessor. Three kilometres north-east you find Solesmes, a village whose famous abbey was founded in the eleventh century, was many times rebuilt, houses magical sculptures carved between 1496 and 1550, and today is a world-renowned centre of Gregorian chant.

THE LOIRE VALLEY

Beside rivers flourished monasteries, fortresses and castles. Montreuil-Bellay was built to dominate the river Thouet and restored in the nineteenth century as a brilliant pastiche of a medieval Gothic

chateau. Another romantic Gothic château in the Loire valley, at Ussé on the bank of the river Indre, inspired Charles Perrault's fairy-tale *The Sleeping Beauty*. Château Chinon overlooks both its village and the wide Vienne. Where rivers merged, creating important strategic places, such delicious towns as Amboise (at the confluence of the Loire and the Amasse) developed. River crossings were jealously controlled as, for instance, by the Maison du Passeur at Montrichard, built in the sixteenth century on the bridge which crosses the river Cher. Sometimes the ensemble of a village, an ancient bridge and priory, is breathtakingly beautiful, as at Argenton-sur-Creuse, where

some of the houses overhang the river.

The Loiret, a dependency of the Loire, has, like many other rivers, given its name to a *département* of France. At Olivet just outside Orleans, it teams with fish, and small boats sail along it. The river impressively rises from its subterranean course in the local Parc Floral de la Source, where throughout the year tulips, irises, dahlias and chrysanthemums successively bloom magnificently around fountains. Not far away in the Loiret valley, the little village of Saint-Cyr-en-Val is surrounded by no fewer than seven châteaux.

Angles-sur-l'Anglin in the Vienne is another exquisite village set beside a river,

River boats ride on the river Loiret under a stormy sky at Saint-Hilaire-Saint-Mesmin (opposite), **just south of Orleans. The river Ognon at Pont-Saint-Martin** (right), **south of Nantes and close to the Lac de Grand-Lieu, is a favoured haunt of fishermen.**

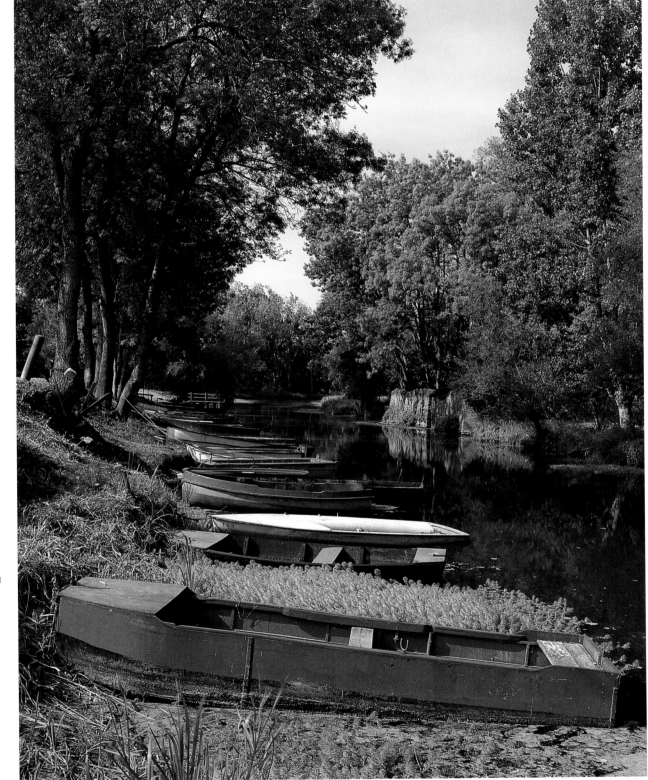

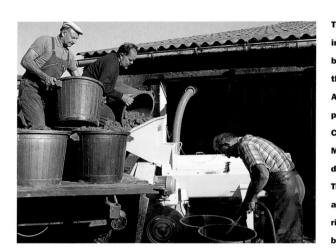

The grapes of La Varenne in the Loire valley, just before the river enters the *département* of Loire-Atlantique, will eventually produce the wines of Côteaux-d'Ancenis, Muscadet-des-Côteaux-de-la-Loire and Anjou. This is a land defined and made beautiful by its rivers of every length and breadth (right).

dominated by the ruins of a strategically important twelfth-century fortress built by the bishop-barons of Poitiers, a fortress rising forty metres above the river. Angles-sur-l'Anglin recalls a savage history. During the sixteenth-century Wars of Religion, the Catholic League held on to its château until it was betrayed to the Protestants. To the south rush the gorges of the Anglin valley, while to the north stands the twelfth-century Romanesque church of Vicq.

Of the longest of these rivers, the Loire itself, Oscar Wilde observed that it mirrors 'from sea to source a hundred cities and five hundred towers.' One of its tributaries, the river Loir, was also a favourite of the poet Paul Verlaine. The Loire has been described as a capricious river. From its source in the Ardèche to its estuary at Saint-Nazaire it glistens through an ever-changing countryside. Initially the river flows through deep gorges, before meeting upstream of Nevers its major tributary, the salmon-stocked Allier. From here the enriched Loire runs between farmlands and

Foliage, water, wild and cultivated flowers create an exquisite rural blend at Angles-sur-l'Anglin, an entrancing village in the Vienne, with a tradition of fine needlework, ancient houses, and a church with a Romanesque belfry.

sandbanks, flowing past islets where birds nest among poplars, alders and willows.

Wooded banks are soon replaced by the vineyards of Pouilly and Sancerre, and then the river turns westwards. Passing through the Sologne, the Loire is swollen by innumerable little streams, and then transforms itself into the royal river, famous for the magnificent châteaux which line its banks: at Amboise, where the Loire is joined by the river Amasse; at Blois, where the Duke of Guise, leader of the Catholic League in the Wars of Religion, was murdered in 1588; at Chaumont, once the home of Henri IV's mistress, Diane de Poitiers; at Beaugency, where the fifteenth-

century château preserves its eleventh-century rectangular keep; at Chambord, whose wild towers make it seem (in Châteaubriand's inspired metaphor) 'like a woman whose hair streams in the wind'; at Sully-sur-Loire, where Henri IV's minister Sully transformed a medieval fortress into a ravishing seventeenth-century château.

The river flows by superb cities, such as Orleans, Angers and Nantes, each with a majestic cathedral. As well as châteaux, monasteries and abbeys were built along its banks – at Le Thoureil between Angers and Saumur; at La-Chapelle-Saint-Mesmin, where in the fourth century St. Mesmin set on fire a monster which was terrorizing the

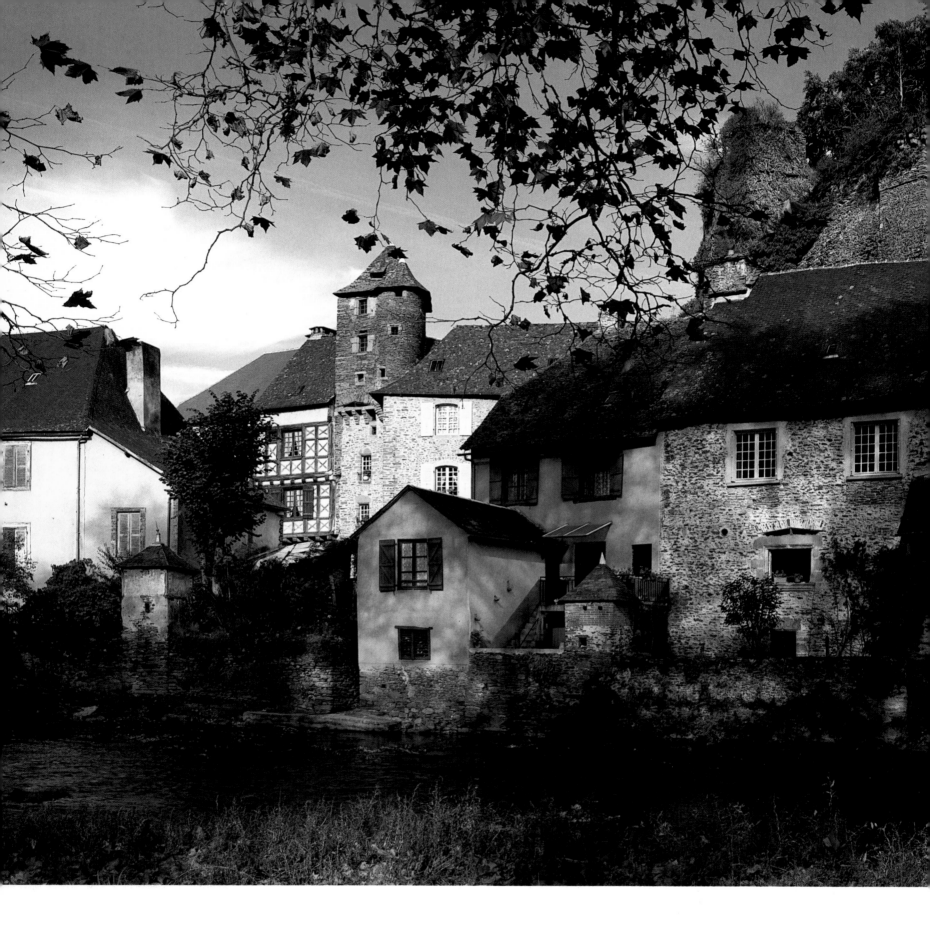

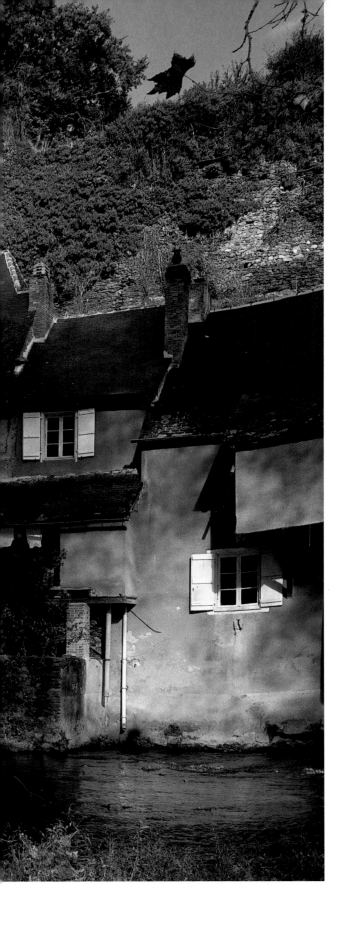

neighbourhood; at Saint-Benoît-sur-Loire, where the Romanesque abbey church still stands and the monks claimed to possess the very bones of St. Benedict. A saint of equal stature, St. Martin, founded an abbey at Tours, which alas is now no more, and in 397 St. Martin of Tours died nearby, in the lovely village of Candes-Saint-Martin.

Other rivers – among them the Loir, the Cher, the Indre – also flow through the lush fields of the Loire valley. The countryside of the Loire is among the most peaceful in France; the finest monument of the Cher is Chenonceaux, where Diane de Poitiers commissioned the architect Philippe Delorme to span the river with part of the château itself. Beside the Indre is the château of Azay-le-Rideau, described by Honoré de Balzac as 'a many-faceted diamond, set in the river'.

Famous for its châteaux, the Loire valley is also admired for its wines; the sparkling ones of Saumur, for instance, from whose château you can see not only the Loire but also the Thouet; those of Chinon, whose château overlooks the river Vienne; the ones grown where the Loire joins the river Anase at Amboise, whose magical urban ensemble is defended by an early fifteenth-century château.

Enticing water-lapped towns and villages disclose themselves further south, in the Limousin. The river Isle flows through Saint-Yrieix-le-Perche, whose thirteenth-century collegiate church is crammed with treasures, including reliquaries, one which contains some remains of the sixth-century St. Yrieix, who founded the little town. Another delicious spot, in the Corrèze, Ségur-le-Château, embraced by a bend of the river Auvézère, has ancient houses and the ruins of a medieval château.

The complexity of French village architecture: Ségur-le-Château (left), **which nestles in a bend of the river Auvézère in the Limousin, boasts both stone-built and half-timbered houses. Like most French villagers, those of the Limousin are extremely amiable, and are always willing, indeed longing, to sell their home-grown produce to visitors** (below).

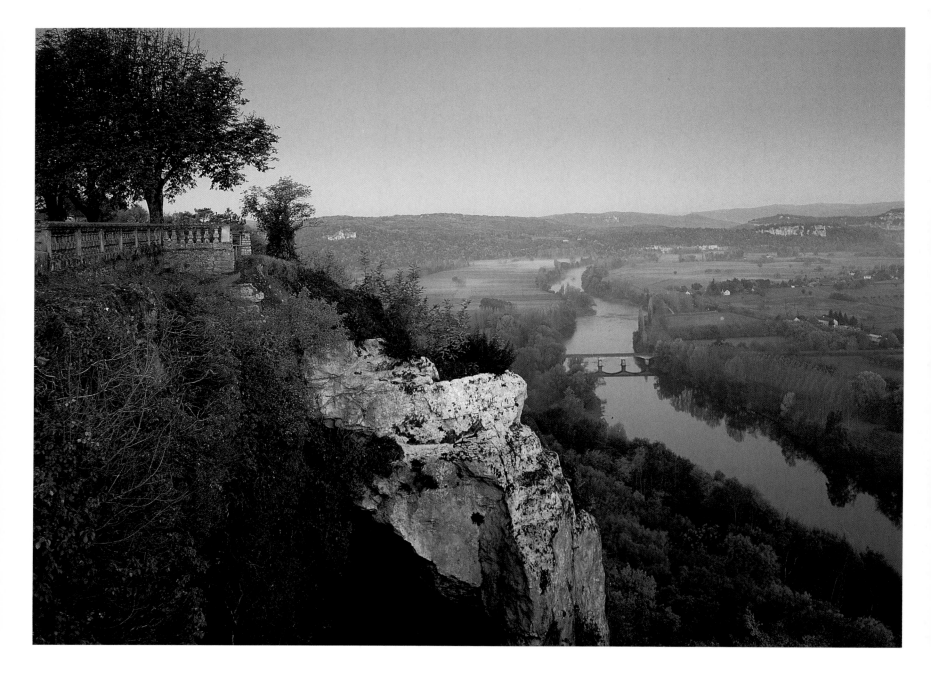

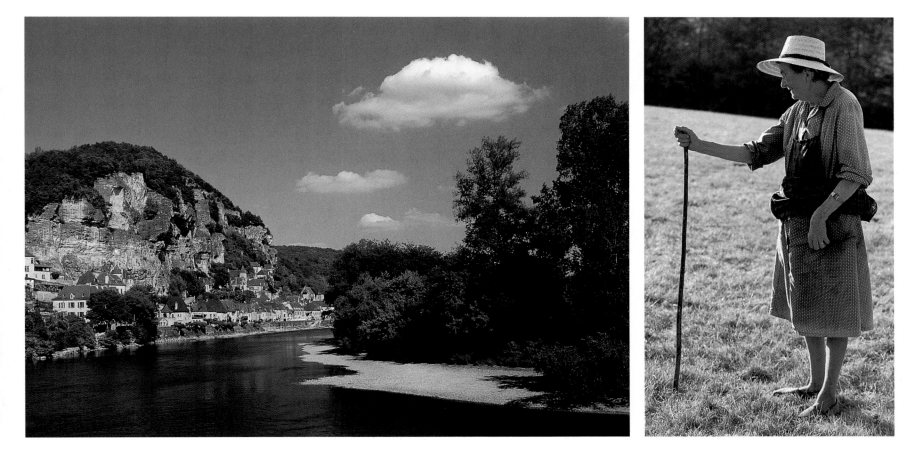

This view of the river
Dordogne (opposite)
is from Domme, the
fortified *bastide* founded
by the French king Philip
the Bold in the 1280s.
And in a Dordogne field,
a farmer's wife stands
with her stick,
contemplating the
dramatic riverscape
(right). **'When the sun**
is setting, you should
contemplate the lovely
curve of the river, as it
cradles one of the most
beautiful countrysides in
the whole world', wrote
the novelist **Albéric
Cahuet** of the Dordogne
near the extraordinary
village of **La Roque-
Gageac** (above).

THREE RIVERS

The *départements* of the Lot and of the
Dordogne are both named after majestic
rivers and are both enriched by gentle
tributaries. Just inside the Dordogne, seven
kilometres south of Bergerac whence this
region's best wines derive, is Monbazillac.
François d'Aydie, Vicomte de Ribérac, built
the château in 1550. Crenellated, with
battlements, grey stones, turrets and brown
roofs, this château is the centre of an
industry producing deliciously sweet white
wines and is also a notable wine museum.
The grapes are luscious, grown in a vine-
yard of 2,530 hectares by a stream called La
Gardonette. Morning mists moisten them;
the afternoon sun swells them. Late in the
autumn a fungus, *botrytis cinerea*, known
in the region as the 'noble rot', attacks
them. Their skins split and they shrivel.
The resulting wine from the harvest has
never less than twelve per cent alcohol.

At the medieval town of Sarlat-la-
Canéda, due west of Souillac, the river Cuze
has now almost disappeared from sight. It
once served the cloth merchants who built
the beautiful Hôtel Plamon in the centre of
the town. Today the river passes beneath it,

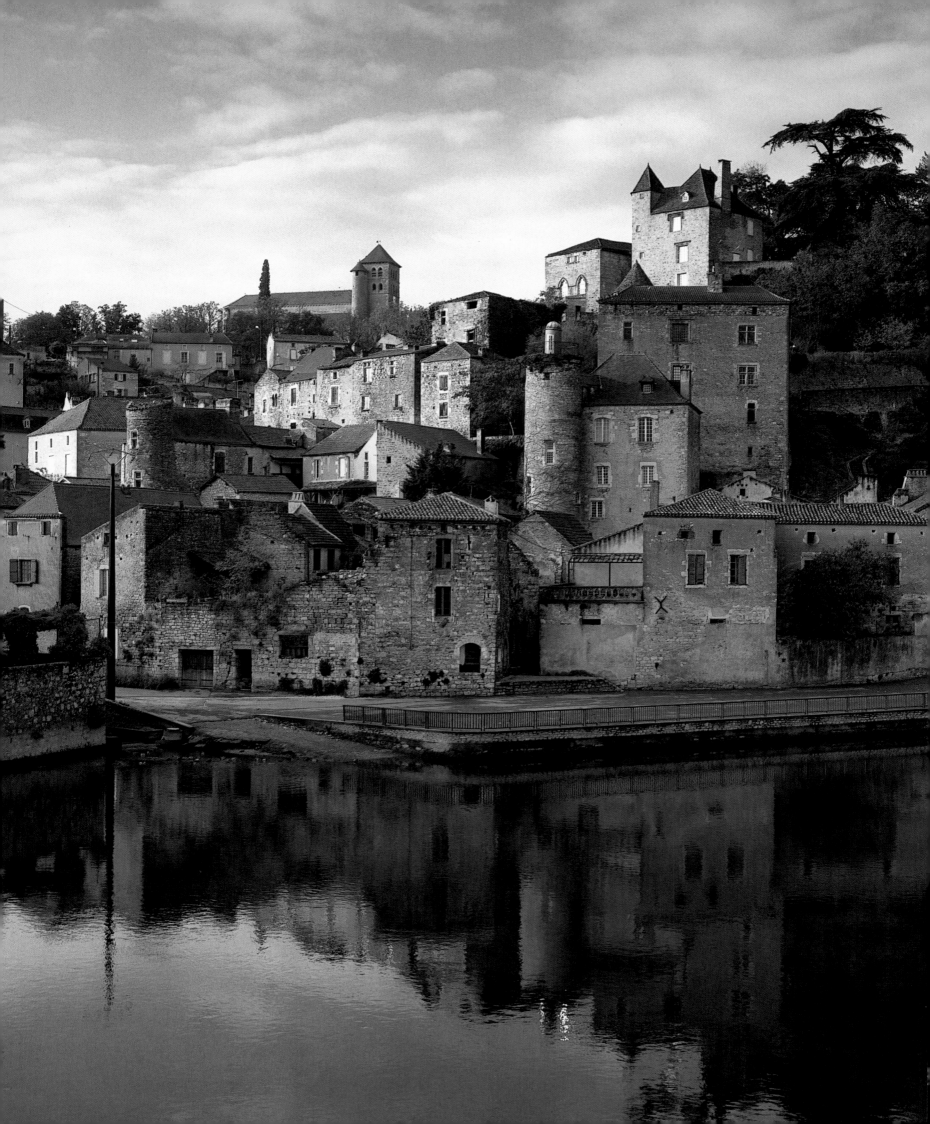

making its sole appearance on the corner
of the Rue des Consuls and the Rue de la
République – a straight thoroughfare which
in 1827 was slashed through this ancient
town to ease the flow of traffic.

From the nearby *bastide* of Domme,
a town fortified in the late thirteenth and
early fourteenth centuries, there is an extra-
ordinary view over the river Dordogne
itself. Not far away is the utterly beguiling
village of La Roque-Gageac. Its houses,
divided by narrow streets which climb up
into the towering ochre-coloured rock,
seem almost to be falling into the river.
In fact, the rock itself is the more perilous
threat, for it has fallen, on occasion, killing
inhabitants of the village. High up on the
cliff are a Romanesque church and
troglodyte houses. At each end of the village
is a château – the nineteenth-century
Château de la Malartie (mimicking a
sixteenth-century one) and the Château
de Tarde, which really does date from the
fifteenth and sixteenth centuries.

On its stately passage the river Lot
performs some picturesque feats. South-east
of Monbazillac, at Puy-l'Évêque, for exam-
ple, it indulges in some extraordinary loops.
Puy-l'Évêque, with fewer than two-and a-
half-thousand residents, rises picturesquely
above the river, dominated at one end by
the keep of its former château and at the
other by its fourteenth-century church.
Inscribed on an escutcheon is '1392 FE',
the letters 'FE' being a contraction of
Francisco Episcopo and referring to
François de Cardaillac-Varaire, Bishop of
Cahors from 1389 to 1404. Its apse is
polygonal, it portal sculpted. Many of the
Gothic and Renaissance houses in this vil-
lage are fortified, for it was fought over by
the French and the English. The English

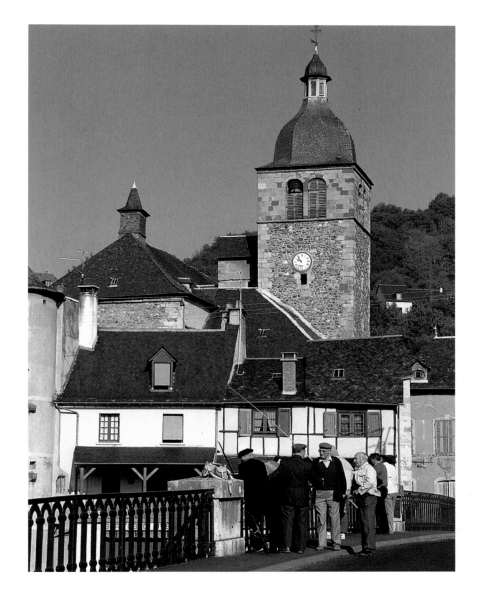

Puy-l'Évêque (opposite),
in the *département* of
the Lot, derives its
quaint name from two
sources: Puy comes from
the Languedoc word
meaning a place on a
height; l'Évêque (bishop)
denotes its vassalage to
the Church after the
thirteenth-century wars
between the Catholics
and Cathars. The church
is still fortified.
At the picturesque
village of Saint-Geniez-
d'Olt (above), in the
Aveyron, local
inhabitants fish in the
river Lot, while others
converse on the
eighteenth-century
bridge. As well as
its ancient riverside
houses, some of them
half-timbered, Saint-
Geniez boasts no fewer
than five churches or
chapels, some with fine
Gothic furniture.

won Puy-l'Évêque in the mid thirteenth century and held it until 1428. This strategic village was again besieged in 1580, and some of the cannon balls which were fired then have left their mark on the north side of the church.

West of Puy-l'Évêque is Luzech, a village of scarcely 1,500 inhabitants embraced by another remarkable loop of the river Lot, creating an isthmus only two hundred metres wide. This tiny spot was once the seat of one of the four baronies of Quercy. Its narrow streets boast arcades and ancient houses And two churches give their blessing to the village: that of the Blue Penitents, which dates from the twelfth century, and the four-teenth-century church of Saint-Pierre. Due north of Luzech, in the valley of the Vert, is Catus, once a fortified village which has preserved medieval houses and above all its Romanesque former priory church, endowed with seventeenth-century furnishings and particularly celebrated for the remarkable sculptures of its Romanesque chapter-house.

Yet more spectacular is the Tarn valley and its gorges. The village of Florac, with its restored château, is a major centre for exploring the river valley and is also capital of the Cévennes national park. Plane trees shade its esplanade. Its Catholic church dates from 1833, the Huguenot chapel from 1821.

Nearby Sainte-Énimie is a quite exceptional Tarn village. Here the river is wide, and the village lies in its deep valley. Steep cobbled streets lead up from the river to the Romanesque parish church, built in the thirteenth and fourteenth centuries. It is filled with statues, one of them depicting Jesus's grandmother, St. Anne, holding her daughter, the Virgin Mary, who in turn carries the infant Saviour. Modern ceramics depict the life of St. Énimie. An exquisite girl, who lived from 604 to 637, her hand in marriage was sought by many, but she was betrothed, she said, only to her Saviour. At her request God took away her beauty, then she contracted leprosy. But an angel bade her bathe three times in a fountain, and the leprosy disappeared.

Two typical villages in the Lot, the picturesque *département* which takes its name from the river (right)**: Castelnau-Montratier** (below left) **dominates the valley of the river Lupte; Loubressac** (below) **boasts a fine château.**

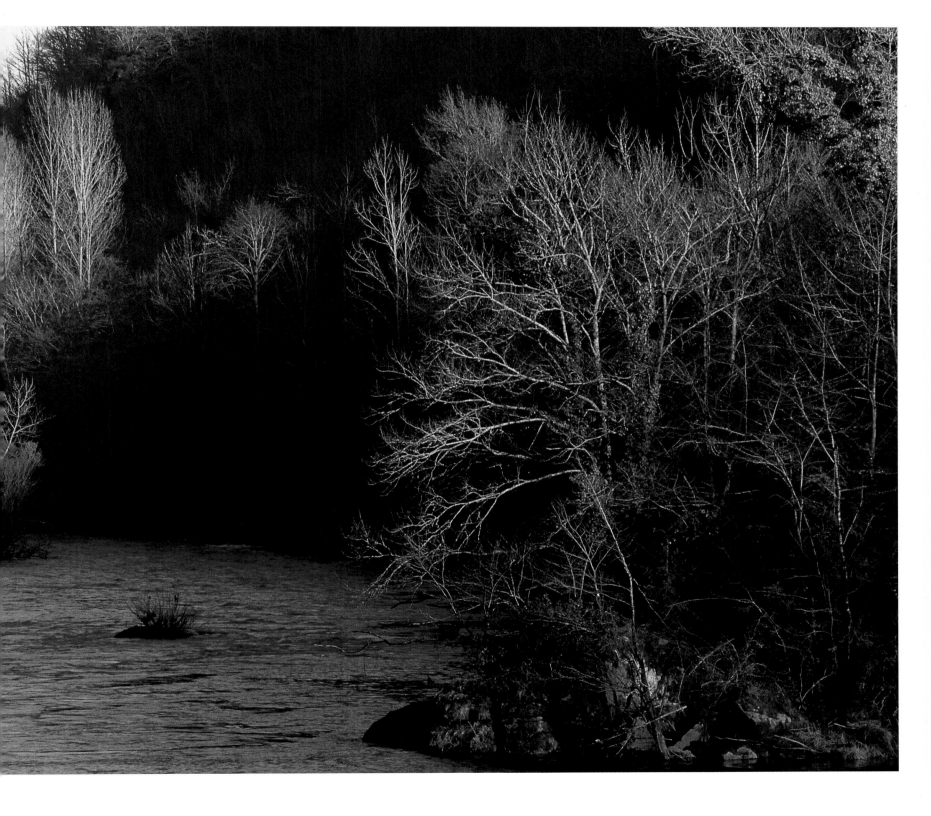

The Aveyron (below) **is a spectacular river; here it forces its way through the countryside near the medieval town of Saint-Antonin-Noble-Val.**

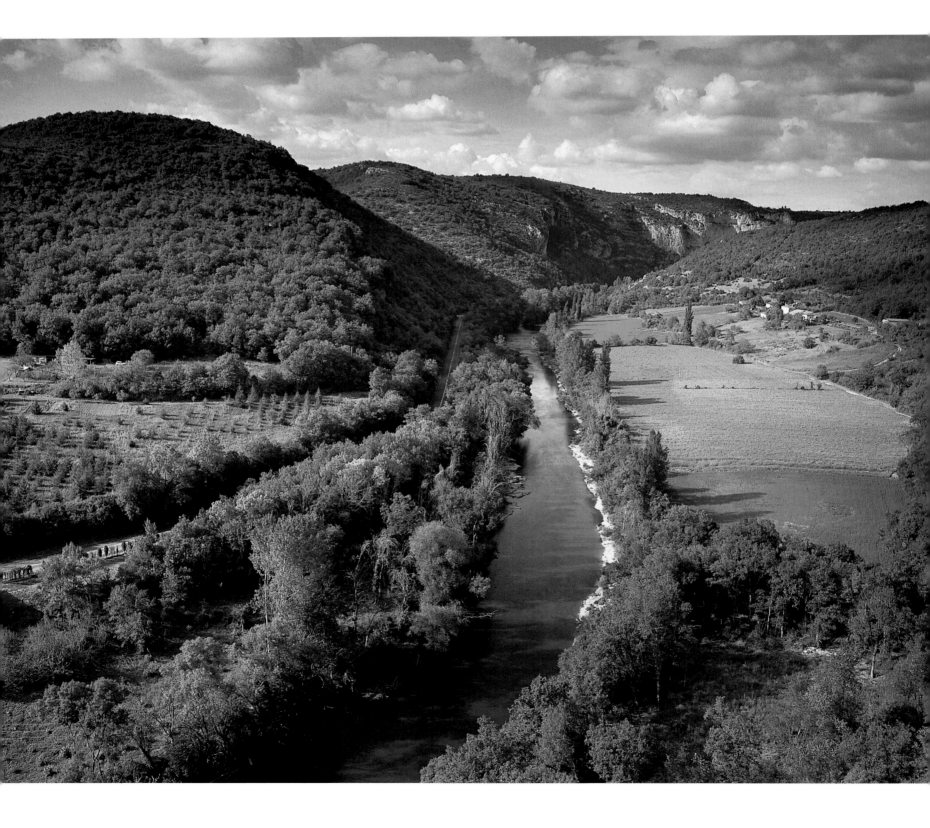

Sainte-Énimie lies in a
deep valley close to this
stretch of the river Tarn
(below), **where hairpin
bends lead dangerously
down to half-timbered
houses and a ruined
medieval abbey.**

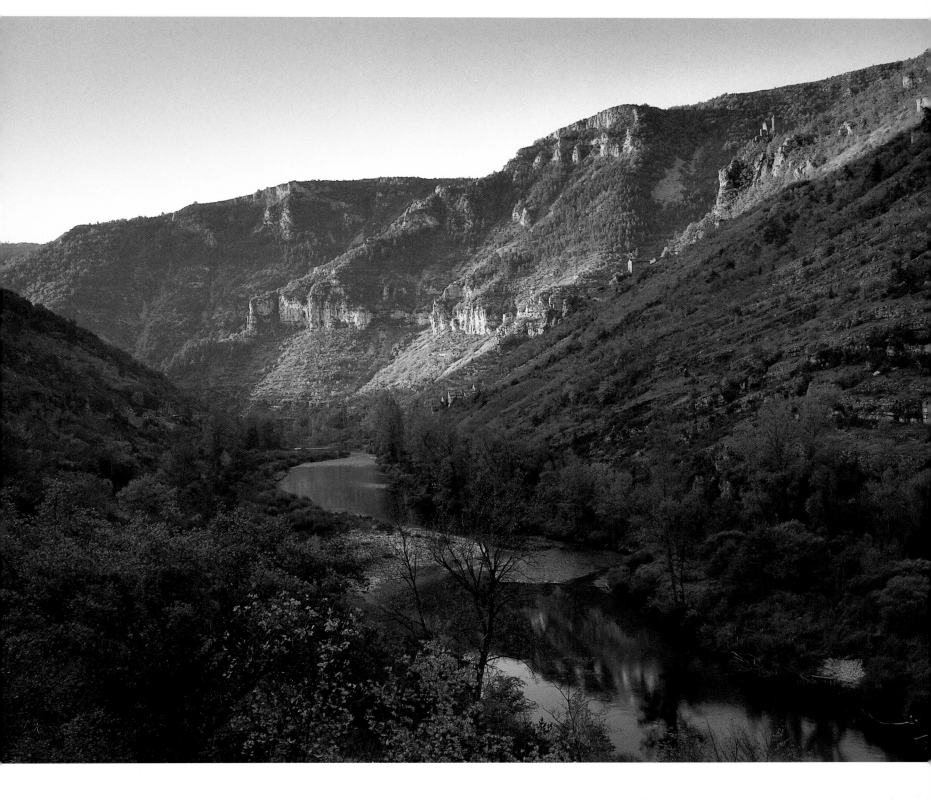

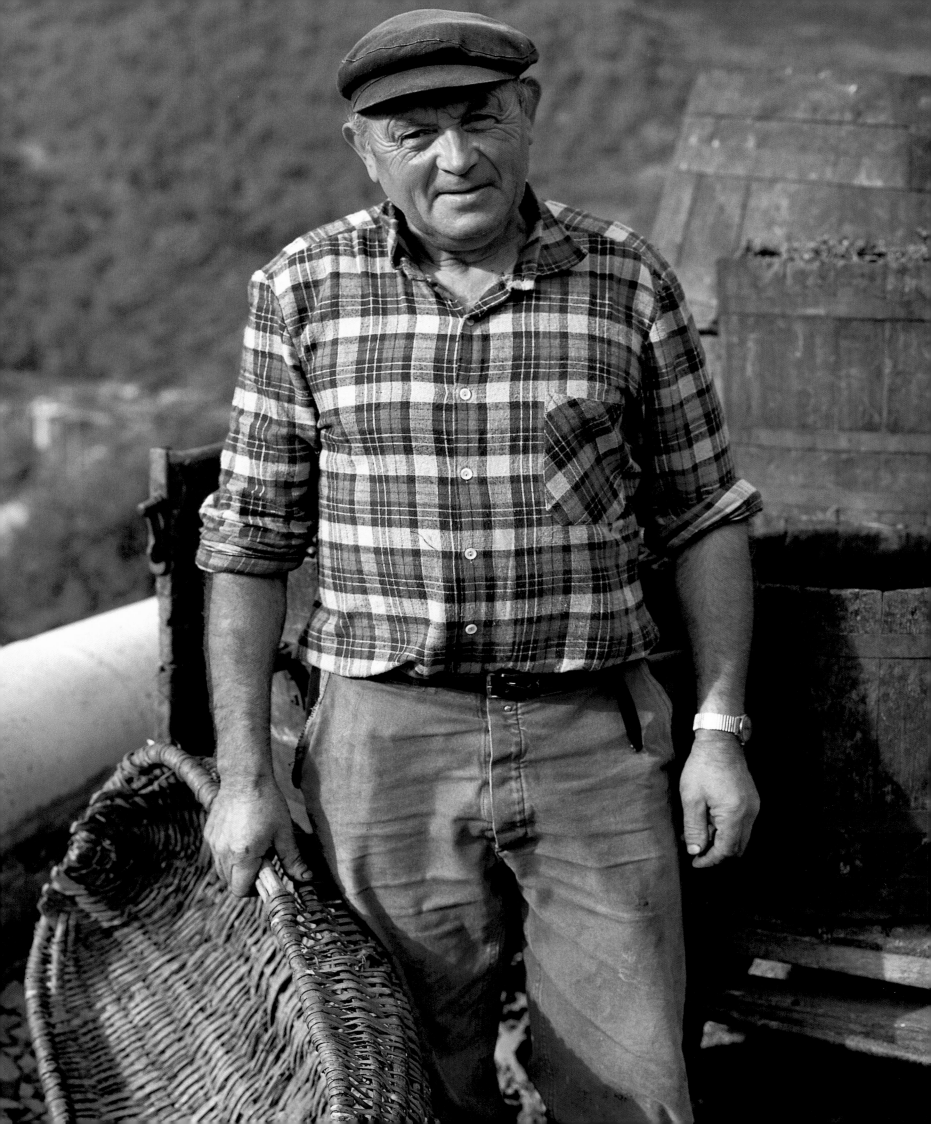

MASSIF CENTRAL AND PROVENCE

Other rivers of the centre have both charm and splendour. In the Aveyron gorges, over-looked by the Quercy plateaux, medieval villages cling to cliffs or shelter in valleys. At the confluence of the Aveyron and the Bonnette, for example, dominated by the Rochers d'Anglars, the fortified medieval village of Saint-Antonin-Noble-Val has preserved an exquisite ensemble of ancient buildings, including a town-hall built in 1125 (the oldest in France) and a magnificent fourteenth-century market-hall. Equally picturesque is the village of Varen, already inhabited in the year 971, a spot chosen in the eleventh century by Benedictine monks to found an abbey church which, with its splendid capitals, still stands, as do many of the fortifications and the château which once protected the village's sleepy homes. There is also a medieval quarter of merchants' houses dating back to the thirteenth and four-teenth centuries, the former Hôtel de Ville to the twelfth (an extremely rare Roman-esque secular building), and the present one to the eighteenth. Not surprisingly, the town is fortified, since it often changed sides in past conflicts, becoming Cathar and then Protestant, and suffering particularly grievously during the Wars of Religion.

The gorges of the Aveyron sweep their way from here west, passing by the village of Penne, made endlessly fascinating by its ruined château and half-timbered medieval houses. Hanging crazily over a limestone cliff, the château seems to defy the laws of gravity. Freda White declared in *Three Rivers of France* that it was 'so improbable that you do not believe in it even as you look at it'. Penne also has a prehistoric cave, the grotto of La Madeleine, with remarkable Stone Age

Farming in the Tarn (opposite) **still has a traditional air. Also venerable is the seventeenth-century Canal du Midi, with graceful locks, bridges and the 45,000 oaks, plane trees and poplars which line its banks** (right). **Another waterway of the south: the Orb carves its way through the Languedoc** (below).

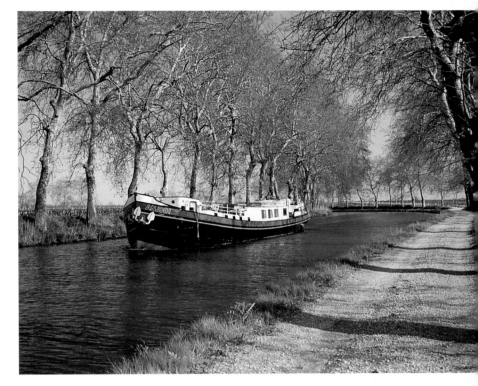

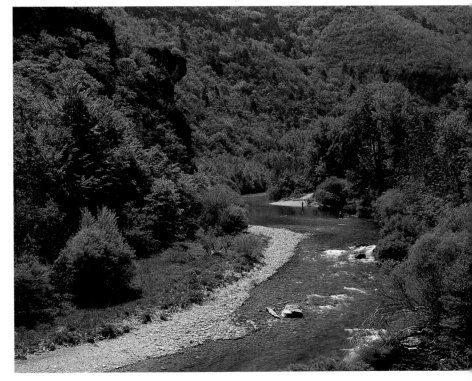

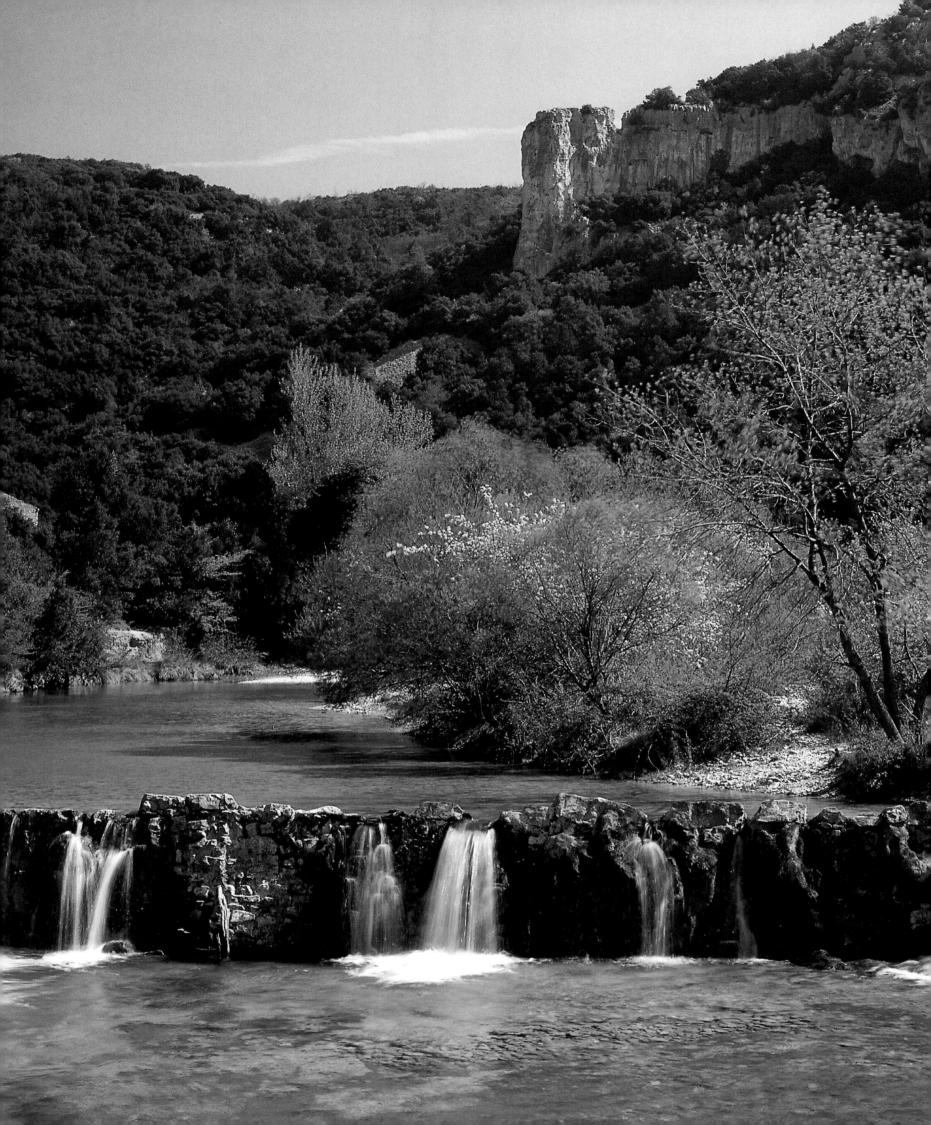

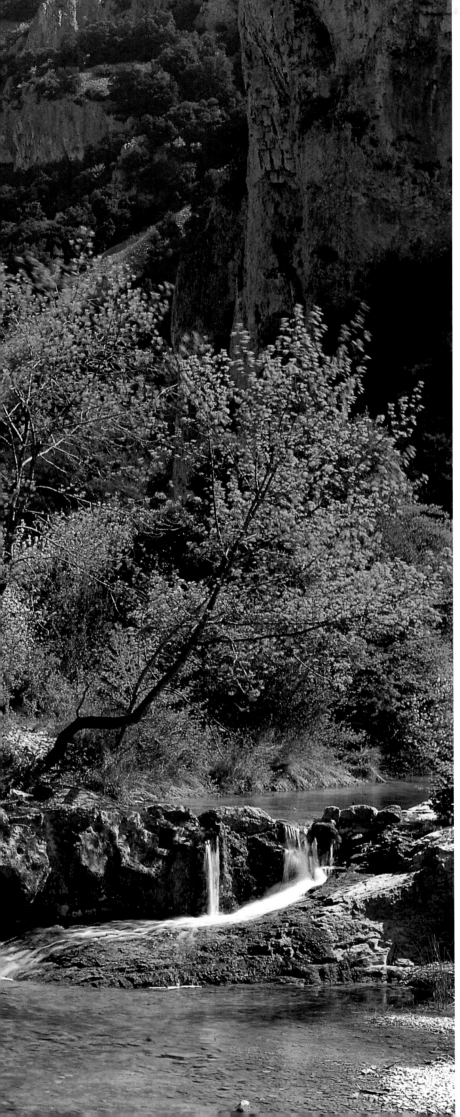

Vallon-Pont-d'Arc, in the Ardèche, is a centre for tourists, in part because it provides an easy picturesque starting-point for a visit to the narrow gorges of the river Ardèche.

reliefs, including a massive, sculpted reclining woman known as the Venus of Penne.

The mountainous region of the Ardèche, on the right bank of the river Rhône, is a realm of chestnut trees and *champignons*. The river from which the *département* takes its name begins as a torrent in its upper valley, before flowing through a sweet countryside of gentle hills and fertile lands planted with vineyards and fruit trees. The finest point of departure for visiting the Ardèche gorges is undoubtedly Vallon-Pont-d'Arc. The view from Pont-d'Arc (the only 'natural' bridge in Europe, 34 metres high and 59 metres wide) is breathtaking. The village itself has pretty seventeenth-century houses, and a seventeenth-century château, now the town-hall, housing Aubusson tapestries. The river begins as a torrent, speedily tumbling a thousand metres. Then it becomes gentler, flowing past such fortified villages as Balazuc, past Sauveplantade and its twelfth-century Romanesque church, and past Voguë, whose feudal château dominates the river.

Further south, flowing through the Hérault to the Golfe du Lion, the river Orb is perhaps seen at its best at Béziers, where it flows under a thirteenth-century bridge past a city dominated by the cathedral of Saint-Nazaire. Here, too, the Canal du Midi connects the Atlantic Ocean with the Mediterranean. This waterway was the brainchild and achievement of Pierre-Paul Riquet, farmer-general of salt taxes throughout Languedoc-Roussillon, who in 1666 persuaded Louis XIV's minister Colbert to issue an edict for the construction of a navigable canal between Toulouse and Sète in Provence. The enterprise involved '12,000 heads' (a man reckoned as one head, three women as two) and cost

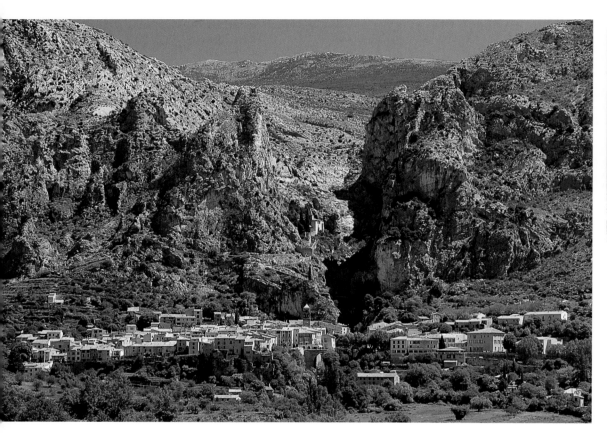

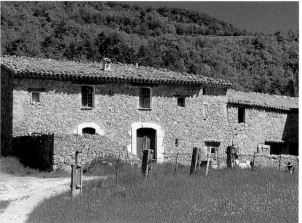

The torrent of Rioul (left) traverses the village of **Moustiers-Sainte-Marie** in the Alpes-de-Haute-Provence. More dramatic Provençal views lie along the canyon of the Verdon, from La Palud-sur-Verdon (above) to the peaks near Castellane (opposite).

17,161,028 livres. Riquet died in 1680 when the canal needed a mere five more kilometres to connect it with the sea. Grain was the principal cargo of its barges, carried south from Toulouse to the Mediterranean.

In Provence, the grand canyon of the Verdon gorges is one of the most dramatic landscapes of all France, as the green-blue river threads its deep way through the lime-stone plateau. The Route des Crêtes offers successive superlative views of the deep rift in the land. Six kilometres from the canyon and a centre for tourists visiting the gorges, the little village of Moustiers-Sainte-Marie, long noted for its ceramics, is traversed by

the Rioul torrent. This is one of the most enticing villages of Provence, with encorbled houses and streets both vaulted and flanked with arcades. Its chapel of Notre-Dame-de-Beauvoir, built in the twelfth century and rebuilt over the next four centuries, attracts pilgrims, especially each year on 8 September; it has a sculpted Renaissance door. The parish church of Notre-Dame is architecturally finer, with its Provençal Romanesque nave, its Gothic choir and its Lombardic Romanesque belfry. The village has a fascinating grotto chapel dedicated to La Madeleine. The local faïence is much esteemed.

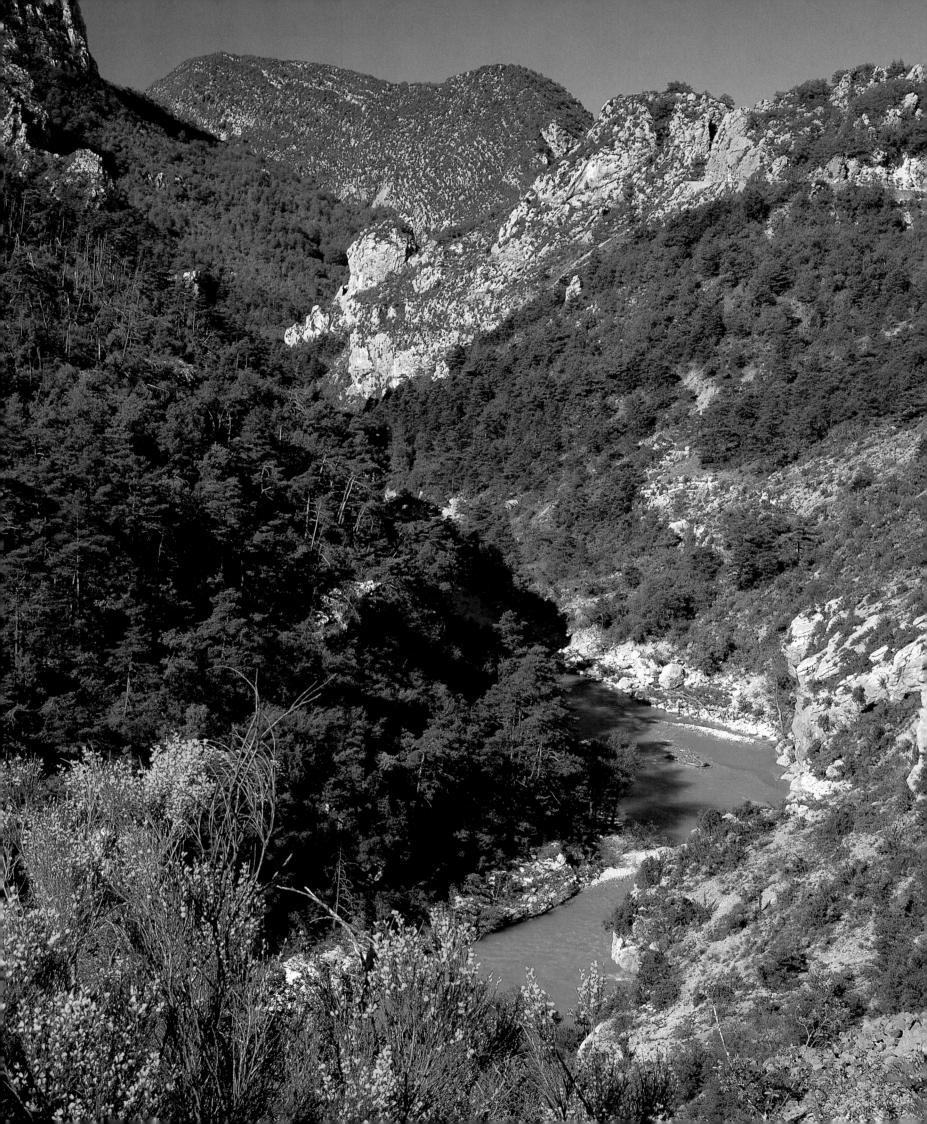

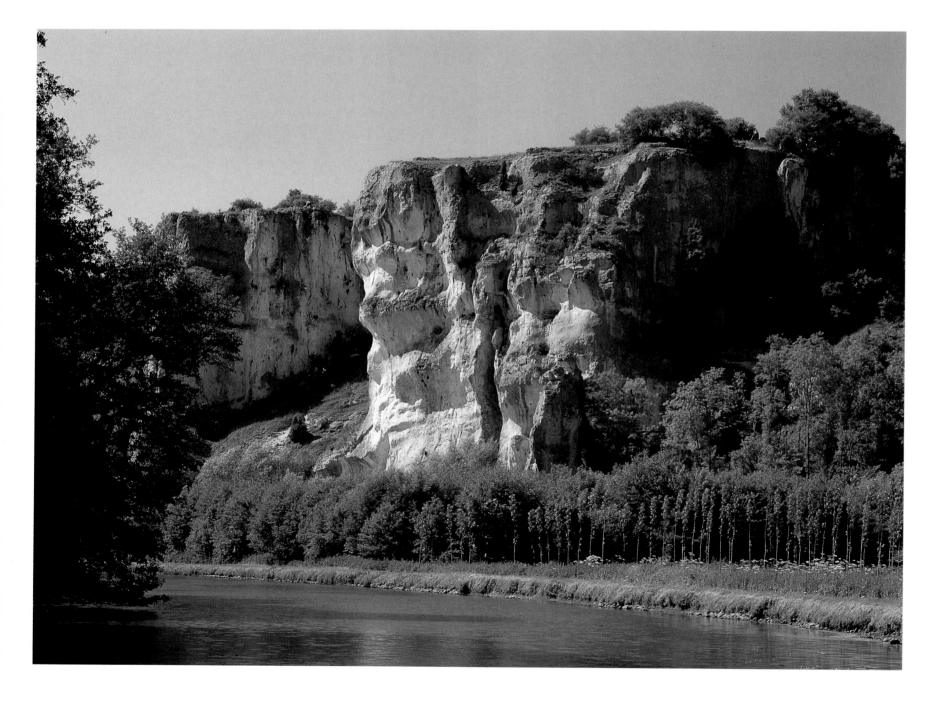

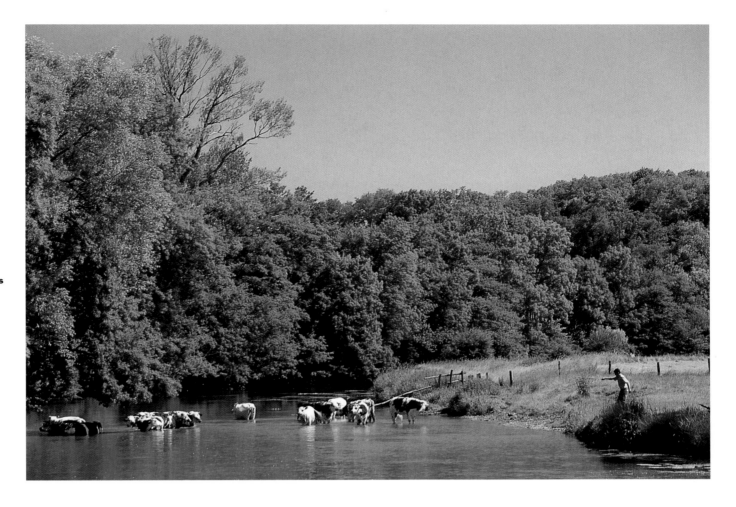

One of the great beauties of Burgundy is the meandering river Yonne and its varied course (opposite and right), as it moves peacefully through the Morvan natural park.

BURGUNDY, CHAMPAGNE, MOSELLE

Northwards to Burgundy, and we find one of the great fluvial treasures of France, the river Yonne which much enriches the *département* to which it gives its name. Among the fine towns and villages which flank the river, Villeneuve-sur-Yonne has thirteenth-century gateways, a Gothic church with thirteenth- and sixteenth-century stained-glass, as well as statues and furnishings dating from the fourteenth to the sixteenth centuries. Half-timbered houses from the same eras enliven the town. And here the Yonne is crossed by a Gothic bridge with fourteen arches. Not far away, the hill village of Vézelay graces the edge of the Morvan natural park.

Bar-sur-Seine in the Aube boasts half-timbered houses, as well as a twelfth-century château. Its church of Saint-Étienne is a lovely mix of flamboyant Gothic and Renaissance architecture. Fourteen kilometres south, Les Riceys is a little commune of fewer than 2,000 souls, formed out of three villages sited beside the river Laigne. Celebrated rosé wines brought prosperity to these villages – Ricey-Haut, Ricey-Haute-Rive and Ricey-Bas – so that each has a splendidly furnished sixteenth-century church, as well as noble houses, while Ricey-Bas is also guarded by a sixteenth-century château with an elegant garden. North of Bar-sur-Seine, Bar-sur-Aube sits in a region of valleys washed by streams and rivers offering from the hillock of Sainte-Germaine a splendid view of the Aube itself and enticing visitors with its two parish churches: Saint-Pierre, built in the early Gothic style at the end of the twelfth century, and Saint-Maclou, begun in the late twelfth century and finished in the fifteenth.

Other river towns and villages of Burgundy, Chablis, Pontigny, Irancy, Noyers, are rich both in wines and architectural heritage. The little town of Noyers, like Pontigny and Chablis on the river Serein, is particularly delightful, with its fifteenth- and sixteenth-century houses, sixteen towers amongst the remains of its former ramparts, the fifteenth-century

church of Notre-Dame and the river winding itself around the town as if unwilling to let it go.

And so north-east to where the river Moselle rises, then flows near Bussang and Gérardmer (a little further north), two Alpine resorts. Thionville is another hive of sporting activitity, a spot favoured and ruled by the Carolingian kings and then successively by the Lords of Luxembourg, by the Dukes of Burgundy and by Austria, becoming French only in 1659. It still retains much of its ancient fortress. The river frames rich forests, especially that of La Haye, embraced by a bend of the Moselle between Toul and Nancy. Toul has preserved its seventeenth-century ramparts and their four gates. They defend a former cathedral, Saint-Étienne,

whose façade is a stunning example of
fifteenth-century flamboyant Gothic,
while inside are Renaissance chapels and
a sumptuously decorated choir. The cloister
dates from the thirteenth and fourteenth
centuries. The twin octagonal towers rise to
65 metres. Charmes, further downstream, is
well worth a visit for its fifteenth-century
church and for the panorama of the Moselle
from the Monument de Lorraine, 3.5 kilo-
metres south-west of the little town. Finally
Épinal is renowned for its medieval basilica
of Saint-Maurice and the beautiful
park of its château.

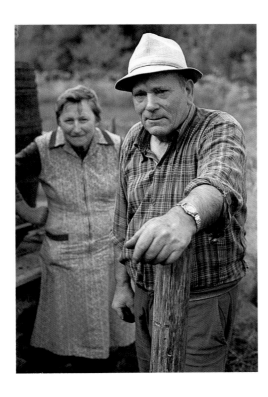

In the vineyard villages
of the Burgundy rivers
and of the Moselle,
time sometimes seems
frozen, perhaps in the
form of an ancient tree,
like this willow in the
Yonne (opposite), or
on the faces of their
inhabitants and
venerable shop fronts
(this page).

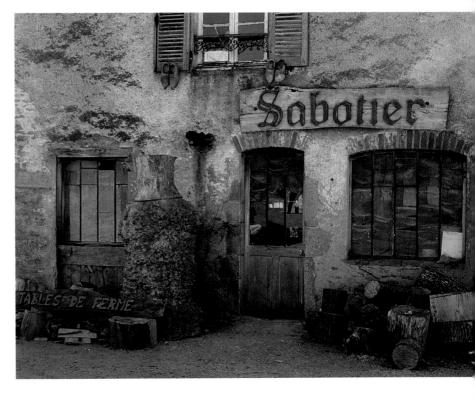

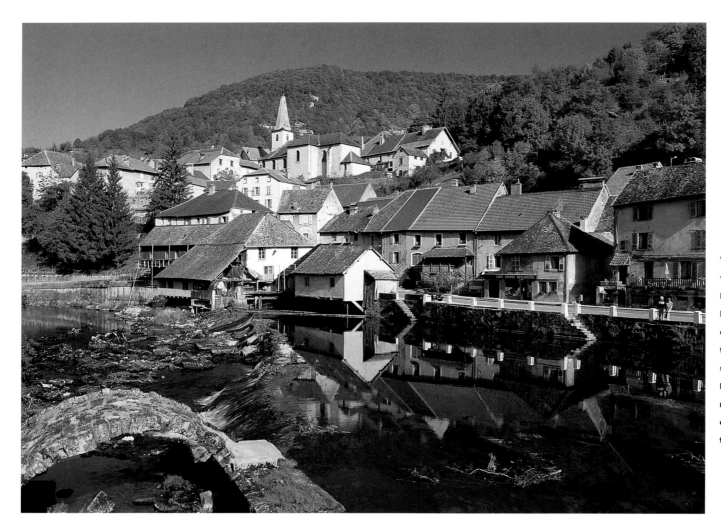

Water mirrors a riverside village in the Doubs, Franche-Comté (left). Pines and then snow-covered hills rise from the Vallée de la Clarée, situated north of Briançon and taking its name from the limpid, clear waters which run through it (opposite).

RIVERS OF THE MOUNTAINS

Upland France, from northern Provence to the Alps of Savoy, boasts some spectacular rivers, before we reach the gentler waterways of the north-east. Parts of the *département* of the Hautes-Alpes miraculously enjoy some three hundred days of sunshine every year. To the west rises the Massif des Écrins, today a national park. The valley of the Durance embraces Sisteron, with its impressive citadel, its fifteenth-century chapel of Notre-Dame and its sixteenth-century fortifications. South-east the river is dominated by the late fourteenth-century château of Château-Arnoux. The Durance also runs close by Manosque, the little town made famous by the writings of Jean Giono, surrounded by hills planted with olive trees, its parish church containing a twelfth-century Black Virgin. Bizarrely, the Durance then veers suddenly westwards, to the abbey of Silvacane (much of its austere buildings still intact), which the Cistercians founded in 1444, to reach the melon capital of

Provence, Cavaillon, which boasts an eighteenth-century synagogue and a Romanesque church dedicated to St. Véran.

In the valley of La Clarée spare time above all for Plampinet and Névache. Today the two parishes have united to present to visitors an enchanting summer holiday resort. Fifteenth-century Saint-Marcellin at Névache houses wall-paintings and a Baroque reredos. Its porch has splendid sculptures. At Plampinet the church of Saint-Sébastien is decorated with sixteenth-century wall-paintings. In the environs are mountain lakes, hamlets and alpine sanctuaries whose chapels have Baroque furnishings and medieval frescoes: the pilgrimage chapel of Notre-Dame-du-Bon-Secours, near Mont Thabor; the chapel of Robion, with its wall-paintings; the chapels of Le Cros, Fontcouverte, Sainte-Barbe, Saint-Benoît and Saint-Sauveur.

Briançon is the chief spot of this region. Fortified by Vauban in the seventeenth century, its defences remain intact.

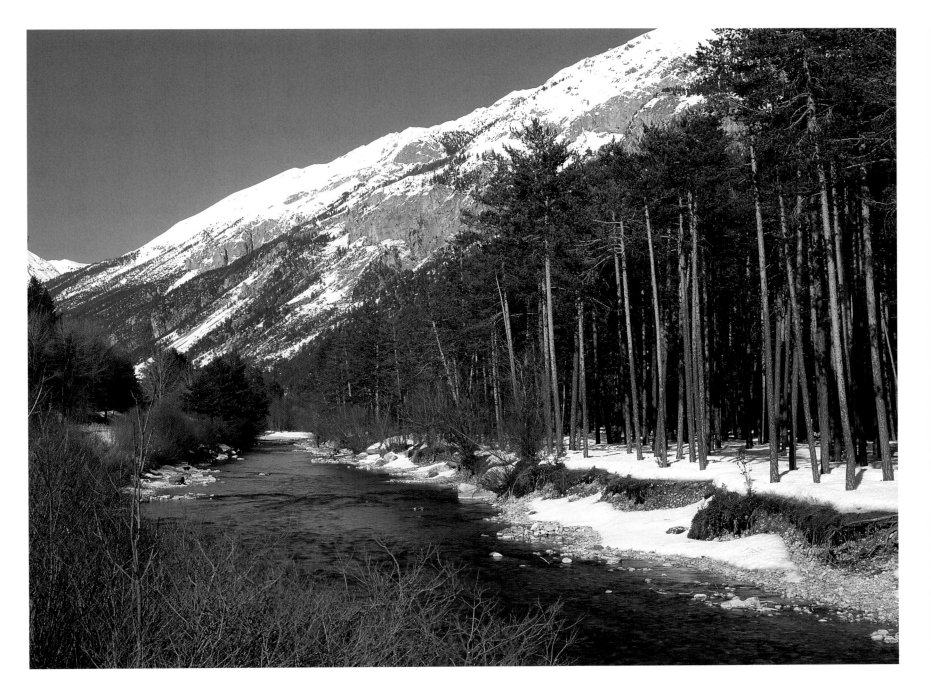

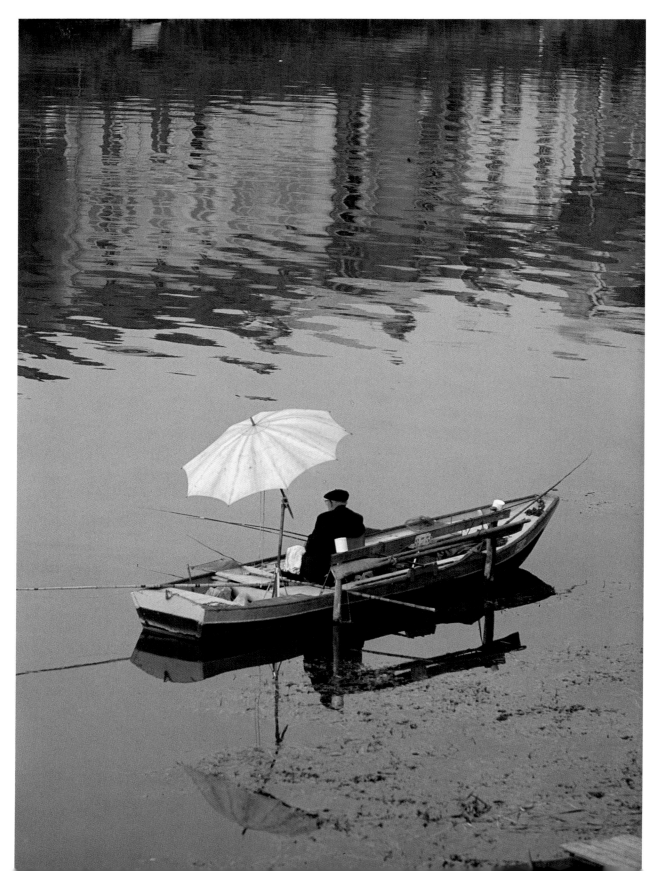

Champagne vines and peaceful fishing characterize the Marne valley (left) near Épernay, one of three regions producing the famous effervescent wine.

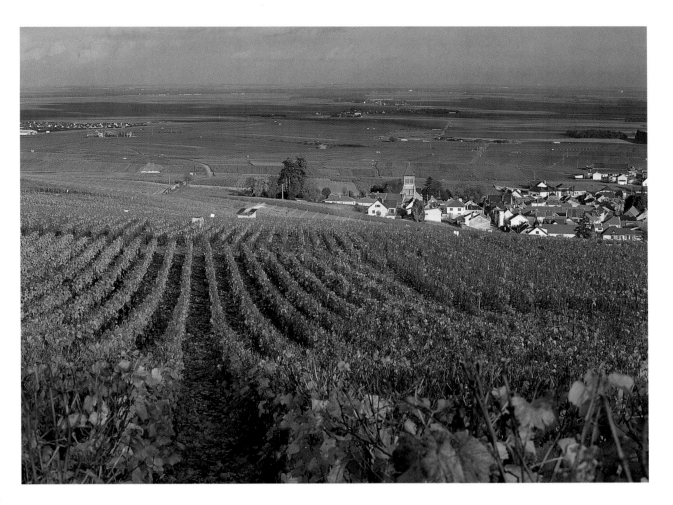

Apart from Épernay, the
other two main
producing regions of
Champagne are the
Montagne de Reims and
the Côte des Blancs; in
the Marne valley the
vines are cultivated on
either bank of the river.

RIVERS OF WINE AND WAR

In the Marne, situated on the river which
gives the *département* its name, Épernay,
with its stupendous wine cellars and its soft
undulations (another phrase of Henry
James) has long been recognized as the cap-
ital of Champagne. The town nestles at the
feet of vine-covered slopes, where its sub-
terranean *caves* draw attention away even
from the church of Notre-Dame, which
has a fine porch sculpted in 1540. The
names of the Champagnes are renowned:
Mercier, Castellan, Moët et Chandon. Dom
Pérignon, the cellarer of the Benedictine
monastery of Hautvilliers, set out in the
seventeenth century the methods by which
Champagne is still produced. But after sam-
pling, spare time for such treasures as the
flamboyant Gothic church at Aÿ, the mag-
nificent furnishings of the church of Saint-
Trésain at Avenay-Val-d'Or (a church
begun in the thirteenth century and com-
pleted in the sixteenth) and – to combine
religious architecture with wine – the
parish church of Rilly-la-Montagne, whose
stalls are carved with scenes depicting the
various stages of the annual toil in the
vineyards.

Forests shade the upper Marne.
Undoubtedly its most significant spot is
Colombey-les-Deux-Églises, where Charles
de Gaulle had a property to which he retired
in 1969 and where he died a year later. Close
by the village he is commemorated by a red
granite monument in the form of a cross
of Lorraine. North of his village and last
resting-place is Cirey-sur-Blaise, whose
seventeenth- and eighteenth-century
château, with its medieval keep, dominates
the river valley. To reach the Marne itself,
travel east to Gudmont-Villiers (with its six-
teenth-century château), where the river is
matched by a canal of the same name. And
another delight of this region is the natural
park of the Montagne de Reims, a protected
zone of 80,000 hectares situated between
Rheims, Épernay and Châlons.

Rolling green countryside, woodlands
and fishing lakes characterize much of the
Somme. Townscapes are enhanced by half-

timbered houses overhanging rivers. The restaurants serve local delicacies, such as *ficelle picarde*, a thin pancake wrapped around several slices of ham and enlivened with mushrooms and grated cheese.

The Somme is also filled with war cemeteries and memorials. The German cemeteries have black crosses. The graves of French soldiers are marked with white crosses. The British and Canadian cemeteries have for the most part simple stone slabs designating the graves. Sometimes an inscription will say, 'Known unto God', since no-one could recognize the body shattered by warfare. The most impressive war memorial in the Pas-de-Calais is the chapel of Notre-Dame-de-Lorette, set on a ridge which saw some of the bloodiest fighting of World War I. In its cemetery lie 18,000 identified bodies and 16,000 bodies of men whose remains could not be identified. Yet, amidst all this reminder of warfare, there are magical towns and cities, such as Saint-Omer (with its narrow cobbled streets and former cathedral),

Amiens (with crumbling gabled houses and the largest Gothic cathedral in Christendom) and Arras (with its Flemish-style urban ensemble of the Grande-Place and the Petite-Place, all overlooked by the city's belfry which is topped by the lion of Arras).

Winter scenes on the rivers of north-east France: the Somme gives its name to a *département* of lakes and marshes (above); a mill-stream harbours ducks at Offin, Pas-de-Calais, while the river Canche (opposite) has the distinctly mournful air of a northern winter.

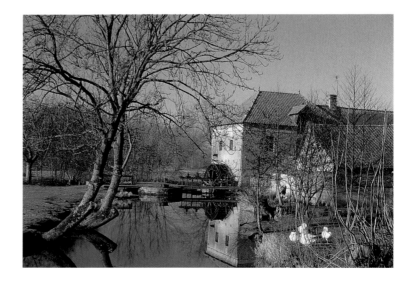

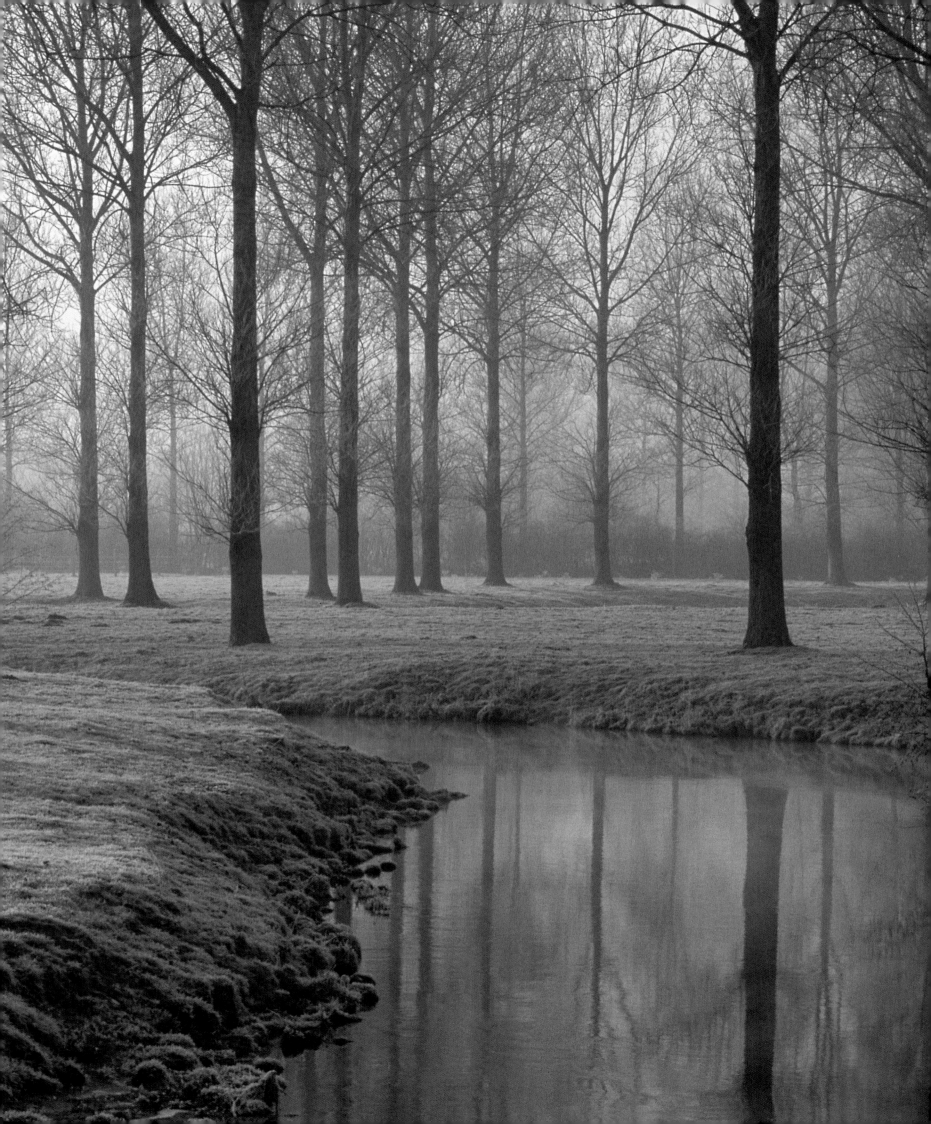

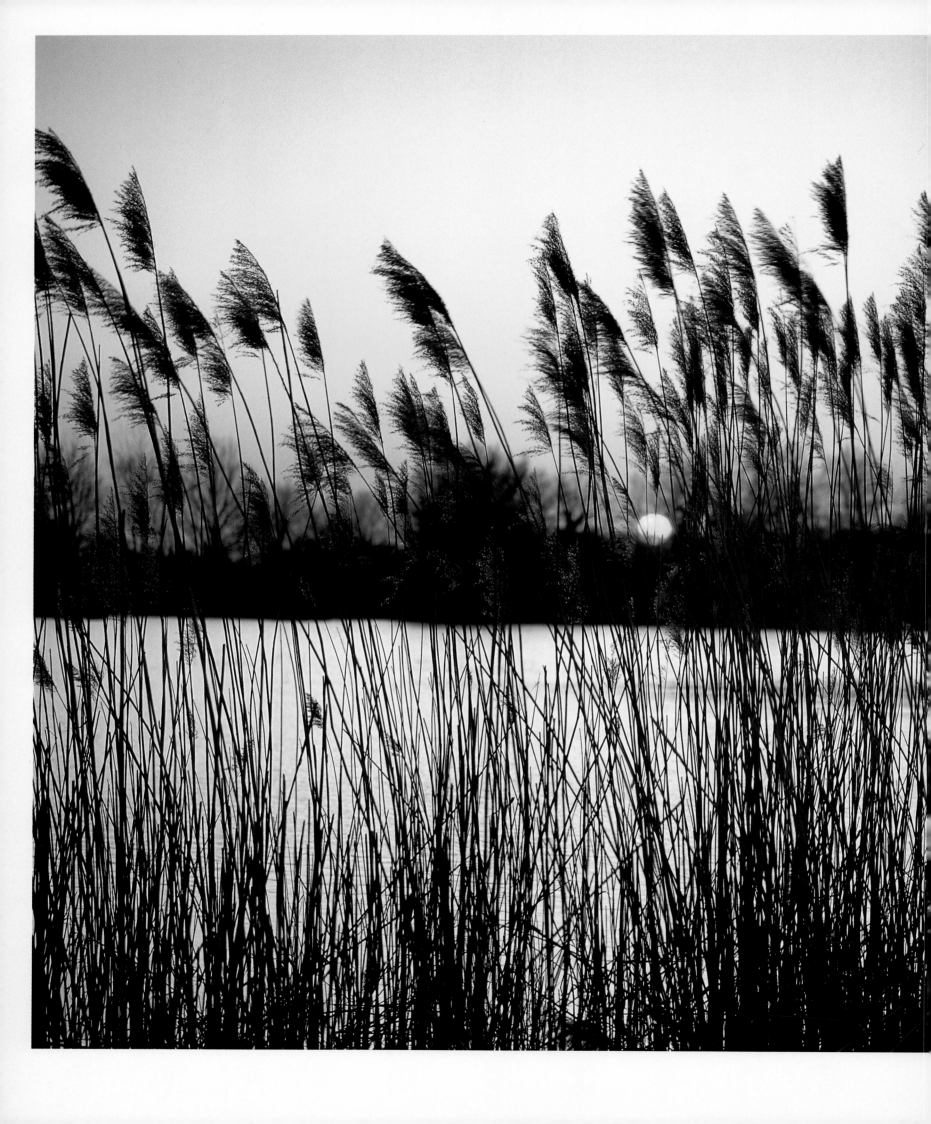

MOST OF FRANCE'S MAJESTIC FORESTS reward extensive exploration. The royal forests outside Paris are amongst the finest, though matched by superb woodlands elsewhere. The forest of Compiègne has great oaks, beeches and ash trees. The forest of Rambouillet, with little rivers that flow into the Seine, is a necessary lung for Parisians. As well as oak trees, that of Fontainebleau boasts Scotch pines, chestnuts and silver birches. All of these forests are marvellously well kept, and dissected by broad alleys – to facilitate the passage of regal hunting parties in the past.

Lakes dot these forests; Compiègne and Rambouillet are punctuated with charming *étangs*. But to find the most impressive lakes of France it is necessary to travel to the Pyrenees or the Alps, or indeed south to the Camargue. In the Auvergne, too, are numerous lakes which fill what were once the outlets of volcanoes. Glaciers too created lakes, such as the Lac du Crozet in the Massif de la Chartreuse. One amazing concentration of lakeland is the Dombes, 'the land of a thousand lakes,' south-west of Bourg-en-Bresse, centre of wildfowling.

Many parts of France are dotted with wetlands, for example the borders of the Somme between Amiens and Abbeville. Some villages, such as Saint-Cado in Brittany, seem to be suspended between the sea and the river, its demeanour that of an island quietly hugging itself. Whole stretches of western France seem to be composed of noth-

ing but wetland, where whole communities use canals for communication and transport as other people use roads.

The importance of water and its associated wildlife has struck many a perceptive writer on the rich variety of France. With only mild exaggeration, André Gide declared that every Normandy hollow seems to be filled with water: pond, pool and river. In truth, Normandy is a beguilingly diverse province, with forests, rich pastures and thermal springs. Its plains support apple trees as well as sugar-beet, maize, wheat and barley. As Gide also observed of the wide valley of the Auge, 'Countless narrow combes and gentle rounded hills reach as far as the valley, which then stretches in an uninterrupted plain as far as the sea.' He added, 'You see no horizon, but only a few copses, filled with mysterious shade, a few cornfields, but chiefly pasture, soft, quietly sloping meadows, where the rich grass is mown yearly, where when the sun is low the apple trees give deep shadows, where untended flocks of sheep and herds of cows graze.' Staying with his uncle near Arras, the poet Paul Verlaine decided to sail into the city along the river Scarpe. 'Along the richly varied banks grew seemingly endless fields of cereals, oats, wheat, rye and winter fodder,' he recalled. 'In virtually bottomless pools slept pike, while eels swam amidst the stems of the bulrushes and water-lilies. Black poplars, white willows and the tall grey grass shaded the river.'

Verlaine loved the ruddy-faced women of the region, patronesses of the inns in the whitewashed villages on either side of the river. He had grown tired of fishing in the lakes around Arras and longed to meet some similar women in Arras itself. Meeting them, he scarcely bothered to notice the magnificent architecture of this major city of the Pas-de-Calais.

From the *marais* of Normandy to the rivers of the north-east, the north of France can sometimes seem a country entirely dependent on watery phenomena, nat-

ural and man-made. The route south from Arras to Compiègne leads through the Somme, a region of lakes and bays, of streams and a littoral. The river itself offers varied faces. At first, on entering the *département*, it traverses swampy land, dotted with lakes. Then, after Péronne, a town with the white walls and towers of its ruined thirteenth-century castle, as well as a sixteenth-century church still pock-marked with damage from World War II, it winds towards Amiens and begins to irrigate a network of canals which in turn irrigate the fields of market-gardeners who navigate the waters in flat-bottomed boats. Finally, it empties itself into a maritime canal and the sea.

Southwards, the Ile-de-France (so-called because it is surrounded by three rivers, the Seine, the Oise and the Marne) has suffered from the overflowing capital city, yet it nourishes the majestic beech, oak and pine trees of the immense forest of Fontainebleau. It is blessed with Giverny, where Monet bought a house and created a water garden that vies with his paintings as a work of art. Monet admired Japanese art, and his water-lilies, iris, bamboo and weeping willows are complemented by a Japanese bridge.

Of the monastic foundations of the Ile-de-France the abbey of Royaumont in the village of Asnières-sur-Oise offers an evocative memory of the Cistercians who built it in the thirteenth century. Ruined in part during the Revolution, its cloister is the largest built by the Cistercians in France, its refectory a Gothic gem, its abbot's palace a later addition designed by Claude-Nicolas Ledoux in the eighteenth century. Asnières-sur-Oise also boasts a moated eighteenth-century château. And a few kilometres south-west is the 10,000-hectares forest of Carnelle, with its oaks, chestnut trees and hornbeams.

Another treasure of these lowlands surrounding the capital is the town of Provins, its twelfth- and thirteenth-century ramparts sheltering a marvellous ensemble of medieval buildings, enlivened here and there by a Renaissance doorway or gable. As for great secular architecture, the château of Vaux-le-Vicomte in the *département* of Seine-et-Marne is a sumptuous masterpiece, built by Le Vau between 1657 and 1661, and matched by its gardens which were designed by Le Nôtre. Little more than five kilometres east stands the château of Blandy-

The massive artificial Lac de Der-Chantecoq in the Haute-Marne was originally designed to regulate the flow of the rivers Marne and Seine.

Preceding pages
The countryside around the village of Saint-Paul-de-Varax, among the lakes south of Bourg-en-Bresse in the *département* of the Ain, is one of the richest areas in France in agriculture and, consequently, in gastronomy.

les-Tours, which was fortified in the fourteenth century and rebuilt in part in the sixteenth and seventeenth centuries, retaining however its five-towered fortifications and its thirty-two-metres-high keep.

Flatlands need not be dull lands. As the train took him from Nantes to La Rochelle, Henry James discovered an exceedingly pretty countryside, bristling with 'copses, orchards, hedges, and trees more spreading and sturdy than the traveller is apt to deem the feathery foliage of France.' He added, 'It is true that as I proceeded it flattened out a good deal, so that for an hour there was a vast featurless plain.' As he drew near La Rochelle, however, he recorded that 'the prospect brightened considerably, and the railway kept its course beside a charming little canal, or canalized river, bordered with trees, and with small, neat, bright-coloured, and yet old-fashioned cottages and villas, which stood back on the further side, behind small gardens, hedges, painted palings, patches of turf.' This journey would have taken him through some of the most beautiful wetlands of western France, now largely preserved as state natural parks.

In the south-west, Aquitaine was known as 'the land of waters' by the Romans. It is for the most part a gently undulating country. One part, Béarn, is a gentle, green and wooded land whose streams drive modest mills and whose lush pastures nourish herds of yellow cattle. One of this region's treasures is the fortified village of Sauveterre-de-Béarn, with the ruined Château de Montréal, once the home of the lords of Béarn, rising sheer from the cliffs of the river Oloron. Another is its medieval bridge, defended by a Romanesque tower. A third is the Romanesque church of Saint-André. And the village is crammed with medieval houses, gateways and manors.

The Gironde in Aquitaine is wine country. Among its finest are those of Saint-Émilion. Some of the town's machicolated ramparts remain intact. Here are Romanesque churches, including a magnificent, half-Gothic collegiate church with its fourteenth-century cloister. The ancient land of Quercy became the *département* of the Lot in 1790. Much of its terrain consists of plateaux, or *causses*, much of them covered with forests of oak trees. The *causse* of Gramat is the most vast and the most desolate. The *causse* of Limogne in lower Quercy is more hospitable and Mediterranean in climate. All of them merit careful exploration.

And north of the Dordogne, between the Périgord and the lower Limousin, is the *causse* of Martel, a plateau which never rises more than three hundred metres above sea level. The little town of Martel (where Henri Court-Mantel, the second and traitorous son of Henry II of England, died of a fever in 1183) is charming, seven towers rising from its ancient buildings. A mint dating from the thirteenth century, fourteenth-century gateways, an eighteenth-century market-hall, and houses built from the fourteenth to the sixteenth centuries make Martel one of the most enticing spots in Aquitaine. And the fortified, fifteenth-century church of Saint-Maur has a Romanesque porch whose tympanum was carved in the twelfth century with a Last Judgment.

Such areas of France – the western wetlands and more southerly woodlands – tend to be forgotten in the tourist stampede to the lakes of the mountain regions and the well-tended forests of the Ile-de-France. Yet all of them repay careful attention and yield great delights – topographical and gastronomic.

Two farmers take time off for a serious exchange of local news in the Marais Vernier.

Cattle graze in a Vendée water-meadow at Beauvoir-sur-Mer (below) **which, owing to silting, is now – despite its name – some four kilometres from the water.**

Two Normandy forests: the Forêt d'Eu, south of Eu in whose château (predecessor of the present one) were celebrated both the betrothment and the marriage of William the Conqueror and Matilda of Flanders; and the Forêt de Lyons, its oaks and beech trees surrounding the lovely village of Lyons-la-Forêt.

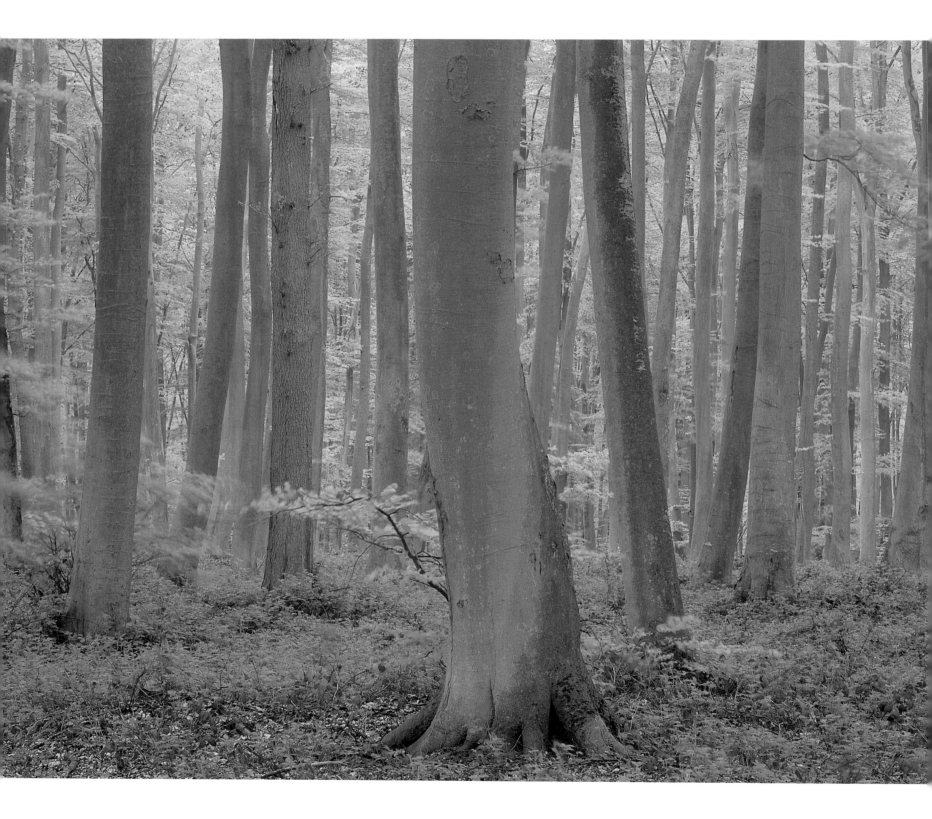

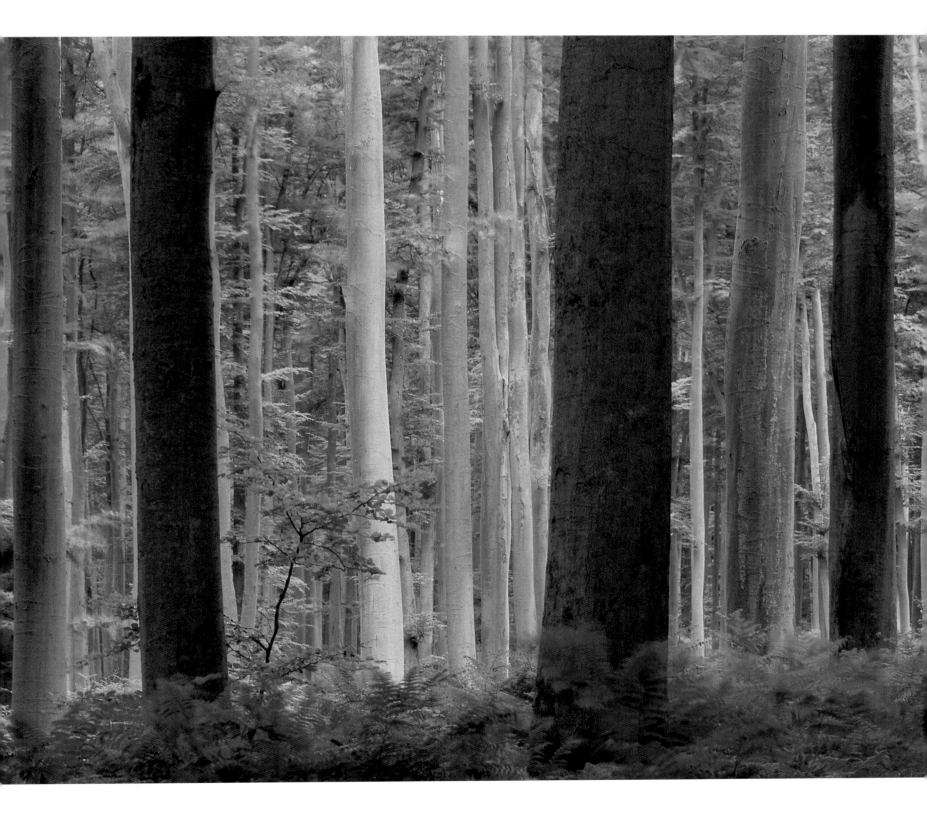

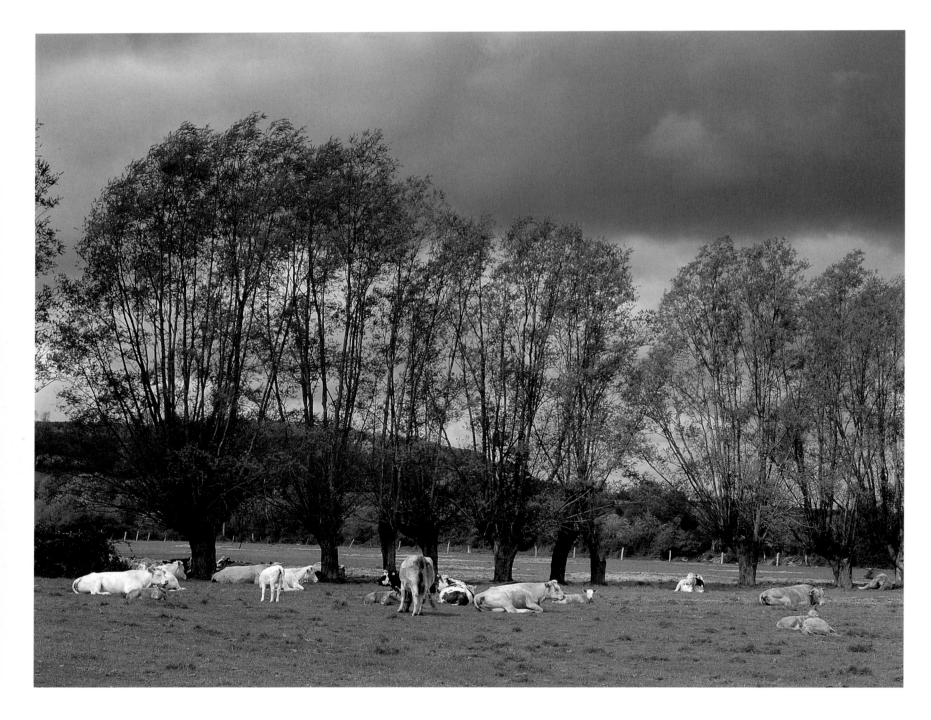

NORTHERN **F**RANCE IS RICH in magnificent forests, some quite wild, others with ordered tracks and alleys, a legacy of court hunting. South-east of Rouen in Normandy, the villlage of Lyons-la-Forêt, with an entrancing cluster of buildings dating from the sixteenth to the eighteenth centuries, stands in the valley of the Lieure in a vast forest of beech trees. In the Middle Ages, enticed by the ready supply of water provided by the river Andelle and its tributaries the Lieure, the Héron and the Crevon, a number of monasteries were founded in the region. Today, most of these foundations lie in ruins, a memory of the Christian culture that once thrived here. South of the village, for instance, stand the sad ruins of the abbey of Mortemer founded by the Cistercians in the twelfth century. At Fleury-sur-Andelle are the yet more evocative ruins of the thirteenth-century abbey of Fontaine Guérard.

Five kilometres west of Pont-de-l'Arche, on the west bank of the Seine, are the remains of the abbey of Bonneport, founded by Richard Cœur de Lion in 1190. An even more splendid ruin nearby, also founded by him, is the Château Gaillard, which he built to dominate a loop of the Seine. It rises on white cliffs over-looking the two charming villages of Les Andelys. Richard built it as a bastion against King Philippe-Auguste, declaring that he would defend it, even if its walls had been made of clay. Philippe-Auguste responded, 'I shall conquer it, even if its walls are made of iron.' And conquer it he did, though by treachery, in October 1203. Much of the château was demolished two centuries later on the orders of Henri IV, but what remains, particularly the fifteen-metres-deep moat, the vestiges of the double ring of walls and a keep with walls five metres thick, impressively demonstrates how much the Normans had learned from Saracen castles on the crusades.

From Rouen the river Seine makes five great loops as it flows towards its estuary. It laps Jumièges, where an abbey was founded in the seventeenth century and rebuilt by

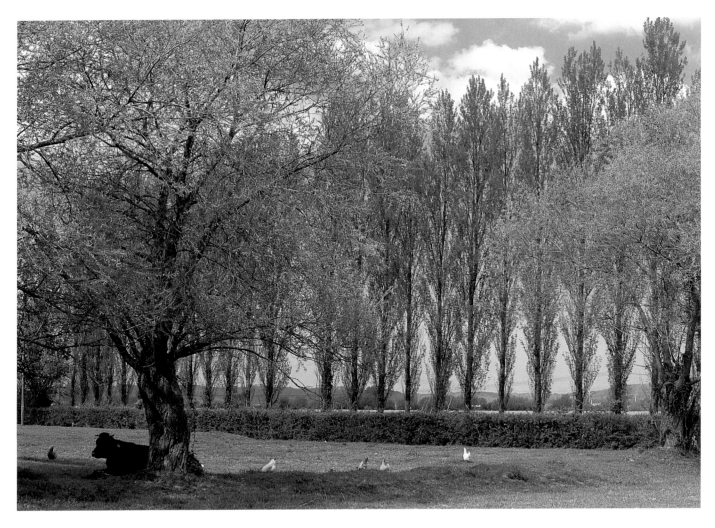

the Normans; its ruins – which include
the façade and the nave of the abbey
church, as well as a twelfth-century
chapter-house and a Carolingian chapel –
are still fascinating. The Seine flows by
another abbey founded in the seventh
century, that of Saint-Wandrille. Monks still
live among these ruins, singing Gregorian
chant in a former tithe hall brought here
from the Eure in 1970 to serve as their
church. Another loop of the river embraces
the Brotonne forest, which you can over-
look from the village of Saint-Wandrille.
The forest itself covers some 6,800
hectares and the Brotonne natural park,
some 50,000 hectares, dedicated to the
preservation not only of the flora and
fauna of the region but also of its cultural
heritage. Then the river winds around the
Marais Vernier, one of the most famous
wetlands of France.

Long ago, a meander of the Seine regu-
larly flooded all of this marshland, leaving
behind a rich alluvial soil. Today, the Marais
Vernier lies in an amphitheatre of wooded
hills, stretching from Quillebœuf-sur-
Seine to Les Pointes-de-la-Roque. The
amphitheatre looks over the present course
of the river, but is separated from it by a
dyke, built by the Dutch on behalf of
Henri IV in the early sixteenth century.
Even earlier another lake, La Grande Mare,
was created in the fourteenth century, to
stop the marshlands drying out, and today
this feeds a remarkable, chequerboard
pattern of canals. Not surprisingly, this is
a land of willow trees and poplars (white
ones, the result of a hybrid between those
from this region and those of the Marais
Poitevin), but the micro-climate of the
Marais Vernier is such that a plethora of
other unexpected flora thrive, including
walnut trees, alders, elders and hazel trees.
Bulrushes, orchids and reed-grass flourish
in abundance. Apple orchards abound and
often surround the quaint half-timbered
houses of the region and flank its waters.
The Brière natural park (La Grande

The Lac de Grand-Lieu in Brittany is set amid a marshland teeming with game. The largest natural lake in France, it is the resting place of thousands of migrating birds as well as the home of many indigenous species. Anglers fish here for eels, carp and pike.

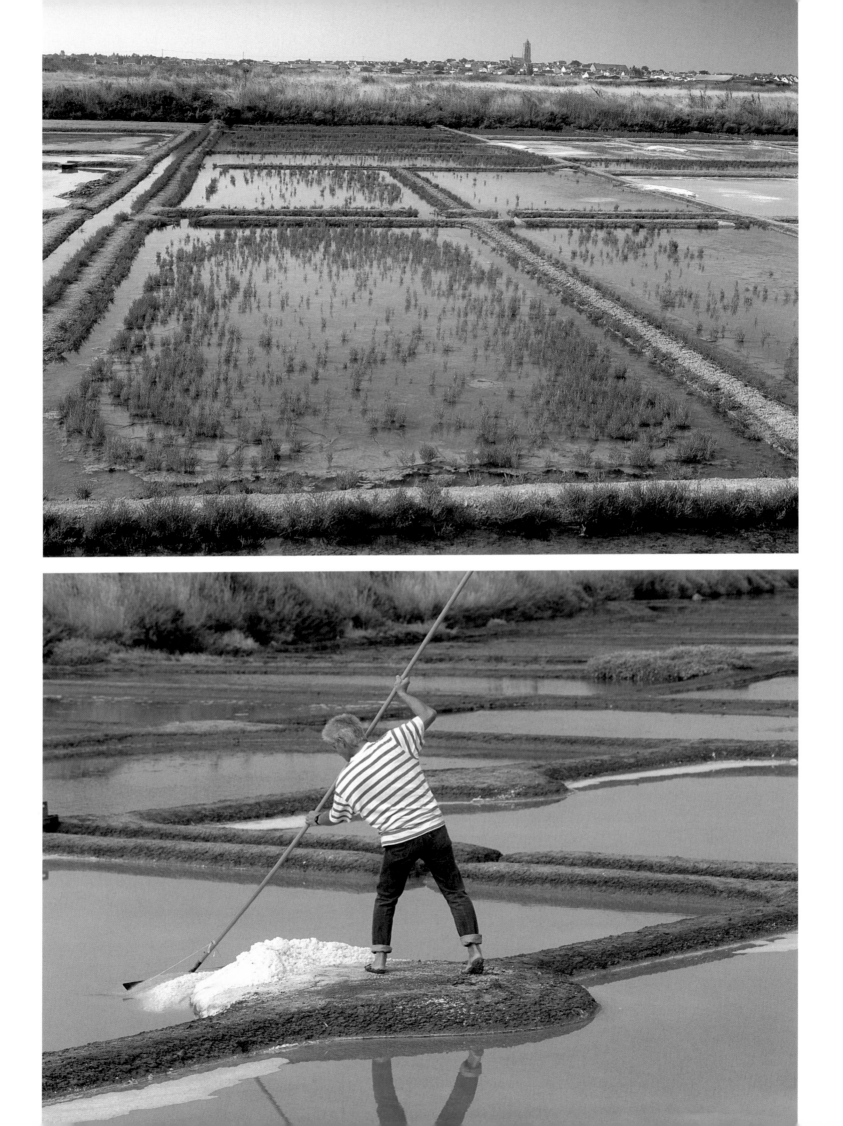

Salt pans (opposite above and below) **outside Guérande, a Brittany town protected by ancient walls: the salt-bearing water evaporates in shallow basins and then the salt is scooped in by long rakes. This white-washed, thatched barn in the Brière natural park, guarded by a rather languid dog, typifies the traditional architecture of the region.**

Brière), west of Nantes, embraces another of the great wetlands of France. It is very different from the wetlands of Normandy, yet equally beguiling. As well as sheltering countless sea birds, its stretches of peat bog are dissected by 100 kilometres of canals, bordered by thatched cottages, some of them in excellent condition, some of them tumbledown. Long before its official creation in 1970, the Duke of Brittany had given the marshland at its heart to the inhabitants of twenty-one communes, a charter confirmed by subsequent French kings. Today, the park comprises some forty thousand hectares, seven thousand of them marshland, peat bog and grassland. Long low houses, the thatch sometimes spreading down over outbuildings like hands blessing the inhabitants, are built of stone and sometimes covered in cob. Here live some fifty thousand Bretons (or *brièrons*, as they also call themselves), among them fisherfolk and wildfowlers.

La Grande Brière was set up specifically to safeguard not only the ecology of the region but also its heritage. A secondary but vital aim was to reconcile the interests of tourism with protecting the environment. Visitors are welcome to meander in the traditional flat boats along some of the 100 kilometres of canals which criss-cross the park. On the coastal edge of the park, Guérande is protected by battlemented walls and massively fortified fifteenth-century gates, a legacy of defence against Saracens, Normans and Spaniards. Enter them to discover a delightfully peaceful town of winding streets.

At some seven thousand hectares, the Lac de Grand-Lieu in the Loire valley, south-west of Nantes, is the largest natural lake in France. In it breed carp, eels and pike. A village of narrow streets with fisher-folks' houses, Passay is the finest spot for viewing the lake. Herons are a protected species in the nearby ornithological park.

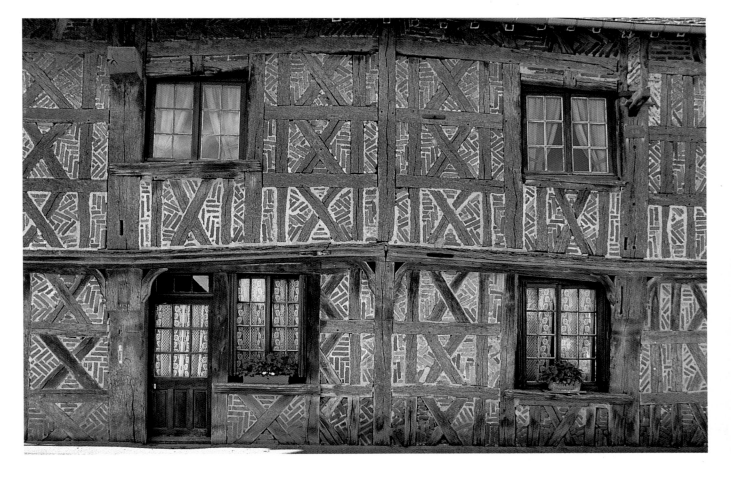

Romorantin-Lanthenay is one gateway to the **Sologne** (opposite), a land of forests, lakes, streams, rivers and heathland. It is also a country of superb half-timbered houses like this one at Neung-sur-Beuvron (right).

A LOST DOMAIN

The wetlands of Brittany and Normandy are the showpieces, so to speak, of watery France. But there are other, equally fascinating but less well-known regions. One such is the Sologne. A heather-clad land dotted with lakes and forests, the Sologne is embraced by a loop of the river Loire south of Orleans. Fishing its lakes and rivers is a favoured pastime and a necessity for its restaurateurs. Its farmers cultivate fruit, maize and, notably, asparagus. In the past it has several times threatened to become a desolate, poisonous land of swamps and diseases, even though it has been inhabited since ancient times. Visiting the Sologne in 1787, Arthur Young found it a miserable province, which the French themselves called the *triste* Sologne. In the nineteenth century Napoleon III instructed his servants to drain swamps, plant trees and lay out new roads. Because of this, he is often credited with saving the region, and also revealing its hitherto neglected riches.

Romorantin-Lanthenay, the main town of the Sologne, sits almost at its southern edge, on the river Sauldre, which pleasingly divides around some of its ancient houses. It boasts a château rebuilt by Jean of Angoulême in the mid fifteenth century and also a chapel built in 1626 and dedicated to St. Roch. The citizens attributed to him their survival from a plague in the 1580s, and inside his chapel is their *ex voto* thanking the saint for this. In 1499 Claude de France was born in the château and married the future François I a mere fifteen years later.

South of the town both the Berry canal and the poplar-lined river Cher flow through the Sologne. Both pass through the fortified town of Selles-sur-Cher, which is much older than Romorantin-Lanthenay. The feudal château of the town was transformed in the late sixteenth century and boasts magnificent sculpted chimneys. La Ferté-Saint-Aubin stands at the north-eastern corner of the Sologne, defended by its early seventeenth-century château and

preserving some of the charming half-timbered houses typical of this region. Between La Ferté-Saint-Aubin and Romorantin-Lanthenay are other picturesque Sologne villages: Courmenin, with its thirteenth-century church; the fortified village of Chaumont-sur-Tharonne; and Lamotte-Beuvron, where was invented a celebrated local delicacy, the caramelized apple pie known as *tarte Tatin*.

Today the whole region has a unique charm. Little tributaries of the Loire water the land. The river Sauldre gathers its waters from the Sologne and with them swells the Cher. Water defines the landscape – the Cosson and the Cisse dividing territories, while the woodlands are strewn with lakes. The western Sologne is today particularly fertile, but the whole region, its sandy soil enriched by a base of clay, supports not only forests but also vegetables, fruit and cereals. Villages such as Saint-Viâtre specialize in raising pheasants and other kinds of poultry as well as breeding and selling fish.

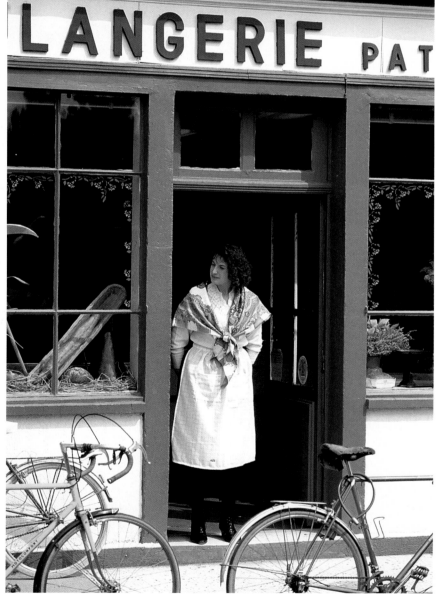

In many a small village in the Sologne can be found the traditional imprints of French commercial life: a memory of a former wine trader at Vannes-sur-Cosson; the *boulangerie* at Jouy-le-Potier. The mysterious watery stillness of the Sologne (opposite) **has given the region the reputation of a lost domain.**

WETLANDS OF THE WEST

The Vendée is best known for its expanse of golden sand and the Atlantic surf; but inland it offers a delicious landscape of little farms and low hills, which merge into the Marais Poitevin. Known as the 'green Venice', the region of 15,000 hectares (though the whole regional park covers some fifty-five thousand hectares) derives its character from the alluvial soil brought by the river Sèvre and its innumerable branches. A labyrinth of rivers, as well as canals dug by monks, bordered by willows, ash trees, poplars and elders, delineates fields in which grow artichokes, garlic, courgettes, broad beans, melons, onions and semi-dry haricots.

The Marais Poitevin displays many different aspects, for the wetland is matched by a larger area which is much drier and mostly given up to raising cattle. A quaint local phenomenon is the Pointe d'Arçay, at the western end of the Marais Poitevin, which grows by around twenty metres a year as a result of being covered by sand borne in by the sea. Across the estuary, at Esnandes (the southern limit of the drier Marais), a Romanesque church has been transformed into a massively fortified Gothic one – no doubt on account of the coastal privateers who were ever ready to invade and pillage.

To the south, the *départements* of the Gironde and the Landes offer more friendly forests. Woodlands dot the Gironde landscape. Then the landscape gives way to the immense pine forests of the Landes, the most forested region of France, though it also includes four superb lakes, the largest of which, the Étang de Cazeux et de Sanguinet, stretches over 5,600 hectares. In 1857 Napoleon III promulgated a law

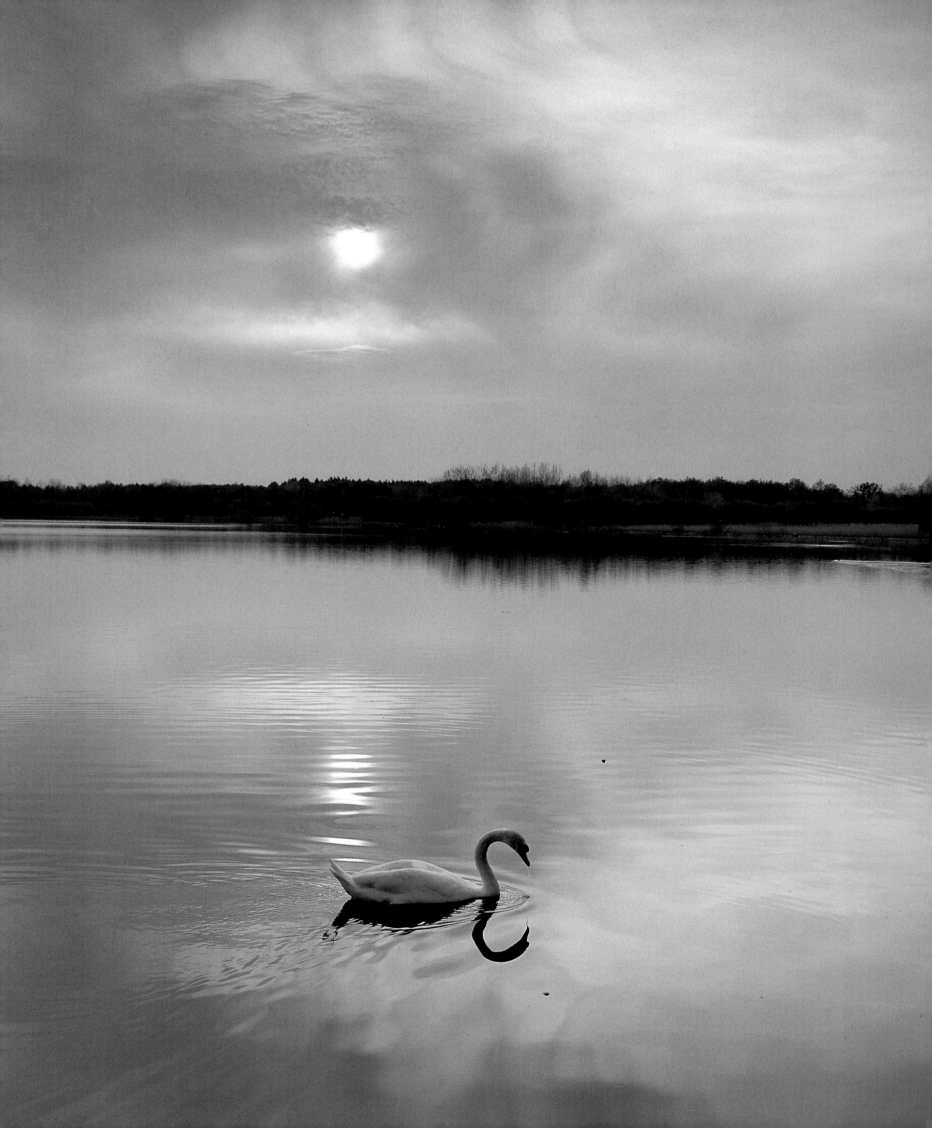

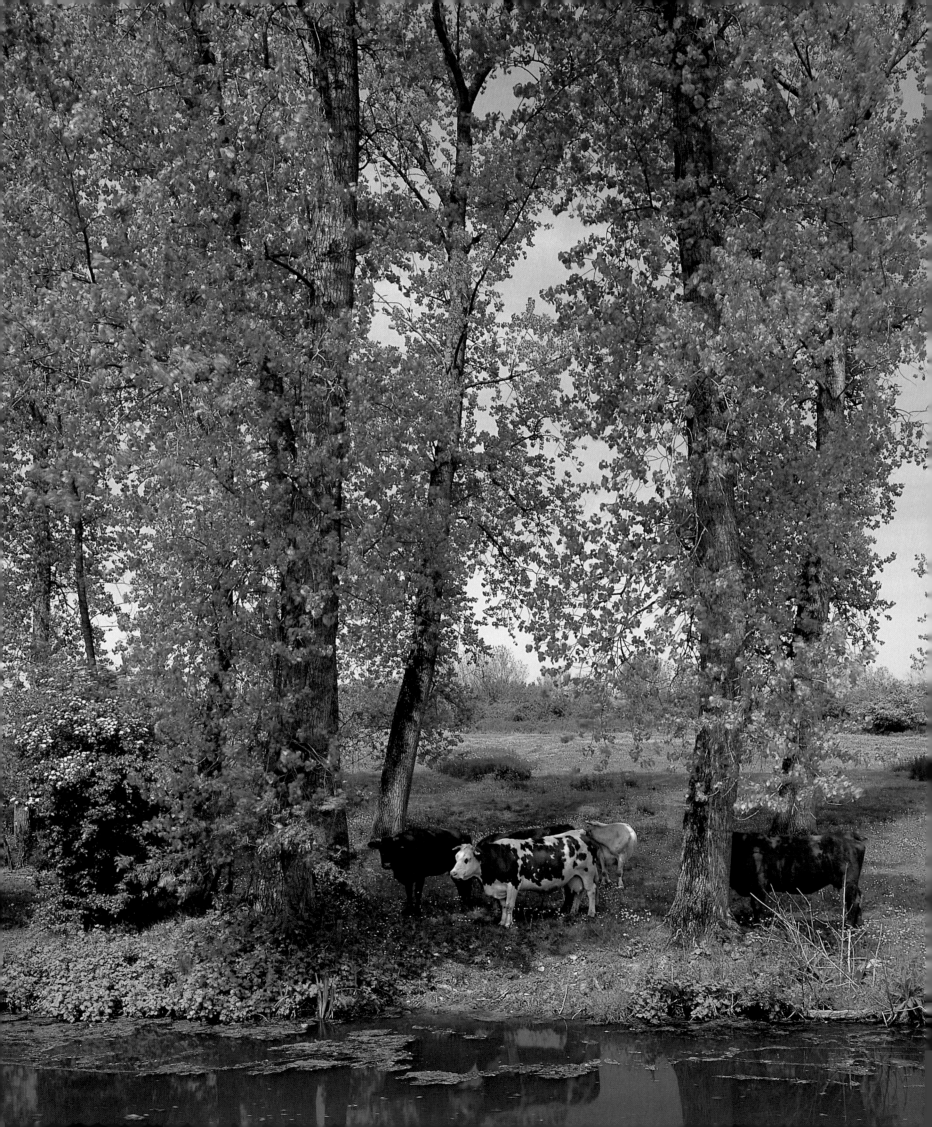

Forest scenes in western
France: **logs in the
Landes** (right); **cattle in
Poitou-Charentes** (left).

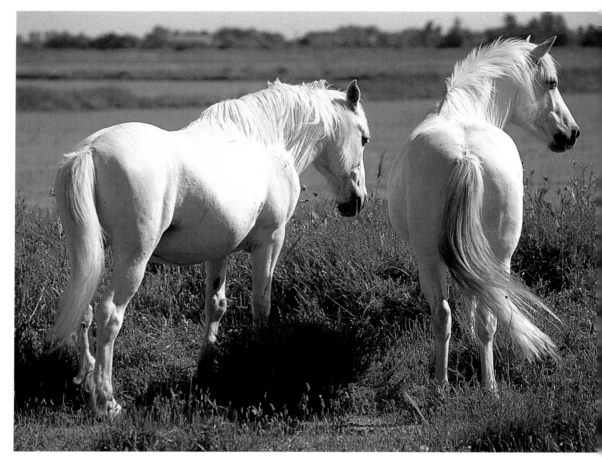

Noted above all for its white horses, the Camargue (above and opposite) **is a marshy, desolate and romantic region. Set between the Petit Rhône and the Grand Rhône and a national park since 1928, it includes lagoons and reed beds on which breed pink flamingoes, storks and cormorants.**

requiring the local authorities of the Landes to create proper drainage and start systematically planting trees. Public funds were made available for this, and the state took responsibility for the roads. Sabres is one spot in the Landes which is ancient, its lovely church dating back to the eleventh century. It is also the location of the Eco-museum of Marquèze, France's greatest museum of the environment. Fittingly, visitors can only reach it by taking an antique railway train for four kilometres along a single-line track.

THE CAMARGUE

Directly across France, on the Mediterranean coast, is the Camargue. Here sand dunes, swamps and lagoons form part of the delta of the Rhône. The coast-line boundaries slowly change over the years, as the sea washes in its debris, streams

bite into the landscape and silt and sand begin to create another promontory. For four months in the year rain never falls in the Camargue, while the sun mercilessly beats down. Violent winds lash it, each given a name: the *mistral*, the *cissero*, the *tramontane* and the *largade*. The Languedoc poet Frédéric Mistral observed all this and concluded that the Camargue was not only without trees or shade but also without a soul. But the *largade* is welcomed, for it presages summer. And the Camargue is a paradise for birds and animals. It is also famous for its Romanies who arrived five hundred years ago, from the continent of India. Four hundred different species of bird live here all the year round, while thousands more stay for a while on their annual migrations. Masses of herons, green woodpeckers, jays and hoopoes find refuge in the Camargue. Huge flocks of flamingoes turn the sky and the marshlands pink, some of them spending the winter here, others migrating to Spain and North Africa.

The squat, powerful Camargue bull was dying out in 1869, when a breeder gave the strain new strength by crossing it with bulls from Spanish Navarre. Fifty or so breeders own them, branding the new-born and then letting them roam free amongst the other black cattle of the land. The people of the Camargue also fight these bulls, but do not kill them, content instead to snatch a red ribbon from between the horns of the noble beasts. They also ride superb white horses, which some say are descended from stone-age animals but in all likelihood were brought from Arabia by the Moors. Oddly enough, for the first five years of their lives the foals of these horses are coal-black, before becoming a startling white.

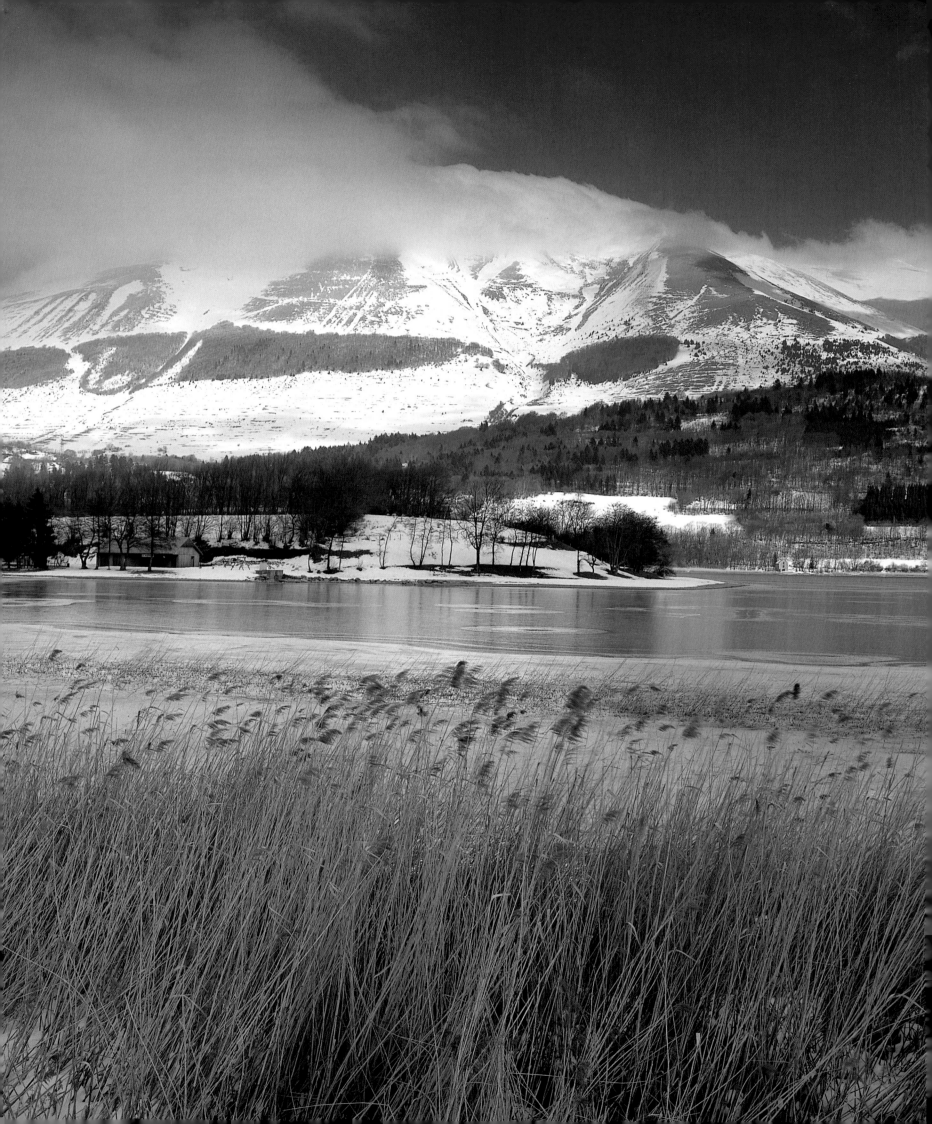

ALPINE WATERS

By the time it reaches the Camargue
estuary the waters of the Rhône have
flowed from as far away as Lyons, their
confluence with the Saône. Henry James
perceptively remarked in his *A Little Tour in
France* that this big brown flood had never
taken time to forget that it was the child of
the mountains and the glacier.

The nineteeenth-century poet Alphonse
de Lamartine sang the praises of the cool
waters to the east: of both Lac d'Annecy,
with its pure waters, and the larger,
magnificently beautiful Lac du Bourget.
Remembering his lost love, he apostrophised
the former to retain the memory of a blissful
night:'Let it remain in your storms, sweet
lake, and in the sight of your smiling hillsides,
and in those black pines and in the wild
rocks which overhang your waters... May
your moaning wind, your sighing reeds, the
light scents of your perfumed air, may every-
thing declare,"They loved!"'

At respectively twenty-seven and forty-
five square kilometres, the Lac d'Annecy
and the Lac du Bourget seem diminutive
compared with the Étang du Thau in the
Hérault (seventy square kilometres), the
Étang de Berre in the Bouches-du-Rhône
9156 square kilometres) and the 200-
square-kilometres French part of Lac
Léman. But they are undeniably beautiful,
and matched in beauty by smaller lakes
such as the Lac de Thuile and the Lac de
Laffrey. These waters also support notable
spas: Aix-les-Bains, Brides-les-Bains,
Challes-les-Eaux, Évian-les-Bains,
Salins-les-Thermes, La Léchère, all with
their accompanying casinos and parks.

Just north of Grenoble, is another
remarkable watery region of eastern
France: the Massif des Sept-Laux, whose

Two lakes in contrasting
seasons in Savoy:
the Lac de Laffrey
(opposite), **and the Lac
de Thuile** (right).

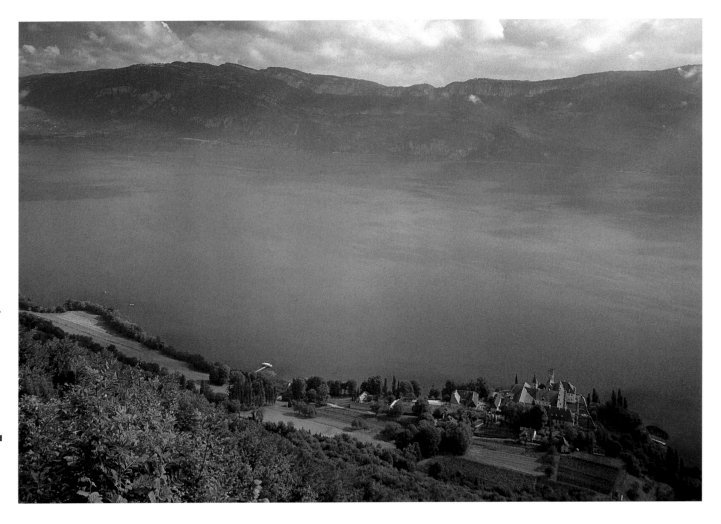

Two views of the Lac du Bourget (right and opposite above)**, which stretches north-south for eighteen kilometres but is at the most only three kilometres wide: it washes Hautecombe on the left bank, where St. Bernard of Clairvaux urged his monks to found an abbey - which still stands. On the southern side is the resort of Le Bourget-du-Lac.**

lakes lie between 1,350 and 2,000 metres above sea level. The finest of these is the Lac de la Mothe; beside it is the Lac Carré, with Lac Cottepens stretching southwards to Lac du Cos. Then the 2,184-metres-high pass of the Sept-Laux divides these lakes from the southernmost three: Lac du Cos, Lac de la Come and Lac de la Sagne.

A THOUSAND LAKES

West of Savoy and a few kilometres northeast of Lyons lies the region of the Dombes known as 'the land of a thousand lakes', for its plateau of eleven thousand hectares does boast approximately that number, some of them enhanced over the centuries by those who lived here, all of them frequented by migrating species who yearly return, all of them rich in carp and bream, which attract fisherfolk as well as birds. The land is dotted

with fine villages, such as Châtillon-sur-Chalaronne, with its ramparts, its fifteenth-century market-hall, the remains of an eleventh-century château and a church half-Romanesque, half-Gothic. One of the most charming of these villages, Saint-Paul-de-Varax, sits amid lakes and woodlands and boasts an eighteenth-century château, built of brick, as well as a Romanesque church with a finely chiselled tympanum. Near Bourg-en-Bresse itself are produced splendid cheeses, in particular the Bleu de Bresse. An entrancing, leisurely tour from this capital of the Ain traverses woodlands to reach the twinned villages of Treffort and Cuisiat. At Treffort sixteenth- and seventeeth-century houses and a market-hall stand in the shade of a Gothic church. On its tympanum is a fifteenth-century Virgin Mary, and its stalls date from the

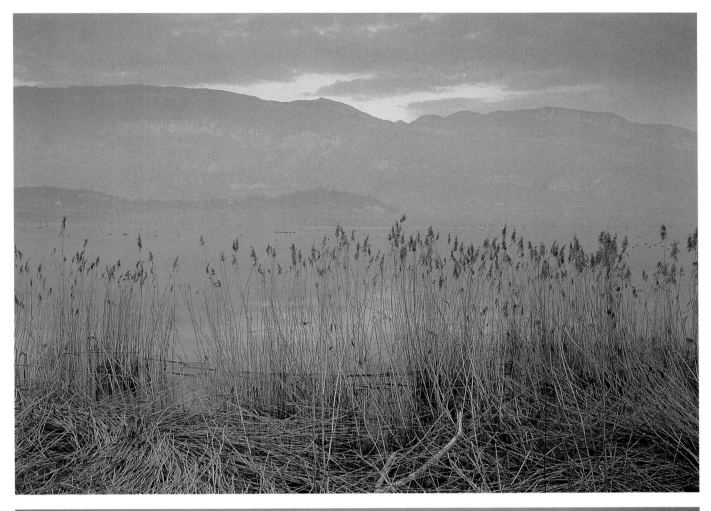

Countless lakes dot the Dombes region south of Bourg-en-Bresse, like this placid stretch of water at Chalamont (below).

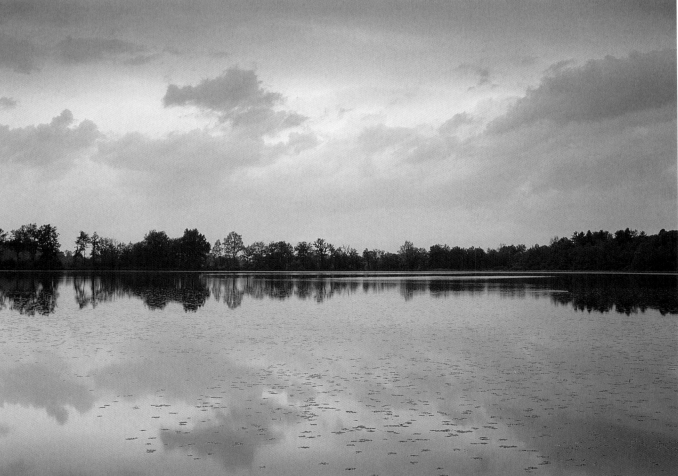

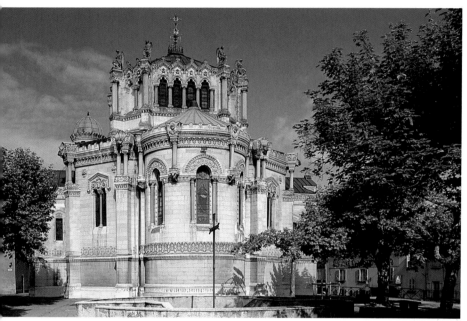

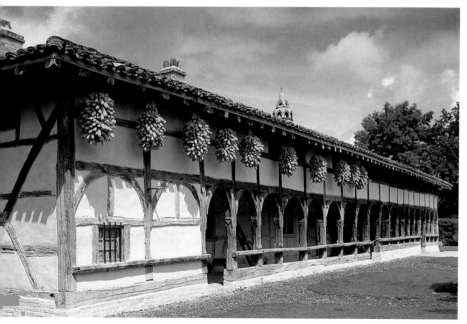

The Bresse region is especially rich in both natural and man-made attractions. The village of Ars-sur-Formans owes its nineteenth-century basilica (left) to the fame of Jean-Baptiste Vianney (1786–1859), who was its saintly *curé* and was canonised in 1925. This gabled, half-timbered farmhouse (below) is typical of the region; the chimneys of such houses often resemble minarets, hence the nickname of *sarrasines* (Saracens). And lakes abound: here the sun sets in winter near Saint-Paul-de-Varax (opposite).

eighteenth century. At Cuisiat rises the thirteenth- and fourteenth-century chapel of Notre-Dame-de-Monfort. A little further north is Verjon, beside the 496-metres-high Mont Verjon, blessed with a Renaissance church with a seventeenth-century triptych. North of Verjon is Coligny, with a fifteenth-century church. Courtes, eighteen kilometres west of Coligny, is the home of the forest's farm and information centre.

Typical farms of the region dot the route, as it passes through Saint-Trivier-de-Courtes and Pont-de-Vaux. Due south is Saint-André-de-Bâgé, whose twelfth-century Romanesque church has an octagonal belfry. Yet further south is Pont-de-Veyle, a village which, as its name implies, clusters around a bridge over the river. A couple of towers still stand from the former ramparts. Finally, to the north-east, is Saint-Cyr-sur-Menton, the home of the museum of Bresse.

Mâcon, west of Bourg-en-Bresse, lies at the heart of reputed vineyards; it is also famous for its poultry. Although its former cathedral of Saint-Vincent is in ruins, Mâcon possesses several stately eighteenth-century buildings. North-west of Mâcon stands the abbey of Cluny, founded in 910 by William the Pious, Duke of Aquitaine. In 1095 Pope Paschal II travelled to Cluny to consecrate the high altar. Its daughter houses then spread throughout France and into Italy, and in time the abbot of Cluny became the superior of around ten thousand monks. Only the crossing remains of the abbey church which in the twelfth century was the largest and highest in western Christendom. But five towers still remain from the fifteen which guarded its defensive walls.

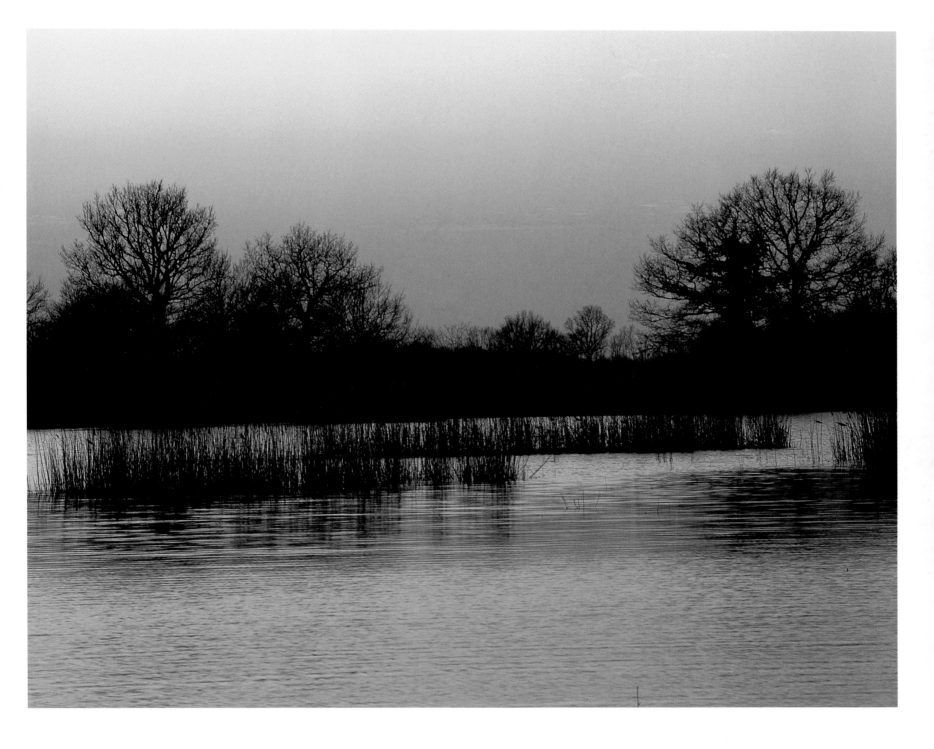

The town of Cluny itself is well worth visiting, as is Berzé-le-Châtel, five kilometres south, whose impressive fortress has two keeps and ramparts fortified with seven towers. The picturesque hilltop village of Berzé-la-Ville lies twelve kilometres south-east of Cluny, its Romanesque chapel decorated with remarkable twelfth-century frescoes, the centrepiece of which is a portrait of Christ in Majesty.

To eat in this region is to become happily corpulent. Raised on milk and maize, the chickens, capons and ducks of Bresse are renowned. A *dodine de canard* consists of the sliced breast of roast duck, served with pieces of truffle and mushrooms, and doused in the *dodine* itself, a sauce created from red wine, juice from the carcase of the duck, butter and cognac. *Foie gras* features on many a menu, for example those offering *fricassées* of locally raised chicken which have been enlivened by the swollen liver of the goose and also perhaps with the additional flavour of *cèpes* and garlic. The most traditional dish in this region is *poulet de Bresse à la crème*.

Amongst the finest lakes in the Dombes, where one may partake of a splendid fish cuisine, is the artificial Grand Étang de Gareins, near the capital of the region, Villars-les-Dombes (with its Gothic church of the Nativity and the remains of its fortifications). Here, too, is a spacious ornithological reserve, half of which consists of lakes. And here are sheltered around 2,000 birds comprising some 400 species – a paradise for bird-watchers.

Country scenes around the village of Saint-Paul-de-Varax (above and opposite)**; the village lies at the heart of the forests of the Dombes, a region sprinkled with a thousand lakes.**

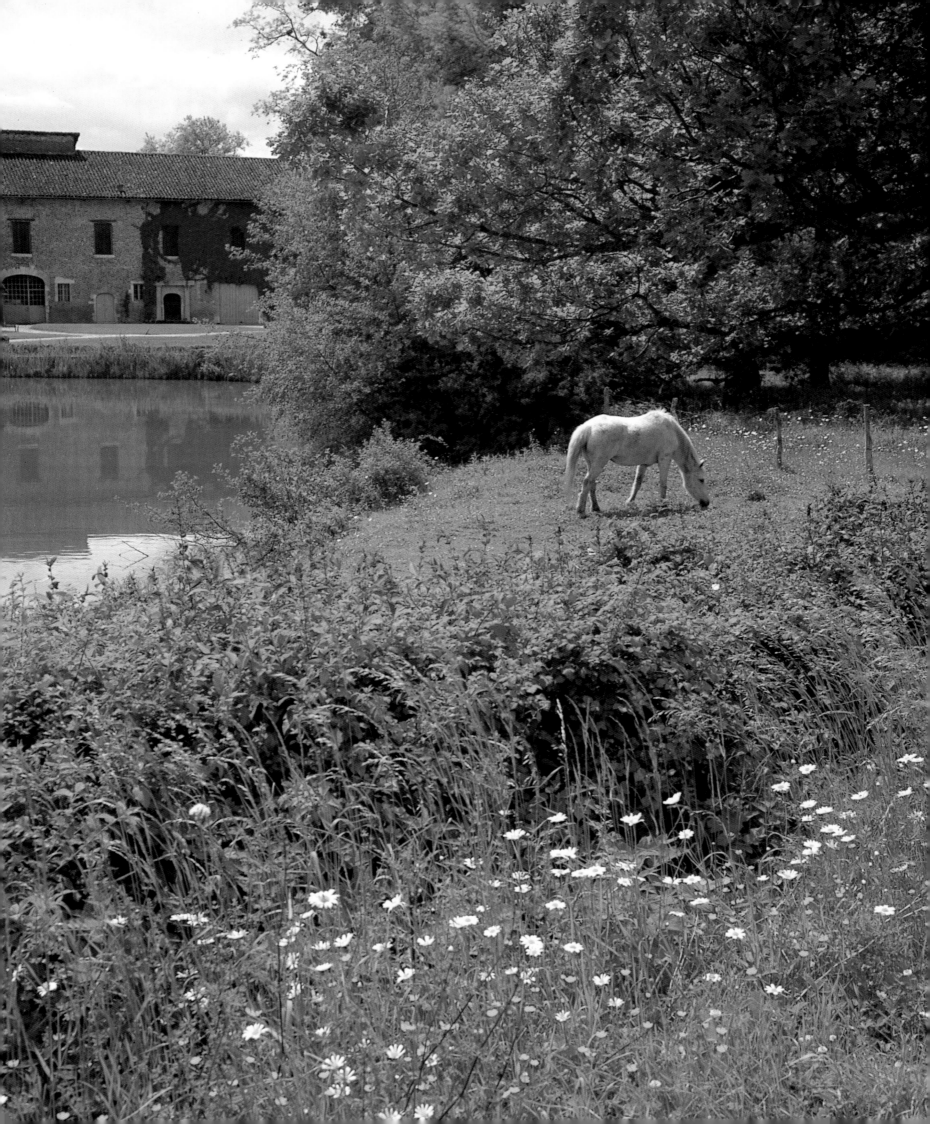

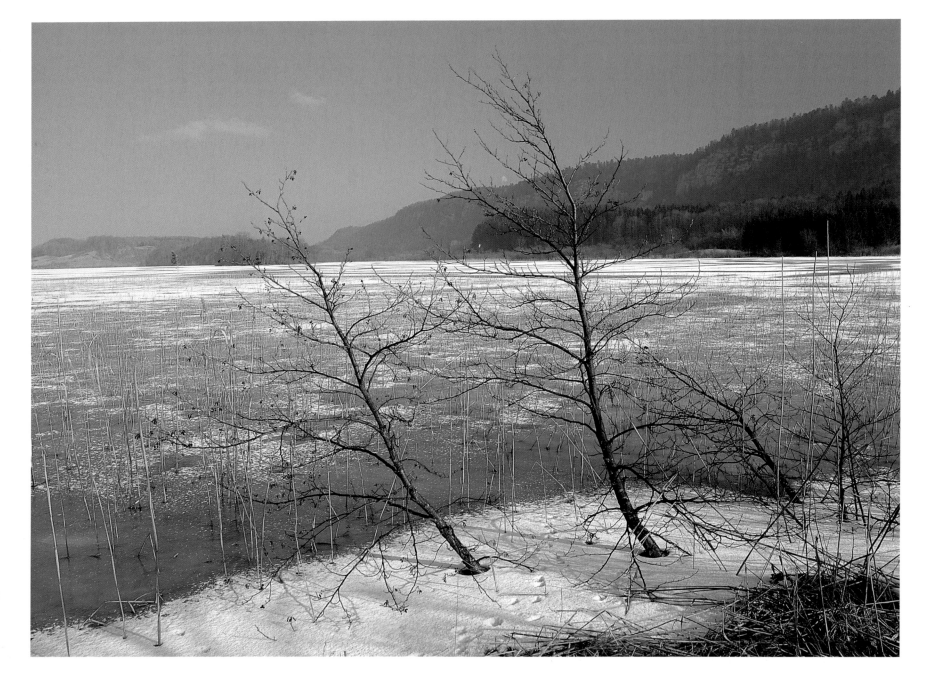

The Lac de Chalain is the
most impressive of the
many exquisite lakes in
the upper Jura. Close by,
to the east, is the

Belvédère des Quatre
Lacs, which yields a
breathtaking view of the
lakes of La Motte, Narlay
and the two of Maclu.

JURA AND DER

North-east of the Bresse country and the
Dombes are the Jura mountains and the
beautiful Lac de Chalain, today a national
centre for open-air sports. South-west lies
the artificial Lac de Vouglans, which stretch-
es for thirty-one kilometres. To the south-
east are more lakes, the Lacs de Chambly
and du Val, de la Motte and de Narlay, as
well as the cascades of the Hérisson. South
of these cascades is the town of Clairvaux-
les-Lacs, whose church has sculpted fif-
teenth-century stalls and
seventeenth-century paintings but whose
renown derives from the Grand Lac de
Clairvaux, as well as the Petit Lac, which is
overlooked by the 611-metres-high hill of
La Rochette on which stands a ruined feu-
dal château. North-east is Bonlieu, whose
lake is surrounded by plantations of fir trees.

The capital of the Jura, Lons-le-Saunier,
lies west of the Lac de Chalain, its Rue du
Commerce flanked with arcades, its
eleventh-century church of Saint-Désiré
boasting a beautiful crypt where the saint lies
in a fifth-century sarcophagus. These are still
wetlands, witness the spa at Lons-le-Saunier
and the two small lakes in its spa park.

Further north, approaching Nancy, Metz
and the border of Germany, lie Joinville and
the Pays du Der. Rising beside the river
Marne, the narrow streets of Joinville,
flanked with their Renaissance and classical
houses, lead to the park of an elegant mid
sixteenth-century château. The town's thir-
teenth-century parish church of Notre-
Dame has a Renaissance doorway and
shelters a reliquary with a belt said once to
have been worn by St. Joseph, the husband
of the Blessed Virgin Mary.

Fifteen kilometres north-west of
Joinville, the Val forest covers eight

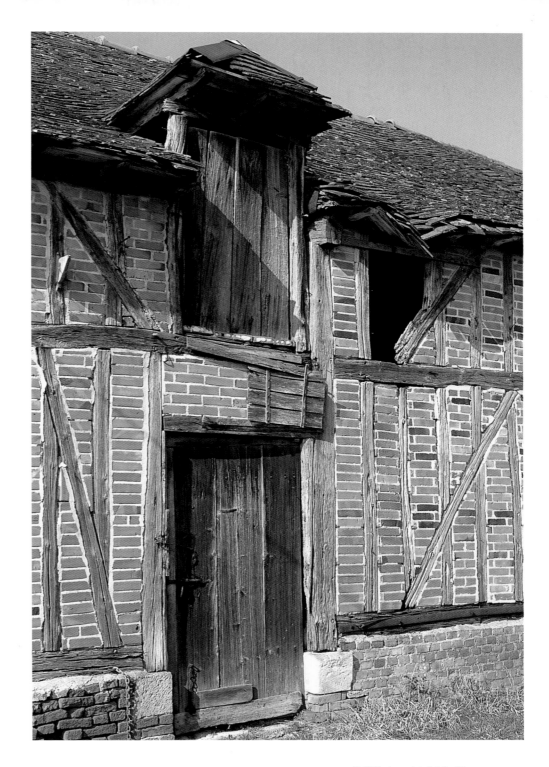

Half-timbered, brick-built
barns are typical of
village architecture in
the Der countryside; this
beautifully preserved
example is near the
village of Puellemontier.

Vendeuvre-sur-Barse in the Aube (left); the parish church has a sixteenth-century statue of St. Hubert, patron saint of hunters, though this forest is now part of a natural park and hunting is therefore regulated. Another winter scene in north-east France: the Lac de Der-Chantecoq has a cold grandeur (opposite).

thousand hectares. Twenty-three kilometres south, huge forests surround the hamlet of Vignory, where you can still see remains of its feudal château and thirteenth-century walls. The parish church is a remarkable survival, since its nave is pre-Romanesque, its choir, ambulatory and three-storeyed belfry Romanesque.

Today the forests of the Pays du Der (a Celtic word, signifying oak) are far smaller than they were in the Middle Ages and before; but they are still extensive, and their influence is seen in the wood used in constructing not only houses here but also village churches. Many of the villages of the region are exquisite. Sainte-Marie-du-Lac, for instance, has magnificent barns, a traditional blacksmith's shop and a typical local dove-cot. The village of Chavagnes has a church begun in the eleventh century and finished in the sixteenth. Montier-en-Der is distinguished not only by a medieval monastery but also by a national stud farm (which took up the place of the former monastic buildings, requisitioned as national goods at the time of the Revolution). The abbey church today serves as the

parish church of the village. This is a pleasingly varied house of God. Basically seventeenth-century in syle, one side dates from the sixteenth, the Gothic choir from the thirteenth and a Romanesque nave from the tenth. Eleven kilometres north-west, the village of Bailly-le-Franc has a half-timbered eighteenth-century church which managed to preserve the sixteenth-century stained glass of its predecessor.

In 1974, to regulate the flow of the rivers Saône and Seine, an artificial lake of some forty-eight square kilometres was created – the largest in Europe. It drowned three villages, but their finest buildings were saved and rebuilt on its bank. And the construction of the Lac de Der-Chantecoq has in no way deterred the forty thousand migrant birds who yearly return to rest in the Der forest.

ROYAL FORESTS

Within easy reach of Paris are a number of famous forests. In the Aube, for instance, which is crossed by the valley of the river from which the *département* draws its name and also by the valley of the Seine, is the

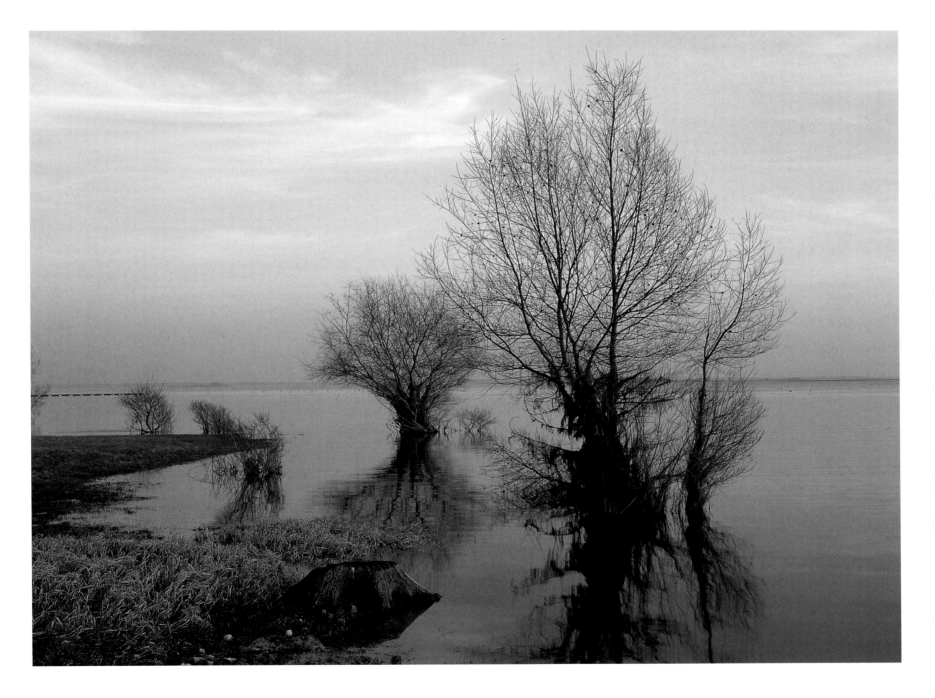

park of the Forêt de l'Orient. North of the capital, the quadrilateral shape of the *département* of the Oise is its only homogeneous feature. This is a beguilingly complex region, taking in part of Picardy, part of the valley of the Oise and a morsel of Normandy. Its finest cities include Compiègne, Beauvais, Noyon and Senlis, the last three with superb cathedrals, Compiègne with a town-hall which Viollet-le-Duc called 'the finest example of secular architecture in northern France.'

Compiègne also boasts a famous forest. At Roye, a detour right to Noyon leads on to the abbey of Ourscamp, established here in 649, refounded by St. Bernard of Clairvaux in 1129 and still retaining its mid thirteenth-century infirmary, though the rest was lavishly rebuilt in the eighteenth century. Further south-east the name of the village Saint-Crépin-aux-Bois indicates that it sits on the edge of the Laigue forest.

Saint-Crépin-aux-Bois is a mere eighteen kilometres from Compiègne, where the road plunges into the forest. Here the national authority has an office displaying the various trees of this rich forest: hornbeams, silver birches, cochineals, chestnuts and oaks. The forest is traversed with streams, such as those that once drove the ancient mill at Vieux-Moulin.

All these forests and woodlands are in ready reach of Paris, and in the past the French court, with its love of hunting, took considerable care of them. Compiègne is not the only one to have profited from this sport. Other famous forests around the capital include Rambouillet, Chantilly and Fontainebleau, the Halatte forest north of Senlis, the Retz forest near Villers-Cotterêts and the forest of Ermenonville.

French forests vary almost as much as French houses. This is certainly the case with the forest of Compiègne (below and overleaf) **which shelters several villages, including Saint-Jean-aux-Bois** (above and opposite), **where geraniums, lace curtains and shutters signal the human imprint.**

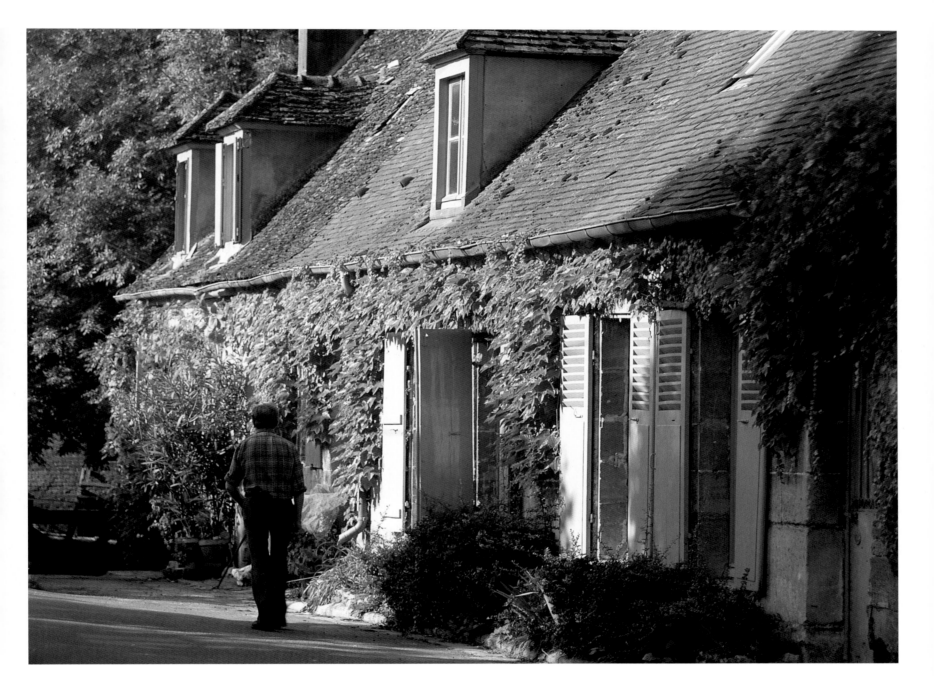

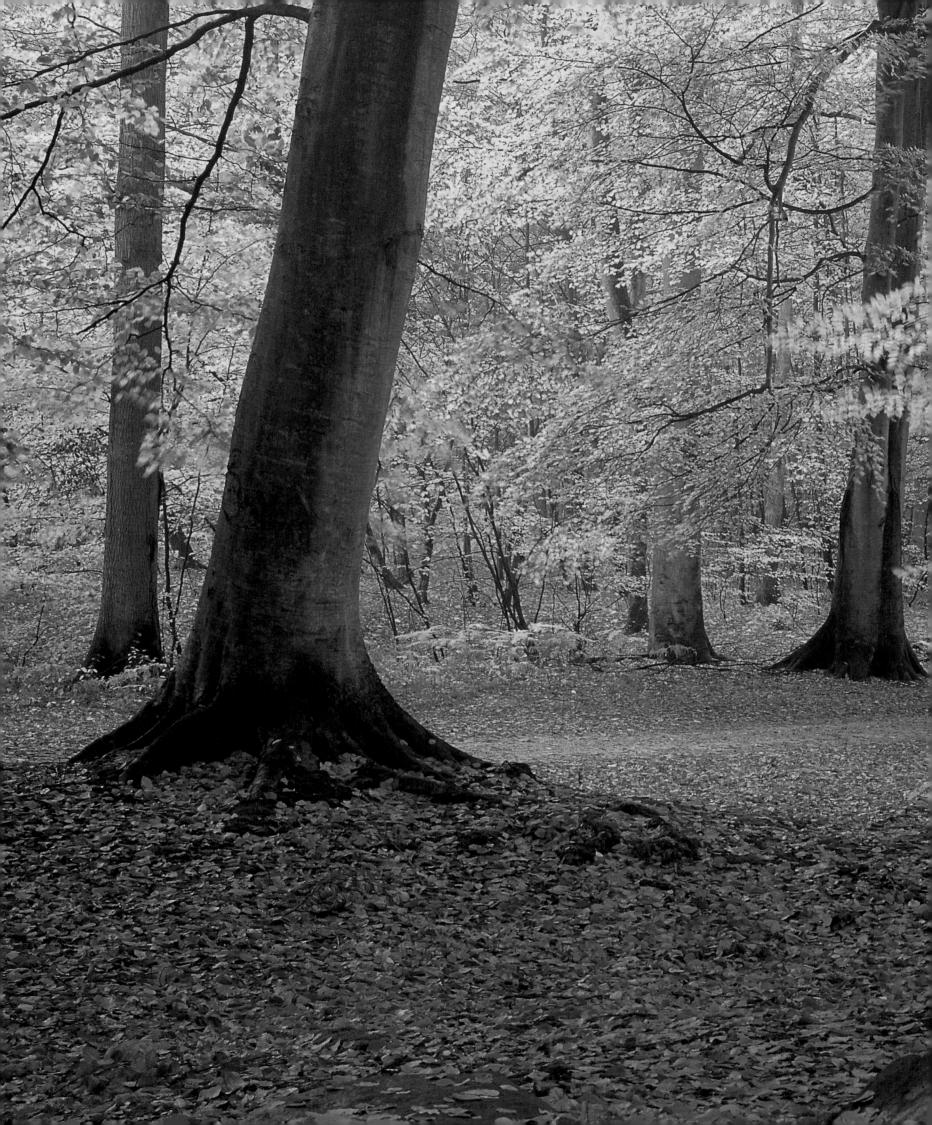

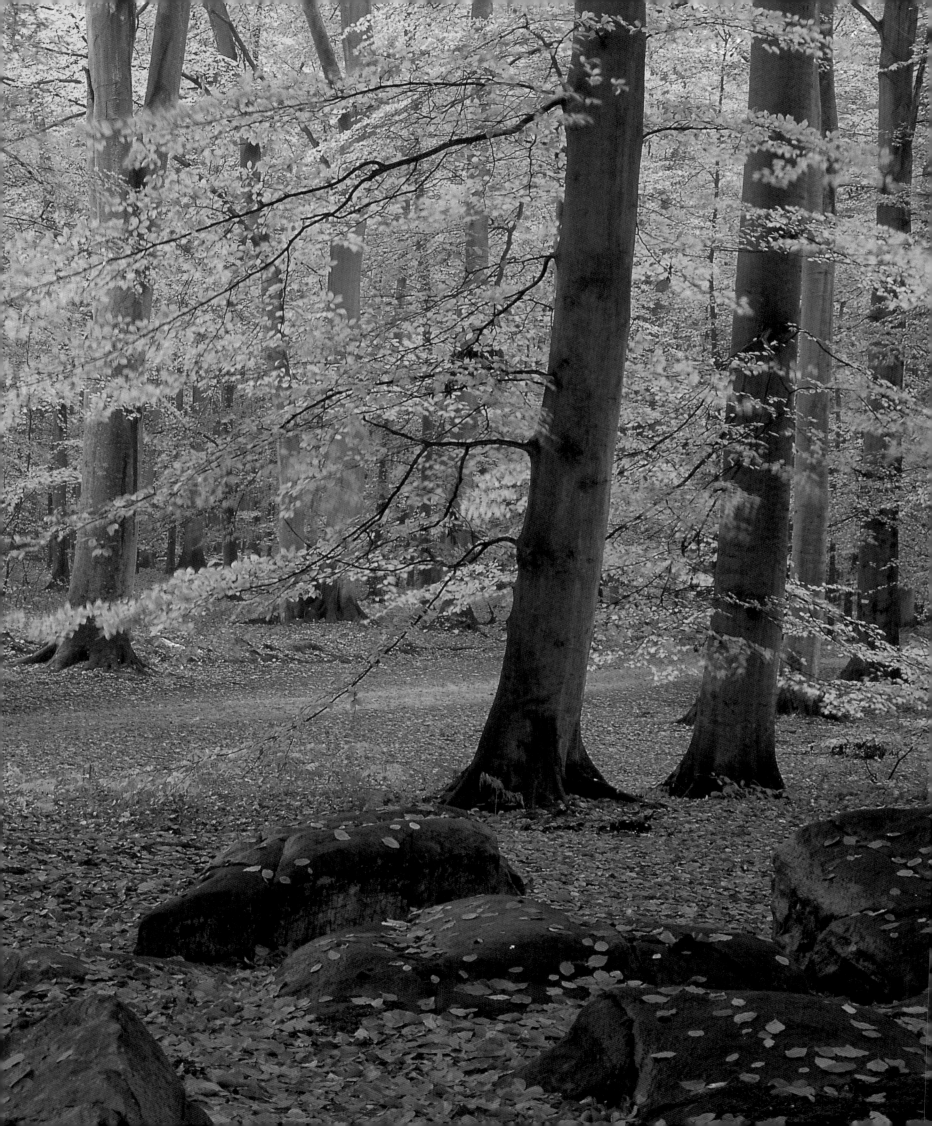

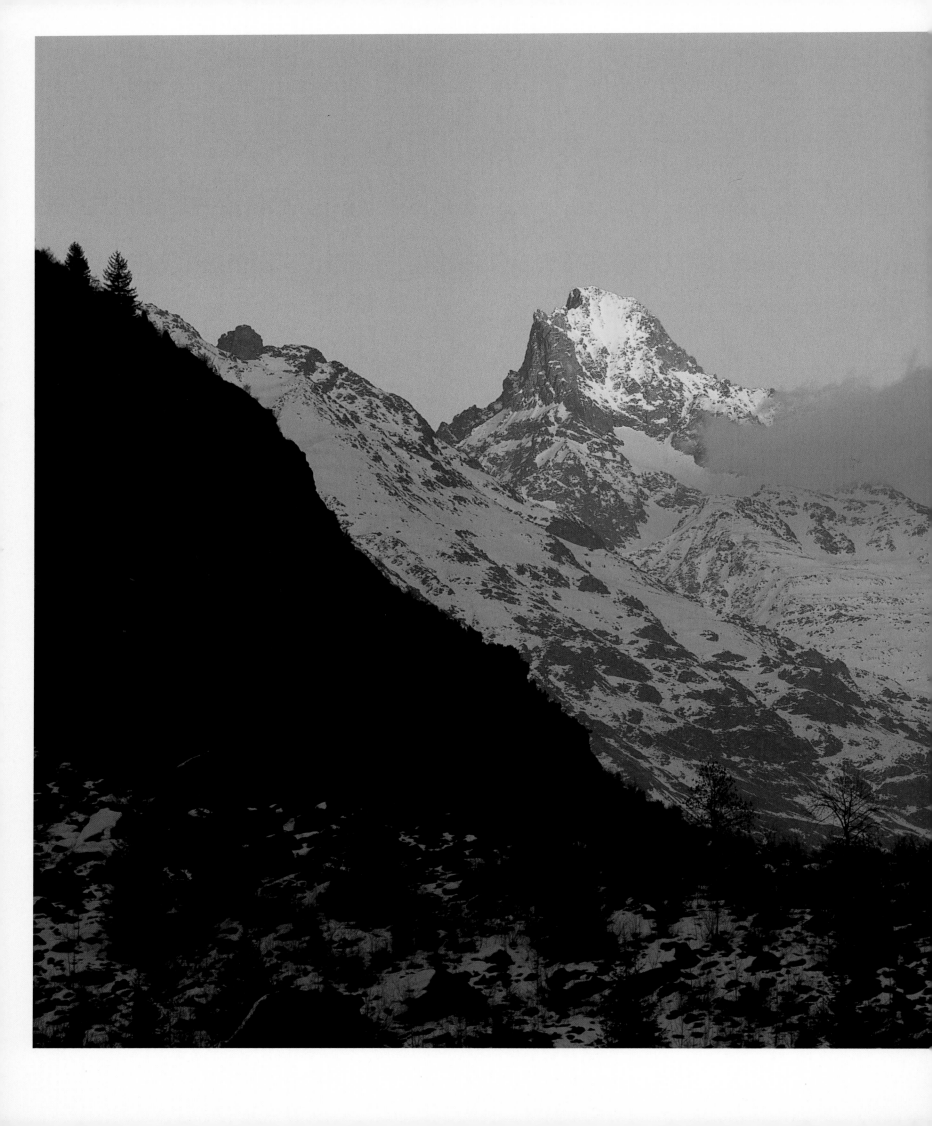

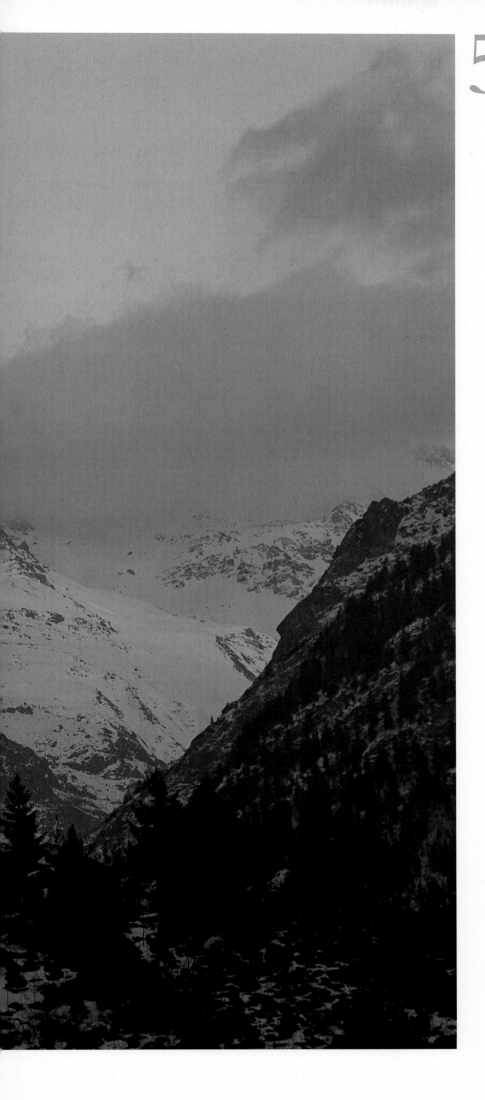

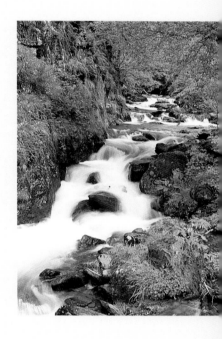

LOVERS OF UPLAND AND MOUNTAIN are superbly catered for in France by national and natural parks: Cévennes, the Pyrenees, the Mercantour, the Vosges du Nord, the Volcans d'Auvergne, the Haut-Jura. Many of them have eco-museums to guide the visitor. Flora and fauna, rare and teeming, are jealously protected. Sombre forests give way to green hillsides and then bleak, snow-clad peaks.

For those who farm them, the uplands of France, between 1,000 and 1,500 metres above sea-level, are not profitable. To till the land is hard, though exploiting the forests brings in a living. Further down the slopes, where the terrain flattens out, modern farming methods enable the citizens to prosper, sowing huge fields with corn and cereals. Spending the winter indoors, the sheep of the Pyrenees emerge when the weather changes and are driven to their pastures on the heights.

Approximately seven per cent of French territory is over 1,000 metres above sea-level. Three summits in the Alps (Mont-Blanc, Mont Maudit and the Dôme de Gouter) reach over 4,000 metres, while thirty-four top 3,000 metres, as do twelve in the Pyrenees. The Massif

Central has twenty summits over 1,500 metres high, including the Puy de Sancy (at 1,885 metres) and Plomb de Cantal (at 1,855 metres).

Naturally, ski-slopes abound. (The first winter Olympics took place at Chamonix in the Alps in 1924.) Alongside these are spas and health resorts. One of the finest of such resorts is Le Mont-Dore, rising in the Auvergne, on the right bank of the river Dordogne and at its source. Here the Romans enjoyed thermal springs, which then declined in popularity till the seventeenth century. Today's monumental thermal establishment preserves some of the columns and capitals of the Roman baths. And the Puy de Sancy, the highest peak of central France, can be reached from here either by foot (in twenty minutes) or by cable-car.

Such mountains are also the refuge of wild animals and rare plants. Agile mountain goats sit soaking up the sun. The fawn is the antelope of the Alps. The snow partridge protects itself from predators by turning white in winter. Blue gentians bloom in spring, while the edelweis is the symbol of these mountain heights.

The national park of the Pyrenees was created in 1967 and covers a vast area. One of its finest features, the narrow Gavarnie valley, ends in an imposing natural barrier which separates France and Spain and supports such rare species as the yellow lily and another deep mauve one, the *lys Martagon*.

The Auvergne countryside is incomparably attractive, watered by the rivers Allier, Sioule and Loire, graced with twelfth-century Roman-

esque churches, but deriving its distinctive character above all from its volcanic mountains. There Royat is a spa which the Romans frequented. Its fortunes revived under the patronage of Napoleon III. Its twelfth-century church was fortified in the thirteenth century. And from Royat you can drive up the impressive Puy de Dôme, whose 1465-metres-high peak offers a magnificent panorama. On the way you pass a Gallo-Roman temple dedicated to the God Mercury.

Monks found solitude on these heights. More than 1000 metres above sea-level, in a countryside sown with hamlets, they founded La Chaise-Dieu (the House of God), one of whose monks was elected Pope Clement VI. The fourth of the Avignon popes, Clement's luxurious court and gorgeous retinues were (in the words of the church historian J. N. D. Kelly) those of a secular prince, not a prince of the church. 'He delighted in banquets and colourful festivities; his predecessors, he declared, had not known how to live as popes.'

This French pope lavished the wealth amassed by his two frugal predecessors on adding to the papal palace at Avignon and also on enriching the monastery which he had joined as a boy of ten. The village of La Chaise-Dieu has scarcely 1,000 inhabitants, yet its monastic church is a superb Gothic edifice, with a flamboyant Gothic rood screen, 156 Gothic choir stalls, a wall-painting of the Dance of Death and splendid sixteenth-century tapestries. The organ dates from the seventeenth century, the convent buildings from the seventeenth and eighteenth. Parts of the cloister still stand, as does the massive, keep-

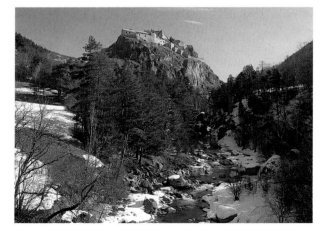

like Clementine tower. When the pope died in 1353, he chose to be buried here, and his tomb can still be seen, though the Huguenots desecrated it and burned his remains.

Another historic spot in these mountains, the town of Brioude, rises on a terrace above the river Allier. Ancient houses, such as that built by the counts of Brioude in the fifteenth century, grace the town. Its basilica of Saint-Julien, begun in the eleventh century, is the oldest, largest and most majestic in the Auvergne.

Many of the mountain regions of France contain such treasures, and many of these will be revealed in the following pages. If one were asked to name the region of greatest beauty, it would take a brave man to answer the question, but he may very well say Savoy, the name most evocative of the high mountainland of France. Here is the greatest mountain, Mont-Blanc; here is the most beautiful lake, the Lac du Bourget; here are the elegant spas of Évian-les-Bains and Thonon-les-Bains; here are the ski resorts of Megève and Chamonix. Savoy is always the best of something to somebody, winter and summer alike.

In a minor key, the individual peaks of Provence excite special affections and associations. Mont Ventoux may very well have been the first French mountain climbed for pleasure - by the poet Petrarch and his brother in 1335. Another Provençal mountain, Sainte-Victoire east of Aix-en-Provence, was immortalized by the painter Paul Cézanne. Cézanne, who was born at Aix in 1839, painted the mountain at least sixty times, breaking it down in canvas after canvas into curious and memorably geo-

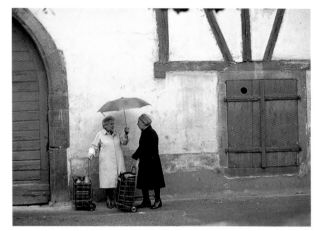

metric planes. Bright greens and pale blue-pinks contrast with pale-blue skies. And sometimes an aqueduct sneaks across the canvas. Cézanne gave his life for the mountain. In 1906 he was painting when a storm drenched the master, provoking a fever from which he never recovered.

Two literary masters of the English-speaking world may be left to sum up the delights of both Provence and Savoy. Walking beside the river Sorgue in the Vaucluse, Henry James marvelled at the aridity of the hills which enclosed the valley, 'There are the very fragmentary ruins of a castle on a high spur of the mountain, above the river, and there is another remnant of feudal habitation on one of the more accessible ledges.' Hilaire Belloc chose a more grandiose source for the inspiration he drew from the mountains of France. In climb-

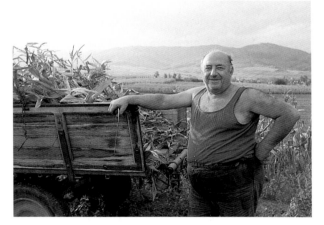

ing the Alps, this Catholic writer glimpsed, as it were, his own religion in the feelings excited by the towering peaks: 'humility, the fear of death, the terror of height and distance, the glory of God.'

The eastern uplands (above): **a conversation in Alsace; maize harvesting near Colmar.**

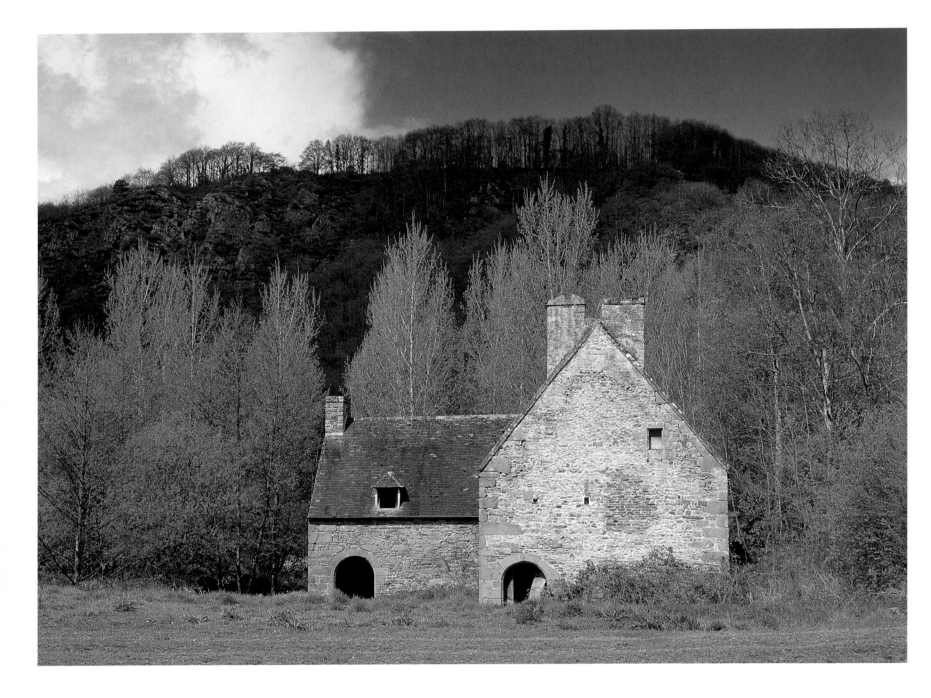

'SUISSE NORMANDE' IS A QUAINT NAME. For a start, none of its peaks reaches 360 metres which scarcely matches Switzerland. Yet here are abrupt cliffs, deep valleys and twisting roads which climb up precipitous hills. Mont Pinçon, for example, fifteen kilometres west of the village of Thury-Harcourt (where you can visit the park of a château destroyed in World War II) rises 365 metres above sea-level and offers a marvellous panorama of the neighbouring countryside. In the picturesque village of Clécy, the heart of Suisse Normande, is a fifteenth-century manor-house which now serves as a museum of old Normandy. From Clécy, visitors attain the Butte de l'Éminence, to discover an enchanting view of the winding river Orne and its neighbouring cliffs. And from the Roche d'Oëtre, south-east of Clécy, you view the most mountainous part of the region.

Normandy is famous for its cheeses, as is a much more mountainous region further south. To create a mere forty-five kilos of Cantal, the most renowned cheese of the Auvergne, takes 450 litres of milk. In a region which produces just over 650 million litres of milk a year, 400 million are devoted to making that cheese. And there are other favoured Auvergne cheeses, first and foremost after Cantal, Bleu d'Auvergne, a nineteenth-century creation; next, Saint-Nectaire, created with the addition of mountain plants which give it its unique scent; and two more reputed names, Le Petit Riommois and the powerful blue-veined cheese of Ambert. Not to be outdone is Auvergne's *chèvre*, its much-admired goats' cheese.

The rivers of Suisse Normande include the Rouvre, whose valley is dotted with fine stone farmhouses (opposite). **Much further south, upland farming is essential to the economy of the Auvergne in the Massif Central** (right).

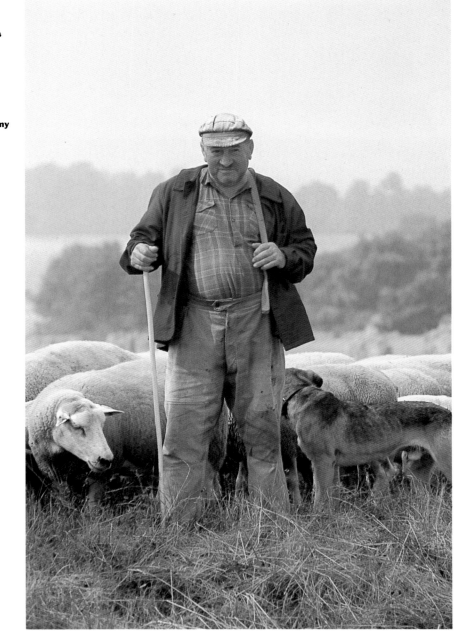

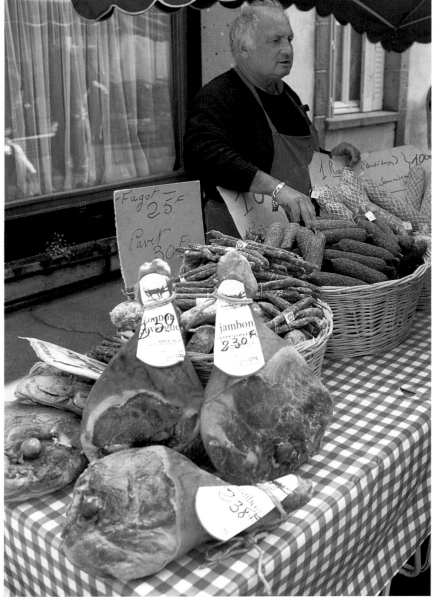

Fine hams (left) **are a speciality of the Auvergne, whose higher points, like the Pas de Peyrol** (opposite)**, offer vast, astounding views of surrounding valleys.**

THE HEART OF FRANCE

The Auvergne is the upland heart of France. Little towns and villages climb and twist their way up steep hills. Volcanic cones rise above lush pastures and woodlands, and have in the past provided the lava which is often used to decorate major buildings. Not only major buildings, but sometimes virtually entire villages are built of lava. Besse-en-Chandesse is one of them, its narrow streets flanked by black lava houses. As one so often discovers throughout this remote area of France, here is a village with a Romanesque church, built in the eleventh century, for no-one had the wealth or even presumed to transform what had long served as the local house of prayer into a Gothic or Renaissance building.

Because of this volcanic activity, the region provides some half of the thermal spas of France. Saint-Nectaire, source of the celebrated cheese, is one of them. To continue with superlatives, at 1,465 metres, the Puy de Dôme ranks among the highest of the peaks of the Auvergne. Long ago this majestic mountain was a sacred site, and still carries the remains of a Gallo-Roman temple dedicated to the god Mercury. From its summit you can see some seventy former craters. The Puy de Dôme, however, is not the highest peak of these mountains. Further south, Le Mont-Dore, dedicated to winter sports and thermalism, sits beneath the culminating peak of the Auvergne, the 1,886-metres-high Puy de Sancy.

There are many pilgrim churches in this remote region. At Brioude, with its panorama of the rich Allier plain, ancient houses cluster around a parish church which prospered on the gifts of pilgrims who wished to venerate the tomb of St.

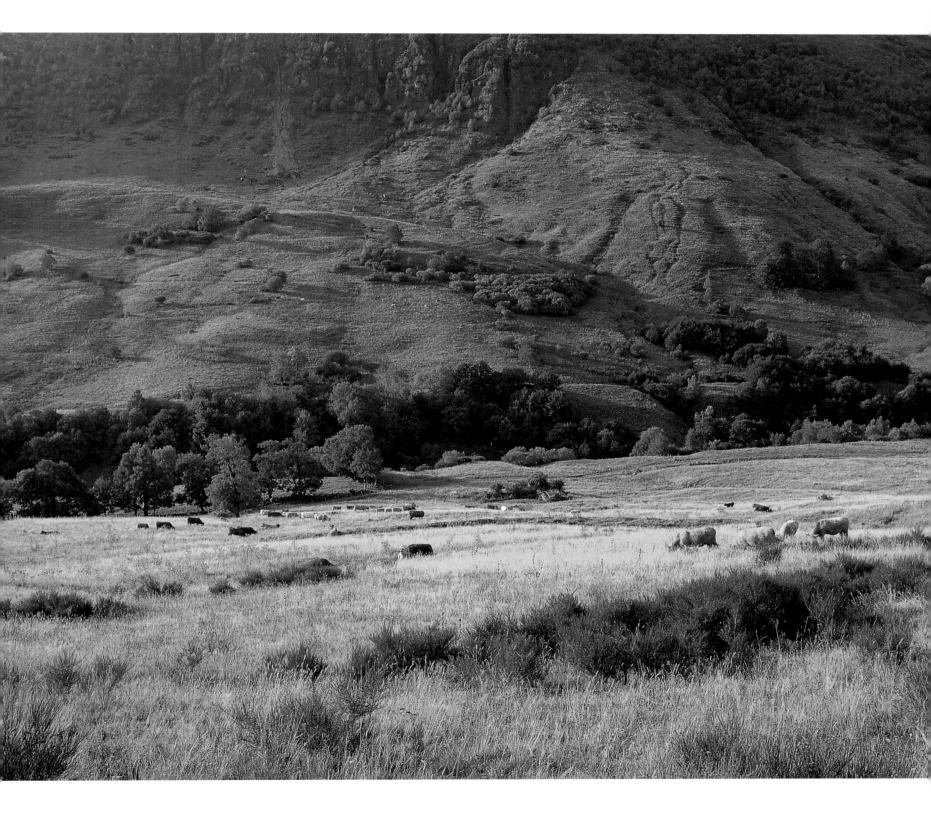

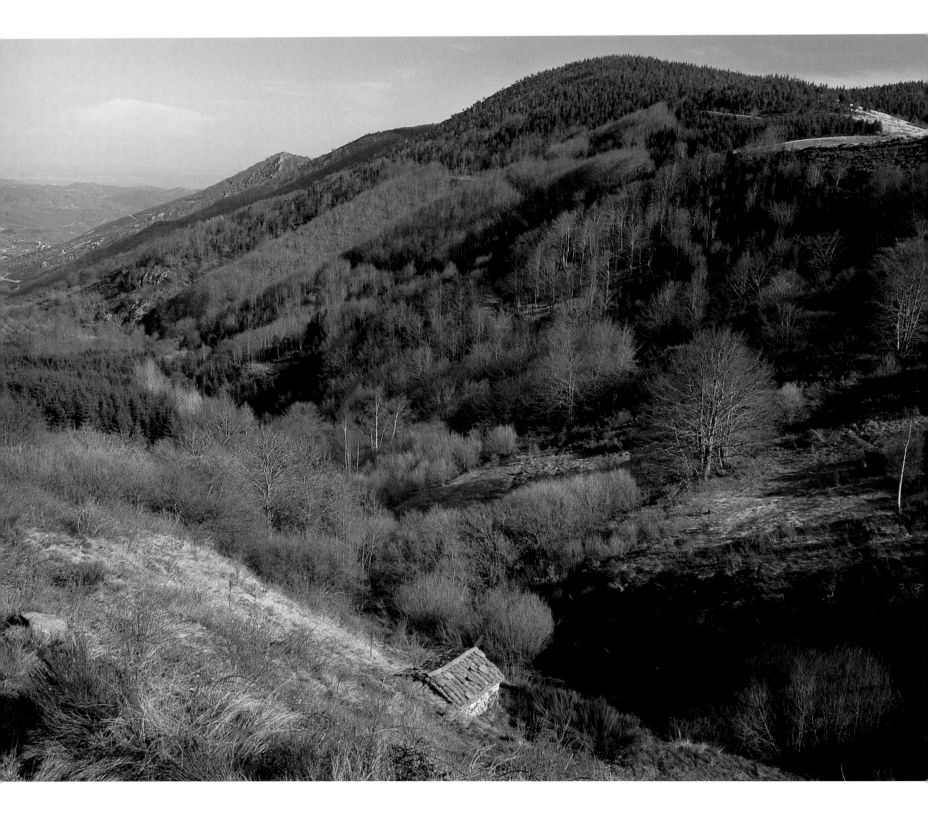

Julien. Of all the religious houses of the
Auvergne, La Chaise-Dieu, set in a village
some 1,000 metres above sea-level, is the
most interesting. Its name means 'House of
God', derived from the Latin *casa Dei*.
Founded by the Benedictines, much was
destroyed by Huguenots; but the Gothic,
fourteenth-century church survives, as do
the cloisters. Inside the church are fifteenth-
century choir stalls (144 altogether, magical,
Gothic) and sixteenth-century tapestries.

In spite of the great charms of La
Chaise-Dieu, the finest pilgrimage centre
here is undoubtedly Le Puy-en-Velay. Set in
a verdant basin surrounded by volcanic
rock (on top of one stands a colossal bronze
statue of the Virgin Mary), Le Puy has a
cathedral, dedicated to Our Lady and begun
in the eleventh century, with six domes
and a polychrome façade. Inside are twelfth-
century wall-paintings, and a fifteenth-
century fresco depicting the liberal arts.

Geographically the Aveyron, the *départe-
ment* due south of Cantal, which runs along
the southern edge of the Massif Central, has
three distinct regions. To the north are the
Aubrac mountains which shade into the
plateau of the Viadène – a once volcanic
region now sliced with deep valleys. Deep
valleys also characterize the plateau of the
Ségala, at the centre and to the west of the
département. The rest, to the east and south,
consists of high, chalky plateaux, the largest
the limestone plateau of the Larzac.

Here are remarkable towns and villages
as well as *bastides*. Villefranche-de-
Rouergue, for example, is a *bastide* created
in 1252 by the brother of St. Louis (King
Louis IX), Alphonse de Poitiers. Situated at
the confluence of the Aveyron and the
Alzou, Villefranche-de-Rouergue divides
the upland of the Ségala from that of

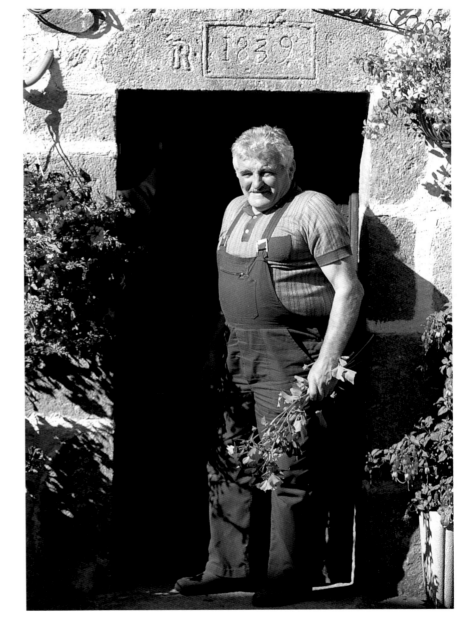

**Mountains lie at the
heart of France in the
form of the Massif
Central: Le Cheylard in
the Ardèche** (opposite)
**enjoys a splendid site,
though this bucolic
scene in the Cantal
sounds a gentler note.**

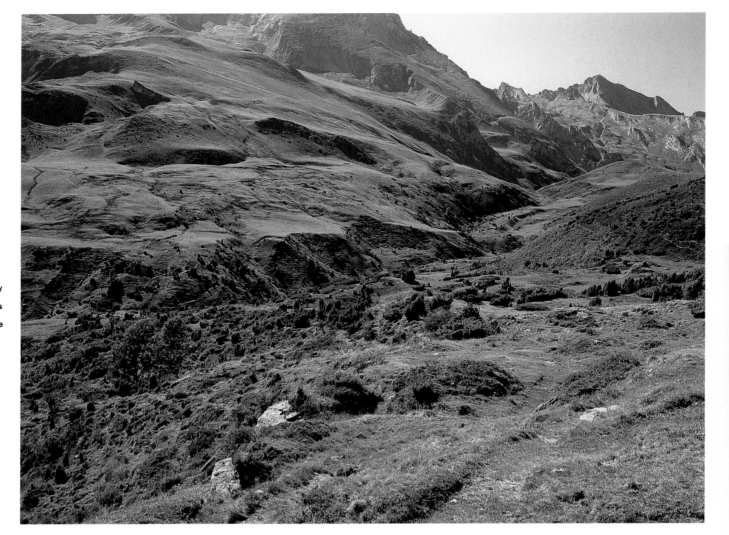

The Souler pass at Arrens in the Hautes-Pyrénées is the gateway to the western Pyrenees national park, a paradise for skiers.

Villeneuve. Set out in chequerboard fashion, its streets converge on the main square, the cobbled Place Notre-Dame, arcaded on all four sides. Half-timbered houses flank these streets, some with Gothic and Renaissance façades.

The foundation of this *bastide* incensed the local bishop, since it threatened his income, luring away farmers whose lands he taxed. To lure them back he founded his own, rival *bastide*. So, on another escarpment of the Ségala, La Bastide-l'Évêque lies due east of Villefranche-de-Rouergue, again perfectly regular in plan, but scarcely more than a village.

Around Rodez, at the heart of the Aveyron, circle delightful villages and small towns. Espalion, to the north-east, straddles the river Lot, which is here crossed by a thirteenth-century, pink-sandstone bridge. Espalion has a ravishing Romanesque chapel. To the north is the village of Estaing. Here the Lot is spanned by a

sixteenth-century bridge. The village has a fifteenth-century church with a flamboyant Gothic porch, and is defended by a medieval and Renaissance château.

THE TORMENTED PYRENEES

The French Pyrenees do not constitute a geographically unified region of peaks. Some parts look down on spas. In other places, long-gone glaciers have left their mark on a tortuous countryside. One bizarre landscape is the Sidobre, a granite massif, with huge boulders and quarries producing some 100,000 tonnes of granite a year. The name Sidobre perhaps derives from the Latin *sine opere*, meaning un-cultivated, and the terrain is certainly rugged and barren. Elsewhere in the Pyrenees are gentle meadows, plains and hills. Here are spas, the highest Barèges, the most celebrated Cauterets, with its twenty-four springs. The region is vast - eight *départements* around Toulouse, for instance,

comprising the Midi-Pyrénées, a region with an extremely variable climate and more extensive than the Low Countries put together. A particular delight is the Pyrenees national park, a hundred or so kilometres of land running through the mountains on the frontier with Spain.

These mountains are again and again described as tormented, 'wilder than the Alps, lapped round with forests rather than pastures,' to quote Freya Stark. So they are; but they are also saturated in a sense of history. Saint-Jean-Pied-de-Port in the Pyrénées-Atlantiques, a lovely frontier town which from 1650 to the Revolution was the capital of French Navarre, lies amidst tree-clad slopes, its waters overhung with balconies leaning from white-washed walls. Leaving the town by its Spanish gateway, you cross the river Nive by a Roman bridge and climb to Roncesvalles, where in 778 Roland, Oliver and twelve peers of France were treacherously slain by the Moors.

Saint-Bertrand-de-Comminges, the finest of the fortified churches of the Pyrenees, rises on a superb defensive site, dominating the valley of the Garonne. Its cloister is a haven of peace, embellished with delicate twin columns, three Romanesque galleries (below) and the fourth one, Gothic.

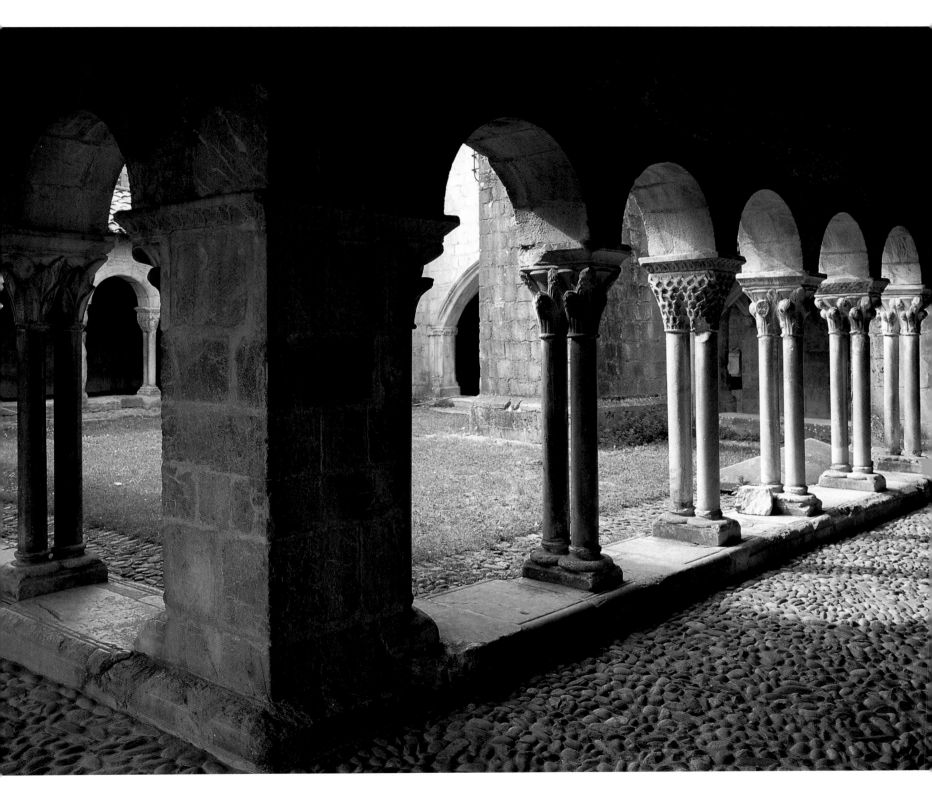

THE LUBÉRON

And so east to Provence, where, as Henry
James put it, 'the silver-grey earth is impreg-
nated with the light of the sky'; the
Lubéron range presents an inviting aspect.
Visitors leaving Apt speedily climb the
slopes of this *aspre montagne*, or 'harsh
mountain', as Frédéric Mistral called it. The
route continues, spectacularly, to the
perched village of Ménerbes. At Ménerbes,
from the former abbey of Saint-Hilaire,
remain its twelfth-century church and a
seventeenth-century cloister, and above the
village stands a Renaissance château. Then
the road dips and rises to Oppède-le-Vieux,
whose parish church has a massive,
hexagonal belfry, from the corners of which
peer eight gargoyles. Oppède-le-Vieux also
has the remains of a château built by the
Count of Toulouse in 1209. Not far away
are Notre-Dame-de-Lumières, a celebrated
centre for Provençal pilgrims (hence the *ex
votos*, offering thanks to the Blessed Virgin,
in a seventeenth-century chapel), and the
village of Lacoste, whose château was once
the home of the Marquis de Sade.

 The terrain and the proximity to the sea
makes for strangely varied weather in the
Vaucluse. 'August evenings in our part of
the country are extremely hot,' wrote
Henri Bosco in his novel *Le Mas Théotime*.
'In the late afternoon the sun sets the
fields glowing like braziers. All one can do
is stay indoors in the shade and wait for
dinner. Flayed by cold winds in winter
and naked to the scorching sun in summer,
the farmhouses were built specifically as
shelters, their massive walls offering some
protection against the fury of the seasons.'
Today Henri Bosco lies in the cemetery at
Lourmarin, as does Albert Camus. Camus's

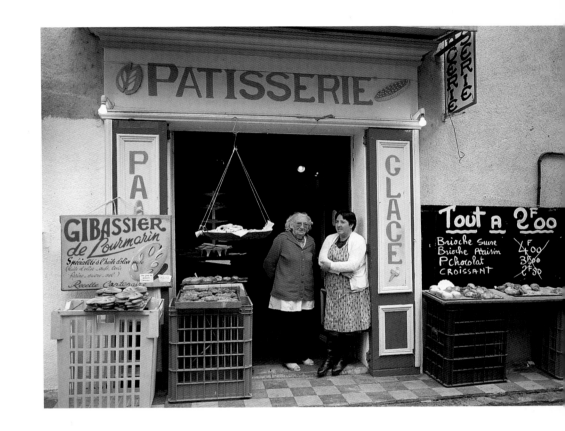

former home is now a museum in his
memory. The village is watched over by a
magnificent château.

 Other châteaux dominate the tops of
peaks in the Vaucluse, which stretches
between the valleys of the Rhône and the
Durance. The fortress of Entrechaux is one,
set atop a peak to guard the entrance to the
Toulerenc valley and to protect Entrechaux
village, which boasts a couple of
Romanesque churches. Not far away,
Malaucène lies on the northern slopes of
Mont Ventoux, a mountain populated with a
hundred different species of bird (including

**On a lazy afternoon, the
Pâtisserie at Lourmarin
in the Vaucluse has cut
the price of its morning
bake to a uniform two
francs. This village is
dominated by the
Lubéron range, where
these poppies** (opposite
above) **grow in a field
near Apt. Saorge**
(opposite below) **is one of
the most remarkable
villages of eastern
Provence, with old
houses roofed in stone.**

This massive 180-metres-high rock (left) overwhelms the little town of Castellane in Haute-Provence; a cascade in the Col d'Allos, Alpes-de-Haute-Provence (below).

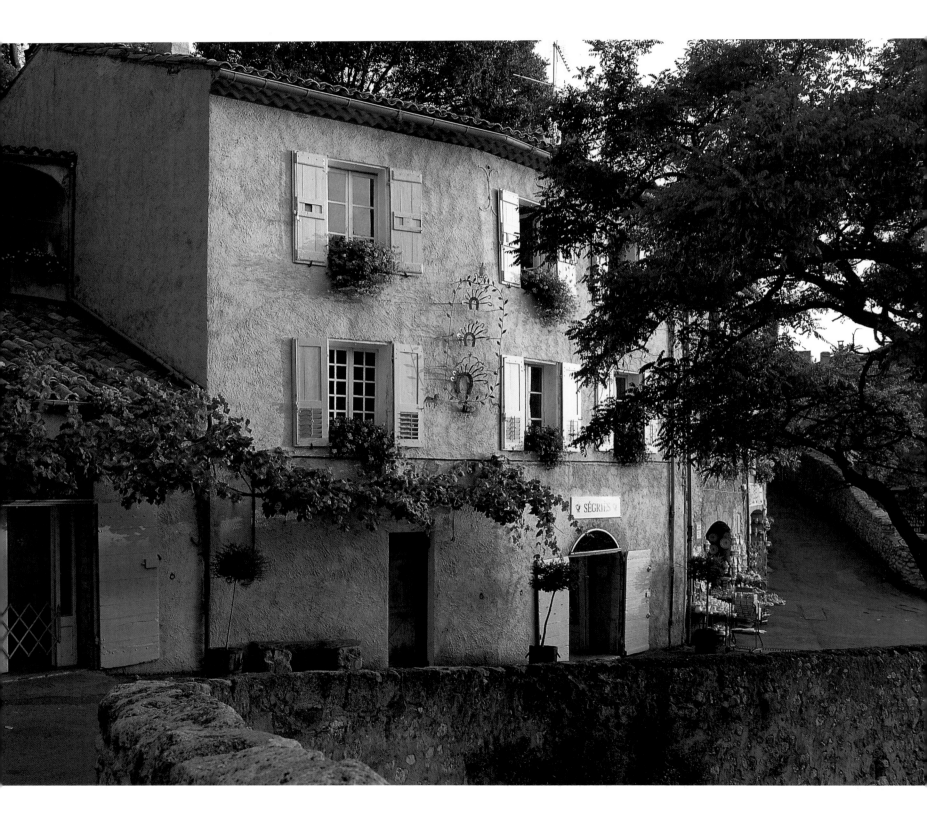

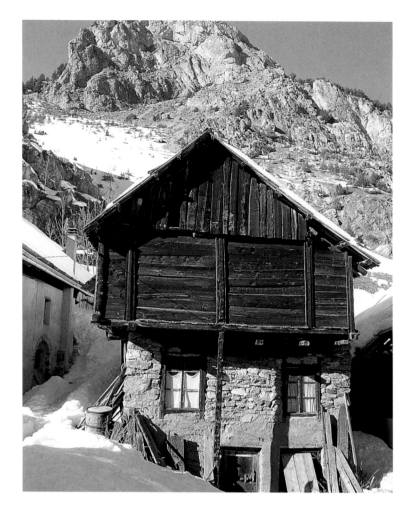

the only eagle to feed on snakes) and clad with limes, pines and cedars. The woods conceal wild boar and doe, red and brown squirrels, fawns, badgers and stags. On lower slopes grow box-wood and juniper trees, as well as narcissi, wild strawberries, iris and wild flax. Its peak juts an imposing 1,912 metres towards the heavens.

The Vaucluse is irrigated by a network of canals filled by the waters of the Durance and the Sorgue. Lavender and thyme scent many of its slopes. Few spots better illustrate its long history than the little town of Vaison-la-Romaine. As its name indicates, this was a Gallo-Roman foundation, and archaeologists have excavated here considerable Roman remains. Alongside these rises the magnificent Romanesque church of Notre-Dame-de-Nazareth, which is built on the site of a Roman temple and has an apse supported by Roman columns. Its altar dates from the sixth century. South of the river Ouvèze (which is spanned by a Roman bridge whose single arch stretches nearly eighteen metres) is its medieval quarter, its twisting streets and delightful squares defended by fourteenth-century walls and a fortified gateway. The sad ruins of a château built in the twelfth century by Comte Raymond of Toulouse offer a splendid view of Mont Ventoux.

The contrast between Vaison-la-Romaine and the pretty village of Roussillon emphasizes the variety of the Vaucluse. Entrancingly sited on a platform of rock, Roussillon, with its fourteenth-century church and rusty-pink houses, is surrounded by cliffs and rocks whose colours range from blood-red through ochre to pink. Nine kilometres north is another marvel of this upland. The village of Gordes is perched above the plain, its

splendid ensemble of steep streets, medieval to sixteenth-century houses and a vast, half-Gothic, half-Renaissance château all defended by twelfth-century walls.

North-east of the Vaucluse are the *départements* of Alpes-de-Haute-Provence and Hautes-Alpes. The former has some fascinating upland communities, such as Moustiers-Sainte-Marie, north of the Verdon, while the latter incorporates an extensive park, Le Queyras. Here rises Saint-Véran, at 2,040 metres above sea-level the highest commune in Europe, and long noted for its woodworkers. This seductive village, with its eighteenth-century chalets and houses with vast lofts, even has a fountain constructed of wood. Outside some houses are little stone seats, originally intended for courting couples.

Contrasting mountain houses: evening sunshine at Moustiers-Sainte-Marie (opposite)**, a village of scarcely six hundred inhabitants, sited at the beginning of the Grand Canyon du Verdon; a typical dwelling with balustrade and awning** (above)**, at Névache in the Vallée de la Clarée, Hautes-Alpes.**

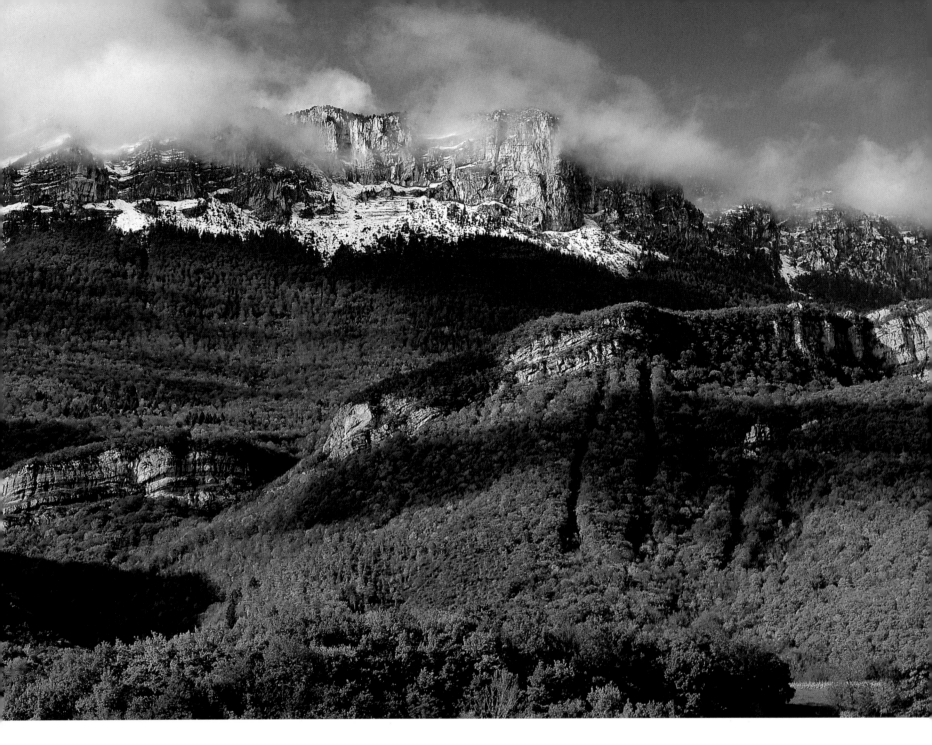

ALPINE FRANCE

To move north from the Hautes-Alpes into the *département* of Isère is to discover a landscape bordered by the two most important pre-Alpine massifs of France: the Vercors to the south and the Grande-Chartreuse to the north. A land of pastures and deserted forests, the Vercors is virtually an entire natural park (its headquarters at Lans-en-Vercors). The small town of Villard-de-Lans, ravishingly situated in the alpine Lans valley, is the region's chief centre for excursions – chiefly on horseback in summer and above all on skis when the snow falls.

The northern region, the massif of La Grande-Chartreuse, wears a mantle of pine forests and boasts superb mountain views and spectacular abysses. Situated between the transverse valleys of Chambéry and Grenoble, in the late eleventh century this was such an isolated range that in 1084, under the protection of the Bishop of Grenoble, St. Bruno chose to lay the

Two formidable mountains in the Massif de la Chartreuse: **Mont Granier** (above) **and a second impressive range near Chambéry** (opposite).

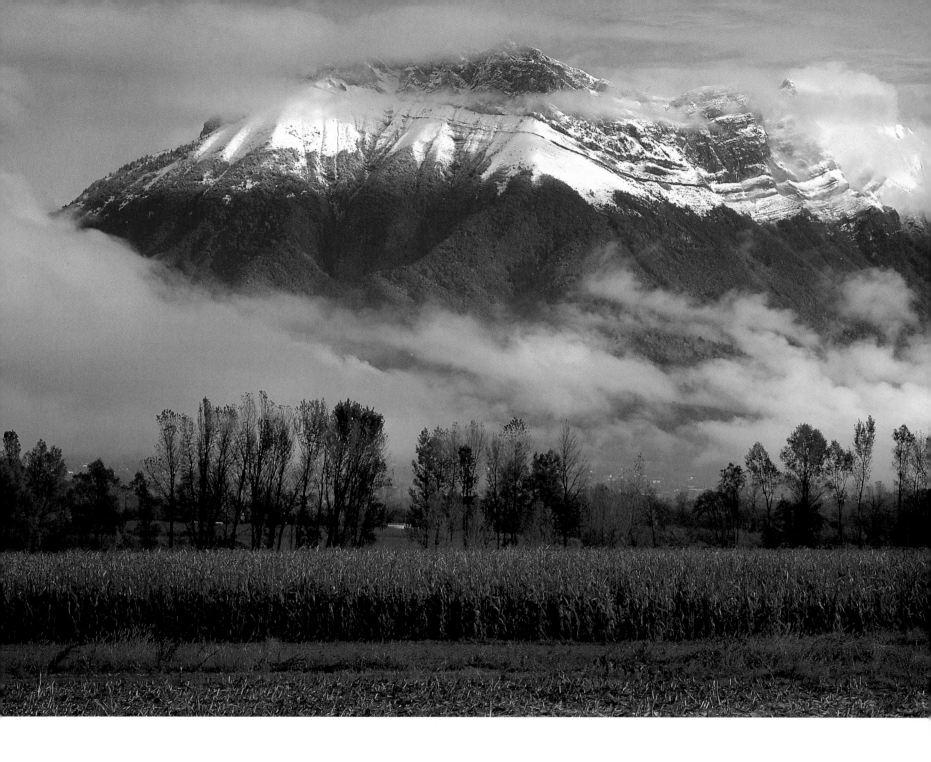

foundations there of the Carthusian order of contemplative monks, who were vowed to silence and the renunciation of the outside world. His primitive monastery, some fifteen miles north of Grenoble, was rebuilt many times; the present buildings date from the late seventeenth century. Today the monks, who were expelled in 1904 and allowed to return only in 1940, create a renowned green-and-yellow liqueur.

The fame of green-and-yellow Chartreuse contrasts strangely with the extremely disciplined life of the monks of La Grande-Chartreuse. Carthusians are committed to prayer, to solitude, to manual labour and to study. They meet daily solely for worship. Only on Sundays and feast days do they eat together, because St. Bruno demanded of his followers a vow of silence, mortification and renunciation of the world. In consequence, visitors are not allowed to enter the monastery, and cars are forbidden. However, the monks have created here a fascinating museum of their

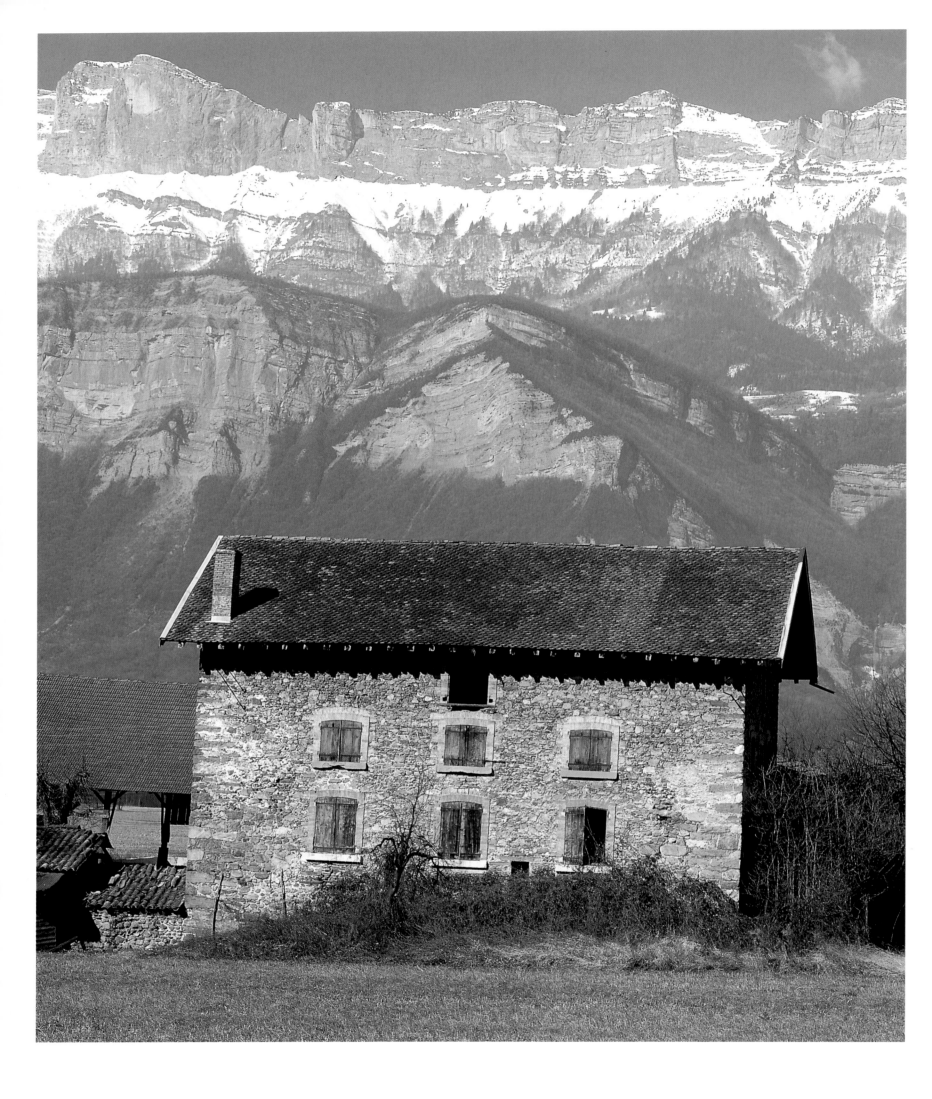

daily life. Close by is the village of Saint-Pierre-de-Chartreuse. Set amid fir trees and alpine meadows, the town profits from its situation at the heart of the spectacular massif to thrive as a summer and winter resort. Its nineteenth-century church of Saint-Hugues is filled with modern art.

Savoy owes its prestige above all to the majestic, 4,807-metres-high Mont-Blanc, Europe's highest peak, and according to Lord Byron, 'the monarch of mountains', at the foot of which sits the town of Chamonix, venue in 1924 of the first winter Olympics. For twenty kilometres the Chamonix valley stretches alongside the river Arve, keeping a height of around 1,050 metres above sea-level. Yet these are but two spectacular places among many in these uplands and mountains. Bonneval-sur-Arc, for instance, the highest village in the Savoy region known as the Maurienne, lies at the foot of the Col de l'Iseran, its houses roofed with heavy *lauzes*, the belfry of its church dating from the seventeenth century. From here stretches the upper-mountain national park of La Vanoise, with its lakes and its thrilling cascades and gorges. Contiguous with the Italian reserve of Gran Paradiso, the park and its neighbour together consitute both the highest and the most extensive protected territory in Europe. And the French reserve, founded in 1962, was the first such domain in the country to be established for the protection of flora and fauna.

Savoy is also border country, only becoming part of France in 1860; until then it had belonged to Piedmont. Long isolated because of the climate and mountains, the Savoyards developed their own cuisine and their own crafts. Lush pastures nourish sheep as well as beef and

This stone house (opposite) **seems entirely at one with the harshness of the slopes of Mont Granier. The village of Saint-Pierre-de-Chartreuse** (above) **lies at the heart of the Chartreuse. St. Bruno and six companions founded a monastery here, though the original foundation was soon demolished by an avalanche.**

milk cattle. The ham of Celliers and Taninges, smoked in the open-air, is famous. Game abounds, while the streams and rivers are full of carp, trout, eels and perch. These are the ingredients of meals often created with *crème fraîche*. On the slopes which face the Midi vines flourish. Savoyards also produce their own cider and beer. As for crafts, local artisans produce exquisite furniture, as well as fine pottery. Privileged in its gorges, rivers and lakes (particularly Lac Léman), this is also a land

of spas, whose thermal waters have been exploited since the time of the Romans. Medieval monks relished its peaceful isolation. In addition to St. Bruno's foundation at Saint-Pierre-de-Chartreuse in 1101, monks from Cluny settled at Le Bourget-du-Lac above the Lac du Bourget, and in 1125 St. Bernard and Count Amédée III founded the abbey of Hautecombe on a magnificent site on the west bank of the same lake.

The nearby city of Chambéry began to

The area of Mont Saxonnex (above)**, in the Haute-Savoie, yields dramatic sites, like that of this country church. Bonneville lies at the foot of the 1,863-metre-high Môle, from where the valley of the Arve** (opposite)**, seen here in its autumn colours, stretches as far as Sallanches, with its dramatic views of Mont-Blanc.**

flourish when the Dukes of Savoy made it their capital in 1232. Their fortress still stands, as does the fifteenth-century cathedral, dedicated to St. François de Sales, and a Gothic jewel (with a classical façade), the Sainte-Chapelle, which was built in 1408. A reminder that this is spa country is Challes-les-Eaux, six kilometres south-east. Far more celebrated is the splendid spa of Aix-les-Bains, set by the Lac du Bourget in a spacious valley overlooked by impressive mountains. The Romans enjoyed these thermal waters, and among the monuments they left behind here are the ruins of their own baths, the arch of Campanus in the Place des Thermes and a temple of Diana (which was incorporated in the sixteenth-century château).

Le Bourget, covering 4,460 hectares and amongst the largest of France's internal lakes, is but one of many which add lustre to Savoy. In upper Savoy the finest are the Lac d'Annecy and Lac Léman. Thonon-les-Bains and Évian-les-Bains are the best-

JURA AND BEAUJOLAIS

Due north of Savoy, the Jura displays
different charms from its neighbouring
départements. This is a land of forested hills,
as well as lakes, rivers and vineyards. The
town of Arbois, still in part fortified (its best
preserved tower, the Tour de la Gloriette,
built in the thirteenth century) lies at the
heart of these vineyards. Its houses, most of
them built between the fifteenth and
seventeenth centuries and many of them
with arcades, overlook the river Cusance.

Not far north-east is Salins-les-Bains, a
spa prized by the Gauls and the Romans,
which was then ignored by the rest of the
world until the baths were rediscovered in
1855. Medieval and classical in style, its
impressive collection of houses is
remarkably homogeneous. The hospital of
the spa dates from the eighteenth century,
and such a seemingly modest place displays
an exceptional group of Gothic churches
and seventeenth- and eighteenth-century
convents.

South of Lons-le-Saunier men and
women in their leisure hours fish, indulge
in water-sports, ski and go pot-holing. Like
Salins-les-Bains, Lons-le-Saunier derives its
name from the word salt, mined here for
centuries. Although the town was set on

fire in 1637 by the troops of Louis XIII
and for the most part rebuilt in the
eighteenth century, its church of Saint-
Désiré still has a Romanesque crypt, while
the upper building dates from the twelfth
to the fifteenth century. Some of the later
secular buildings line arcaded streets.
Lons-le-Saunier saw the birth in 1760 of
Rouget de l'Isle, writer and composer of
the *Marseillaise*, and his statue by Bartholdi
stands in the Promenade de la Chevalerie.

Shaded by overhanging cliffs, Baume-
les-Messieurs sits in an exceptional site, the
Cirque de Baume, seventeen kilometres
north-east. Its abbey, founded in the sixth
century, retains a Romanesque abbey
church, with a Gothic façade, whose statues
were sculpted by Burgundian masons. Inside
is a Virgin Mary carved in the fifteenth
century and canvases painted by seven-

teenth-century Flemish masters. The choir
of the church dates from the thirteenth to
the fifteenth centuries, the nave from the
twelfth and the thirteenth centuries.

Close by is the little hilltop village of
Château-Chalon. Once, it was sheltered by
a Benedictine abbey and a fortress, but both
today are in ruins. However, the village
houses, roofed in stone, remain picturesque,
and the local pale yellow wine is relished
by connoisseurs. And ten kilometres west of
Château-Chalon is another picturesque
hamlet, this one with medieval houses.
Arlay is, again, protected by the remains of
a fortress which include its keep and an
underground Romanesque chapel.

The *département* of the Rhône, west of
Savoy, is the smallest of France after that of
Paris. It is filled with varied geographical
delights, among them the Mont-d'Or, the

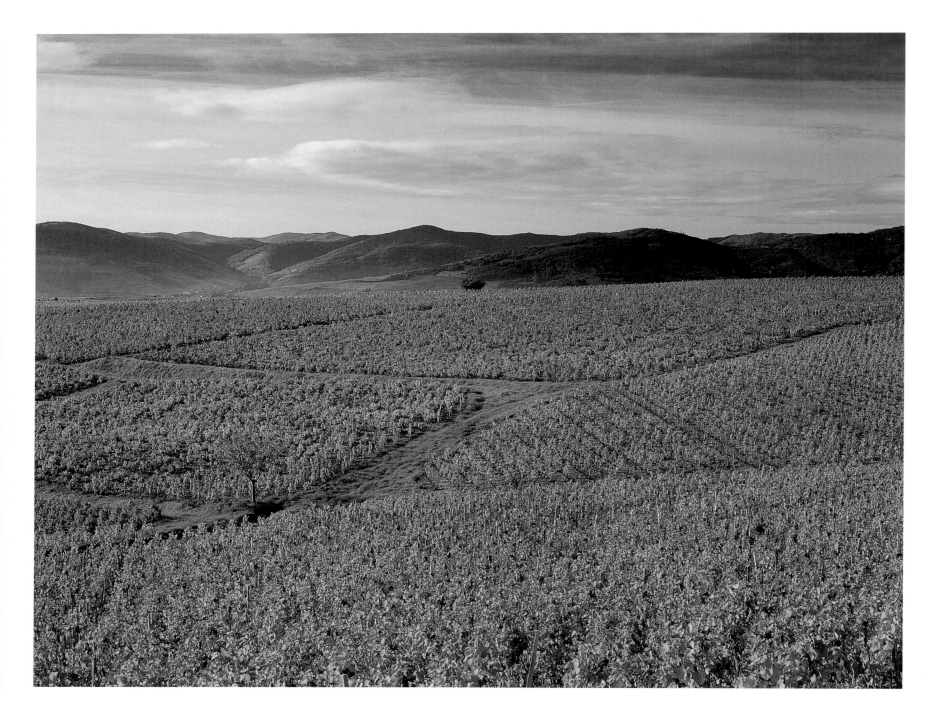

region around the valley of the Saône, the
Lyonnais and Tartare mountains and the
Beaujolais. Countless tributaries of the
Saône cut through it to water the pastures
of this rural land. From the 762-metres-
high Col du Fût d'Avenas a panorama of
vineyards stretches out. (Altogether the
Beaujolais boasts fifteen thousand hectares
of grapes.) Granite mountains reach their
highest point with the 1,012-metres-high
peak of Mont-Saint-Rigaud. One village
of fewer than 700 souls has become
charmingly famous. Vaux-en-Beaujolais was
the setting for Gabriel Chevallier's highly
comic novel, *Clochemerle*.

THE VOSGES

Finally, the easternmost part of France,
Alsace, its vineyards sheltered from harsh
winds and excessive rain by the slopes of
the Vosges mountains, is (apart from
Champagne country) the most northerly of
French wine regions. Often fought over by
France and Germany, it shares the virtues of
each land (though the people speak a
dialect that is neither French nor German).

Riquewihr is a typically Alsatian town,
most of its houses - many of them with
oriel windows and sculpted galleries -
dating from before the beginning of the
Thirty Years' War. Its rectangular walls were
built at the end of the thirteenth century.
Here are two ruined and one intact
châteaux. Over the doors of many of the
houses in the outrageously beautiful
Grand'Rue are inscribed the dates when
they were built. Ancient wine presses and
Renaissance fountains enliven other streets.
Inside some of the houses are courtyards
with staircase towers and wells.

Hunawihr, surrounded by fourteenth-
century fortifications, is a town named after

Classic Beaujolais wine comes from the region north of Villefranche-sur-Saône; its vineyards are centred on the village of Fleurie, near where these vines (opposite) flourish. In French villages long-established building traditions survive: this half-timbered house (above) in the Vosges is roofed in the ancient fashion and shelters an immense stack of well-cut timber.

a charitable noblewoman who used to wash the linen of sick people. Fittingly, Hunawihr's fountain is named after her. The town has another reason for praise. Storks used to nest on the rooftops and in the chimneys of houses, but had begun to die out; the good folk of Hunawihr then introduced a programme of hand-rearing, and so the storks live on. These citizens are peaceable folk, and their fifteenth-century church of Saint-Jacques has been shared by Catholics and Protestants since 1687.

Kaysersberg in Alsace has a special claim to fame, as the birthplace in 1875 of the brilliant theologian, Bach scholar and doctor, Albert Schweitzer. His birthplace is now a museum devoted to his memory. Around the fortified bridge of Kaysersberg, which was thrown across the river Weiss in 1511 and carries a small oratory, is the finest ensemble of buildings in this town, most of them dating from the sixteenth and seventeenth centuries. Corbelled houses surround the church square, which centres on a fountain topped by a statue of Constantine, the first Christian emperor. The town takes its name from 'the mount of Caesar', a nearby hill on which the Romans built a fort to control the route across the mountains into Gaul. On the site of this fort the Emperor Frederick II built a fortress whose ruins still stand. In this town, just before the Reformation, lived a celebrated preacher, Geiler von Kaysersberg. In a memorable remark, Albert Schweitzer recalled not only this preacher but also the splendid wines of Alsace, 'As a boy I used to pride myself not a little,' he wrote, 'on having been born in the town where Geiler von Kaysersberg had lived, and in a famous wine year, for the season of 1875 was an extraordinarily good one for the vines.'

The success of modern France has been to embrace a twentieth-century technology without allowing it to overwhelm the traditional ways of life. No doubt change will come to this farm at Hunspach, Alsace, but one feels that these two dignified ladies will cope ably with it, as their ancestors did with the rigours of the past.

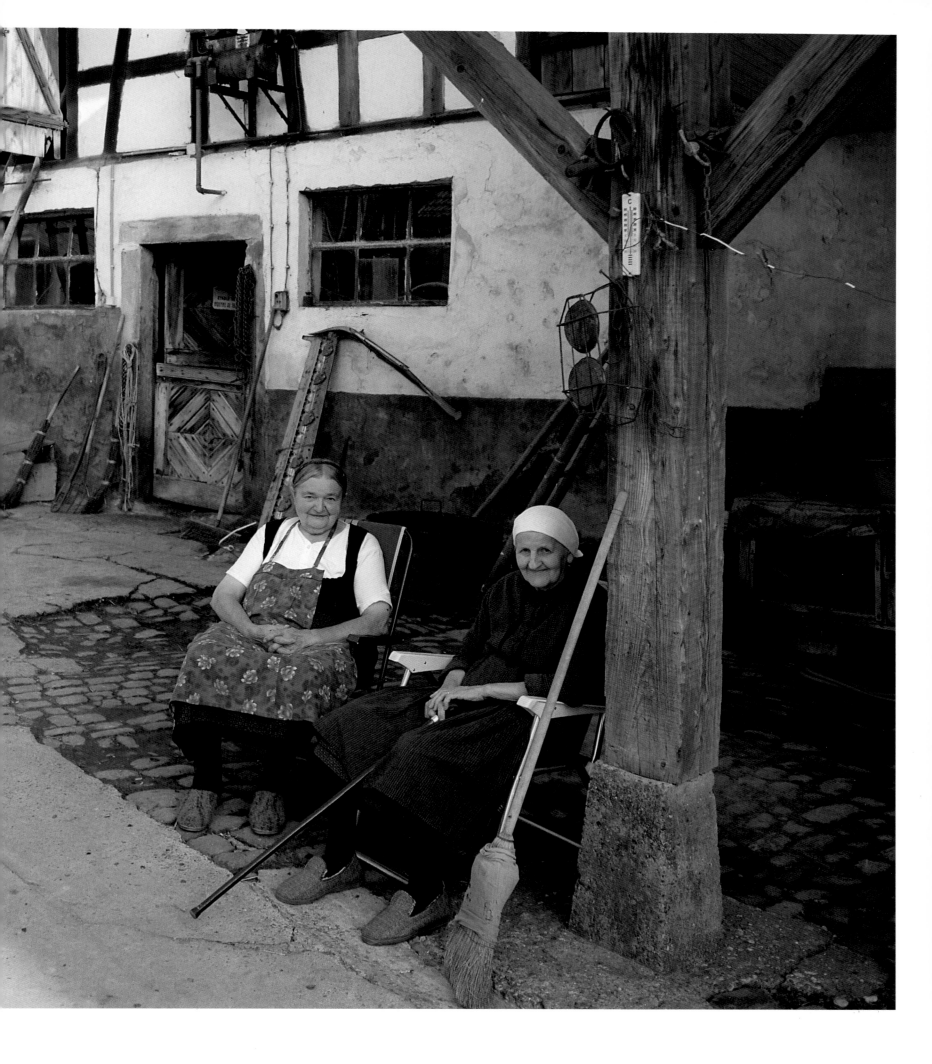

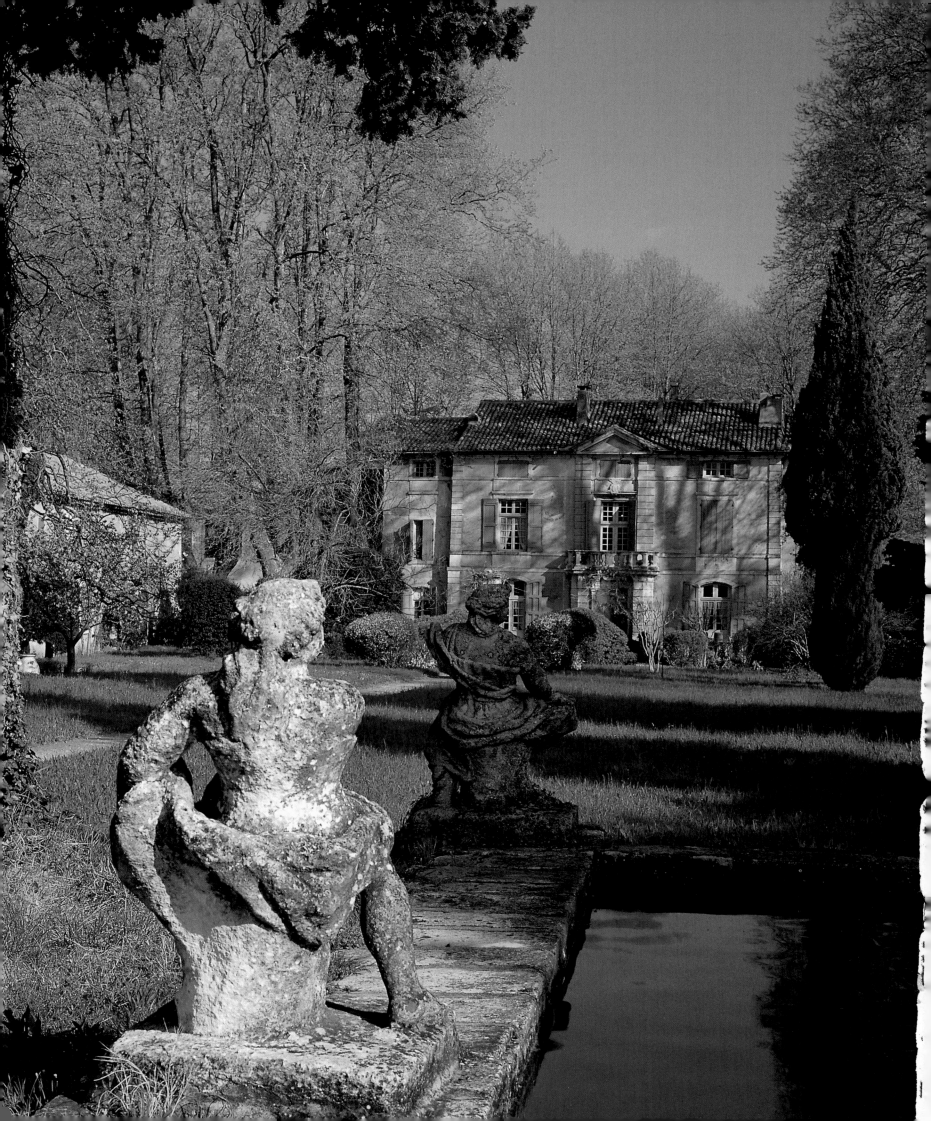

The turrets, crenellations, battlements and solid grey stones of Château Monbazillac in the Dordogne (right), built for the Vicomte de Ribérac in 1550 and now one of the delights of the region; its sweet white wine is among the most celebrated of the Bergerac vineyards.

From luxury mobile homes, tents on superb four-star campsites and self-catering villas, through half-board accommodation, where guests can learn the secrets of regional cooking, France offers an immense variety of *pieds-à-terre* for the traveller. Hotels range from this delightful house in Provence (opposite) to grand châteaux.

THIS SECTION MIGHT BE MORE accurately entitled 'Random Thoughts on Random Parts', since it is hardly a guide to the country, either for the tourist or for the prospective settler. In such a discursive book as this, it seemed more appropriate to offer a few of the author's reflections, distilled from many miles and many days of travel in the country. In any case, Michelin, of green, red and yellow varieties, continues to supply irreproachable factual information.

To live and to travel in France is a glorious experience, and especially to live in a village, one perhaps that perches on a craggy rock and is blessed with a Romanesque church. Rolling fields, snow-capped Alpine cliffs, deep silent forests, rich vineyards with ruby or white grapes, fish-filled rivers, torrential gorges, spectacular coastlines and the flavour of fine food combine in an irresistible mix. 'What a bewitching land it is! – What a garden! Surely the leagues of bright green lawns are swept and brushed and watered every day, and their grasses trimmed by the barber. Surely the hedges are shaped and

measured, and their symmetry preserved, by the most architectural of gardeners.' The words are those of the American Mark Twain, writing about France in 1869.

To enjoy France fully, however, requires a little foresight. As Marcel Proust observed, 'The best holidays are those we picture in our minds to ourselves before we set off.' France is superbly furnished with hotels and guesthouses, some of them run for generations by the same families, others belonging to prestigious chains, some expensive, some marvellously affordable.

Relais & Châteaux, a chain set up some forty years ago, promises and delivers quiet, comfortable and – as its president puts it – personalized hotels in the heart of the French countryside. Their proprietors have created them out of mills, manor-houses, abbeys, farms, châteaux and other high-quality homes. Many, for example the eighteenth-century Château d'Audrieu in Calvados and Château d'Esclimont in the *département* of Eure-et-Loire, are set in extensive parks, often with lakes. Others, such as the Manoir de Lan-Kerellec, a nineteenth-century

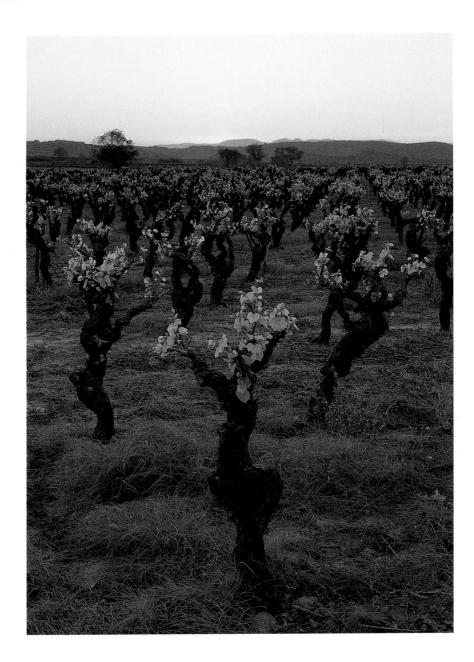

Vineyards near Pézenas, a delightful town in the Hérault, which celebrates its annual grape harvest with an animated festival.

Breton manor-house, overlook the sea. In the Corrèze, at Varetz, the Domaine de Castel Novel is a transformed thirteenth-century residence and was adored by the novelist Colette. Another novelist and lover of south-west France, Henry Miller, stayed at Le Vieux Logis at Trémolat, a Dordogne hotel which was once a seventeenth-century Carthusian monastery. Another superb building, this one overlooking the nonchalantly flowing river Dordogne itself, is Château de la Treyne at Lacave in the Lot, built in the fourteenth and seventeenth centuries and set in a forest which covers some hundred and twenty hectares. In the same *département* at Mercuès you can now stay at the Château de Mercuès, once the summer retreat of the bishops of Cahors.

Travel south to find, for example, the eighteenth-century Domaine de Châteauneuf in the Var, at the foot of the massif of the Sainte-Baume. Find in the same *départe-*

ment at Trigance the Château de Trigance, which began life as an eleventh-century fortress built by monks at the entrance to the gorges of the Verdon. In the Alpes-Maritimes at Saint-Paul-de-Vence is a sixteenth-century house now transformed into the Hôtel Saint-Paul.

The same chain boasts similar superb hotels in Alsace as well as Burgundy. Château de Gilly in the Côte d'Or was once an abbey. At Tournus in the *département* of Saône-et-Loire is a hotel/restaurant named after the artist Jean-Baptiste Greuze and standing beside the Romanesque abbey of Saint-Philibert. La Côte Saint-Jacques at Joigny overlooks the river Yonne. In the same Yonne *département*, L'Espérance at Saint-Père-sous-Vézelay is close by one of the finest medieval religious buildings of France; it also boasts a three-star restaurant, one of the most distinguished in this part of France.

Small Luxury Hotels of the World also offer entrancing French hotels. Château de Bellinglise at Élincourt-Sainte-Marguerite near Compiègne is one of the finest, set amidst gardens and a forest, built for the most part in the sixteenth century but boasting a tower in which, it is said, Joan of Arc was imprisoned. In southern France the same chain has a seventeenth-century hotel, the Auberge de la Vignette Haute, at Auribeau-sur-Siagne, near Cannes, the eighteenth-century Hôtel de la Mirande in Avignon, and Hôtel Lana in the ski resort of Courchevel (a hotel which opens only in winter). In Èze village on the Côte d'Azur, Château Eza once belonged to the Swedish royal family. North of the peaks of the Alpilles, in the town of Saint-Rémy-de-Provence, is the Hostellerie du Vallon de Valrugues. And between Sainte-Maxime and Saint-Raphaël, close by Saint-Tropez, is Villa Saint-Elme, on the Corniche des Issambres. To view Mont-Blanc, stay at the Hôtel l'Antares at Méribel-les-Allues.

As for wine country, the Château Grand Barrail sits just outside Saint-Émilion, at the heart of Bordeaux's vineyards; Burgundy country is served by the Hôtel Le Cep at Beaune, Champagne by the Château de Fère at Fère-en-Tardenois, a hotel which rises beside the magnificent ruins of a thirteenth-century castle built for Comte Robert de Dreux, who was grandson of King Louis VI of France, and is reached through woods.

Stringent rules govern the inclusion of any hotel in the annually produced guide, *Logis de France*. This is a voluntary organization of over four thousand, mostly family-run hotels, covering the whole of France (save for Paris). They are graded by a symbol of a chimney. One, two or three chimneys indicate the quality of food, the level of comfort, the general facilities. On the basis of two guests in a room the guide gives a range of prices. When such hotels fall below the necessary standard, they are cruelly but rightly weeded out of the next edition of the guide. No such *logis* should ever complain if a potential client asks to see a room before deciding to stay. Equally, from the point of view of the family running the hotel, no such *logis* will necessarily welcome a visitor who arrives late at night, expecting a night porter. Travellers planning to arrive late should always telephone ahead.

Travelling independently in France, the main rule is to start finding a hotel around 6 p.m. at the latest. In every town and in many villages, independent hotels, not belonging to any chain, are delightful, sometimes deliciously old-fashioned in their décor and ambience. In their bars and their restaurants the locals chatter in their *patois*. The man who serves petrol in the garage next door wanders in, doffs his cap, drinks a glass of Calvados and then hurries out to fill up the car of his next customer. Busy people, not surprisingly, often prefer to arrange their stay in advance, rather than trust to finding a lodging day by day. Numerous tourist organizations can arrange precisely that.

France is also festooned with campsites – for caravans and for those who like to live in tents. Many such sites are of a high quality, graded like hotels. There is, however, no need to use these sites. Provided you get the agreement of a farmer, you may camp on one of his fields. Finally, there are throughout France rural *gîtes,* bed-and-breakfast homes and youth hostels. *Gîtes de France* is the official guide to these rural retreats.

Naturally, French local tourist offices offer help and organize guided tours for travellers. In Savoy and Haute-Savoie, for example, hidden in many churches are stunningly beautiful Baroque carvings and altarpieces. From Chambéry, for instance, professional guides take visitors

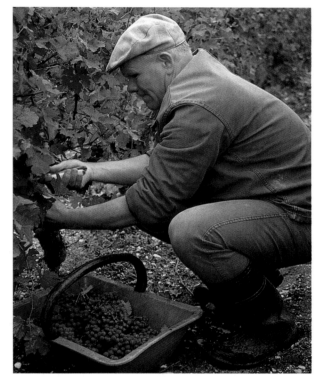

Médoc vines are carefully gathered, north-west of Bordeaux, for the celebrated vintages of the Château Margaux, which was built here in 1804 and boasts an exceptionally fine park.

on a tour of sixty-four such churches. Annecy Tourist Office offers information about the old town and about the lunch and dinner cruises on that exquisite lake. Visitors to Alsace may taste the pleasures of a wine route created by the vintners of Alsace that runs for 120 kilometres from Obernai in the north to Thann in the south. It is lined with stalls and cellars, whose owners invite visitors to sample the produce. The vineyards themselves stretch on either side, merging into the woodlands on the far horizon. In summer the people of Alsace sit under parasols by the roadside, selling not only wine but also their home-produced honey.

On such outings always try to make time to eat and drink. Because France is such a remarkably varied country, its gastronomy is equally diverse. Indeed, one of the best and most practical ways for a traveller to explore is to do it gastronomically, beginning in the north.

Provençal dishes (below) can be spicy, but the locals have a proverb, declaring that richly-spiced soup is a life-preserver. Sausages in France (below right) come in countless shapes and sizes, and are complemented by *saucisson*, dry, often seasoned with garlic, and eaten raw.

The farmers of the Pas-de-Calais and Picardy cultivate hops, and thus the favoured drink here is beer (with, as a runner-up, juniper liqueur). In its origins and traditions, this is in part Flemish country, hence the *pot-au-feu* made from beef, onions and beer is known as *carbonnade à la flamande*. The Pas-de-Calais is also a fish-lovers' mecca. Étaples, for instance, has a fish market, above which is a fish restaurant, its delights including a *cassoulet* of mussels and leeks. And attached to the market is a shop for buying wines to match the fish. The locals also adore tripe, which is much relished at the annual second-hand fair held at Saint-Quentin in September.

Normandy is lush. Its apple trees flourish and their apples create powerful ciders. The cream from the region's cows is the richest in France. Both cider and cream enrich Normandy dishes. *Lapin au cidre*, for instance, is a complex dish in which the rabbit is cooked with onions, garlic, *bouquet garni*, shallots, fresh cream, the rabbit's own blood and cider. As for the region's cheeses, these include the entrancing Camembert, as well as the piquant, yellow and crusty Livarot, Neufchâtel, often sold moulded in the shape of a heart, and Pont-l'Évêque (a cheese which monks were making as long ago as the twelfth century and one lauded in the *Roman de la Rose*).

Normandy's most famous liqueur, Calvados, combines with cider to enhance the cooking of the fat grey geese from the region of Alençon. The bird is stuffed with minced pork mixed with apples and the liqueur. As it is cooking its offal is blended with onions, carrots and shallots to make a sauce. Throughout the cooking the goose is kept moist with liberal doses of cider. Then it is served with an apple purée.

In Normandy *crêpes* are often *flambées au calvados*. Calvados serves another culinary purpose in this and other parts of France by creating *le trou normand* ('the Norman hole'). A goblet drunk in the middle of a meal

It is sometimes said that French cuisine is one of wine and bread; from the evidence of this table (opposite page), it is clear that there are also many other delights.

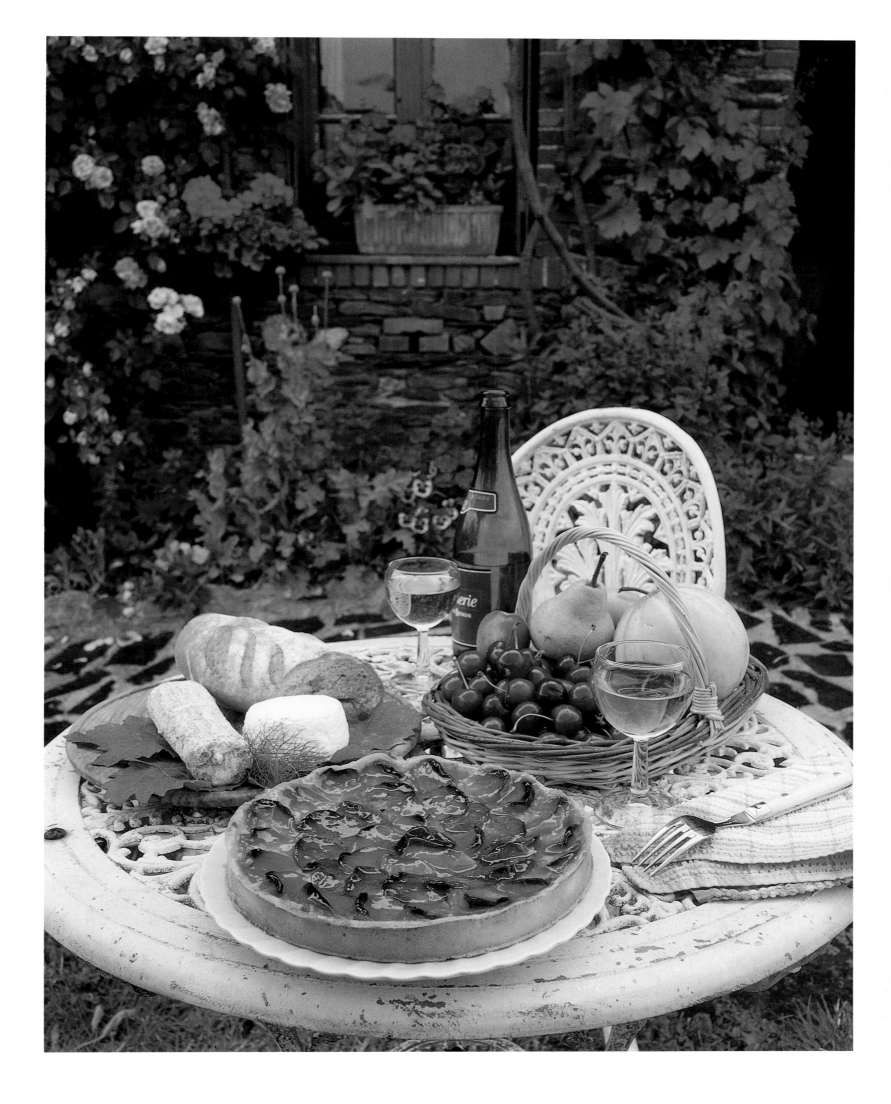

The vineyards of the Médoc are laid out on the left bank of the rivers Garonne and Gironde. Lower Médoc to the north of the region is distinguished from upper Médoc in the south, where some of the wines, for instance Saint-Estèphe, Saint-Julien and Pauillac are particularly esteemed.

deglazes the fatty elements of what has already been eaten and perks up the stomach for what is yet to come. A reminder that pilgrims passed through Normandy on their way to the shrine of St. James the Great at Compostela is the dish *timbale Saint-Jacques à la normande* - scallops with prawns, mussels, cream and mushrooms, the scallop shell being one of the symbols of the saint.

West of Normandy Brittany's farmers specialize in cauliflowers and artichokes, while their green beans, onions and tomatoes swell satisfactorily in the Breton climate. Their delicious apples produce equally delicious

cider. Because this is a coastal land, on local tables appear oysters, the most reputed those of Cancale. Here one tucks into *andouilles*, spicy sausages made from the intestines of pigs. And the bakers' shops sell the mouth-watering butter biscuits called *galettes de Bretonne.*

The Loire valley also nourishes apple trees, but is far better known for its asparagus, its red cabbage, its *rillettes* (shredded pork or goose meat, cooked in lard and pounded with a mortar) and its wines. The asparagus, sold to restaurateurs in the Val d'Oise, has created a celebrated soup, *potage Argenteuil,* a delight strengthened with egg

yolk and cream. The region's rivers harbour pike and trout. Nearly all its cheeses - those of Salles-sur-Cher, Valençay and the Sologne, as well as the noted Crottin de Chavignol - are made with goats' milk. The proximity of the coast brings oysters and sardines to the table. One cheese produced here (distributed throughout the rest of France) is entertainingly named the 'Laughing Cow' (*La Vache Qui Rit*). Port-Salut is another.

The wines of Saumur, Sancerre and Chinon are reputed, as are the Muscadet and Gros-Plant produced around Nantes. One of the most enjoyable times for sampling some of these wines is the weekend of Whitsun, when Sancerre holds its wine fair. Another is the fourth weekend of August, when the same vintners hold their 'wine days'. But at any time one can call on wine merchants for a free tasting, after which they hope their visitors will buy at least a case.

Lovers of pork sausages should visit the pork sausage fair, held on the second Sunday in June in the town of Jargau, south-east of Orleans, a spot where on 12 June 1429, Joan of Arc led the French to a bloody victory over the English.

Around Limoges are nurtured superb cattle whose beef is then sold throughout the rest of France. Less well-known outside this region are its mutton, its veal, its apples and its raspberries. Limousin-Poitou-Charentes, which comprises the three Limousin *départements* of Corrèze, Creuze and Haute-Vienne and the four Poitou-Charentes *départements* of Charente, Charente-Maritime, Deux-Sèvres and Vienne, is noted also for Cognac. French law insists that the name Cognac can be applied only to brandy distilled from the white grapes grown around the city of Cognac itself. One treat in this region is the aperitif *pineau*, consisting of one-third Cognac and two-thirds grape juice.

In Aquitaine the prestigious Bordeaux wines - Médoc, Saint-Émilion, Graves - have been classified since the mid nineteenth century. Reputed wines of the Dordogne include those of Bergerac, the sweet white Monbazillac and the rich red Pécharmant. Lampreys *à la bordelaise* is a classic dish in which the fish are cooked in a sauce made from Bordeaux wine. And the Dordogne (or as the inhabitants mostly call it, the Périgord) is famous for its food: omelettes with mushrooms, *confits*, fried potatoes flavoured with truffles. Geese are force-fed here with boiled maize to produce *foie gras*. As André Malraux put it, 'In the Périgord one does not simply eat well; one eats in style.' Here and from upper Provence derive the finest truffles in France, as well as twelve other juicy mushrooms. The truffle has been described as 'the perfumed soul of the Périgord.'

Another delight of this particular region of France is the length of its meals. Usually French restaurants serve only four courses, offering at the beginning either an *hors-d'œuvre* or a soup, the former at midday the second in the evening. In the Périgord you are always offered both. And here, as virtually everywhere in France, the weekday midday meal is a bargain, provided one chooses what all the locals eat: a menu, with no choice of what you are about to eat, but inexpensive, with a litre or so of red wine included. As your litre is reduced, the *patronne* of the restaurant will sometimes remove the carafe, causing consternation, but then return with it filled.

Visiting the Auvergne, the land that produced Vercingetorix (the Gaul who revolted against Rome and was defeated by Julius Caesar), enjoy its gentle climate and above all its cheeses: Cantal, Bleu d'Auvergne, Saint-Nectaire and Fourme d'Ambert. As this land is threaded by rivers, succulent carp and pike appear on menus. Other delicacies of the region include ham and the beef from the cattle of Salers. One culinary glory of this region is a stew based on the flesh of a young goose.

Savour the food of the Midi-Pyrénées and other culinary delights of south-west France: *confits*, crayfish, duck, geese, hams, and superb cheeses, particularly of course Roquefort. The whole is washed down with powerful Cahors wine, as well as the wines of the Frontonnais and of Gaillac, where vines were first grown by Roman

Champagne, a province comprising roughly the *départements* of Aube, Marne, Ardenne and Haute-Marne, owes its world-wide reputation to its sparkling wine. South of Rheims, this wine-cellar stores the precious liquid.

legionaries. Medieval monks developed the wine: then, in the sixteenth century, it became a prime ingredient in the economy of the Midi-Pyrénées, exported to Scandinavia, Russia, England, Flanders and the Low Countries. The rival vintners of Bordeaux managed to stifle this profitable trade by decreeing that no Gaillac wines should leave France until the whole of their own product had been sold.

Blanquette de Limoux, produced in Languedoc-Roussillon, claims to be the first sparkling wine ever to have been produced. Local pepper cakes (or, as they are called in the language of the Languedoc, *fogassets al pebre*, and in French *gâteaux au poivre*) stimulate a thirst for such wines. The wine sweetly complements the *fricassées* of this part of France, richly sauced mixtures of ham, diced pork, livers, kidneys, sweetbreads, heart, spleen and knucklebone, accompanied by a side-plate of white beans.

Yet Blanquette de Limoux vies for attention with other wines of the region: Minervois, Saint-Chinian, Corbières, Collioure, as well as the Muscats of Banyuls, Frontignan and Rivesaltes. In a region blessed with a seacoast and lakes, these wines best accompany fish dishes on local tables. The anchovies of Banyuls and Collioure are unrivalled elsewhere in France. Stuffed squid is another delicacy. And a Spanish element can enter the cuisine here, with for instance snails cooked *à la catalane*, that is to say garnished with ham, onion, peppers and parsley and served with the garlic mayonnaise known as *aïoli*.

Provence and the Côte-d'Azur benefit from fish caught in the Mediterranean, among them sea bream, mullet and bass. These, along with crabs and sometimes even calamaries, create the rich fish soup (*bouillabaise*) of the region. Olives proliferate, and olive oil enriches the vegetables of Provence, particularly its tomatoes, as well

Some succulent ingredients of traditional French cuisine: wild green asparagus, *morilles* in the foreground, and *chanterelles* with garlic in the basket (right).

as the reputed lamb from Sisteron. Greeks first brought vines to this part of France. Then the Romans added the Syrah grape. Their descendants produce such famous Côtes du Rhône varieties as the brilliant Châteauneuf-du-Pape, which is followed by such excellent wines as those created in the vineyards of the Lubéron and the Muscat of Beaumes-de-Venise.

Further north, in Savoy, are created subtle white wines, as well as smoked hams. In the same Rhône-Alpes region, the vintners around Lyons produce the ten major varieties of Beaujolais. The area around the city is also celebrated for its sausages. The Vivarais nourishes sheep whose milk is turned into a cheese known as Le Pelardon. Fish abound in the rivers of this part of France (particularly in the *départements* of the Loire, the Drôme, the Isère and the Ardèche) and eventually appear on the tables of restaurants as, for example, *quenelles de brochet sauce Nantua* (finely chopped pike bound with eggs into a dumpling and garnished with a Nantua sauce).

Lovers of such fine food could not do better than enjoy one of the 200-kilometre trips in the Bresse countryside offered by CDT Ain, which also take in Romanesque and Gothic churches and the celebrated poultry farms. This is another countryside producing superb wines: Chablis, Côte de Nuits, Côte de Beaune, Mâcon, Pouilly-Fuissé and the rest. Burgundy fowl is the most esteemed in France, and in consequence here the local *coq au vin* is magical.

Charolais cattle, including lambs, also enrich the tables of this part of France. So do Burgundy snails. *Bœuf à la bourguignonne*, beef in red wine, is world-famous. A *fondue à la bourguignonne* consists of fillet steak, cut into pieces and fried in oil, before being served with sauces. And the locals have nearly a dozen local cheeses to choose from - including Emmenthal from nearby Franche-Comté. They triumphantly crown their meals with a *kir*, one-third *crème de cassis*, two-thirds white wine.

Ham features prominently in the cuisine of the Ardennes, so much so that it has its own society, the Confrèrie du Jambon Sec d'Ardenne. In the restaurants of all the four *départements* which compose the region of Champagne-Ardenne (Ardenne, Marne, Aube and Haute-

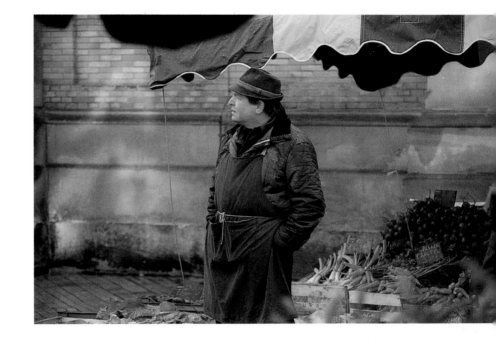

Waiting for customers at the Bergerac market, which sets up each Wednesday and Saturday. On warm September days shiny *cèpes* are sold in the shade of Bergerac's gloomy Gothic cathedral. The market is an essential part of experiencing French attitudes to food and its preparation.

Marne), *charcuterie* and various sorts of pork often predominate, though the rivers of the region also offer their fish. One need not drink here solely Champagne, for the slopes of the Riceys and of Cumières, for instance, also produce excellent wines, as does the *département* of Haute-Marne.

East, on the border with Germany, Alsace-Lorraine is celebrated for its *sauerkraut*, for its onion tarts, for *quiche lorraine* (a flan stuffed with eggs, cream and rashers of bacon) and for *tarte flambée*, a savoury confection of lardons, onions and cream. *Baeckoffe* is created from marinated meats - lamb, beef and pork - cooked with potatoes. The region's seven wines and its beers also enhance the cuisine, so the visitor might well be offered a fillet of beef *au pinot noir* or else *le coq fermier à la bière*. *Foie gras* here is marinated in sparkling wine and then encased in pastry, to be served as *brioche de foie gras*. Small wonder that the *gastronome* Brillat-Savarin, writing about Alsace in 1811, noted that this was one of the regions of Europe that had most stirred his refined taste-buds. But famous gastronomic festivals such as those mentioned

Like the market, a good café is a crucial meeting-place in France for people concerned with food and drink, and its consumption. This is especially true in the sun-lit Midi, where Provençal restaurants, like this one, line the broad pavement with table and chairs under the shade of bright awnings and ancient plane trees.

above are not the only ones in France. Each region, many towns and even some villages regularly celebrate their own past and culture, sometimes for a weekend, sometimes for as long as a week. Thann in Alsace plays host to a festival of classical music in August. In that month the sea is blessed at Calais and at many other coastal towns. In Aquitaine, Gujan-Mestras celebrates an annual oyster fair. At Chambon-sur-Voueize in the Limousin is held a festival of *boules* (or *pétanque*). Dijon celebrates its harvest with a festival at the beginning of September, while the one at Tain-l'Hermitage in the Drôme takes place a fortnight later. In the same month Nîmes celebrates its harvest with bullfights. Gourin in Brittany has a *fête de la crêpe* in July. Eight villages in the Limousin host an annual story-telling festival.

Once in France a motorist will find the roads less crowded than in any other country of western Europe. The motorways are excellent, charging a toll. The Routes Nationales are frequently as good as the motorways and more scenic. Only the Paris ring road, the Boulevard Périphérique, supposedly designed to ease one's passage, regularly holds people up.

Thanks to the TGVs (Trains à Grande Vitesse) rail travel in France is speedy, taking passengers to Lille for entry to Picardy and Nord-Pas-de-Calais, to Dijon for Burgundy, to Tours (for the châteaux of the Loire and for the Sologne), to Bordeaux for the Dordogne, and to many more tourist centres. There is also a comprehensive network of less speedy trains, some still fast, such as those from Paris to Toulouse, some leisurely, such as the ones

that trundle from Bordeaux to Périgord's medieval Sarlat and back.

Airlines connect all the major French cities. Air Inter is France's internal airline. To rent a car at major railway stations and at airports is simple, though best done in advance through the main agencies. And another entry to France and a way of seeing the country is by way of its coach services. One possible handicap is to arrive in France around a public holiday, when banks, shops, restaurants and supermarkets may well be closed. These holidays are 1 January (New Year's Day), Easter Day and Easter Monday, 1 May (Labour Day), 8 May (V.E. Day), Ascension Day (the sixth Thursday after Easter), Whitsunday (the second Sunday after Ascension Day), 14 July (Bastille Day), 15 August (the feast of the Assumption), 1 November (All Saints' Day), 11 November (Armistice Day), and Christmas Day.

This Normandy restaurant proclaims its local delicacies, above the serious business of consumption and conversation.

Select Bibliography

Atterbury, Paul and Baker, Michael, *The North of France*, London, 1990.

Barrier, Philippe, *La Mémoire des fleuves de France*, Paris, 1989.

Belloc, Hilaire, *The Path to Rome*, London, 1902.

Bentley, James, *Alsace*, London, 1988.

Bentley, James, *The Most Beautiful Villages of the Dordogne*, photographs by Hugh Palmer, London and New York, 1996.

Bentley, James, *A Guide to the Dordogne*, revised edition, London, 1995.

Bentley, James, *The Loire*, London, 1986.

Bentley, James, *Languedoc*, London, 1987.

Borel, Pierre and Paschetta, Vincent, *Côte-d'Azur*, Paris, 1961.

Brighelli, Jean-Paul, *Entre Ciel et Mer, Le Mont-Saint-Michel*, Paris, 1987.

Centre - Val de Loire, Paris, 1995.

Chévenot, Christian, *Bourgogne*, Paris, 1988.

Claval, Paul, *Que sais-je? Géographie de France*, Paris, 1993.

Clébert, Jean-Paul, *Guide de la France Thermale*, Paris, 1974.

Frangin, Bernard, *Le Guide du Beaujolais*, Paris, 1989.

Germain, Félix, *Cimes et Visages de Savoie*, Paris, 1960.

Garmier, Jean-François, *Le Guide du Mâconnais*, Paris, 1990.

Grandin, Michel, *Villages de France*, Paris, 1991.

Grandin, Michel, *Rivières de France*, Paris, 1993.

Ile de France, Paris, 1988.

James, Henry, *A Little Tour In France*, London, 1884.

Jacobs, Michael, *The Most Beautiful Villages of Provence*, photographs by Hugh Palmer, London and New York, 1994.

Kaltenbuch, Ronald, *Le Guide de l'Alsace*, Paris, 1992.

Languedoc-Roussillon, Paris, 1988.

Le Lot. Pays de Quercy, Paris, 1985.

Madier, Monique, *Poitou-Charentes Limousin*, Paris, 1989.

Minvielle, Anne-Marie, *La France à pied*, Paris, 1993.

Normandie, Paris, 1988.

Pellerin, Pierre, *Nature Insolite en France*, Paris, 1983.

Latta, Claude, *Le Guide de la Corrèze*, Paris, 1991.

Pérès, Jean-Louis and Ubiergo, Jean, *Montagnes Pyrénées*, Paris, 1973.

Piquard, Maurice, *Jura. Franche-Comté. Belfort*, Paris, 1973.

Rossignol, Gilles, *Le Guide de la Champagne*, Paris, 1989.

Suffran, Michel, *Le Guide du Bordelais*, Paris, 1991.

Tocqueville, A. de, *La France d'Ile en Ile*, Paris, 1993.

Valéry, Paul, *La France*, Paris, 1951.

White, Freda, *Three Rivers of France: Dordogne, Lot, Tarn*, London, 1952.

Index

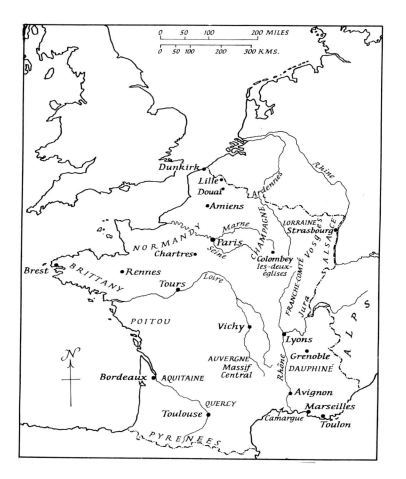